THE **EYE** IN THE TEXT

THE **EYE** IN THE TEXT

ESSAYS ON PERCEPTION, MANNERIST TO MODERN

Mary Ann Caws

PRINCETON UNIVERSITY PRESS • PRINCETON, NEW JERSEY

We should keep our eyes on eyes themselves,
eyes to see how they see.

—Balthasar Gracián
Arte de ingenio, tratado de Agudeza

And when I look in his eyes, it is not
 his eyes that I see.

—Donald Hall
"A Poet at Twenty"

Copyright © 1981 by Princeton University Press

Published by Princeton University Press, Princeton, New Jersey
In the United Kingdom: Princeton University Press, Guildford, Surrey

All Rights Reserved

Library of Congress Cataloging in Publication Data will be
found on the last printed page of this book

Publication of this book has been aided by a grant from the
Paul Mellon Fund of Princeton University Press

This book has been composed in Linotron Optima

Clothbound editions of Princeton University Press books
are printed on acid-free paper, and binding materials are
chosen for strength and durability

Printed in the United States of America by Princeton
University Press, Princeton, New Jersey

Designed by Laury A. Egan

for Peter

PRINCETON ESSAYS ON THE ARTS

1. *Guy Sircello*, A New Theory of Beauty
2. *Rab Hatfield*, Botticelli's Uffizi "Adoration": *A Study in Pictorial Content*
3. *Rensselaer W. Lee*, Names on Trees: *Ariosto Into Art*
4. *Alfred Brendel*, Musical Thoughts and Afterthoughts
5. *Robert Fagles*, I, Vincent: *Poems from the Pictures of Van Gogh*
6. *Jonathan Brown*, Images and Ideas in Seventeenth-Century Spanish Painting
7. *Walter Cahn*, Masterpieces: *Chapters on the History of an Idea*
8. *Roger Scruton*, The Aesthetics of Architecture
9. *Peter Kivy*, The Corded Shell: *Reflections on Musical Expression*
10. *James H. Rubin*, Realism and Social Vision in Courbet and Proudhon
11. *Mary Ann Caws*, The Eye in the Text: *Essays on Perception, Mannerist to Modern*

CONTENTS

LIST OF ILLUSTRATIONS xi
ACKNOWLEDGMENTS xv
PREFATORY NOTE xvi
ABBREVIATIONS xvii

INTRODUCTION • For a Poetics of Perception: Some
Strategies of the Private Eye 3

PART I • AT THE THRESHOLD OF THE TEXT

1 • About Thresholds 15

2 • The Eye in the Text: French Poetry from Reverdy to Jabès 20

PART II • FROM GESTURE TO CREATION

3 • Gesture, Gaze, and Mirror: From Designation to
Contemplation, Mannerist, Metaphysical,
and Surrealist 35

4 • Look and Gesture 49

5 • Reflections in a Rococo Eye: Arabesques and Serpentines 70

6 • Outlook and Inscape in Dada and Surrealism 87

7 • The Annunciation of the Text: Rilke and the Birth of the
Poem 104

PART III • HOMAGE TO MALLARMÉ

8 • Brancusi and Mallarmé, or, About an Egg 125

9 • Dada's Temper, Our Text: Knights of the Double Self 133

10 • Mallarmé and Duchamp: Mirror, Stair, and Gaming Table 141

PART IV • THE INNER SEEN

11 • Baroque Lighting in René Char 161

12 • The Art of André Malraux 168

13 • For a Cinema of the Central Eye: Saint-Pol-Roux to
Spatialism 174

14 • Dwelling on the Threshold 189

INDEX 201
ILLUSTRATIONS 207

LIST OF ILLUSTRATIONS

1. Magritte, *The False Mirror*. (1928, oil on canvas, 21¼ by 31⅞.) The Museum of Modern Art, New York.
2. Redon, *The Vision*. Bibliothèque Nationale, Paris. © S.P.A. D.E.M., Paris/V.A.G.A., New York.
3. Rembrandt, *Flayed Ox*. Louvre, Paris. Photo: Musées Nationaux.
4. Soutine, *Flayed Ox*. Musée de Grenoble. Photo: IFOT-Grenoble.
5. El Greco, *Laocoön*. National Gallery of Art, Washington, D.C., Samuel Kress Collection. Photo: Courtesy of the National Gallery.
6. Titian, *Venus and the Organ Player*. © Museo del Prado, Madrid. All rights reserved.
7. Tintoretto, *Leda and the Swan*. Galleria degli Uffizi, Florence. Photo: Anderson-Giraudon.
8. Desnos, "Vanity Memory of the Swan." Drawing accompanying the manuscript of *The Night of Loveless Nights*, 1928. Special Collections, the Library, The Museum of Modern Art, New York, and by the gracious permission of Dr. Michel Fraenkel.
9. Tintoretto, *Suzanne and the Elders*. Louvre, Paris. Photo: Musées Nationaux.
10. Titian, *Venus and Adonis*. © Museo del Prado, Madrid. All rights reserved.
11. Seghers, *St. Teresa in Ecstasy*. Koninklijk Museum voor Schone Kunsten, Antwerp. Courtesy of A.C.L. Brussels.
12. Bernini, *St. Teresa in Ecstasy*. Courtesy of Santa Maria della Vittoria, Rome. Photo: Alinari.
13. de La Tour, *Magdalen with the Vigil-Lamp*. Louvre, Paris. Photo: Musées Nationaux.
14. de La Tour, *Repentant Magdalen*. National Gallery of Art, Washington, D.C., Ailsa Mellon Brice Fund. Photo: Courtesy of the National Gallery.
15. Titian, *The Magdalen*. Hermitage, Leningrad. Photo: Giraudon.
16. Rossetti, *Beata Beatrice*. The Tate Gallery, London. Photo: Viollet.
17. Poussin, *Shepherds of Arcady*. Louvre, Paris. Photo: Musées Nationaux.
18. Uccello, *Battle of San Romano*. Louvre, Paris. Photo: Musées Nationaux.
19. Titian, *Noli me tangere*. National Gallery of Art, Washington, D.C. Photo: Courtesy of the National Gallery.

20. Correggio, *Noli me tangere.* © Museo del Prado. All rights reserved.
21. Bologna, *Mercury.* Louvre, Paris. Photo: Musées Nationaux.
22. Brancusi, *Bird in Space.* The Museum of Modern Art, New York.
23. Il Parmigianino, *Self-Portrait in a Convex Mirror.* Kunsthistorisches Museum, Vienna.
24. Titian, *Venus of Urbino.* Galleria degli Uffizi, Florence. Photo: Alinari.
25. Ecole de Fontainebleau, *Woman at her Toilette.* Courtesy Musée de Dijon. Photo: André Berlin.
26. Ecole de Fontainebleau, *Woman at her Toilette.* Courtesy Worcester Art Museum.
27. Clouet, *Diane de Poitiers.* Cook Gallery, Richmond. Photo: Anderson-France.
28. France, second half of the sixteenth century, *Portrait of Gabrielle d'Estrées in her Bath.* Musée de Condé, Chantilly. Photo: Lauros-Giraudon.
29. Ecole de Fontainebleau, *Double Portrait of Gabrielle d'Estrées and her Sister.* Louvre, Paris. Photo: Musées Nationaux.
30. Ecole de Fontainebleau, *Gabrielle d'Estrées and the Duchesse de Villars.* Hôtel de Lunaret, Montpellier. Photo: Lauros-Giraudon.
31. Bordone, *The Chess Game.* Staatliche Museen Preussischer Kulturbesitz, Gemälde-Galerie, West Berlin. Photo: Jörg P. Anders.
32. De Chirico, *The Enigma of Fatality.* Kunstmuseum Basel, Depositum Emanuel Hoffmann-Stiftung.
33. Desnos, "In the Middle of Signaling Fists and Fingers." Drawing accompanying the manuscript of *The Night of Loveless Nights.* Special Collections, the Library, the Museum of Modern Art, New York, and by gracious permission of Dr. Michel Fraenkel.
34. César, *Thumb.* Centre Georges Pompidou, Paris. Photo: Musée National d'Art Moderne, Paris.
35. Duchamp, *Encore à cet astre.* Arensberg Collection, Philadelphia Museum of Art.
36. Duchamp, *Etant donnés.* Arensberg Collection, Philadelphia Museum of Art.
37. Hopper, *Rooms by the Sea.* Courtesy of Yale University Art Gallery, Bequest of Stephen Carlton Clark, B.A., 1903.
38. Magritte, *Poison.* Edward James Foundation, Sussex. Courtesy of L. M. Bickerton.
39. Magritte, *The Month of Harvest.* Private collection. Courtesy of A.D.A.G.P. Alain Robbe-Grillet/René Magritte, *La Belle Captive.* Photo: Bibliothèque Nationale.

40. Magritte, *In Praise of Dialectic*. Musée d'Ixelles, Brussels. Courtesy of A.D.A.G.P. Photo: Lauros-Giraudon.
41. Magritte, *Reproduction Forbidden*. Museum Boymans-van Beuningen, Rotterdam. Copyright Frequin-Photos. Courtesy A.D.A.G.P.
42. Magritte, *The House of Glass*. Museum Boymans-van Beuningen, Rotterdam. Copyright Frequin-Photos. Courtesy A.D.A.G.P.
43. Martini, *The Annunciation*. Courtesy of the Koninklijk Museum voor Schone Kunsten, Antwerp.
44. Masolino da Panicale, *The Annunciation*. National Gallery of Art, Washington, D.C., Andrew Mellon Collection. Photo: Courtesy of the National Gallery.
45. Lippi, *The Annunciation*. National Gallery of Art, Washington, D.C., Samuel H. Kress Collection. Photo: Courtesy of the National Gallery.
46. Barberini, *The Annunciation*. National Gallery of Art, Washington, D.C., Samuel H. Kress Collection. Photo: Courtesy of the National Gallery.
47. Maître de Moulins, *The Annunciation*. Courtesy of the Art Institute of Chicago.
48. Rossetti, *The Annunciation*. The Tate Gallery, London. Photo: N. D. Roger-Viollet.
49. Tintoretto, *The Annunciation*. Staatliche Museen zu Berlin, Gemälde Galerie, West Berlin.
50. Tintoretto, *The Annunciation*. Scuola di San Rocco, Venice. Photo: Alinari.
51. Titian, *The Annunciation*. Cattedrale, Treviso. Photo: Alinari.
52. Titian, *The Annunciation*. Scuola di San Rocco, Venice. Photo: Anderson-Viollet.
53. Poussin, *The Annunciation*. Musée Condé, Chantilly. Photo: Lauros-Giraudon.
54. Poussin, *The Annunciation*. The National Gallery of Art, London.
55. Brancusi, *Beginning of the World*. Musée National d'Art Moderne, Paris. Photo: Musées Nationaux.
56. Brancusi, *Beginning of the World*. Dallas Museum of Fine Arts, Foundation for the Arts Collection, gift of Mr. and Mrs. James H. Clark. Photo: Bill Strehorn.
57. Poussin, *The Blind Orion Searching for the Rising Sun*. The Metropolitan Museum of Art, New York, Fletcher Fund.
58. Poussin, *Moses Saved from the Waters*. Louvre, Paris. Photo: Musées Nationaux.
59. Garnier, "Soleil Mystique." From *Spatialisme et Poésie concrète*, © Editions Gallimard, Paris, 1968, pp. 168-169.

60. Ray, Passage from *Les Métamorphoses du biographe, suivi de la Parole possible,* © Editions Gallimard, Paris, 1971, pp. 118-119.
61. Caravaggio, *St. Jerome.* Galleria Borghese, Rome. Photo. Il Gabinetto Fotografico Nazionale.
62. Magritte, *L'Oeil.* Collection of Madame Georgette Magritte, Brussels. Alain Robbe-Grillet/René Magritte, *La Belle Captive.* Photo; Bibliothèque Nationale. Courtesy A.D.A.G.P.

ACKNOWLEDGMENTS

THE FOLLOWING ESSAY is based on research supported by the John Simon Guggenheim Memorial Foundation, the Senior Fulbright-Hays Fellowship Program, and the Research Foundation of the City University of New York. Initially, the inquisitive and witty students of the Graduate School of the City University of New York and of Princeton University encouraged these odd forays into the perception of certain thresholds: they have my warmest gratitude.

My thanks to the Coda Press and the University of Iowa for permission to reprint the essay on "Dada's Temper: Our Text" from *Dada Spectrum: the Dialectics of Revolt*, 1978); to the *Millennium Film Journal* (no. 1, 1978), for permission to use the essay-manifesto "For a Cinema of the Central Eye"; and to the *New York Literary Forum*, who first printed the essays "Baroque Lighting in René Char" (no. 2, Intertextuality issue, 1978), and, under another title, "The Art of André Malraux" (no. 3, Malraux issue, 1979). Another version of Chapter 3 appears in French in *Mélusine*, no. 1, 1980.

I gratefully acknowledge the permissions to quote from John Ashbery, *Self-Portrait in a Convex Mirror*, New York: Viking Penguin, 1975, © John Ashbery; from William Carlos Williams, *Collected Earlier Poems*, New York: © New Directions, 1938; from Robert Creeley, *Pieces*, New York: Scribner's, 1969, © Robert Creeley; from my translations of Tristan Tzara, *Approximate Man and Other Writings*, Detroit: © Wayne State University Press, 1973; from Rainer Maria Rilke, *Gesammelte Werke*, Frankfurt: Insel Verlag, 1938; from Yves Bonnefoy, *Poèmes*, Paris: © Mercure de France, 1978.

In the preparation of the manuscript, Joan Dayan and Dona de Sanctis gave me invaluable aid, as did Lisa Goldfarb, on whom fell also the brunt of collecting permissions; Jerry Sherwood and Rita Gentry of Princeton University Press contributed their patience and their good and good-humored advice.

In various forms and alterations, some of these chapters have profited from the generous comments of many colleagues, especially Klaus Berger, Dorrit Cohn, Arthur Danto, Victor Lange, and in particular, Peter Caws, for whose reading and whose perception I am more than grateful.

PREFATORY NOTE

IN GENERAL, I have given, for the poetry the original and my translation, and the latter alone for the prose. For prose poetry and poetic prose, I have made a subjective choice of the passages it seemed essential to give also in the original. The illustrations are arranged in juxtaposition, so that some implicit and explicit references can be clearly seen in the doublings, and others suggested.

ABBREVIATIONS

A Blaise Cendrars, *Aujourd'hui* (Paris: Grasset, 1931).

AI E. H. Gombrich, *Art and Illusion* (Princeton, Princeton University Press, 1960).

AM Tristan Tzara, *Approximate Man and Other Writings of Tristan Tzara*, ed. and trans. Mary Ann Caws (Detroit: Wayne State University Press, 1973).

An Louis Aragon, *Anicet, ou le panorama* (Paris: Gallimard, 1921).

AP Yves Bonnefoy, *L'Arrière-Pays* (Geneva: Skira, 1972).

Ar Antonin Artaud, *Oeuvres complètes* (Paris: Gallimard, 1956).

AVP Rudolf Arnheim, *Art and Visual Perception* (Berkeley, University of California Press, 1969).

B Athena Tacha Spear, *Brancusi's Birds* (New York: New York University Press, 1969).

C Robert Desnos, *Cinéma*, ed. Andre Tchernia (Paris: Gallimard, 1966).

Cr Michael Cayley, ed., *Richard Crashaw* (Oxford: Carcanet Press, 1972).

CV Saint-Pol-Roux, *Cinéma vivant* (Paris: La Rougerie, 1972).

Da George Ribemont-Dessaignes, *Dada* (Paris: Projectoires/Champ libres, 1974).

DLS Yves Bonnefoy, *Dans le leurre du seuil* (Paris: Mercure de France, 1975).

E Edmond Jabès, *Elya* (Paris, Gallimard, 1969).

EAP Harvey Allen, ed., *The Complete Tales and Poems of Edgar Allan Poe* (New York: Random House, 1938).

FV Brian Woledge, Geoffrey Brereton, and Anthony Hartley, ed., *Penguin Book of French Verse* (Harmondsworth: Penguin, 1975).

H Jules Laforgue, "Hamlet" in *Moralités, Légendes* (Paris: Gallimard, 1977).

Ha Yves Bonnefoy, *Haiku* (Paris: Arthème Fayard, 1977).

IO Lionel Ray, *L'Interdit est mon opéra* (Paris: Gallimard, 1963).

ITP Charles S. Singleton, ed., *Interpretation: Theory and Practice* (Baltimore, Johns Hopkins University Press, 1969).

L Saint-Pol-Roux, "Liminaire," in *Les Reposoirs* (Paris: Rougerie, 1972).

LQ Edmond Jabès, *Le Livre des questions* (Paris: Gallimard, 1963).

LR Edmond Jabès, *Le Livre des ressemblances* (Paris: Gallimard, 1978).

M Stéphane Mallarmé, *Oeuvres* (Paris: Pleiade, 1945).

MI Stéphane Mallarmé, *Igitur, Divagations, Un Coup de Dés* (Paris: *Poésie/Gallimard*, 1978).

MP Helen Gardner, ed., *The Metaphysical Poets* (Harmondsworth: Penguin, 1957).

MS Marcel Duchamp, *Marchand du sel: Ecrits de Marcel Duchamp* (Paris, Le Terrain Vague, 1958).

N André Breton, *Nadja* (Paris: Gallimard, 1928).

NA Allison, Barrows, Blake, Carr, Eastman, English, eds., Norton Anthology of Poetry (New York: Norton, 1975).

NH Stéphane Mallarmé, *Noces d'Hérodiade*, ed. Gardner Davies (Paris: Gallimard, 1962).

NP René Char, *Le Nu perdu* (Paris: *Poésie/Gallimard*, 1978).

NR Yves Bonnefoy, *Le Nuage Rouge* (Paris: Mercure de France, 1977).

P André Breton, *Poèmes* (Paris: Gallimard, 1955).

PP Louis Aragon, *Le Paysan de Paris* (Paris: Gallimard, 1923).

S Sidney Geist, *Brancusi: A Study of Sculpture* (New York: Grossman, 1968).

SP John Ashbery, *Self-Portrait in a Convex Mirror* (New York: Viking, 1975).

Tz Tristan Tzara, *Oeuvres complètes*, ed. Henri Béhar, 2 vols. (Paris: Flammarion, 1975 and 1977).

VS André Malraux, *Les Voix du silence* (Paris: Gallimard, 1951).

THE EYE IN THE TEXT

INTRODUCTION

FOR A POETICS OF PERCEPTION: SOME STRATEGIES OF THE PRIVATE EYE

All perceiving is also thinking, all reasoning is also in-
tuition, all observation is also invention.
—Rudolf Arnheim,
Art and Visual Perception

ON SEEING

ONE OF THE MAJOR PROBLEMS of the textual critic is learning to see and learning to pass on that knowledge. I would like to begin with that commonplace and to consider some ways of training the literary eye, of giving it proper and sustained *in-struction*, in the etymological sense, so that it might perceive inner structures and relations and relate them to its own complex knowledge and experience and to the outer context.[1] If, as the nineteenth century termed it, "the innocent eye" is never again to be ours[2]—for we cannot *de-cultivate* our vision and our past—then we must manage to maintain both our knowledge and our flexibility together with a fresh insight and outlook. Rudolf Arnheim's statement in his *Art and Visual Perception* seems to me to be conceived along the right lines: "It is the purpose of this book to discuss some of the virtues of vision and thereby to help refresh and direct them."[3]

To keep the vision immediate and yet to find, or even supply, a connecting thread between disparate objects that will serve to renew the mind by its relations was the preoccupation of the surrealists, which we take as our own inheritance. The most farsighted critic should at the same time keep his eye trained upon the object at hand and on the inner object. In pondering this paradox of the in-training and the instruction of the eye, the literary critic might turn for imaginative exercise first to one of the most obvious and approachable of trainers, Ernst Gombrich, who states

[1] Peter Caws is at the origin of my interest in this term.

[2] See E. H. Gombrich, "The Evidence of Images," in *Interpretation: Theory and Practice* (Baltimore: Johns Hopkins University Press, 1969), p. 43. Hereafter cited as ITP.

[3] Rudolf Arnheim, *Art and Visual Perception* (Berkeley and Los Angeles: University of California Press, 1969), p. vii. Hereafter cited as AVP.

the preparation or instruction quite simply: "Thus the visual arts have taken on the role of exercises in the variability of vision" (ITP, p. 43). Theoretical phenomenology and psychology of perception may help in the practical refreshing of the literary gaze; these essays in seeing are meant, however, as examples only, with no claim as to their theoretical or psychological usefulness beyond their limited practice.

The private eye, I call this, because I see the visual object not as an exterior element, but rather inside the subject in what I think of as an inner seen. In the meditations on line, gesture, and structure, on the deictic and the reflective and self-reflective, on reversals and linkings, complications, and clusters, the surface texture may capture the eye as Magritte's clouds capture the film of the eye, although to profit from the fullest range of correspondences, the eye must be permitted to link and to continue (figure 1). Both the strategies of arrest and the strategies of correspondence and continuity may act as eyeopeners to an expanded threshold of perception. The eye here occupies the center of the stage, as in Redon's *Vision*, to be observed and perceived as an act unto itself and about itself (figure 2).

TRAJECTORY AND DEVICE

Now I have left the principal problem dangling by suppressing an un-likeness of terms; the distance between the verbal and the visual cannot, perhaps, be so simply bridged (AVP, p. 7). If, as Arnheim says, "All seeing is the realm of the psychologist," and it is art history which Wölfflin describes as "the history of seeing,"[4] then the psychology of perception is bound to fall in one or the other of those realms, by right. Has the literary critic the right to his own share in that realm?

One of Gombrich's best-known essays was originally entitled "How to Read a Painting," and the literary critic may well write, and not only about concrete poetry, "How to See a Text."[5] Gombrich's discussion, in *Art and Illusion*, of the "beholder's share" or the participatory perception widespread in contemporary culture, is an invitation to our own constructive creation and re-creation of the texts and intertexts we claim as our field, reminding ourselves always that this "Far Field" must remain also near and present, that all fields are open, adjacent, and mutually fertilizing for the eye.

[4] Quoted in Gombrich, *Art and Illusion, a Study in the Psychology of Pictorial Representation* (Princeton: Princeton University Press, Bollingen Series, no. 5, 1960), p. 17. Hereafter cited as AI.

[5] Later called "Illusion and Visual Deadlock," in Gombrich, *Meditations on a Hobby Horse* (London: Phaidon, 1963).

I have tried elsewhere[6] to demonstrate, in relation to French poetry, an open approach to reading and to second readings of the poetic text that would include both intuitive and analytic methods, adaptable to the particular poem under study; I should like now to extend that attempt to the interrelations between visual and verbal texts, that demand, just as surely, an approach not predetermined but adjustable.

The choice of the way stations or moments observed along this way of interpretation and double-focused seeing has been made according to what one might call a criterion of textual self-consciousness. It is certainly not a question here of influence of one art upon the other, but rather of their meeting in the place of the mind's own reflection in its working. The movements of particular interest are precisely those in which the text whether painted, sculpted, or written reflects upon itself and the lines along which it is drawn; from Mannerism and Baroque to Rococo, from Symbolist to Surrealist and into contemporary reflections, the instructed eye sees afresh, refusing the habitual and the classic balance of gesture and word. The art is off-centered and highly gestural. So too the commentary upon it, decentered and decentering in a multiple play of shifting perspective, altered stress, and vivid relighting. So the play is recast according to the textual systems chosen, those where a passionate gaze contemplates both gaze and passion. The nervous intensity of the moments and movements considered here is singular, and often uncomfortable.

As Gombrich studies one and another "device to prevent a consistent reading" (AI, p. 284), that is, to train that responsiveness of vision in which I assume it is the practice of the good critic to instruct himself and others, I should like to attempt, however modestly, to present a loosely-framed series of strategies for seeing, aimed at the preservation of what is vital in perception, what is the "moving life and liveliness" of the gaze and of the text.[7] Each age has, says Mario Praz, its handwriting and its own version of the spatial and temporal interpenetration that forms the basic exterior justification for the present essays, whether or not that interpenetration be conscious in its realization.[8] In consequence the style

[6] For instance, "Antonin Artaud: Suppression and Sub-Text," in Mary Ann Caws, ed., *About French Poetry from Dada to Tel Quel: Text and Theory* (Detroit: Wayne State University Press, 1974); *Presence of René Char* (Princeton: Princeton University Press, 1976); *The Surrealist Voice of Robert Desnos* (Amherst: University of Massachusetts Press, 1977).

[7] Murray Krieger, "Mediation, Language, and Vision in Literature," in *Interpretation: Theory and Practice*, p. 234. Krieger insists, in opposition to Poulet, that the poem should not give up its paradox of "unmoving movement at the heart of the stillness of the Keatsian urn" and simply yield to "the boundless, caseless flow of our experience" (p. 232). My sympathies are in this case with Krieger's position.

[8] Mario Praz, *Mnemosyne: The Parallel Between Literature and the Visual Arts* (Princeton: Princeton University Press, Bollingen Series, no. 16, 1970), p. 27, and title of final chapter.

of these essays may seem to alter according to the changing expression of the text observed.

"To have a good eye," a critical and self-critical awareness not only of the allusions and ellipses and densities of the perceived text or visual object, but also of the relations between them, should inform and direct an adequate reading. In Michael Riffaterre's view of intertextuality, to choose the critic who has best explored the subject, knowledge of the previous text as the referent of the object under consideration prevents any other reading of the latter, whose very ungrammaticality may point back to the grammaticality of the entire system as a whole. The clue is given by a sign (or a series of signs) that "translates the text's surface signs and explains what else the text suggests." The revelation is no less luminous for its certainty, and all the best critics have their moments of passion: "when the structural equivalences become apparent all at once, in a blaze of revelation."[9]

In the realm of visual arts also, intertextuality blazes.[10] Leo Steinberg's discussion of "Rustling" prefacing *Art about Art* makes a brilliant display of the fashion in which a specific image, here that of a horse raising a delicate knee to a velvet mouth, is passed along from artist's hand to artist's hand, not as a robbed possession but in homage to a tradition.

With all due respect to the right and the evident, I should like in my own work to temper this discoverable reading with some private obsessions, in no way proper to reading, although, regrettably perhaps, rarely of an exciting impropriety (with the possible exception of the pointing finger in my study of Mannerism). I have time and time again fallen willingly into the clutches of that animal bodied forth by an obsessive overall interpretation into whose maw everything can be swallowed—

[9] The quotations in this paragraph are from Michael Riffaterre, *Semiotics of Poetry* (Bloomington: Indiana University Press, 1978), pp. 81 and 166. In art too, "proper" or correct readings have their place, and the fullest and best reading is determined by the references, as in Panofsky's crack about art historians, quoted by Steinberg: "He who has the most photographs wins" (in "The Glorious Company," *Art about Art*, ed. Jean Lipman and Richard Marshall, New York, Dutton, 1978, p. 10).

[10] This second "blaze" may be seen—intertextually—as an allusion to the Sherlock Holmes' story about horse-stealing, "Silver Blaze," of which Peter Caws reminded me. The discussion of "Rustling" occurs in Leo Steinberg, "The Glorious Company," in *Art about Art*, ed. Lipman and Marshall, especially pp. 8-9. Never was an animal better treated, and this eulogy of a good steal makes a superb read; the critic given to the creation of linguistic bridges might envision Steinberg's study and Riffaterre's together, entitled by a telescoping: "The Horse as Hypogram." Henri Peyre suggests "Hippogram," which perfectly fits my hippothesis.

the friendly monster Panofsky called the Boa Constructor,[11] creator of a sort of private myth for what I think of as the private eye. That animal may take up more than the renowned beholder's share, and Gombrich says that we should make of him our friend and our necessary companion; that I have done. Wanting above all to give a true picture of the dynamic tension between the visual and the verbal in one mind but deliberately askew in correspondence with that fruitful tension Arnheim comments on between observer and observed, I have leaned to the side of decentering and of cobuilding, of reconstruction and what I mean as a textual metaphor related to architecture, discussed in the final part of this introduction under the title of "architexture."

In the sharing of consciousness, in that passage from interior to exterior and vice versa, best illustrated by my final chapter on the *inner seen*, dealing in part with the cinematic gesture as it is defined by its reception, not only the visual suppositions and suggestions are to be investigated but also the perspective the observer adds, a willingness to employ slight deformations, oddly enriching in all their tensions. It is clear that the reception-aesthetics of such critics as Hans Robert Jauss and Wolfgang Iser[12] can be taken as the background support for such decentering and such multiple perspectives on the text, while I prefer to place in the foreground for this preface my primary emphasis on the studies of Gombrich, Steinberg, and Arnheim, all the more valuable as they are not commentators of the literary text. For the critic involved in bridge making, the far field (with apologies to Roethke) may seem to shine more fair.[13]

Considering that the maze made in one observer's mind, with all its perplexing and obsessive figures and its intricate array of textual shards and visual fragments, is worth exploring at length, and all the more so if it can shed some illumination on the object observed without, I have tried to maintain the threshold stance in linguistic expression that would

[11] Quoted by Gombrich, in "The Evidence of Images," in *Interpretation, Theory, and Practice*, p. 71.

[12] In particular, Wolfgang Iser, *The Implied Reader and the Act of Reading* (Baltimore: Johns Hopkins University Press, 1974 and 1978). Iser's theories of literary effects and responses are based on the genre of the novel, "since this is the genre in which reader involvement coincides with meaning production" (p. xi, Introduction). The text for Iser prestructures the potential meaning, which the reader actualizes or discovers. (I would argue, I think, with the prestructuring, and thus allow for an unpredictable discovery; but I can only heartily support the process of the reader's self-awareness of the nature of his faculties of perception, and the development of these faculties which Iser encourages, as the reader establishes "for himself the connections between perception and thought") (p. xix). With the various perspectives the text offers, he sets the work in motion and with it, his own responses, increasingly dynamic.

[13] Theodore Roethke, *The Far Field* (New York: Doubleday, 1964).

approximate, as nearly as possible, the double vision already described. Thus the word play and the reversals and interruptions of imagery are meant to remain true to the text. Arnheim quotes Braque's advice to the artist "to seek the common in the dissimilar. 'Thus the poet can say: The swallow knifes the sky, and thereby makes a knife out of a swallow' " (AVP, p. 435). I have attempted also to seek the uncommon in the similar, and the dissimilar in what is commonly perceived.

For example, the arabesques of Rococo and its own serpentines may render the path more agreeable, like a winding *allée*, from Pope to Poe, from Rousseau to Valéry and to the Surrealist passage along arcade and garden. As for the game, the chess and checkered garden of Paris Bordone and the Game of Chess of Marino may be replayed by the "checker'd shade" of an eighteenth-century garden (perhaps even in some Windsor Forest) and the dice Mallarmé throws may lead, by chance, to a twentieth-century Chateau de Dé as well as to a chess game by Duchamp, Man Ray, or de Chirico. The eye, like the mind, should be a roving one.

TEXTURALITY AND ARCHITEXTURE

Arnheim maintains that the "literary image grows through accretion and by amendment" (AVP, p. 249), and I would assume that each reading enriches each text by its own additions and deformations. As Georges Poulet's merging of consciousness between reader and author and text repersonalizes reading, stressing both an "interior distance" and a presence to the text,[14] I should like to stress the *camera obscura* as a metaphor of reading, with its mingling of interiorization—taking its own enclosed view of its own objects—and density, its darkness and its vision, toward its end: that of *developing*. To find an equivalent stylistic expression for its peculiar mental self-reference and labyrinthine intercameral connections would be the object of an investigation far lengthier than this one. But I have tried to make some overt stylistic expression of the eye-catching complications in which the observing I is caught. In certain instances of these essays, the style calls attention to its own texture and its knots, with an intention parallel to the making strange of some Russian theorists, the *Ostraneniye* or defamiliarization of the surface, in order that it be seen. These punning and playing passages are supposed to seize the gaze and

[14] Georges Poulet, in particular "The Phenomenology of Reading," *New Literary History*, 1 (Fall, 1969), 53-68. Whereas objects, says Poulet, are closed, the book demands our presence: "You are inside it; it is inside you; there is no longer either outside or inside" (p. 54). The consciousness is one with its object, thinks another's thoughts, speaks, feels, suffers as another: "The work is a sort of human being . . . constituting itself in me as the subject of its own objects" (p. 59).

hold it, slowing down the mental transcription into message, lest, as Gombrich says, the surface be lost. "Losing the surface" (ITP, p. 59) may be essential to transparent rendering of content, but in this instance I do not believe that what is desired is a see-through style. Here I have wanted to stress the problems of the passage from outside to in, along the lines of the text upon the text: describing a Mannerist architecture, Gombrich speaks of the play of "punning inside and out," and the description perfectly fits.[15] Presumably, the "water" of a mirror should not deform, nor the "mirror" of a water, or then they should not be called upon to mirror; art, on the other hand, deforms in order to be, for it begins where deformation begins and ceases where deformation ceases.[16] *The play of the light of the mind*: thus I would define the object of these essays, reflecting on the further play of that light and that dark chamber. This is the meaning I would choose to assign also to texture; Gombrich defines it fittingly: "the way, that is, in which light behaves when it strikes a particular surface" (AI, pp. 43-44).

The texture, then, may catch the light, may arrest the awareness as an image or a phrase is oblique or arresting, and these stops in language are designed to signal the rough weave of the textual surface, becoming textural. As the dark and dense visual moments capture the gaze and illuminate it, as the intertwinings of the verbal ensnare in their most fertile complications, so does construction, private and collective, of these rough passages in their interreferential shifts and their structural relations compose what I call their *architexture*.[17]

By *architexture* I mean in general to refer to the combination of structure and texture visible in a given work and its constructive attachment to other works in an overall building developed in the reader's mind. Of this building, a passageway between two works would be part: the construction takes place starting there. Within the term, the emphasis falls on the surface of the text and on the building process equally. (Gérard Genette's recent *Introduction à l'architexte* uses the term in a different sense from mine, as he points out referring to a previous work of mine.)[18] I mean to retain also the idea of a private architexture, the subject of another work, *A Metapoetics of the Passage: Architextures in Surrealism and After*.

[15] Gombrich, "Illusion and Visual Deadlock," *Meditations on a Hobby Horse*, p. 154.

[16] Taylor, *Design and Expression in the Visual Arts* (New York: Dover, 1964), p. 3.

[17] For example, "Vers une architexture du poème surréaliste," in *Éthique et esthétique de la littérature française du XXᵉ siècle*, ed. Cagnon (Stanford: Anma Libri, 1977), pp. 59-68.

[18] "Passage du poème: interrogation du seuil," *CAIEF*, no. 30, May (1978), pp. 225-243. Here he refers to the second of the above writings.

Architexture is meant, in brief, to stand for the building of the text as it is seen and is formed with the reader's collaboration, special attention being given to the surface of the building material, its *texturality*. T. E. Hulme, speaking of poetry, defines the knottiness I am here trying to describe:

> It always endeavors to arrest you, and to make you continuously see a physical thing, to prevent you gliding through an abstract process. It chooses fresh epithets and fresh metaphors, not so much because they are new, and we are tired of the old, but because the old cease to convey a physical thing and become abstract counters.[19]

I am speaking then of the very physicality of the texture. Here the textual and the intertextual are further knotted in special ways on special occasions, such as the Mannerist and Baroque, the Symbolist, and the Surrealist: I have therefore taken the liberty of terming them *texturality* and *architexture*, meaning the inconstant and obsessive co-constructions of observer and texts, where a roughness and deformation signal the high points of interest. I have, for instance, added or subtracted letters, in what I intend as my own modest gesture toward the text. It is again a matter of not losing the surface, either through automatic reactions or through a classic transparency-to-the-message. If we think of Sartre's distinction between poetry and prose,[20] then we shall easily understand why the poem of vision as we see it in its intertextural complications necessitates arrests and meanders, both at the stylistic or surface level, and deep underneath, in the recesses of the chamber of the mind.

[19] T. E. Hulme, "Romanticism and Classicism," in *Speculations*, ed. Herbert Read (New York: Harcourt, Brace, 1924), pp. 134-135.

[20] In *Qu'est-ce que la littérature* (1946), reprinted in Jean-Paul Sartre, *Situations II* (Paris: Gallimard, 1948), p. 75 on the transparency of prose style, and *passim*. On the contrary, for poetry, as for art, the surface holds the message: "Cette déchirure jaune du ciel au-dessus du Golgotha, le Tintoret ne l'a pas choisie pour *signifier* l'angoisse, ni non plus pour la *provoquer*; elle *est* angoisse, et ciel jaune en même temps. Non pas ciel d'angoisse, ni ciel angoissé; c'est une angoisse faite chose, une angoisse qui a tourné en déchirure jaune du ciel et qui, du coup, est submergée, empâtée par les qualités propres des choses, par leur imperméabilité, par leur extension, leur permanence aveugle, leur extériorité et cette infinité de relations qu'elles entretiennent avec les autres choses; c'est-à-dire qu'elle n'est plus du tout lisible" (p. 61; This yellow rent in the sky above Golgotha was not chosen by Tintoretto to *signify* anguish, nor to *provoke* it; it *is* anguish and yellow sky at the same time. Not a sky of anguish, nor an anguished sky; it is an anguish made thing, an anguish which has turned into a yellow rent in the sky and which is at once submerged and rendered denser by the qualities proper to things, by their impermeability, by their extension, their blind permanence, their exteriority and this infinity of relations which they maintain with other things; that is to say it is no longer readable at all).

In sum, this poetics of perception insists upon the immediacy of the eye and upon an *intertexturality* of the visible and the audible and the understandable in their mobile interrelations. Its primary concern is to point to the surface, with its implied tension, and to some connecting threads. This double exposure to the visual and the verbal, by repeated acquaintance or in the rapid flicker of a nervous gaze, is meant to illuminate the play and attractions of text and mind, which a passionate reading informs.

PART I

AT THE THRESHOLD
OF THE TEXT

1

..

ABOUT THRESHOLDS

Ma place est au seuil.
(My place is on the threshold.)

—Edmond Jabès
Le Livre des questions

THIS WORK is dedicated to the lure of threshold imagery, as in the title of
Yves Bonnefoy's epic poem *Dans le leurre du seuil*. Whether or not the
less used Greek sense of *limen* as refuge or harbor is added to the far
more widespread Latin sense of *limen* as threshold, the present awareness
of liminality and its applications is of far reach.[1] This broad threshold
includes at once the multiple notions of border, hinge, and articulation—
Jacques Derrida's concept of *brisure* or the joining break neatly resuming
those meanings—of beginning and exit, of the place for crossing-over,
and of the link between inside and out. Any serious mention of liminality
has to take into account the anthropological notions of passage and its
rites; their largely metaphoric use here is illustrative of a certain form of
thinking in contemporary poetics.

I might have extended the present investigation toward that of the
mise-en-abyme, the setting of settings one inside the other, like so many
nesting boxes, or infinitely receding thresholds, but have preferred to
limit myself to a simple study of the place-for-passing-through and the
fascination with that passage itself, in an architexture[2] of textual construc-
tion, less stable than a regular architecture, and more open to change.
There is no pretense here of monumentality.

[1] The *limen* or threshold in its primary meaning here is responsible for the term "liminal
poetics," and a fitting beginning for a text situated on the threshold. See the work of Van
Gennep, Turner, and so on, discussed at greater length in my *A Metapoetics of the Passage:
Architextures in Surrealism and After* (Hanover, N.H.: The University Press of New England,
1981); Van Gennep, *Les Rites du Passage* (Paris: Nourry, 1909); Victor Turner: *Drama,
Fields, and Metaphors* (Ithaca, New York: Cornell University Press, 1974). For a study of
the threshold and its rites, see Henry Clay Trumbull, *The Threshold Covenant* (New York:
Scribners, 1896). My colleagues Angus Fletcher (*The Prophetic Moment: an Essay on Spen-
ser*, Chicago: University of Chicago, 1971) and Rosalind Krauss (*Passages in Modern Sculp-
ture*, New York: Viking, 1977) have concerned themselves previously with such topics and
titles.

[2] See my explanation in the very brief introduction to a poetics of perception included
here.

The following pages are meant as a putting-into-practice of the stated attitude of reciprocal sensitivity between art and literature, as an application of the textual psychology of the in-between, like Hölderlin's *zweilicht* or the French *entredeux*, of which Michel Deguy speaks most convincingly:

> Le seuil-partage qui laisse jouer la porte par où s'entrebaille le monde pour un être qui parle, c'est en cette utopie que se tient le poème, transporté à chaque lisière où joue ainsi la différence dans sa figure.[3]

> The sharing threshold which gives play to the door where the world yawns slightly open for a speaking being; in this utopia stands the poem, transported to each boundary where the difference plays thus in its figure.

As to the location of the threshold, the spaces and times it joins and separates, widely differing responses are required by the various incursions into the textual passage and simultaneously into the individual reader's state of mind: to some degree the choice, illustrative only, remains arbitrary. That the scope of the essays included here should extend from Mannerism to Symbolism, Dada, Surrealism, and Spatialism, and should include a double visual and textual component is only an indication that the crossing-over does not choose to set its limits too narrowly. These are intended as practical readings of text and canvas and image and film, set deliberately on the threshold where flexibility may be assumed to reign, rather than within a system: set at the outskirts of a structure; set, that is, on a margin and in a marginal moment, between speech and silence.

In Aragon's autobiography, *Je n'ai jamais appris à écrire ou les Incipit* (I Have Never Learned to Write or the Incipit), a perfect image of the threshold in all its implications is mentioned in passing.[4] Matisse's "Porte-fenêtre" or "Door-Window" expresses the double point of juncture between inside and outside—between looking toward the exterior or the interior—and the scene on which the opening or outlook opens—between the gaze and the gazed-at. Here my text takes its double beginning, for the threshold is meant to face both ways by its nature and its intentional function: the simplest page or image can be, simply stated, a place of passage.

How much space can one make on the threshold, how much time can be given to its traversal? What is the relation of the *limen* to the

[3] Michel Deguy, *Figurations* (Paris: Gallimard, 1960), p. 47.
[4] (Geneva: Skira, 1969).

corridor, of the boundary moment experienced to the leisurely stroll through some connecting passage, from here to there? How is the door through which the passage is made actively related to the window through which the look passively receives, or then actively creates? These questions lie implicit at the basis of these essays; the central question raised here is first to be posed backwards, for it deals with Baudelaire's poem on windows, "Les Fenêtres" and by implication with Mallarmé's, a year earlier: can we now learn to value sufficiently, as do the Symbolists, the dark window through whose frame we gaze, filling it with the substance of our own imagination? Must our look at the text be uniquely receptive, or may we pass through it—that is to say, is there room, even now, or now in particular, for the self-regarding text?

Such a threshold for the gaze seems plainly subjective, as is the focus of the look: but the point is not the text in the eye, but the I too, in the text itself. From this perspective, this dual-faced image should illuminate the double textual interest; the poem is seen as mandala, as gesture, as scene, and it is endowed with a certain lighting, whether Baroque or Symbolist or Dada or Surrealist or then Metaphysical, whether the lighting is diurnal or nocturnal or "à contrejour."

Pierre Reverdy, and the surrealists after him, would have had us select elements from diametrically opposed fields in order to provide the proper illumination for our perception: yet any attempt at juxtaposing the visual and the verbal may encounter grave obstacles, exterior as well as interior.[5]

Occasionally, the choice is unproblematic for most viewers, for instance, of three of Picasso's lithographs of a lamp and a table and some fruit, only one may correspond to the lighting of a certain poem containing the same objects. One depiction of a scene or figure may prevail over another and constitute a familiar ground of reference, such as Rembrandt's *Flayed Ox* (figure 3) cited by writers as different as André Malraux, René Char, and Jean Paris; each depiction reinforces the others for the attentive reader and observer. Chaim Soutine's image of this exposed flesh in a market stall is all the more powerful in its impact because of our acquaintance with the Rembrandt: it bears a cumulative charge (figure 4).

[5] Consider, for example, the poems of Reverdy, Roethke, and Char with the identical elements. The difference is revelatory. But Mario Praz, *Mnemosyne: The Parallel between Literature and the Visual Arts* (Princeton: Princeton University Press, 1970), comments on the necessity of open-mindedness as to the matching of images. Speaking of Shakespeare's *The Rape of Lucrece*, Praz claims Shakespeare was responding "to a taste widely diffused in literature rather than to the impression of a special painting. . . . The fact that one critic has thought of Titian, and another has compared Shakespeare's treatment to Rubens, shows that the common way of approaching the parallel between the various arts must be wrong" (p. 105).

Now one might think it necessary to match the images chronologically; if, for instance, the text and the image are both from the same hand—say that of Rossetti—then the reader of both has strong guidance in his passage, whereas if the text is composed after the image, in homage to it, or the image in homage to the text, the reader may make a more complex response, both to the initial text or the original image and to the second or corresponding event, in a sort of dialectical interaction. Still a third possibility allows for the meeting of an image or group of images and a text or group of texts within a reader's mind, setting the scene for what may turn out to be a close encounter of a third kind, that is, to consider a Renaissance painting only with a Renaissance poem, and so on. An example of one of the most obvious and fruitful comparisons to be made, for instance, is that of the wavy or serpentine lines of Mannerism and Baroque as pictured so vividly in El Greco's *Laocoön* (figure 5), in the twists of Tintoretto's *Leda and the Swan* (figure 7) and some other maidens (figure 9), or of a Titian *Venus* at her ease (figures 6, 10, and 24) with the windings and reversals of Donne, Góngora, Sponde, and Marino.[6] But once the vital caveats as to difference have been made, a specific Renaissance or Baroque image can serve to illuminate a contemporary poem and to intensify its impact: the contemplation of the figures of de La Tour and Poussin (figures 13, 14, 15, 57, and 58) may render a reader of contemporary French poetry more sensitive to its high lighting and setting, just as a Mannerist swan (figure 7) may sharpen our enjoyment of a Surrealist recall of a swan such as Desnos' "Vanité souvenir du cygne" (Vanity Memory of a Swan) (figure 8).

Another obvious possible concentration is the comparison of renderings, verbal and visual, of some highly dramatic moment: Rilke's poem of the "Annunciation to Mary" offers an unusually rich field of investigation for several reasons, all of them connected to the possible play between text and verbal enunciation (figures 43 through 54). Another possibility, more obvious still, is the treatment of a parallel theme, image, or setting. At the center of this volume, three texts, starting from Mallarmé—in a modest kind of homage—turn about a tower and a stairway for ascent or descent, a great glass, a mirror, and a door (figures 35 and

[6] Louis Martz in *The Wit of Love* (Notre Dame: The University of Notre Dame Press, 1969) has pointed out the wavering lines of John Donne. We might illustrate the point with one other example, cited also in Chapter 5: Góngora describes the nymph Galatea, in his *Fábula de Polifemo y Galatea* with the words "pavón de Venus es, cisne de Juno (1.64)." In this line the classic association of peacock with Juno and of swan with Venus plays against the actual chiasmatic exchange established within the line itself, in the sort of double wavering detectible in the windings of figures and snake in the *Laocoön* (figure 5).

36). Here it is a question of sharp ellipsis and transparency invoked. A passage is made by reader, poet, and visual thinker through all these openings, into a contemplation of the double and the multiple, into an attitude receptive to and creative of exchanges of theme and space and moment, for a mind endowed with flexibility of imagination, and with ins and outs (figures 37 through 42). All of these essays deal rather with what I have here called *inscape* rather than with *outlook*, that is, with an inner scene whose opposite would be the excursive gesture: the passage makes an incursion across the threshold, into a private space.

A small number of visual images recur throughout these pages, like an openly haunting series of talismans casting a connecting thread between the worlds Breton termed "exterior and interior reality," or then, here, between the actual texts and their reverberations in the imagination of one reader. The Surrealist passerby is called upon, after all, to stake a believer's faith on the flagrant contradictions to logical stability, visual and verbal. It is this interpretation that I would like to place on the flagrant passage of the watching gaze from the *Vases communicants* (Communicating Vessels), joining Nadja's wandering steps and obsessive certainty to a view, both recurring and free, of the aura of a few chosen objects, images and texts.

2

THE EYE IN THE TEXT:
FRENCH POETRY FROM
REVERDY TO JABÈS

> . . . as if once past the surface a look were to come
> toward me from the depth of the canvas.
> —Leonardo, *Notebooks*

THE MAIN CONCERN of this essay can be indicated by an image and an angle, both contained in Duchamp's epigraph for a book of Denis Roche ironically called *Récits complets: Poèmes* (Complete Tales: Poems) "cet angle exprime le coin de l'oeil nécessaire et suffisant" (this angle expresses the corner of the eye, both necessary and sufficient). We recognize the "necessary and sufficient" from well-tried philosophical terminology and take the corner of the eye to indicate an indirect look, an oblique angle by which we look at things: indirect indeed, yet all the more appropriate to what Pierre Reverdy calls the interior poetic act. The question is here, as always or at least often, how to look from the inside at what we perceive outwardly, how to include ourselves in a writing which we, after all, only read; my topic, then, is the inclusion of the "I" within the text. Each of the poets discussed here uses a multiple significance of terms whenever possible, and I shall do the same: I mean the eye in the text, and the reflexivity between text and reading, as mirror and mirrored object, in an extensive interchange of function, action, and glance, the goal or rather the "spacious illusion" toward which I should like to move.

Mallarmé is always a good starting point, and the place many contemporary poets have started. Two of the poets I shall discuss are clearly his descendants: Edmond Jabès, whose *Le Livre des questions* (Book of Questions)[1] has now lasted a decade in its unfolding, and Pierre Reverdy,

[1] Edmond Jabès, *Le Livre des questions* (Paris: Gallimard, 1963-1965). Hereafter cited as LQ. The depth and universality of Jabès' questioning demand a patient reading: his interrogation deserves our fullest attention and the most faithful—not of answers—but of answering interrogations. See the excellent English translations of Jabès done by Rosemarie Waldrop for Wesleyan University Press, 1975; and the articles of Phillipe Boyer, Joseph Guglielmi, and Jacques Derrida, whose "Edmond Jabès et la question du livre," in *L'Ecriture et la différence* (Paris: Seuil, 1967) introduced Jabès to a wide reading public. See also the Jabès number of *Obsidiane* (Paris, 1981).

the real importance of whose work has not yet been fully recognized. The third is Lionel Ray, whose concern is also with the writing of writing, with the look projected in and at the text, and with the mirror as well as the eye and hand. His *Lettre ouverte à Aragon sur le bon usage de la réalité* (Open Letter to Aragon on the Proper Use of Reality) is a sufficient indication of his debt to Surrealism (compare the letter of André Breton on "le peu de réalité"), to its former practitioners and to its sustained theoretical presence; he is also one of the most inventive poetic minds of recent date.

Situation and Sight

Let me start with some constantly recurring motifs, indicating how they situate us and our reading and how they relate to each other, in what Jabès has called the "hope by writing." The poetic word or image is condensed in Bonnefoy's words:

> Les mots comme le Ciel,
> Infini,
> Mais tout entier soudain dans la flaque brève.[2]

> Words like the Sky,
> Infinite,
> But in the brief puddle suddenly entire.

This word condensed operates in a contrary sense also. For Jabès, it divides and generates; as typical examples, the verb "lier," to link, can be reread: "le texte nous lie," and we read also, as well as the text linking us, the text reading us, as if it had been "le texte nous lit." Or again, "soleil" or sun gives the word "sol" or earth, in a startling production of opposites, and the letters of "étoile" or star, once reshuffled, give "*loi*" or the law, as well as "oeil" or eye like the letters of "soleil." All is inclusive of or referential to all. The seriousness of this apparently playful approach cannot be overemphasized: it has far-reaching consequences not only for poetry, but for the thought that language itself produces.

Lionel Ray is an equally convincing advocate of division and multiplication of meanings:

> We start from the idea that every logical discourse, every co-
> herent sentence, contains the linguistic material appropriate for
> twenty, a hundred or a thousand texts. It is only a matter of

[2] *Dans le leurre du seuil* in *Poèmes* (Paris: Mercure de France, 1978), p. 29. See the chapter on Bonnefoy concluding the present volume.

restituting these lost texts by the discontinuity or fragmentation of the word into splintered sentences and meaning, of finding by the complete disarticulation of discourse a poetic language where words themselves in a state of dreaming constitute the only reality. The poem must not only propose a definitive text but also lend itself to an infinity of readings, must open multiple paths.[3]

These apparently opposite movements—the condensation of the infinite into a word and the breaking apart of the word into infinitely other meanings—work with each other to create a self-consciously textual gesture.

Ray's definition of aleatory poetry begins with a vision of the poem as a festival, leaving poetry open and limitless, yet enclosing its own boundaries, as in the rituals of play. It is marked by a prophetic tone of hope: "Quel sémaphore nous invite aux terres qui cèdent entre distance et prophétie?"[4] (What semaphore invites us to the lands which yield, between distance and prophecy?). Now this liminal or boundary time between is also the moment of ritual sacrifice: the notion of poetry as sacrifice has long been with us, and no doubt long before the incision that so haunted Mallarmé. The knife inserted between the pages of a book prepares the sacrificial victim, while the poet-priest officiates in a ritual no less solemn for dealing only with the word. The blood-stained edges of a Mallarmé volume, like some crimson-edged missals redolent of mystery are with us still:

Le reploiement vierge du livre, encore, prête à un sacrifice dont saigna la tranche rouge des anciens tomes; l'introduction d'une arme, ou coupe-papier, pour établir la prise de succession.[5]

The virgin refolding of the book, still, enables a sacrifice from which the red slice of ancient volumes used to bleed; the introduction of a weapon or paper-cutter, to establish the taking of the succession.

But now the reader forms part of the sacrifice: Dupin's meditation on writing called "Moraines" from *Embrasure* (1969), describes reading as a fatal trap, in which, clearly, we are all inextricably caught: "Tu n'en

[3] Lionel Ray, *Les Métamorphoses du biographe*, with *La parole possible* (Paris: Gallimard, 1971), p. 10.

[4] Lionel Ray, *L'Interdit est mon opéra* (Paris: Gallimard, 1963), p. 31. Hereafter cited as IO.

[5] Stéphane Mallarmé, *Igitur, Divagations, Un Coup de Dés* (Paris: Poésie/Gallimard, 1976), p. 270. Hereafter cited as MI.

sortiras pas" (You shall not leave). The writing no longer simply invites the reading, but commands it, mirrors and mocks it, imprisons and envenoms it (figure 60). Of the related images of the eye I want to trace in these three authors, one has perhaps the gravest implications: the wound at the center of the text, within the I, or the wounded "eye" in the mirror, again furnishing a double vision of both passage and threshold.

As for the wound since Mallarmé, French poetry shows it profoundly. Reverdy's "blessure inouïe" is multiple, for the "inouïe" or the unheard of is also unheard, a denial of the "ouïe" or hearing: this wound is also the silent hurt.[6] Elsewhere, Reverdy again draws attention to what, he says, he is not saying; calling it the wound we never mention, and elsewhere, his livid wound.

I am not insinuating, of course, that each poet bears the same wound or the same trace. Reverdy's, closely related to the intimate difficulties of his own personality, a silent but all the more speaking secret, is far from resembling that of Valéry, at once more intellectual and more erotic, as the bee sting wounds at once the mind or the consciousness and the body, waking them doubly to life. Valéry's famous line: "O dangereusement de ton regard la proie" (O dangerously of your glance the prey) includes the wound, the mirror, in full consciousness of duplicity in its strongest sense. His "fecund wound" could be the emblem of Dupin's poetry in its early stages and of the fertile wound in René Char, the green scar, the hurt river or spring. The red streak frequently found at the center of Char's texts, a "raie rose" or a "lézarde rose" is the source of vital eroticism and of tragedy, of blood and of death at the center of life, and the source also of poetry. It will initiate Char's volume called La Sièste blanche, a paradoxical title—the white siesta like a sleepless night—being itself the faintest and most minimal trace of the deepest wounding, unspoken but all the more strongly felt.[7] Jabès also places the wound at the beginning of his text. At the threshold of his Le Livre des questions (Book of Questions), thus the threshold of the threshold ("Au Seuil du livre") we find the indication: "Marque d'un signet rouge la première page du livre, car la blessure est invisible à son commencement" (Place a red marker on the book's first page, for the wound is invisible at its beginning). So the book takes its origin in pain: Compter sur une blessure, c'est régler sa vie sur elle, en fonction du tranchant de la douleur. (LQ 3: Yukel; To count on a wound is to rule one's life by it, on the cutting edge of pain).

In brief, the wound, in all its metaphysical as well as erotic gravity,

[6] Pierre Reverdy, Au Soleil du Plafond (Paris: Teriade, 1955), p. 126.

[7] See my Presence of René Char (Princeton: Princeton University Press, 1976).

finds a motivation in Char and Bonnefoy entirely different from its primarily metatextual use in the three poets to be discussed later: Reverdy, Jabès, and Ray. In Char's epic love poem Le Visage nuptial (The Nuptial Countenance), the act revealing the deepest love reveals at once the deepest undoing: the wound is acknowledged to be "irreparable," mortal as it is marvelous. I shall quote two passages from Char, different in appearance but linked as the myth of the unicorn is linked to the myth or then the reality of love, as the images of water and the fountain are linked to the legend of life, and by extension of both love and life, poetry.

> L'horizon des routes jusqu'à l'afflux de rosée,
> L'intime dénouement de l'irréparable[8]

> The horizon of roads until the abounding dew,
> Intimate unknotting of the irreparable

From thirty years later, another wound, never to be healed, incised also by time:

> Temps, mon possédant et mon hôte, à qui offres-tu, s'il en est, les jours heureux de tes fontaines? A celui qui vient en secret, avec son odeur fauve, les vivre auprès de toi, sans fausseté, et pourtant trahi par ses plaies irréparables?[9]

> Time, my possessor and my host, to whom do you offer, if there be any, the happy days of your fountains? To the one coming in secret, with his wild scent, to live them out near you, without any falseness, and yet betrayed by his irreparable wounds?

Here the tapestry of legend spreads out into all we have seen and read of the unicorn by the fountain, of the wounding horn that is also the curing horn. So too does the text provoke, trouble, disturb, and calm, and so too, the poet: "Celui qui vient au monde pour ne rien troubler ne mérite ni égards ni patience" (He who comes into the world to trouble nothing deserves neither respect nor patience). And Bonnefoy sounds a different tone, no less impregnated with the weight of legend; here the river runs eternal, like time, and the dialectic of penetration and fulfillment is sensed as both death-dealing and life-giving:

> Mais le temps mûrissait, plainte des combes,
> La blessure de l'eau dans les pierres du jour.[10]

[8] "Le Visage nuptial," from Poems of René Char, translated and annotated by Mary Ann Caws and Jonathan Griffin (Princeton: Princeton University Press, 1976.

[9] René Char, Le Nu perdu (Paris: Gallimard, 1972), p. 104.

[10] Yves Bonnefoy, Hier régnant desert in Poèmes (Paris: Gallimard, 1978), p. 144.

But time was ripening, lament of ravines,
The wound of water in the stones of day.

Char and Bonnefoy, in spite of their affinities with Mallarmé, have completely different concerns from those discussed in this chapter: they serve here as the silvering on the other side of the mirror that makes possible some reflection on the present side: "the one in the other" of Surrealist terminology is also, at least in my present reading, "the one through the other," another ambiguity of the threshold: the imagery makes a fecund source for re-reading, re-contemplation, and particularly, in the light of the imagery involved here, for our reflection. Which is not to say that one side is more present, either temporally or spatially, than the other. The poets of these texts, then, are poets of The Book, *Le Livre* in Mallarmé's all-encompassing sense, like Jabès' *Livre de Questions* (Book of Questions) and his *Retour au livre* (Return to the Book) like Dupin's *Dehors* (Outside) at once the outside of the text and the text outside and Lionel Ray's *L'Interdit est mon opéra* (The Forbidden is my Opera). In each, various senses of wound, of mirror and threshold and sign are intertwined, furthering the implications of the reader's implication in the reading.

INSIGHT

As is plain, the eye can be well-concealed in the text. Within the poem itself, a continuing theme may not appear immediately upon the surface, preferring to hide in the underlying structure, where it is implied rather than disguised, and whence it informs the poem effectively. My example here comes from Pierre Reverdy, one of the most metatextual poets of all, much of whose work can be re-read as a reflection on the poem itself as poem. The following text is, on the surface, a simple description of a nightscape:

DEHORS

Des chemins détournés des villes basses, d'où viennent des bruits
 sourds, passent les taillis sombres contournant les remparts.
Les pierres bleues couvertes de sueur luisent entre la pâte épaisse
 de la terre au courant de la peur.
Tous les doigts, toutes les feuilles d'arbres, toutes les paupières
 remuent.
Les prunelles à travers les rayons du ciel sont à l'affût. . . .
Les étoiles remuées au fond de la corbeille.
Les vers luisants piqués aux feuilles de la treille.

Tous les yeux attachés au fil qui coud la nuit.
La route décidée à travers tous les plis.
Et la voix qui va sans qu'on la craigne.
Des passes du veilleur aux gouttes de rosée qui luisent sur la
 plaine.[11]

<div align="center">

OUTSIDE

</div>

Paths turned away from low-lying cities, whence come muffled
 sounds, pass by the somber brushwood outlining the ramparts.
The blue stones covered with sweat shine through the thick paste
 of the earth when fear rages.
All the fingers, all the leaves of trees, all the pupils are stirring.
The pupils through the sky's rays are on watch. . . .
The stars stirred up in the basket's bottom.
The glowworms stuck in the trellis leaves.
All the eyes attached to the thread sewing the night
The road decided across all the pleats.
And the voice moving without anyone fearing it.
Watchman's rounds through the dewdrops shining on the plain.

The correspondence between the human eyes and the stars gleaming
in the basket of the sky is marked by fear and its images: the stones
shining with dew are compared in the poet's obsessed imagination—
which is eventually transferred to our own—to the perspiration of fright,
the quaking of fingers and the trembling of leaves, even to the fluttering
of eyelids, as the road remains open to whatever menace might come.
The night watchman on his rounds about the lowlying town parallels the
text, which is always on watch. In the quiet nuances of Reverdy's style,
no element protrudes to any striking degree, so that the scene itself is
always in low relief. Reverdy in fact advocated what he called the static
poem; his image of the "chambre noire," in which we may read a
developing room as well as a darkened bedroom, contains all the drama
of an interior theater, that drama I see as peculiar to poetry.[12]

But reread with a slight deforming twist on the reader's part the poem
reveals a metapoetic obsession of the first order. The text lies in watch
above all for its own being. We might think here of Jakobson's having
said that ambiguity is characteristic of all self-centered messages. So the
scene is introduced by a question: where are these sounds coming from,

[11] Pierre Reverdy, *Flaques de verre* (Paris: Flammarion, 1972), pp. 25-26.

[12] See my *Inner Theater of Recent French Poetry: Cendrars, Tzara, Péret, Artaud, Bonnefoy*
(Princeton: Princeton University Press, 1972).

stifled as they are: "D'où viennent ces bruits sourds?" Those blue stones on which the night dew is seen as sweat by the fearing glance are now apparently a set of blue eyes shining, or—by the suppression of one letter—reading between the lines of the earth, as those other starry pupils shine also from their reading in the luminous text of the sky; as "luisant" gives "lisant," or

<p style="text-align:center">l[u]isant,</p>

so "luisent" gives "lisent," or

<p style="text-align:center">l[u]isent.</p>

The "rayons" or the star's rays are also the rows of a bookcase (rayons also): instead of "speaking volumes," these stars are not only "remuées" or stirred up in the basket but also, by a one-letter alteration, "re-muets," fallen once more to silence, whereas the glowworms themselves: "vers luisants," may suggest also by a parallel one-letter alteration, a simple omission of a "u," "verses reading"—*vers lisant*—lines shining and sensed, stuck in the leaves and wrinkles of the night's book, sewn in by a thread linking the multiple openings or *plis* of the volume, like a Mallarméan meditation on metapoetic. Even the dew glistening at last on the plain is a half-veiled reminder of the dewy and lustrous eyes shining from their reading: the play of "luisant" and "lisant" again—the fact that the poet stresses this suggestive term by using it three times in such a short text indicates its importance, in the re-reading. The text fascinates by its own concern with reading, with the eye or "I" implicated in the object observed, which returns the glance. Walter Benjamin describes the spectator's desire that the spectacle return his glance: this particular spectacle more than meets that desire.

THE BOOK OF THE GAZE

As Derrida says of Jabès, "The writer is a *passeur* [a ferryman], and always destined to an imaginary meaning."[13] The book into which Jabès invites or in which he implicates us, is not necessarily, I think, the book of the Jew, although Derrida maintains otherwise. To be sure, the Jewish race issues from the book, as Derrida points out; to be sure, the rabbis to whom the word is given in Jabès' writings are as real in the text, although at the same time invented, and the poet is always both poet and rabbi. The metaphor of the letter extends to each of us through the responsibility of our own vision, where the "I" is kept firmly in that text. It is after all,

[13] In his "Ellipse," pp. 428-436 of *L'Ecriture et la différence* (Paris: Seuil, 1967).

of our fate also that Derrida speaks: "For the subject is broken therein and is opened even as it represents itself. Writing writes itself but also sinks into its own representation." Re-presentation is what we find in the mirror, in the text, in the poet, and in the reader. The Jew is, as Jabès says, "a wandering question," and that may be said too of his writing, as it interrogates language itself.

Jabès claims that the book "multiplies" the book, that the noun must "germinate" or prove itself false. In the "eye" of the reading, as the writing, this multiplication is required. For instance, in Jabès' vision, "voir" or seeing implied in the "savoir" or knowing, is ours, but also the faith or "foi" reshuffled from "folie" or madness. Even the tale or "récit," properly that of the poet, becomes reshuffled and rearranged, our "écrit" or text. As for the Surrealists, one in the other: the exchange works throughout the images as well as the sign. Sign and swan converge, in Mallarmé, and in these poets too, "cygne" with "signe." And in each of these three poets the exchange is clearly accepted, marked, used. Jabès calls the swan the bird of margins ("Cygne, oiseau des marges") and by that he means also the sign in the margins, as white attracts white, a white swan in a white sign, and vice versa, like the "Candeur du signe" (LQ, p. 95; The Candor of the sign). If we accept that writing is to make an incision in the whiteness of the page, wounding the matter and the mind, and inscribing a fatal trace, then the links between the swan and the white lake, as in Mallarmé, between the sign and the drawing of blood, the red streak or crimson crack already perceived take on their proper importance. Furthermore, the wing ("aile") is not only the wing of the swan but also of the "El" or "L" which is the nameless book and the single letter signifying everything else, this "elle" more universal for being unspecific.

Jabès' *Yaël* describes the eye active and passive, and its mutual interpenetration with its own vision:

Oeil dormant. Oeil poussant. L'arbre devient ce qu'il voit.[14]

Sleeping eye. Growing eye. The tree becomes what it sees.

The interchange is all the more powerful in its charge and implications for the distance acknowledged between the writing hand and the being to whom it belongs and as the book is acknowledged to be a book of sight, it makes of us and of itself a mirror, for a doubled reflection:

Le livre, dans son ambition, se voulait le livre du regard.
L'être, la chose n'existent que dans le miroir qui les contrefait.

[14] *Yaël* (Paris: Gallimard, 1967), p. 130.

Nous sommes les innombrables facettes de cristal où le monde
se reflète et nous renvoie à nos reflets, de sorte que nous ne
pouvons nous connaître qu'à travers l'univers et le peu qu'il a
retenu de nous.[15]

The book, in its ambition, wanted to be the book of the gaze.
Being, and things only exist in the mirror which counterfeits them.
 We are the innumerable facets of the crystal where the world is
 reflected and returns us to its reflections, so that we can know
 ourselves only through the universe and the little of us which it
 has retained.

The word "contrefaire" in the text just cited is worth dwelling on
a moment: to counterfeit, but also, and literally, to make against: this is
the truest function of the mirror in these texts. The writing at once captures
and recreates us, in our opposition which becomes our resemblance: this
is one of the meanings of Jabès' *Livre des ressemblances* (Book of Re-
semblances). Resemblances and otherness are the contradictions and
likenesses on which we base our look which is our reading.

 The book can only be read in the "broken mirror of words" and not
in the universe beyond them, and even there the discovery is far from
being complete: "The book is veiled in the book."[16] The seeing and the
seen, the interrogation of oneself and the world are self-reflective and
mutually reflective, denying, and abolishing, leaving us our vision of the
writing set upon the "depth of an abyss." The abyss is itself the silvering
of that mirror enabling us to read, in reflection as it is not simply sameness:

"Qui suis-je?" ai-je demandé.
"Qui suis-je?" ai-je répondu.
La répétition est, dans sa différence, accomplissement. (E, p. 95)

"Who am I? I asked.
"Who am I?" I answered.
Repetition is, in its difference, accomplishment.

All the questions Jabès asks, and by which, paradoxically, he answers,
seem at once final and original, fertile but terribly silent:

—Avons-nous été le livre?
. . . peut-être avons-nous été le moment ou le livre sur sa soif, se
replie. (E, p. 123)

—Have we been the book?

[15] *Yaël*, p. 161.
[16] *Elya* (Paris: Gallimard, 1969), p. 51. Herafter cited as E.

. . . perhaps we have been the moment when the book gathers
itself upon its thirst.

For Jabès, every sheet of paper is, on the other hand, a space of
white, in which to look, but without the silvering that in a mirror enables
reflection and forbids our passage to the other side; the onlooker loses,
therein, not only his face but his being as a totality of self:

But how white everything is around me. WHITE. WHITE. WHITE.
Shall I ever vanquish this whiteness? Shall I ever vanquish myself,
this white self drowned in all the whiteness?[17]

The pages of such a book are similar, are identical, and evoked as such,
while in a supremely paradoxical vision, they are also self-contradictory,
different, and individual:

Nous évoquerons la ressemblance du blanc avec le blanc; de
l'également blanc avec le parfaitement blanc. (LR, p. 90)

We shall evoke the resemblance of white to white; of the equally
white to the perfectly white.

This meditation on the white of a page demands at least the partial
sacrifice of textural integrity: "To engrave the white in the white ends
only by making a hole within the white. The morning of the book is a
perforated morning" (E, p. 96). The hole in the text remains, reminding
the reader of the tent's torn and textual canvas in Mallarmé's "Le Pitre
châtié" (The Chastised Clown); the clown dives upward through the tent,
as if it were a window on the ideal "azur," and downward into the
deepest water, his makeup and his role are washed off by water in an
unhappy baptism. This is the poet seen by himself in his mental mirror:
"La mise en accusation de l'oeil" (LR, p. 109, the accusation of the eye)
is perhaps the most perfect metaphor of the text, in its relation to the look
we direct toward it and toward our role as observer.

THE ANGLE OF THE EYE

In L'Interdit est mon opéra (The Forbidden is my Opera), which is to
say, my works (opus in the plural), Lionel Ray insists on a poetry of
chance for the observer as for the writer: "The poem imposes nothing
but the multiple freedom of its reader . . . source of a meaning always
renewed" (IO, p. 109). The poem is valued for the rapidity of its for-
mulation and inscribed always under the sign of surprise, astonishment

[17] Le Livre des ressemblances (Paris: Gallimard, 1976), p. 142. Herafter cited as LR.

even: "The gaiety of the text renewing the sentence" whose parts are, as it were, "joyously scattered into shreds" (IO, p. 109). The celebration of the scattering is stellar, and turned forward: "Such is my ritual, the dance, the project, the figuration, the ceremonial and the enthusiasm of the stars, which climb from who knows where, backwards, similar to the stars of the future" (IO, p. 17).

In the exchange of metaphors, which Ray claims as "our only commerce" (IO, p. 10), the "eye" and the "I" are inscribed in the "other," and in Rimbaud's self as his, and our, other: "Je [et] est l'autre." Here the two sides of the mirror take on their full operative quality: "The metaphor as a functional field, a transformative milieu, the inalterable fire of the mirror . . .The essential metaphor establishes the motion from a system of rupture (I and the other) toward the statute of a double consciousness; it shows a search for unity, for the identity of being and existence" (IO, p. 10).

And here, in Ray's prefatory essay, "Poésie aléatoire" (Aleatory Poetry), the passionate alphabet that renews and begins language afresh at its springs and sources is contrasted with the glance that hides the spectacle, the latter implicitly condemned in the name of reality itself. "Words are porches, come in, here are my likings" (IO, p. 7), cries the poet, and ends his open letter to Aragon on the "sensible" use of reality by the celebration of the simplest object: "I love things as they are visible things independent of words a chair of red leather" (IO, p. 107).

Finally the point of much poetry, and even of the Surrealist poem would be to make visible in the universe one chair, for instance, and the words by means of which it is seen, to keep intact both the energy of the gesture and the vitality of the spectacle so that neither becomes stale or dulled, as in Breton's ancient warning about preventing the "road of mental adventure" from being covered over ("sur la route de San Romano"). Modern poetry has inherited his hope, against habit:

> . . . mon séjour parmi les traces l'encre nue les signes la pâleur je rêvais de vous alliance du poème et des hommes travail des oracles. (IO, p. 43)

> . . . my sojourn among the traces the naked ink the signs the pallor I dreamed of you alliance of the poem and men the work of oracles.

or again:

> poète au foyer d'ombre, salut! sous ce front l'alhambra de fontaines labyrinthe de sentiers sans chute l'onde aux doigts de radium (IO, p. 64)

> poet at the hearth of shade, welcome! under this forehead the
> alhambra of fountains labyrinth of paths without fall the wave
> with radium fingers

These paths and these traces lie at the source of what we might see as
a poetry begun anew, borne like Noah's ark across the flood, for a
renascence of the poem by the "I" included forever in it, and in which
it is, forever, included: "les matins seront nos arches aveuglant les sources
pour la recharge des origines" (IO, p. 33; mornings will be our arks
blinding the springs for the refilling of origins).

If, as Derrida points out, the origin cannot be traced, if all our poetry
is to include the sensible ellipse of that lost origin, our faith in the poet
may call for a different basis from that on which we formerly based it,
now origin-less and timeless, limitless to the eye: "the multiform sentence
compensates for the variations of the instant," says the poet, and pro-
claims his return as "jeu" or game as well as "je" or "I" to the literary
game and self: "Ce jeu littéraire." Even Mallarmé is seen afresh:

> Partition bruissante de paroles, le poème, inaugural, logos de
> l'aube. Dépossédé de tout rivage, inscrire sur cette mer aven-
> tureuse le livre d'Ulysse: *L'explication orphique de la Terre qui
> est le seul devoir du poète, et le jeu littéraire par excellence
> . . .*", dit Mallarmé. (IO, p. 10)

> Noisy libretto of speech, the poem, inaugural, word of dawn.
> Dispossessed of any riverbank, to inscribe upon that adventur-
> ous sea Ulysses' book: "The orphic explanation of the Earth
> which is the poet's only duty, and the literary game par excel-
> lence . . ." said Mallarmé.

Finally, whatever the angle we take on the text, Surrealist or not, we may
be assured that if we so choose, our eye will determine in part its as-
sociative history, its vital presence, and its possible future.

PART II

FROM GESTURE TO CREATION

.

3

GESTURE, GAZE, AND MIRROR: FROM DESIGNATION TO CONTEMPLATION, MANNERIST, METAPHYSICAL, AND SURREALIST

> For in love's field was never found
> A nobler weapon than a wound.
> —Richard Crashaw, "The Flaming Heart"

THIS GESTURE of an essay passes from one epoch to another, one genre to another, one observational style to another as a mental experience of the sort of scientific experiment termed the *Vases communicants* or "communicating vessels" by Breton for the flow of opposites into each other encouraged by Surrealism. The purpose of this essay is to compare the similar gesture of two aesthetic moments seen "one within the other" like the name of one of the intensely serious Surrealist games. For the game's duration, I would choose not to be concerned about which is contained within the other, that is, to disregard the chronological leap of four centuries—the sixteenth century to the twentieth century—in order to give free play to whatever ideas might be generated by this interchange. Take, for example, Breton's illustration of the lion contained within the match, the brilliance and form of his mane inscribed potentially in the flame. The compression of ideas and the elliptical expression make of this image a perfect representation of the metaphor we consider Baroque or Metaphysical.[1] We might call it an exploding metaphor, for its result is all the more powerful and all the more wide-ranging precisely because of its condensation. But the conception of one-within-the-other comes also from the rhetorician Tesauro, for whom "a metaphor vigorously locates all objects in a single expression, and forces you to see them one within the other in an almost miraculous fashion,"[2] for whom, as Jean Rousset

[1] See Gerard Genette, *Figures III* (Paris: Seuil, 1975), on the reversibility of the Baroque image.

[2] E. Tesauro, *Il Cannochiale Aristotelico* (Venice, 1655), p. 310. Quoted by Mario Praz in *The Flaming Heart* (New York: Doubleday, 1958), p. 207. On Tesauro and Crashaw and on "the transition to illusion through disillusion," see Peter Schwenger, "Crashaw's Perspectivist Metaphor," *Comparative Literature*, 28, no. 1 (Winter, 1976): 24, 197.

explains, the *concetto* was an optical game permitting the simultaneous appearance of many objects or many notions originally distant and distinct. Mannerist, Baroque, and Metaphysical poetry exemplify "the union of incompatibles," in which the text becomes a "center of convergence and the melting-pot of a new creation."[3] For its difficulty of conception and its remarkable condensation, this poetry is called "strong-lined" by its critics; it is these qualities, visible in certain poems and certain canvasses, that remind us of some "strong-lined" contemporary poems.

I am not, however, interested only in the retrospective and reader-oriented relation between two moments or two attitudes: between the "Mannerist" or "Baroque" and the "Surrealist," as they may illuminate each other in a double and single vision, also a singular one. Rather, my present concern is that of the reciprocal interplay between the object pointed out or designated or even created, and the finger pointing, and then the eye regarding finger and object, all this in mutual reflection. Leonardo describes this relation best: "In a single mirror or a single pupil is found the image of all the objects placed before it, and each of these objects is complete in the complete surface of the mirror and complete in each of its least parts. . . . As if the eye's rays, diverging on the surface of the canvas, were to converge in the depth of the canvas or, still according to the image of the divergent bundle of rays, as if once past the surface, a look were to come toward me from the depth of the canvas, as if in it something were to gaze out: quite as if, having been charged, the look were to turn back on itself."[4] I would choose to speak of a charged vision in the electrical sense of the word, to which the innocence of a neutral origin is lacking, but which has an exceptional density from its very consciousness of reversibility.

The Baroque, and in particular Mannerism, in many of its aspects and however one defines it—there is no need here to go into any detail about that special and often-studied controversy—the Mannerist attitude, let us say, provides a space rich in multiple and conflicting speculations and visual perspectives on text and canvas.[5] We see, we perceive, finally or ideally, we participate in a conscious stress on the gesture, exacerbated and exaggerated.[6] In *Die Welt als Labyrinth* (The World as Labyrinth)[7]

[3] Jean Rousset, *L'Intérieur et l'extérieur* (rev. ed., Paris: Corti, 1976), p. 205.

[4] Leonardo, quoted in Jean-Louis Schefer, *Scénographie d'un Tableau* (Paris: Seuil, 1969), pp. 24, 197.

[5] I shall not dwell here on the distinctions between Mannerism and Baroque, for they are delicate. These two labels are often discussed; I am, however, contented simply to compare to Surrealism the poetic projection sometimes called Mannerism. Most of the illustrations could properly be said to be Mannerist rather than Baroque.

[6] Gérard LeCoat, in his *Rhetoric of the Arts, 1550-1650* (Basel: Lang, 1975), reminds us of the corporeal rhetoric of such interest for the actor, the orator, the poet and the painter

Gustave Höcke describes the Mannerist gesture as it bears witness to a convulsive beauty like that later advocated by Surrealism; Henri Zerner sees the playfulness of Mannerism as both a mask and a kind of para-doxical pretext for gravity, revealing a deep unrest and an unconfessed torment; and Thomas Greene sees in it ideal matter and style for auto-criticism.[8] It is, in short, the style of excess and self-conscious contra-diction. If our only result here is the constitution of a mosaic of *concetti*, of a composition in contrary motions or *contrapposto*,[9] the pull against each other of figures set in conflicting attitudes or of a spectator's universe vertiginous and contradictory to an extreme degree, we shall at least have followed the counsel of the Mannerist Marino, who suggests that we combine "disparate images" or discover "hidden analogies" between objects which have in appearance no relationship between them, and those of Tesauro whose guarantee it is that if we put two obscure sentences together, they will become luminous. Tristan Tzara, or "Dada/Tzara," claims, in parallel fashion, that the hope of Dada was to strike two contradictory elements together for a most luminous obscurity: "Darkness is productive if it is a light so white and pure that our neighbors are blinded by it."[10] The similarity with the Baroque metaphor is clear, for there too, as in the lyrics of Saint John of the Cross, a black radiance illumines with all the paradox of true poetry.[11] It would be my more modest hope here to reach beyond the paradox of two moments super-imposed upon each other in a lyric reversibility of attitude, toward a principle of union itself, seeking that *fil conducteur* between apparently unconnected things, the linking principle which André Breton advocated throughout his own highly charged work. (That the images should be so often those of electricity or then—on another level—of alchemy should not surprise, but rather instruct.) We too should learn to link the disparate, as it may clarify, in whatever vessels we find for communication and, occasionally, for transformation.

of the Baroque and Mannerist periods, and in particular of Lomazzo's fascination with the study of muscular contractions in their relation to the motions of the psyche (pp. 58-59).

[7] Translated as Gustav Höcke, *Labyrinthe de l'art fantastique: le surréalisme dans la peinture de toujours* (Paris: Médiations, 1967).

[8] Henri Zerner and Thomas Greene in Robinson and Nichols, *Mannerism* (Hanover, N.H.: New England Press, 1972), *passim*.

[9] See Wylie Sypher, *Four Stages of Renaissance Style* (New York: Anchor, 1955), on the technique of *contrapposto* and on Mannerism as an art projecting a message contrary to its apparent structure.

[10] Tristan Tzara, in "Note on Poetry" in *Approximate Man and Other Writings of Tristan Tzara*, tr. Mary Ann Caws (Detroit: Wayne State University Press, 1973), p. 169.

[11] Tesauro guarantees that the combining of two obscure sentences makes both luminous. In Praz, *The Flaming Heart*, p. 210.

METAPHOR AND PERSPECTIVES

Let me begin this brief disquisition on looking and seeing by a quotation from William Alabaster, a metaphysical poet whose conceptions would not have been considered prosaic even by the Surrealists. Meditating "Upon the Ensigns of Christes Crucifyinge," Alabaster claimed implicitly that the transfer of elements, one into the place of the other, enabled each to function afresh.

> . . . My tongue shall bee my Penne,
> mine eyes shall raine Tears for my Inke.[12]

So the speaking and the writing merge, and emotion furnishes the matter in which the regret is transcribed. What better example could we have of the transfer from spirit to letter, from inner passion to outer trace?

Two bodily parts will serve as guides to the labyrinth chosen, and to the charged look: the eye and the finger. Both lead to imaginary extensions, explicit and implicit: first, the finger indicating, designating, and pointing out a plurality of meanings, choosing and creating, this often phallic finger of election for which almost any pointed object can be substituted, for example, flame, lance, or dart. And then the eye, inflamed by its gaze until it also becomes rippled with tears like a river of fire. This juxtaposition of contraries, or recreation, might inspire a series of Bachelardian speculations on the attraction of opposite matters, on the rivering of the impassioned and feverish gaze and the fire of a reading that takes its watery being from a tragic meditation, a meeting of contradictory elements representing the vision of one in the other, a convergence of tears and passion at the peak of highest intensity.

In this condensing of energy through a *via obscura*, an intellectual short-circuit takes the place of an easy continuity. (Parenthetically, we notice once more the electrical vocabulary befitting the Surrealist attitude Breton described as an "explosante-fixe," this expression, used for a dance, for instance, has the quality, like the celebrated "convulsive beauty," of setting its two parts in apparent conflict. The term "ellipsis" can be well applied to the poetry of word and picture, as in some of the more remarkable monuments of the Mannerist period, insignia or emblems.[13] (I have already quoted from William Alabaster's "Upon the

[12] In *The Metaphysical Poets*, ed. Helen Gardner (Harmondsworth: Penguin, 1957), p. 12. Hereafter referred to as MP.

[13] As an example of an emblem done in the contemporary manner, of a visual and conceptual short-circuited metaphor, or of the one seen in the other, consider the image of a bird given by René Char in *La Nuit talismanique* (Geneva: Skira, 1972) and entitled "The Snake."

Ensigns of Christes Crucifyinge": many of the emblem-books and meditative devices exemplify this contradictory concentration.)

In the celebrated red sonnet of La Ceppède, the short-circuited or strong-lined text invites, by its very intensity, the meditator who is the reader, to wrap himself, as does the writer in his own meditation, in the expressive folds of the poem, itself reddened by the crimson tears of repentance:

> Aux monarques vainqueurs *la rouge cotte d'armes*
> Appartient justement. Ce Roi victorieux
> Est justement vêtu par ces moqueurs gens d'armes
> D'un manteau qui le marque et prince et glorieux.
>
> O *pourpre*, emplis mon têt de ton jus précieux
> Et lui fais distiller mille *pourprines larmes,*
> A tant que, méditant ton sens mystérieux,
> *Du sang trait de mes yeux* j'ensanglante ces carmes.
>
> Ta sanglante couleur figure nos péchés
> Au dos de cet Agneau par le Père attachés:
> Et ce Christ t'endossant se charge de nos crimes.
>
> O Christ, ô saint Agneau, daigne-toi de cacher
> *Tous mes rouges péchés*, brindilles des abîmes,
> *Dans les sanglants replis* du manteau de ta chair.[14]

> To conquering monarchs the tunic's red
> Justly belongs. This victorious King
> Is justly clad by these mocking men-at-arms
> With a cloak which marks him prince and glorious.
>
> Fill my head, oh crimson, with your precious juice
> Make it distill a thousand crimson tears
> Until, meditating your mysterious meaning,
> With the blood drawn from my eyes, I redden these songs.

[14] "Théorèmes spirituels," in *The Penguin Book of French Verse*, ed. Brian Woledge, Geoffrey Brereton, and Anthony Hartley (Harmondsworth: Penguin, 1975), pp. 220-221. Hereafter cited as FV. The purple of the second stanza must be imagined as a deep reddish hue, akin to the royal purple, and, of course, to blood. For an interesting study of the use of the word "blood" in Mannerist poetry, see James Sacré, *Un Sang maniériste: étude structurale autour du mot sang dans la poésie lyrique française de la fin du seizième siècle* (Neufchâtel: La Baconnière, 1977). The author points out that it is not the repetition of this word that matters, but its articulation in positive and negative values, along with that of the word "blood," and the associated tensions of the term *passim*. One of the best studies of the Mannerist metaphor is that of Claude-Gilbert Dubois, *Le Maniérisme* (Paris: Presses Universitaires de France, 1979).

Your crimson color figures our sins
Attached by the Father to the back of this Lamb:
And this Christ wearing you takes the burden of our crimes.

Oh Christ, oh holy Lamb, deign to conceal
All my red sins, kindling of the depths
In the bleeding folds of the cloak of your flesh.

The poem works itself from exterior to interior, as the royal suffering, crimson and purple, leads, by opposition and transmutation, into crystal, and crystal, into crimson blood of repentance and suffering, with the heat and color of hell, until redeemed by the blood or cloak of Christ, his symbol now become his, and our, flesh. The object of meditation arouses contrary fires and tears, and leads to the effective convergence of passion with repentance, crimson with crystal of tears, sacrifice of Christ and observer of his sacrifice, exterior cloak and interior cloak-made-flesh and blood so that finally the reader converges with the poem meditated upon, wound in the windings of its own being-as-passion.

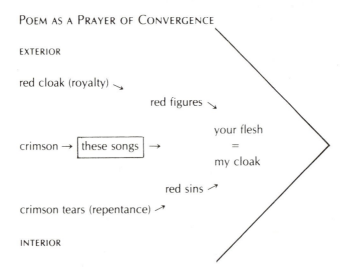

Now this meditation on the passionate and redemptive nature of blood can be doubled by a meditation on the regretful tears and redemptive power of water, while the concept of fever may lead to the notion of a watery inconstancy and undulation. The Mannerist or Baroque images of the water clock, of the temporal stream, enter into a schema

of oppositions whose brilliance is enhanced, even forced, by the elliptical expression. You are fluid, says John Donne in his "Second Anniversarie" to two beings whose being itself slips away like water: thence the image of the face as it flows, in which the linking term—that is, the water— remains implicit:

> . . . *that* she, and *that* thou
> Which did begin to love, are neither now;
> You are both fluid, changed since yesterday.
> . . .
> So flows her face.[15]

We might compare this love of stylistic and imaginative ellipsis with a Surrealist poem on the subject of water and the gaze—a poem of Robert Desnos having for its center a chameleon, a Baroque animal to be chosen above all others, for it best represents metamorphosis:

> Dans l'escalier je la rencontrai. Je mauve, me
> dit-elle et tandis que moi-même je cristal à plein
> ciel-je à son regard qui fleuve vers moi . . . Eh
> quoi, déjà je miroir.

> I met the animal on the stair. I mauve,
> it said, and whereas I myself crystal to the full
> sky—I at her gaze rivering toward me . . . Well,
> what about it? Already I mirror.[16]

This crystalline and rippling gaze is intensified by the ellipsis of the two verbs "to be"—that is, one would normally say: "I am the color mauve . . . I am like crystal . . . I am a mirror"—and intensified also by the startling position of the pronoun attached to the noun as if it were a verb: "sky-I." Compression and repetition themselves serve as stylistic mirrors for the conception of a fixed explosive—an "explosante-fixe"—an expansive-repressive point, paradoxically spreading out through the space of the poem. Moreover, this obsessive desire of the onlooker to be included in the scene forces the constant addition of the "je," as an emotional state redetermines the rules of grammar. Equally intense is the ironic catastrophe of the final capturing by the mirror in a rigid pose of the very person who would have chosen to remain at the highest point of a gesture recognized as one of motion and lyrical flexibility, in a

[15] In John Donne, *Complete Poetry and Selected Prose*, ed. John Hayward (London: Nonesuch, 1949), p. 225.

[16] From my translation in *The Surrealist Voice of Robert Desnos* (Amherst: University of Massachusetts Press, 1977).

Mannerist universe given to the celebration of change simultaneous with the lament at the passing of things. Here, very precisely in this instance, the paradoxical and convulsive beauty of Mannerism is visible, especially by the dark gleam of Surrealist re-vision.

A certain current of Metaphysical poetry is called "the poetry of tears":[17] numerous conscious and unconscious streams of wept water irrigate the texts, occasionally finding a tearful response in the reader's eye. Often the poetry seeks its own self-laceration, symbolized by its crimson tears, as in La Ceppède's sonnet, or Richard Crashaw's "The Pelican," the latter being a worthy ancestral figure for Musset's romantic pelican whose bleeding heart nourishes its offspring, both animal and literary:

> O soft self-wounding Pelican!
> Whose brest weepes Balm for wounded man.
> Ah this way bend thy benign floud
> To a bleeding Heart that gapes for blood.
> That blood, whose least drops soveraign be
> To wash my worlds of sins from me![18]

The remorse of the poet, himself spectator and reader, before the passion of a suffering Christ figure causes his own tears which wash as crystal and yet burn as fire, both to purify and to console, recurs in a profusion of poems formed by the joining of opposed and interdependent elements: fire and water, passion and repentance, wound and balm.

Two saintly figures guide me here in this study of the privileged gesture, of contrary elements, and of the imagination I am terming Mannerist and Baroque, and they originally motivated my choice first of the finger, then of the eye, as agents of perception. First, Saint Teresa as Seghers and then Bernini represent her (figures 11 and 12) chosen or designated by the sky as the celebrated and amorous dart indicates, like a finger of election, and second, Mary Magdalen, the tearful sinner, particularly as Titian shows her, weeping (figure 15), or as Georges de La Tour represents her (figures 13 and 14) keeping a sorrowful watch by her candle at night, a figure whose tears will once more set the sky aflame as water attracts fire. In both cases, the meditation of the saint is supposed to inflame the reader by the observation of the very contradictions themselves. Saint Teresa in ecstasy, ravished with love ("How kindly will thy

[17] In particular see Louis Martz, *The Poetry of Meditation* (New Haven: Yale University Press, 1954) and Terence Cave, *Devotional Poetry in France, c. 1570-1613* (Cambridge: Cambridge University Press, 1969).

[18] Richard Crashaw, *The Complete Works*, ed. William B. Turnbull (London: John Russell Smith, 1858).

gentle *Heart*/Kisse the sweetly-killing Dart!") becomes the image of the noble sufferer by her wounding, the eroticism of which is scarcely in doubt: by her election, she becomes all the more human.[19] But in her representation by Crashaw, the dart is directed also toward us, making of the saint the agent of our own woundings, profitable to our soul, so that the task of art is to enfever, just as our reaction to the double wounding or to our own election is submissive.

> Each heav'nly word, by whose hid flame
> Our hard hearts shall strike fire, the same
> Shall flourish on the browes, and be
> Both *fire* to us, and *flame* to thee. (MP, p. 212)

We are supposed to receive, from the poet's own crimson meditation on the impassioned saint, the passion communicated doubly, now to us:

> O sweet incendiary shew here thy art,
> Upon this carcasse of a hard, cold heart.[20]

When the saint, by her celestial smile, "shall dart/Her mild rayes through thy melting Heart!" (MP, p. 212), we are meant to dissolve in tears before the fire of this love as it is accepted and whose radiance wounds us in our turn: "Give her the dart, for it is she, / Fair youth, shoots both they shaft and thee" (Cr, p. 87). Once more the mixing of the elements water and fire intensifies vision, expression, and reaction.

Mary Magdalen (of whom Saint Augustine says that she changed her object but not her passion), this Venus clothed in burlap, as she has been

[19] Quotation from Crashaw in *The Metaphysical Poets*, ed. Gardner. "I saw that he had a long Dart of gold in his hand; and at the end of the iron below, me thought, there was a little fire; and I conceaued, that he thrust it, some seuerall times, through my verie Hart, after such a manner as that it passed the verie inwards, of my Bowells; and when he drew it back, me thought, it carried away, as much, as it had touched within me and left all that, which remained, wholy inflamed with a great loue of Almightye God. The paine of it, was so excessiue, that it forced me to utter those groanes; and the suauitie, which that extremitie of paine gaue was also so very excessiue, that there was no desiring at all, to be ridd of it" (Crashaw's translation, taken from Louis Martz, *The Wit of Love*, Notre Dame: University of Notre Dame Press, 1969, p. 122). See also Robert Petersson, *The Art of Ecstasy* (1st American ed. Atheneum, 1970). Louis Martz in his *Wit of Love* (Notre Dame: University of Notre Dame Press, 1969) makes a convincing case for the visual referent for the "Hymn for St. Teresa" (which cannot, of course, be Bernini's Saint Teresa, posterior in date). His frontispiece comes from Gerhard Seghers (1591-1651), whose *St. Teresa in Ecstasy* Crashaw could have seen displayed in the Church of the Discalced Carmelites in Antwerp in the 1640s, when he lived in the Low Countries; another copy, dating probably from the seventeenth century and attributed to Velasquez, is in the English convent at Bruges. My thanks to Frank Warnke for his help on this point.

[20] In *Richard Crashaw*, ed. Michael Cayley (Oxford: Carcanet Press, 1972), p. 88. Hereafter cited as Cr.

called, this avatar of the Beautiful Beggar, perfectly represents the Mannerist and Baroque metamorphosis first in France and then in England.[21] La Roque sums up the transformation thus:

> Enfin la belle Dame orgeuilleuse et mondaine
> Changea son miroir en livre et ses yeux en fontaine.

> Finally the lovely Lady, prideful and worldly,
> Changed her mirror for a book and her eyes for a fountain.[22]

In a great number of works in prose and verse, her tears, are given the value of diamonds as they are precious:

EMOTIONAL VALUE		SYMBOLIC MATERIAL VALUE
liquid crystal	→	hardened crystal
(tear)		(diamond)

This in turn leads to a meditation on the parallel transformation of blood to ruby; again the emotional value is converted to a symbolic material value:

EMOTIONAL VALUE		SYMBOLIC MATERIAL VALUE
liquid red	→	hardened red
(blood)		(ruby)

In both cases, the mark of suffering is converted into the symbolic precious stone. But to continue with the tears of repentance, still increasing in value, they then rise toward the Milky Way, by virtue of the crystalline purity transposed into the pure and maternal love of the Virgin Mary, and thus the mother's milk joins the myth of the heavenly water above the sky. These same tears, having served for the breakfast of the cherubim insofar as they nourish like milk, fall once again to earth as heavenly drops of rain, attracted by the heat of Mary Magdalen's passion. Here the red-blood-ruby sequence appears, in order to become her tears, at once red and crystal, ruby and diamond. The one who washes the Lord's feet thus finds once more her passion for him, yet another spot to be cleansed, and she must repent once more for the cycle to begin anew.

Le Moyne's sonnet "La Madeleine," for example, plays on a full range of arousal and regret, stimulation and suffering:

[21] See the poems of Malherbe, Favre, Pierre de Saint-Louis, Chasteuil, Southwell, and, in Italy, Marino, etc.

[22] In *Anthologie de la Poésie Baroque Française*, ed. Jean Rousset (Paris: Colin, 1968), II, p. 26.

Ici, d'un repentir célèbre et glorieux,
Madeleine, à soi-même indulgente et cruelle,
Guérit de son péché la blessure mortelle
Et par ses larmes tire un nouveau feu des cieux.

Son luxe converti devient religieux.
Ces rubis sont ardents de sa flamme nouvelle
Et ces perles en pleurs se changent à ses yeux.

Beaux yeux, sacrés canaux d'un précieux déluge,
Innocents corrupteurs de votre amoureux juge,
Ne serez-vous jamais sans flammes et sans dards?

Au moins pour le moment faites cesser vos charmes.
La terre fume encore du feu de vos regards,
Et déjà vous brulez le ciel avec vos larmes. (FV, p. 283)

Here, in a famous repentance full of glory,
Magdalen, indulgent and cruel towards herself,
Cures the mortal wound of her sin
And by her tears draws a new fire from the skies.

Her converted lust becomes religious.
These rubies are ardent with her new flame
And these pearls change to tears before her eyes.

Lovely eyes, sacred channels of a precious flood,
Innocent corruptors of your enamored judge,
Will you never be without flames and darts?

At least for this moment, bid your charms cease.
The earth is still smoking with the fire of your looks,
And already you burn the sky with your tears.

These tears can also, as we saw, be changed to wine, that ruby liquid reminiscent of the meditator's tears themselves colored by passion, and marking the communion ritual: "so to drink the blood of our Lord and Savior Jesus Christ." The wine is then used, by transposition, for Christ's own drink, while the angels imbibe as if it were milk, the crystal of repentance, that weeping river. The convergent symbols provide an extraordinary density to these poems. Compare Crashaw: "The debt is paid in ruby tears/Which thou in pearls did'st lend" (Cr, p. 29).

Among a great profusion of poems both English and French, I shall quote Crashaw again on Saint Teresa. The reversing of images is made more noticeable by its exaggerated character: Mary Magdalen weeps upwards, this liquid is inbibed by the breast of the sky, to become there

a sort of enriched milk, or rather cream, floating above the ordinary—
although stellar—milk, and the whole vision is meant to instruct in cos-
mogony as well as in piety.

> Upwards thou dost weepe,
> Heav'ns bosome drinkes the gentle streame,
> Where the milky Rivers creepe
> Thine floates above, and is the creame.
> Waters above the Heavens, what they bee,
> We are taught best by thy Teares, and thee. (MP, p. 198)

As the weeping river nourishes, and as each product is given added value
by its insertion into the *system of conversion*, and as each leads to each,
the reader of multiple sonnets to the figure of conversion may establish
a sketch something like this:

CONVERSION/ REVERSION AND REVERSAL

passion = lust → sin → flame/heat/red → ruby
↑↓ attracted by sun and enamored ↓
repentance = heaven → tears/fresh/clear crystal
↑↓ flowing water and falling rain ↓
nourishment = earth → milk/rich/white cream
└─── floating above ↙

The entire operation is cyclical: the weeper by her passionate tears attracts
dart and responding celestial flame; thus, the rain of tears red with blood
of repentance falls upward to burn the sun, whose rays once again re-
kindle the red of passion and the crystal of repentance. What falls down
in tears is kindled upward, in flame and descends again to continue the
cycle.

This is a teaching poem and has the strong lines of what we might
call conviction-for-conversion. A meditation on Mary Magdalen is often
constructed about this series of oxymora: flames and cool waters, red
and white, purity and spot, radiance and extinction, passion and re-
pentance:

> Her flood lickes his feets faire Staine,
> Her haires flame lickes up that agine.
> This flame thus quench't hath brighter beames:
> This flood thus stained fairer streames.[23]

[23] "The Weeper," in Richard Crashaw, *The Complete Works*, ed. William B. Turnbull
(London: John Russell Smith, 1858), p. 27.

The Magdalen represented as a red-head, thus with her hair aflame, can quite easily with her look and its rivulets of tears, lick the object of her love as the tongues of flame lick their prey in an erotic representation of the language of passion, like Artaud's recreation of the tongues of fire into a fire of tongues. Our tongues and our eyes are supposed to be inflamed by the dis-ease of desire and by the repentance such presentations kindle: we participate in the meditation of the figure upon whom we gaze, whose beauty is partly made up of the convulsive extremes occasioned by all these instances of reversibility. If the spot the Magdalen washes from the feet of Christ is crystalline in its purity, thus reviving the light of the flames and the splendid blaze of the waters, all this is included in the beauty of her eyes impassioned and repentant, as they meet the eye of the hearers, as it rains beams of light upon the fire of these human and saintly eyes. These texts are properly inflammatory, and exemplify what the Surrealists will call, after Breton's *Nadja*, a "convulsive beauty."

Above all, the condensation of what is properly termed a marvelous image—*meraviglie*, said Tesauro and the other rhetoricians—much, indeed, to be wondered at, provides the atmosphere for the interior explosion advocated for the poetic image by Reverdy and the Surrealists after him: to illustrate the likeness of our two communicating vessels and moments, specifically the Mannerist and the Surrealist, we shall take two final examples as our reading modifies them: they offer a privileged space for the study of outward designation and inward contemplation. The first is provided once more by the Magdalen's eyes as they are red from a flame both exterior and interior, by the proximity of La Tour's candle and her own passion. The conjunction of tears and flame mirrors exactly in a reverse image that of Christ's wounds where the hot crimson calls forth the liquid of repentance from the onlooker, whose eyes, crimson from the weeping itself as from the reading, contaminate the color. These tears are not easy, they are bled: "Her eyes bleed Tears, his wounds weep blood," says Crashaw, or again:

> Lo where a Wounded Heart with Bleeding Eyes Conspire.
> Is she a Flaming Fountain or a Weeping Fire?[24]

In correspondence to this play of contraries, we read the conclusion for a poem of Breton entitled "Sur une route qui monte et qui descend" (On a Road Rising and Descending), where the desire for a wild flame ("une flamme barbare") guides poet and poem to an absolute convergence, a brief summit of explosive intensity and intertwining:

[24] These lines form the text for the emblem of the weeping female on the bleeding heart which accompanies "The Weeper." See Ibid., p. xii.

Dîtes-moi où s'arrêtera la flamme
. . . Et la flamme court toujours

. . .

Je pense à une flamme barbare

. . .

Flamme d'eau guide-moi jusqu'à la mer du feu[25]

Tell me where the flame will stop
. . . And the flame is still running

. . .

I think of a barbarian flame

. . .

Flame of water lead me to the sea of fire

[25] André Breton, "Sur la route qui monte et qui descend," in *Poèmes* (Paris: Gallimard, 1948), p. 79.

4

···

LOOK AND GESTURE

'Twas his well pointed dart
That dig'd these wells, and drest this Vine
And taught that wounded heart,
The way into those weeping Eyne.
—Richard Crashaw, "The Weeper"

AS THE SECOND THRESHOLD for the reading of gesture and look in the Mannerist and Surrealist conceptions of indicating finger and of visionary eye, I shall first take two canvasses of particular interest for the idea of reading itself. Poussin's *Shepherds of Arcady* reminds us not only of death in the center of each Arcadia, by its tomb-centered inscription: "*Et In Arcadia Ego*," but also of the collective sharing of the text inscribed, once it has been found (figure 17).[1] This is in fact, and above all, an image of inscription itself, signaled by the finding fingers and located in the center of the canvas, like a text centering another, in a *mise-en-abyme* of mortal dimensions. Here, the reader might concentrate not only on the gesture, as in the Mannerist mode, but rather on the text, its designation, its inscription and deciphering.

In fact, most of the texts discussed here, be they Mannerist or Surrealist, call for at least two divergent readings: the designating gesture frequently has an importance at least equal to that of the object designated or the sense, stated or implicit. For the Mannerist stresses his own gesture, and our present receptivity to such images as the pointing finger can be taken as an image of our own obsession with signs and stressed gestures. Giacometti's *Man Pointing*, like César's *Thumb* (figure 34), signals the observer's situation in face of the sign, and the gesture. The double fascination for both Mannerists and Surrealists of designation or pointing and of the gesture observed leads to the frequent convergence in their art, whatever its form of expression, of the finger and the eye. For the Dada or Surrealist metronome of Man Ray, time is marked not only by the mechanical finger but also by the eye watching over space, whereas Albert Flocon, Dali, and others inscribe an eye in the center of an ex-

[1] See Louis Marin on Poussin in *Etudes sémiologiques, écriture, peinture* (Paris: Klincksieck, 1970), and in *The Reader in the Text*, ed. Suleiman and Crosman (Princeton: Princeton University Press, 1980), pp. 293-324.

tended palm of the hand, to make a greeting whose ambiguity is increased by the gaze directed upon it.

The gesture fascinates us above all in the representation of the Magdalen in Correggio's *Noli me tangere* (figure 20) where the separating gesture drawn by the finger of Christ, himself both ambivalent and stylized, befits the step of a complicated dance. (The curve of the Titian *Noli me tangere* [figure 19] is completely different, and the triangular mass of the composition does not lead out beyond the canvas: self-enclosed, it does not point elsewhere.) Eugenio d'Ors, at Pontigny in 1931, analyzed the complexities of this gesture in a poetic prose: "Mais ne me touche pas, ne me touche pas, car tu pourrais souiller encore"[2] (But do not touch me, Do not touch me, for you could still soil), says his Christ finally to his Mary Magdalen, and the finger points to this sky beyond the canvas, which remains invisible to us. About the sky, of course, there is no shadow of doubt, for we know what the finger designates; but in fact, the sky thus pointed to does not appear in the canvas, and leaves only the trace of a suggestive and elegant gesture. Correggio calls attention to the aesthetic aspect, to the line leading from the knees of the Magdalen upward, by the delicate hand of the man rejecting the woman as she implores, rejecting with her earth, nature, and visual reality in favor of the sublime and the spiritual, toward which, in principle, the graceful arabesque guides the gaze: this is the Mannerist game. We thus consider the canvas on two levels: first form and then meaning, as a Mannerist gesture primarily self-aware.

In order to see the distinction between the strong-lined gesture calling attention to itself as in Mannerism and Surrealism, and the other we regard as a useful or outwardly-directed gesture characteristic of other attitudes, we could follow *grosso modo* a line cutting across several periods. First, in the Renaissance, the idea of deciphering holds the same attraction for the textually-oriented beholder as does the gesture of pointing. In Uccello's *Battle of San Romano* (figure 18) the lines of the broken lances upon the ground designate the middle of the scene, the vanishing point, as if they were so many fingers.[3] In itself, the gesture does not hold us, for we are naturally more interested in the dramatic architecture, in the scene itself. Poussin's Arcadian shepherds (figure 17), in the moment in which they find that inscription we too are privileged to read, point with their fingers to what others have inscribed. One could say the same thing about the *Oedipus* of Ingres as he interrogates the Sphinx, one finger

[2] Eugenio d'Ors, *Du Baroque* (Paris: Gallimard, 1968).

[3] As Vasari says of Uccello: "perspective . . . kept him ever poor and depressed up to his death." In *Lives*, tr. G. de Vere quoted in George Kubler, *The Shape of Time: Remarks on the History of Things* (New Haven and London: Yale University Press, 1962), p. 51.

curved toward it or of Salomé pointing to the head of Saint John the Baptist in Moreau's *Apparition*. In each of these images, the finger points out a specific thing: a scene, a legend, an enigma, or a warning. These paintings do not show a gesture of primary interest in its self-consciousness as gesture; they are thus to be contrasted with the Mannerist paintings about pointing. As a prime example of the latter, the finger in Giovanni de Bologna's statue of Mercury is charged to a Mannerist extreme: the gesture takes pleasure in its own gesturality: it is really a pointing at pointing (figure 21). Tintoretto provides a more strident example still; where the finger is apparently pointing out the scene of the *Discovery of the Body of Saint Mark*, the line of the arm leads our look toward the capitals on the columns, toward the curve of the arch and, by extension, toward a small white rectangle in the distance, as an opening out from the darkness, but surrounded and almost devoured by the enveloping black about it. Once again, the gesture has an odd fascination, like the oblique position of the body as it is found, and the extraordinary twisting of the other figures in the scene, each of which reinforces the central gesture pointing out beyond it all. The strength of line may be seen to take precedence here even over the legend.

Of all the gestures, signaling and self-signaling, which impinge upon the free reading of the visual text by their aggressively deictic function, one of the most enigmatic and most endowed with ambiguous intensity is the celebrated *Self-Portrait in a Convex Mirror* of Il Parmigianino (figure 23). John Ashbery's poem about that canvas bears brilliant witness to the complexity: the hand seems posed as if to block our access, as if "to protect what it advertises," in the words of the poem.[4] Neither in the mirror itself, nor in the mirror of the text, does any reflection welcome us; the dim symbols of the half-visible writing remain forever without plausible interpretation, and the hand, whose back we see, will never come into contact with our own. Enclosed in the round form of the mirror, the head seems to exclude both our thoughts and our portrait-in-response from this perfected world. Although the circular form of the frame responds to the round form of our head and our eye, the canvas irrevocably excludes us from that possible *tête-à-tête*. Or does it? On another reading, we might feel welcomed by the fingers pointing inward, by the hand placed at the edge in order to guide us toward the artist's own reflected gaze, sweeping our own gaze along with it, into the globe.

And then again, our own reflection is at third hand, as we reflect on the reflecting of and on reflecting:

[4] John Ashbery, *Self-Portrait in a Convex Mirror* (New York: Viking, 1975). Hereafter referred to as SP. The mannerist hand (*maniera*) is evident.

Chiefly his reflection, of which the portrait
Is the reflection once removed. (SP, p. 68)

The face mirrored, impressed, held still, and reflected upon remains vivid
in its illumination, lighting the poem as it does the canvas:

The time of day or the density of the light
Adhering to the face keeps it
Lively and intact in a recurring wave
Of arrival. (SP, p. 68)

The searching gaze depends on ours, rejects and beckons, like the hand.
This mirror text is itself a speculum and a speculation: what do we learn
from it? That the hand cannot, as Ashbery says, penetrate the globe
outward, nor is there any penetration to the soul. We are, perhaps, invited
in as surely as we are rejected,

. . . But your eyes proclaim
That everything is surface. The surface is what's there
And nothing can exist except what's there. (SP, p. 70)

Il Parmigianino's picture, this first mirror portrait, mirrors us, in our
gaze, directed also at this poem of our own generation, in its perfect
response:

. . . the whole of me
Is seen to be supplanted by the strict
Otherness of the painter in his
Other room. We have surprised him
At work, but no, he has surprised us
As he works. (SP, p. 74)

In fact, the designation of this mirror as mirror is made by the writing
and drawing hand, an allusion to the situation I share as I write: being
conscious of consciousness, I can only take this poem and picture as
center for seeing and thought:

. . . Since it is a metaphor
Made to include us, we are part of it and
Can live in it as in fact we have done,
Only leaving our minds bare for questioning. (SP, p. 76)

Whereas in Correggio's canvas Christ's finger at least draws our look
toward the sky and its lines are the continuation of others in the canvas,
in the case of Il Parmigianino, the hand is exaggerated in size and dis-
played almost out of bodily context. This disassociation resembles the

painting made of two legs only, representing Lazarus, hung on the wall in the next example of Mannerism I want to consider, that of the *Double Portrait of Gabrielle d'Estrées and her Sister* (figure 29).[5] Here the observer may think of the Surrealist fondness for artificial legs and limbs of all sorts, taken out of their context, made unbourgeois, as it were, and of the fascination certain high heels exercised over Desnos (regardless of the feet within them), of the predilection of Bellmer, of Audiberti, of the young de Chirico for dolls and mannequins—that is, for the forms stripped of natural life. Exactly as in Clouet's portrait of Diane de Poitiers in her bath (figure 27) the concentration on the isolated hand or the finger makes an ironic statement about this kind of gesture as it chooses and designates, or the eye as it observes, both with a certain detachment, almost inhuman, thus associating parody and fetish with serious consciousness and erotic cruelty, as with the creating hand and instrument.[6]

The precise gesture and the cold stare, within and without, of this double portrait—this portrait of a woman cut in two twice, against this

[5] Alternate versions are titled *Portrait of Gabrielle d'Estrées and the Duchesse de Villars* or *Portrait of Gabrielle d'Estrées and the Maréchale de Balagny.*

[6] I have reproduced a number of the paintings referring to the Diana's bath theme, some with slight variants, some with greater ones, wanting to embroil the reader and viewer at least to some extent in the tangle and multiplicity of versions of these portraits both single and double. They are themselves a reflection upon the tangle of erotic and religious textual elements, on which I can only reflect briefly in this note. The double bath pictures with Gabrielle d'Estrées include one of her sisters, either the Duchess of Villars or the Maréchale de Balagny, or then Henriette d'Enagues who succeeded her after her death. These products of the "hydrotherapy school" of painting (Maulde la Clavière's term) include, of course, the famous Diana in her bath paintings, and their imitations.

Of the most celebrated of the double portraits, the one of *Gabrielle d'Estrées and her Sister* found in the Louvre (figure 27), the interpretations have been many; the gesture at the breast may well represent, rather than a symptom of sapphism or a gesture toward the birth of César Duke of Vendôme, as has been thought, a satire of the inclinations of Henri IV, given to peeking at the bathers (one blonde, one brunette, as the double models of feminine beauty). In this latter interpretation, the servant Madame de Sourdis would represent Gabrielle d'Estrées, helping her to subjugate the king.

As for the *Lady at her Toilette*, Diane de Poitiers holds, in some versions, a little wood cross and puts a ring into a jewel case, thus, showing a mixture of eroticism with her Catholicism, or then, as in the Dijon version, hides a portrait in a jewel on her breast, love thus replacing the cross. In this case, the ropes and the pearls represent Diana as Venus; in some versions, the mirror shows an entwined couple, emphasizing still more the theme of amorous reflections. The Worcester version, reproduced here, and on which Jean Paris comments, is a replica of an original Diane de Poitiers or Gabrielle d'Estrées. For all this information, the best source is the Catalogue of the exhibition of *L'École de Fontainebleau* at the Grand Palais, Paris, 1972-1973 (published by the Editions des Musées Nationaux), especially pp. 214-245. For some amusing allusions to the controversy, see *Point de Vue* (Paris, April 14, 1955), with pictures of Gabrielle and Diana side by side, one of the paintings signed "Pourbus." The most renowned version is, of course, the Clouet Diane, on which my commentary turns here.

double theatrical scene—are accentuated by the dramatic red curtain and the empty box, the *baignoire* serving both for bath and theatrical situation. (Actually, the art historians tell us, it is a play on "being in a hot spot" or "in hot water"; historical reality subtracts nothing at all from our obsessed reading.)[7] Not only is the body violated by the onlooker's gaze, that is, in contemporary terminology, "transgressed," but also the very surface of the canvas is interrupted by this surface of a darker color, as a curtain behind a curtain, thus creating a theater behind another one. No look answers our own to welcome it: the lady dressed in red looks away as she prepares the trousseau for the marriage—to which a reference may be made in the pinching of the breast to indicate its future function as a source of nourishment.[8] The trunk itself is centered but covered in black, thus it also is blind to the extent of refusing any intellectual pen-etration, forming an abyss in the middle of this canvas. Compare, in other renderings of the *Woman at her Toilette* by the Fontainebleau school (figures 25 and 26) and in Titian's *Venus of Urbino* (figure 24) the open trunk into which a servant is peering, placed as in the *Double Portrait*, behind the main figures, but in the latter, the mystery remains unopened and all the more powerful as a central feminine darkness.

The symbolic fire in the hearth is associated in an erotic fashion to the legs spread apart in the interior canvas and to the dark and specifically enclosed mystery of the trunk—significantly it portrays the raising of Lazarus. The leg of the chimney also, like a missing third leg for the two legs isolated in the canvas, points, by its supplementation—like some obscene and thickened finger—to the front of the scene and the bathtub from which the water is absent. (For the faithful reader of Bachelard, who was constantly aware of opposite elements, the fire calls attention once more to that absence of water.) Furthermore, the needle with which the lady sews will never serve to restore the parts of the body, the ones to the others, will never be able to match this top of the canvas, where the legs alone appear, to the bottom of the canvas where only the top half of the body is apparent. Marcel Raymond has pointed out that the evo-cation of the body in Mannerist art proceeds by the dismemberment of the body into its component parts: breast, fingers, eye. The same is often

[7] My thanks to Colin Eisler for his clarification of this point.

[8] See Jean-Louis Schefer, *Scénographie d'un tableau* (Paris: Seuil, 1969), who shows the play between this canvas and Bordone's *Chess Game* (figure 24). In each, the aggression of a "duplicitous glance" responds to the other duplicity; in the Bordone, the hand posed above the chessboard is in the same position as the aggressive hand in the anonymous picture, thus establishing an exchange, at least in the observer's eye, between the two designating gestures. The pinched breast is singled out and repressed, and the pawn is displaced on the board: in both cases the rules are violated as the look turns away from the object the hand represses. Thus the hand and the eye are seen to transgress.

true of Surrealism, for instance of Breton's celebrated poem, "L'Union libre," which details the parts of the body as in the Renaissance blazons: "Ma femme à la chevelure de feu de bois . . . Ma femme aux yeux de savanne"[9] (My wife with woodsmoke hair . . . My wife with savanna eyes). The blazon is also inscribed under the double heading of consciousness and cruelty.

By sheer chance, perhaps, or then by a parodistic backward gesture, as one canvas brings to mind another, at least for the charged and inward look, Magritte's *Le Galet* (The Pebble), in which a woman in the shower caresses her own breast, shows a blatant autoeroticism without the subtlety of the celebrated double portrait, and it is perhaps only in a highly charged imagination that the correspondence between them takes place, as if that needle were to sew together the pieces of our own vision. Now in any painting of a woman before her mirror, the spectator has the right to stare at the woman or then, at the woman and the mirror. But there is every chance that in a Mannerist canvas either the look will find itself repulsed—as by a first reading of the hand of Il Parmigianino's *Self-Portrait in a Convex Mirror*—or the spectator, however unwillingly, will become the accomplice to some act of cruelty. In the painting of *Diane de Poitiers* by Clouet (figure 27), which we might link to the *Double Portrait* by its glazed surface of indifference and its disquieting extreme of self-consciousness, the right hand operates with an extreme cruelty and precision, contrasting precisely with the round forms of three figures who represent the three ages through which Diane has passed: the round breast of the nurse offered to the infant, the round jar the girl holds, and her own exposed torso as a young woman. In the painting hung on the wall, a stag—an animal often replacing the unicorn—may point the way for the observer to a dream of that image, the single horn as a source also of creation and of suffering, like another cruel and impassioned finger, inflicting passion: this *conjunctio oppositorum* of male and female forms is all the more powerful for being veiled until now.

The instrument with which Diane's fingers are toying—as if to spear the cherries—would also make an incision in the cloth, like the stylus for the inscription to be made by the drawing or writing hand. A parallel might be established with Cellini's famous *Salt-Cellar* made for the use of this pointed instrument, whose cruelty and whose generative force are interconnected: the extravagance of the gesture and the material value of the ornament in relation to its modest dimensions stress the very gratuity of the object in its sensual and next-to-useless elegance. The god holds his trident exactly like Cupid's dart and the equivalent instruments already

[9] André Breton, *Poèmes* (Paris: Gallimard, 1955), pp. 65-66.

mentioned, while his partner points to her own breast in an erotic response scarcely more subtle than the gesture in *The Double Portrait* (or Magritte's *Pebble*). The generating or potentially generating force is kept in the background of the Clouet painting and is implicitly directed toward the female torso occupying the foreground, whose gesture, however delicate, is parallel to the implicit gesture of generation with its jabbing motion. (I need not continue to point out that this interpretation is, deliberately, subjective, as perception often is.)

The fact that the lower edge of the *baignoire*, already framed as at a theatrical performance, is parallel to the bottom edge of the frame on which the left arm rests, and on which the right hand plays, and dramatically, brings the gesture violently to the foreground. The repetition, in a mirror image, of the arm's posture by the girl's corresponding and opposite arm in the background emphasizes the line from one age to another—from one generation to another—stressing the position of the horned animal in the picture within this picture at the source of it all.

The entire scene, like that of the double portrait, is framed between bath and theater, displaying the curtains at the edge and above, like the sheets for all the dialectic of exposure and concealment. The framing sets off the line of the three principal figures, whose heads, along the horizontal, form the narrative line of the story. Moreover, another repetition stresses the same story and the relation of the three generations to each other, here figured: the ample bosom of the nurse and the head of the sucking baby are echoed in the far daintier breasts of Diane and the head of the older child, tilted away from those breasts, but held on their level. The visual hints work like rhymes in a poem, stressing the connections the reading is meant to make.

Now seen in comparison to the *Double Portrait*, the tripartite division is all the clearer. The drapes hang in the same way, as top-edge framing for the bath or theater box—the *baignoire* in which the bare torso is exposed, singly in one case, doubly in the other. The nurse, furthermore, is to be read in relation to Diana, as the two figures are to be read in relation to each other in the double portrait; as the space between the latter figures is interrupted by the sewing lady, here the nurse and Diana are separated by the young girl, the intervening figure serving as a mediation in both cases. Against the rear wall both tables reveal only one leg, partly concealed by the trunk in the double portrait and the table in the single one. As for the picture within the picture, which gives inner sense to the whole, whereas the legs of Lazarus point to the averted gaze of the sewing lady in the double portrait, here the stag is placed in direct relation to the anatomy of the girl, and it is here Diana who averts her gaze from ours, unlike the girl.

Diana's left arm rests on the edge of the *baignoire*, while its mirror

image balances it behind; that of the right arm of the girl crooked in exactly the same way. In the double portrait, both sets of arms serve as frame for the action, and the arm of the sewing lady is crooked at just the same angle. In both portraits the little fingers are slightly separated from the others, and Diana's arm wears a bracelet; Diana and the two bathing ladies are all three presented against an inner curtain, like an inner frame, behind which the nurse and the girl are located. All these bath and exposure pictures are constructed for the double delight of peeping king and peeping reader, the eye upon the text which sees both spectacle and its own spectatorship. The space of the painting has, like the theater it represents, a background and a foreground: The attitude of the staring figures intrudes upon our own space and leaves us no room to rearrange or to reinterpret: fiancée in the case of the double portrait, mistress in the other case, these are both exposure and challenge. They are surrounded with images of generation and procreation, with nour-ishment and raiment, or with the stripping off of raiment and the toying with nourishment. From cherries to breasts, and dowry to nakedness, from painting to play and sensual to sense, the double reflection of the double portrait against the single one and of the inner pictures to the outer ones illuminates multiple relations in the observer's mind. And in both portraits, relations are plainly meant to be dramatized, thus the theatrical setting, and the reference to myth: Diana the huntress and her stag in one case, the contemplation of marriage and the raising from the dead or the rekindling of latent fires in the other.

All this double play is a ritual of ceremony and concealment, of exposure and averted gaze, of a bath with no water visible, and of curtains framing the *baignoire* from which, precisely, the theater is itself to be seen: the look out and the look in converge. Our eye and our mind are forced back and forth, in space and time, in room and in age, unquietly, but fascinated. In his *L'Espace et le regard*, Jean Paris speaks of the representation of Diane de Poitiers owned by the Worcester Art Museum in Worcester, Massachusetts (figure 24) as an example of the way in which the mirror modifies the gaze within the painting and the reader's or onlooker's gaze upon that gaze. As she sits, pointing at her breast, Diane retains in the mirror the same identity as before, a feat not possible unless this is all seen in a mirror held before the painting. This explains, he says, the uncertain expression of the girl, and in turn this reflection of a reflection in a mirror and the servant digging in the trunk are the projection of the scene in a third mirror. "In short, every mirror de-realises its object insinuating some doubt upon the situation, upon its nature."[10] The relation, assumed by the onlooker, between the pointing gesture and

[10] Jean Paris, *L'Espace et le regard* (Paris: Seuil, 1965), p. 249.

the digging in the trunk, as in a dowry of rich garments or in an accumulation of memory, can scarcely fail to provoke a few Freudian interpretations, as it does in the other similar paintings reproduced here. In this reader's interpretation, the connection as read is just as psychologically as it is historically significant: the potential is pointed at in one case, birth and nourishment, and in the other, at another sort of bringing to the light and supplying. Both cases involve the female as the agent of production, as the bringer-forth from dark to light, one from the deeper recesses of the hiding vessel, the other from a more material surface container, thus one a lady, the other a servant, one presented frontally for our contemplation, in a noble light, and the other, half-turned away, so that we may not see. These are paradigm cases of the open and the unrevealed, twice over, or doubled as in the mirror of our own viewing conscience. What more perfect illustration of the studies of Melanie Klein concerning the importance of the breast in the infant consciousness and its lasting importance to the artist as Anton Ehrenzweig describes it at length in his *Psycho-Analysis of Artistic Vision and Hearing* and in *The Hidden Order of Art*? Whether our reactions to it and those of the artist are of a "pathological" or a "healthy" nature, whether it is singled out as a form not yet integrated and still dangerous or integrated into our whole scheme of things, the paintings utilizing this image are rather more conscious than unconscious in their appearance, leaving aside the obvious historical reference once more. Or rather, their obvious historical setting should not blind us to the hidden significance. The aesthetic feelings connected with these particular paintings might be what Ehrenzweig terms "conscious signals of intense articulation processes upholding a successful articulation against the disintegrating pull of inarticulate depth perception," while at the same time there might be seen to be a "plastic quality to the conscious perception which would thus serve as a signal for the hidden existence of repressed inarticulate perceptions."[11] The most extensive work along these lines has been done by Adrian Stokes in his *Invitation in Art*, where art is seen as celebrating "multitudinous mergings and fusings with good corporeal fragments" in a reparation of the former disintegration of the self. His article "Form in Art" describes the re-creation of experience and the projection of emotional stress and of one-ness, as well as the "unblushing display of conflict" and the "attack" with the paintbrush as a working-through of aggressive impulses,[12] for example, of painter against the woman as object, carefully

[11] Anton Ehrenzweig, *The Psycho-Analysis of Artistic Vision and Hearing* (London: Routledge & Kegan Paul, 1953), pp. vii, ix, x.

[12] Adrian Stokes, *The Invitation in Art* (London: Tavistock, 1965), especially pp. xxi ff.; "Form in Art," in *New Directions in Psycho-Analysis* (London: Tavistock, 1955), pp. 406-420, especially pp. 406 ff., where he describes the renewal of oceanic feeling as it

designating that part of herself felt as both dangerous and good or nour-
ishing.

The Clouet and its imitations seem to be perfect illustrations of this
aggression and the reader's response; the aggression is transferred here
to the figures within the canvasses, and as they stare at us, we are indeed
visually aggressed. The possible net of linkings is vast between this open-
ness—of the stare, of the erotic and manipulating gesture—and the op-
posed images of rummaging in the trunk (as in Titian's Venus of Urbino,
figure 24) and the corresponding hiding of the lady's parts in the Venus
of the picture. Her hand and the hand of the *Self-Portrait*, here placed
in juxtaposition, further accentuate the suggestion of manipulation: con-
cealment and openness may be equally aggressive, both for the inscrip-
tion and for the reading eye trained within and upon the text.

THE MANNER OF THE HAND

This extraordinary construction of the portraits portraying exposure and
implicit desire, ceremony and surprise, stag and maiden, specific cruel
gesture and generalized eroticism, resurrection and generation, and the
highly presentational mannered style have a close parallel in the Cluny
tapestry and in the poem it inspires in the contemporary poet René Char.
In relation to this engendering of erotic imagery, we might consider his
poems of the scorpion and the dark, of the single horn, concealed or
extended, and of virginity, cruelty, suffering, and redemption. Mannerist
gesture precisely points to its own pointing: here the gesture, highly self-
conscious, combines self-reflective form with the profound impulse of
myth: consider two texts of Char that face each other on two opposite
pages in *La Nuit talismanique* (The Talismanic Night) of 1972. The two
parts of the presentation play one against the other their pointed and yet
ambiguous fascination: to the left, in a "Cérémonie murmurée" (mur-
mured ceremony) the white scorpion, all the more dangerous for its
apparently innocent color, inflicts on the very image of innocence a
suffering at least in part erotic, so that this ceremony doubles religion and
danger, the cultural and the civilized, flame and pointed instrument:

> Comme une communicante agenouillé tendant son cierge,
> Le scorpion blanc a levé sa lance et touche au bon endroit.
> Surprise lui prêta ruse et son jarret.

combines "the sense of fusion with the sense of object-otherness." The sublimation is highly
wrought, he says, and surely this is the best way of speaking of these Mannerist exempli-
fications of the intensified experience of painting that in their turn intensify the observer's
reaction. For the notion of "attack," of primary importance, see p. 419: it is along these
lines, he says, that further studies of psychoanalytic form should be undertaken.

As the girl at her first communion, kneeling, extends her candle,
The white scorpion has raised its lance and touches the exact
 place.
Surprise lent to it ruse and the calf of her leg.[13]

Like the nipple-pinching and cold stare of the ladies in the Fontainebleau
picture, who intrude their gesture and their gaze upon our presence—
the cruelty of both echoing the erotic movement of the jabbing needle
or of the stag's horn—in this staged poem and scene, infliction and
acceptance form the sensually complementary sides of this Mannerist
picture. Char is no Mannerist, but has absorbed the complicated balance
visible in such works of art. In this volume, on the other side of the scene,
a solitary unicorn as in the Cluny tapestries chews and spits out the tender
part of the guelder-rose, the flower called, in the Vaucluse, the snowball,
whose virgin color indicates sufficiently its role in the sense of the poem:

A qui lui demanda:
L'avez-vous recontrée? Etes-vous enfin heureux?
il dédaigna de répondre et déchira une feuille de viorne.

To the questioner:
"Have you finally met her? Are you happy at last?"
he did not deign to reply, and tore a leaf of guelder-rose.[14]

The poem, Char explains it himself, shows the deliberate exhaustion of
the virgin possibilities by this horn that chooses, designates, and destroys.
The nature of this horn, generative and destructive, becomes clear in
another of Char's brief poems, "Le Taureau" (The Bull), which opposes
an animal force worthy of the battle to the solitary human sword which
kills, like the amorous dart, by an erotic designation of the victim: "Fauve
d'amour, vérité dans l'epée, Couple qui se poignarde unique parmi tous"
(Love's wild beast, truth of the sword, Nonpareil couple stabbing each
other).[15]

 Now, this interchange between contemporary poetry and the art of
the past illustrates a reading in reversed time: what we have read of
Desnos, Artaud, and Leiris, for example, what we have seen of Max
Ernst, Magritte, or Picasso serves us in our reinterpretation of the can-
vasses and texts we are calling Mannerist, Metaphysical, or Baroque. I

[13] René Char, La Nuit Talismanique (Paris: Skira, 1972; reprint. Paris: Gallimard, 1979),
p. 92.

[14] Poems of René Char, translated and annotated by Mary Ann Caws and Jonathan Griffin
(Princeton: Princeton University Press, 1977), p. 275. The translations are slightly adapted
here.

[15] Poems of René Char, p. 145.

think, for example, of the "spanking given to the baby Jesus by the Virgin Mary" in a painting of Ernst, the chastisements of the same kind given by the headmistress in the boarding school of Desnos' *La Liberté ou l'amour!* (Freedom or Love!) and of his obsession with the writing hand to which a long passage in *The Night of Loveless Nights* (so entitled) bears witness. In all these cases, the erotic is strongly linked to cruelty and fear and to the parallel consciousness of creation. As in so much Baroque and Metaphysical poetry, a mournful black plays against the white of hope, a virgin white against the red of passion, the open in form and attitude against the closed and the enigmatic, and the I as well as the eye against the "I" or "eye" of the other:

Il y a des mains blanches dans cette nuit de marais.
Une main blanche et qui est comme un personnage vivant

. . .

Il y a des mains terribles
Mains noircies d'encre de l'écolier triste
Main rouge sur le mur de la chambre du crime

. . .

Mains ouvertes,
Mains fermées
Mains abjectes qui tiennent un porte-plume
O ma main toi aussi
Ma main avec tes lignes mystérieuses
Pourquoi? plutôt les menottes . . .

There are white hands in this night of swamps.
A white and like a living being

. . .

There are terrible hands
Sad schoolboy's hands stained black with ink
Red hand on the wall of the room of crime

. . .

Open hands,
Closed hands
Abject hands grasping a penholder
Oh my hand you also
My hand with your mysterious lines
Why? let me have handcuffs rather.[16]

[16] Translation from Mary Ann Caws, *The Surrealist Voice of Robert Desnos* (Amherst: University of Massachusetts Press, 1977). Compare Eluard's "La Roue" ("The Wheel"), from *Les Soirées de Paris*, June 15, 1914, pp. 345-346: "Les éclairs étaient des mains. Et la Femme m'apparut au milieu des airs, dans un cercle de mains. Toutes ces mains

The creating and designating hand here constitutes itself a prisoner in preference to yielding up its mystery. A drawing of Desnos found with one of the manuscripts of this poem shows a gigantic thumb (figure 33) and the criss-cross lines he used to start a drawing, here adding to the confusion of signals and metatextual concern, among the signaling fists and fingers. We might compare this text with the gigantic bronze sculpture of a thumb, *Le Pouce*, by the contemporary sculptor César (figure 34), which seems the very image of aggressive creation. I read the thumb as a phallic sign of graceless designation, representing the creator's hand, imposed in order to model, as does the sculptor's thumb, to control the gesture of the spectator as he gazes. The object assails us by its mass turned against us and suppressing the surrounding space.

Like the thumb sculpted by César, like that of Desnos, the gigantic finger that guides the traveler in Michel Leiris' *Point Cardinal* imposes its shape on the imagination: the exigence of the aggressive finger fascinates. "The walls of the room were whitewashed, the thighs of the woman whitened with ceruse; and from a crack in the ceiling from which the paint was scaling off there appeared a gigantic plaster finger pointed toward the gaping sexual hole, the central point of the room attracting to it all the molecular whirlwinds and the perspectival lines."[17] As in

l'entouraient. Toutes ces mains se tendaient vers elle. Il y avait les mains maigres de l'artiste, les mains moites du banquier; celles, crochues, de l'avare et celles, gourdes, du vieillard; il y avait les mains timides du jeune homme, les mains adoratives du prêtre et les mains sacrilèges de l'assasin. Les mains de tous les hommes, les mains de toutes les générations se tendaient éperdues vers la Femme, la Prostituée. Il y avait aussi les mains hallucinées du Christ." (Lightning was the hands. And the woman appeared to me in the middle of the air, in a circle of hands. All these hands surrounded her. All these hands stretched towards her. There were the thin hands of the artist, the damp hands of the banker; the gnarled ones of the miser, and the stiff ones of the old man; there were the young man's timid hands, the priests' adoring hands and the assassin's sacrilegious hands. The hands of all men, the hands of all generations stretched out dazzled towards the Woman, the Prostitute. There were also the hallucinated hands of Christ.)

[17] Michel Leiris, *Le Point Cardinal* in *Les Mots sans mémoire* (Paris: Gallimard, 1927; reprint., 1969), pp. 34-35. See, in Roland Barthes' *S/Z*, the following passage: "Le signifié de connotation est à la lettre un *index*: il pointe mais ne dit pas; ce qu'il pointe, c'est le nom, c'est la vérité comme nom; il est à la fois la tentation de nommer et l'impuissance à nommer (pour amener le nom, l'induction sera plus efficace que la désignation): il est ce *bout de la langue*, d'où va tomber, plus tard, le nom, la vérité. Ainsi, un doigt, de son mouvement désignateur et muet, accompagne toujours le texte classique: la vérité est de la sorte longuement désirée et contournée, maintenue dans une sorte de plénitude enceinte, dont la percée, à la fois libératoire et catastrophique, accomplira la fin même du discours." (The connotative signified is literally an index: it points but does not tell; what it points to is the name, the truth as name; it is both the temptation to name and the impotence to name [induction would be more effective than designation in producing the name]: it is the tip of the tongue from which the name, the truth, will later fall. Thus, with its designating,

Uccello's Renaissance perspective (figure 18) where the broken lances of the Battle of San Romano seem to guide us toward the central point, the lines serve as conscious directing forces.

Now, in full awareness of this abundance of signals, let us return to a few further gestures that could be interpreted as erotic and aggressive and that point themselves out as such, so that the gesture itself imprisons artist and observer. Another canvas of Correggio—whose *Noli me tangere* has already appeared (figure 20)—shows the seduction of Io by Jupiter in the form of a cloud: her right hand indicates her ecstasy and her abandonment, like Saint Teresa's left hand as Bernini sculpts it. This seduction does not openly reveal itself as an attack by an explicitly pointed instrument, but we may compare it implicitly with Bernini's statue of Saint Teresa where it is clear that the angel's arrow designates its object quite as clearly as a finger might, or Cupid's arrow, or the unicorn's horn, the scorpion's dart, or the bullfighter's sword point. A designation by the sky, granted, for the celestial finger makes itself the dart: precise, it wounds and honors by its selection. (The smile of the saint and that fainting pose are not so far from the attitude and the smile of a madwoman, photographed at the Charcot laboratory, of whom Breton—having himself worked in such a place—kept an image;[18] her open hands are raised to signify her total acquiescence. The *Immaculate Conception* of Breton and Eluard could have borne this same image on the cover.)

As for the gesture by the hand, one of the most dramatic is imagined by Breton's chosen madwoman, Nadja, as it combines the contraries: an isolated hand flamés over the water, seeming a signal. Nadja anxiously questions Breton, in the book devoted presumably to her (and whose own contrary would have been of equal interest: if only Nadja had written a book called *Breton*): "Cette main, cette main sur la Seine, pourquoi cette main qui flambe sur l'eau? C'est vrai que le feu et l'eau sont la même chose. Mais que veut dire cette main? . . . Mais qu'est-ce que cela veut dire pour toi: le feu sur l'eau, une main de feu sur l'eau?" (That hand, that hand over the Seine, why that hand flaming on the water? It's true that fire and water are the same thing. But what does that hand mean? . . . But what does that mean, do you think: fire over water, a

silent movement, a pointing finger always accompanies the classic text: the truth is thereby long desired and avoided, kept in a kind of pregnancy for its full term, a pregnancy whose end, both liberating and catastrophic, will bring about the utter end of the discourse; Roland Barthes, *S/Z*, Paris: Seuil, 1970, p. 69.) My thanks to Frederic St. Aubyn for reminding me of this passage.

[18] Reproduced in *La Révolution surréaliste* (no. 11, March 15, 1928) to celebrate the tenth anniversary of Charcot's discovery of hysteria. See also Dali's "Le phénomène de l'extase" in *Le Minotaure* (no. 3/4, December 1933).

hand of fire over the water?). In this most immediate pointing, the hand of fire singles out its paradoxical source in the ocean-mother, as in René Char's transcription of a Surrealist dream called *Eaux-Mères* (Water-Mothers), the aquatic equivalent of the alchemical *materia prima*. The marking image sets ablaze in a fertile fashion: Nadja's Breton was, after all, the sun for her.

The representation of pointing as such in modern art, Surrealist and other, is a key topic: in almost every case in which the finger or a like object is involved, we feel a strong pull between the erotic and the self-reflection on art in the making. One of Giacometti's sculptures represents a man by an iron arrow whose point tries to pierce a concave form, a headless woman in *The Elephant Célèbes* of Max Ernst raises one finger in a mystifying curve felt by the observer as a vague menace, and, still worse, the fingers coming out of the window in his *Oedipe Roi* are penetrated with a terribly precise needle. The arrowhead that the Minotaur often holds in Picasso's drawings of the Vollard suite mixes aggression and art, passion and, in particular, passion for the gesture itself, especially for the gesture as it is seen.

In one of these drawings of the Vollard suite, the woman holds out toward the beast who is artist-lover and Minotaur at once, her own mirror, as if, all the while looking at herself, she were extending an instrument of menace or a possibility of a renewed consciousness, now made necessary. The modestly potential aggressivity on the woman's part can always be interpreted as helpfulness—for by her the man sees his own visage—and it is less remarkable perhaps than the implications of this extension of the vision from one individual image, that of a woman before her mirror, or then two women before the mirror of the public, toward an offered vision shared by a greater number. "Donner à voir," said Eluard, "To give to have" or "Giving/seeing," in two possible translations of his title, concerning art: to grant vision is to be granted it, and to hold it. Possibilities are multiple in Surrealist conception and reception, and each bears its own responsibility: in place of the simple *scène de toilette* as an image for the retina in the sense in which Duchamp and Breton so scathingly used the term, the observer of the Surrealist adventure as it is determined in part by the visions preceding it might turn to the recommendation made in alchemical lore, where texts were to be written out and in, noticing the frequency with which a vision is said to pass, as Artaud in his madness was also said to do, "to the other side of the mirror" (like Leonardo's glance returned from the text observed toward the observer). The eye controls the self, the vision makes up the personality of the "I."

[19] André Breton, *Nadja* (Paris: Gallimard, 1928), pp. 84-85.

Now, the simple exterior vision may be of less concern: a whole series of images could be adduced to confirm a passage through a willed blindness or *dis-regard*, toward another interior landscape. The Pre-Raphaelite woman with her inward vision is perfectly represented when the finger of the sundial points exactly toward the closed eyelids of Rossetti's *Beata Beatrice* (figure 16) or then in ecstasy and thus unseeing, such as the portrait of *Stuart Merrill's Wife*, by Delville, where she stares upward, blind to all but the already *occulted*. In many a Symbolist painting, the eye takes fire, as in Redon's celebrated image of the eye as a balloon in flames, or then the eye is drowned, as in his floating head of Orpheus, closed to any but another world: thus the two contrary elements of fire and water reappear, at the extremes of sight and blindness. One of de Chirico's Surrealist canvasses shows Apollinaire wearing not dark glasses, but a dark glass, for only half of his face is visible, as a dark circle covering the gaze. The Surrealists as a group close their eyes in Magritte's famous multiple portrait where the body of a nude woman forms the center: this is a suppressed image, for they do not see her, says the title clearly, *Je ne vois pas la femme cachée dans la forêt* (I don't see the woman hidden in the forest). And so for her name or open designation, they substitute a picture of her body, at which their eyes are not looking. If Eluard writes in praise of the mirror as it returns the image of the woman loved, multiplying it a hundred times, if Magritte makes a *False Mirror* of the eye, literally clouded (figure 1) and if Breton writes in eulogy of the crystal, Tzara demands obscurity's blinding radiance that sends us back to all the darkened and black mirrors of Hopil and the other poets Mannerist and Baroque, while we contemplate in our interior gallery such canvasses as Picasso's suppression of the mirrored gaze in his girl holding a black mirror simply called *Interior with Woman.*

Of course, and best of all, on the other side of the mirror, the image may reflower as contemplation on the other side of designation. In one of Breton's poems from a collection called, significantly, by a transfer of elements, "L'Air de l'eau" (The Air of Water), the legend of a faraway black beach gives rise to that of a second sun after one lost paradise and to the final explosive reversal and explosion of the "flowering apple tree of the sea." The idea of this poem's opening in its closure will give its clarity and its expansive radiance to the notion of poetic interior with which I should like to close, an interior in which the center of the labyrinth is occupied by the inner gold glimpsed after the "black spot on the image" which haunts Bonnefoy as the black spot on the sun haunted the metaphysical poets, as the default in the universe haunted Valéry's "Cimetière Marin" (Cemetery by the Sea) and as our own necessary default in vison disquiets and obsesses us. Bonnefoy describes the place of true poetic contemplation, as it is close by, "ce proche destin, cette heure, ce séjour"

(this near fate, this hour, this place), always a specific here endowed with a universal language appropriate for such evocation:

> Ouvre-toi, parle-nous, déchire-toi,
> Couronne incendiée, battement clair,
> Ambre du coeur solaire.[20]

> Open, speak to us, rip yourself to shreds,
> Crown consumed, clear beating,
> Amber of the solar heart.

But the "ambre" is never far distant from the "ombre," a shadow which it bears like a doomed trace. The alchemical work had no center brighter than this.

Now another pointed and interior signal, the memory of one flame, returns to haunt the passionate reader, Georges de La Tour's candle flame that causes the eyes of Mary Magdalen to water (figures 13 and 14)[21] and, within the poetic imagination, as in the metaphysical poets, transfers her own passion to the observer. From then on, the factual or exterior and the imagined or interior gesture are seen like two spaces essentially inseparable. René Char's voice speaks from his own vigil kept by his own candle and this picture: "Nous sommes deroutés et sans rêve. Mais il y a toujours une bougie qui danse dans notre main. Ainsi l'ombre où nous entrons est notre sommeil futur sans cesse raccourci" (We are displaced and without a dream. But there is always a candle whose flame dances in our hand. Thus the shadow we enter is our future sleep ceaselessly abbreviated).[22] In the observing and the re-observing of multiple signs along multiple roads, the reader believing still in a Surrealist "état d'attente" or expectant attitude—corresponding to what is for religion a state of grace—should refuse none of the possible indications existing in profusion: "Qui m'appelle?" (Who is calling me?) Char questions, from the depths of his own *Talismanic Night*, and his answer is no less multiple: "Chacun m'appelle" (Each one is calling me). To the passionate onlooker all signs and gestures are thus in correspondence and can be revivified by a privileged reading.

It may be that a single blue glove, isolated from its partner, the glove which, in *Nadja*, Breton finds inserted miraculously between the pages of a book at the Flea Market, responds by an interior correspondence to that red glove playing on the tiles of a chessboard in de Chirico's painting

[20] Yves Bonnefoy, *Poèmes* (Paris: Mercure de France, 1978), p. 224.

[21] See Char's poem on the Magdalen, quoted at the end of this essay, where he uses ellipsis and condensation, rendering the tears and the blood of passion interior.

[22] Char, *La Nuit Talismanique*, p. 28.

The Enigma of Fatality (figure 32). Beside a tall cyclindrical object of an implicit erotic shape, that red glove[23] serves as another clear representation of self-designation, emptied of all content and pointing only to itself, and to the absence of the hand inside. For the reader in whose mind all these pointings and gestures are interreferential—the reader, it goes without saying, of the image as of the text—this chess set is a replay of such chess games as those of Paris Bordone, where the aggressively frontal stare of the two figures, and the position of the fingers squeezing the chessmen works in a counterplay to the *Double Portrait* of the two ladies in their hot water (figure 31).

Another of de Chirico's canvasses, ironically entitled *Love Song*, points the way with one more empty red glove, to the exhaustion of the traditional act of designation and the gesture of possession: propped up, it is now only a prop, reduced to inaction, pointing to emptiness, or to an interior way. Here the flame's finger may return, as in La Tour's picture of the repentant lady with her vigil lamp, whose light, as René Char describes it, casts before us an impossible enigma, as "a little oil spills out by the dagger of the flame onto the impossible solution."[24] His poem of the Magdalen will reappear with the dagger of its flame and its paradoxical figure, vigilant in her contemplation, lost in her mirror's meditation. Breton's own "Vigilance" responds now, in its effort at linking, to this figure and her vigil, directing the reader's gaze toward the center of the labyrinth and its mysterious windings, whether that labyrinth be called Metaphysical, Baroque, Mannerist, or Surrealist, in whatever epoch it may exist within the imagination, keeping still its singularity and its coherence.

For the labyrinth is that of our own perception, caught in the threads of allusion spun by the gaze from the text to the canvas to the text again,

[23] Nicolas Calas explains the red glove by the typology of the name of de Chirico. De Chirico's fascination with the glove is based on his encounter with Max Klinger: *Paraphrase über den Fund eines Handschuhs* (Paraphrase on the Discovery of a Glove) of 1878, in the Berlin Academy, engraved in its third edition already in 1881: this young man's infatuation with a lost glove leads to Duchamp's *Pocket Chessboard with a Rubber Glove* (L'Echiquier de poche au gant de caouthouc), of 1944, reconstituted in 1966. The glove is found in de Chirico's *Enigma of Fate, The Destiny of a Poet, Turin Spring,* and *The Song of Love,* all of 1914. He says further of the image: "The fat glove of colored zinc, with the terrible gilded nails, which used to swing over the door of the shop in the very sad city afternoon breezes, showing me, with its index pointed towards the sidewalk pavings, the hermetic signs of a new melancholy." And from that, he said, there "surged forth the new annunciatory paintings." Quoted in Patrick Waldberg, *Les Demeures d'Hypnos* (Paris: Editions de la Différence, 1976), p. 82. (Dawn Ades, in her *Dada and Surrealism Reviewed,* London: Arts Council of Great Britain, 1978, points out the Klinger source also, as does James Thrall Soby, and she indicates the connection with the Duchamp, p. 30.)

[24] *Poems of René Char,* p. 93.

pointed to by the finger, first the artist's or writer's, and then our own. The perceptual sensitivity is formed of just such pointings or designations, is trained in the foregroundings of words and images, or then in the stress of odd conjoinings: weeping eye and pointing finger, both already *metagestural* in that they concern vision and are seen, pointing and are pointed to. Like the fountain and the flame, each leads to each and interrogates each other term and image. As the portrait is a pose, and the self-portrait a pose even more complicated, so the visage contemplating and contemplated poses the question of a larger scene, mirrored by this mirror of a text and a canvas.

Ashbery's poem replies perfectly to the interrogation of the image:

> But what is this universe the porch of
> As it veers in and out, back and forth.
> Refusing to surround us and still the only
> Thing we can see? (SP, p. 77)

About human sentiment, Il Parmigianino's *Self-Portrait* (figure 23) leads to this reflection on infinite recession and anamorphosis twisting in the mind. Of its windings and unwindings, we know that they

> Lead nowhere except to further tributaries
> And that these empty themselves into a vague
> sense of something that can never be known. (SP, p. 77)

What have we finally learned from all the gestures, from all the designations we have been careful or impassioned about making, each with its own stress? We shall at least have learned that on this surface which we have not lost, the perception of the present is still more present:

> . . . All we know
> Is that we are a little early, that
> Today has that special lapidary
>
> Todayness that the sunlight reproduces
> Faithfully in casting twig-shadows on blithe
> Sidewalks. No previous day would have been like this.
> (SP, p. 78)

Presence does not depend on our grasp upon it: it cannot be seized in the moment, which is where and when we are:

> . . . Today has no margins, the event arrives
> Flush with its edges, is of the same substance,
> Indistinguishable. (SP, p. 79)

As we cannot expect to get a hold on the picture, we cannot see ourselves then in the mirror which is, in any case, not ours, even as we interrogate its surface, and are moved:

> . . . I go on consulting
> This mirror that is no longer mine
> For as much brisk vacancy as is to be
> My portion this time. (SP, p. 77)

The hand gestures, then, and the finger points, sometimes trembling, to what we are not and cannot be, even as it holds the eye:

> . . . This otherness, this
> "Not-being-us" is all there is to look at
> In the mirror, though no one can say
> How it came to be this way. A ship
> Flying unknown colors has entered the harbor. (SP, p. 81)

And now at last, after the strong-lines of Baroque and Mannerist gesture lead us to the paradoxical and equally strong-lined twisting of the surface of the Surrealist text, the long effort not to lose the surface of the visual or the verbal presentation can end with one final image. For the confrontation with that "not-being-us" of the other, we might look at one more door of Marcel Duchamp as our guide to the outer and the inner held together. The shut door of his *Étant donnés* or *Given . . .* (figure 36)—a closure in rough wood—is ambivalent to the extreme, for it closes off the scene inside and yet forces us to its own perspective upon that scene: we cannot change the position of the two eye holes within the door, as its secret must be contemplated by this observer we have set up too, with its private eye. And in this last convergence of a Dada and a Surrealist text, the drawing and pointing and designating hand meets the eye observing as the Magdalen's pointed flame lights her sorrowful figure; this union is to be contemplated beyond and behind the outward appearance of things seen and shown and mirrored, within the private labyrinth established inside the most subjective vision, enabling the most passionate and inward grasp:

> Je ne touche plus que le coeur des choses
> je tiens le fil[25]

> I touch only the heart of things
> I hold the thread

[25] André Breton, *Poèmes*, p. 104.

5

REFLECTIONS IN A ROCOCO EYE: ARABESQUES AND SERPENTINES

O Courbes, méandres
(Oh Curves, meanders)
—Paul Valéry, L'Insinuant"

MY FIRST MOTTO comes from Friedrich Schlegel: "The critic is a reader who ruminates. Therefore, he ought to have more than one stomach."[1] And my second is the simple Rococo criterion of "agreeable disorder." For this view of the Rococo view is really a glance at a metaphor only, an ode to an arabesque line, then to a sinuosity free to wander as it likes. As critics have a certain calling, the serpent might be expected to have a certain coiling, redefining, by definition, its own serpentine line.[2]

Further, my text itself is meant to have a wandering line, to play—

[1] Fragment 27 of *Critical Fragments*, from Friedrich Schlegel's *Lucinde and the Fragments* (Minneapolis: University of Minnesota Press, 1971), p. 143. For a commentary on the Fragments and on Schlegel's attitude toward the arabesque, the fragment, the speculative aphorism, see Victor Lange, "Schlegel's Literary Criticism," *Comparative Literature*, 7, no. 4 (Fall 1955), 289-305. These mixed genres appealed to him since the purer classical forms "are now absurd"; perhaps it is partly for that reason that they appeal also to us.

[2] The serpentine epigraph comes from Paul Valéry, *Poèmes* (Paris: Poésie/Gallimard, 1958), p. 84. Insinuated here also are all the windings of his serpents, the "Hydre absolue" (p. 105) of the "Cimetière marin," the "trépied qu'étrangle un serpent" of "La Pythie" (p. 75) and the "Ébauche d'un serpent" (pp. 85-96) where the "dreaming reptile" and the "amateur d'échecs" propose a temptation: to cede to the pleasures of the body: "Je vais, je viens, je glisse, plonge,/Je disparais dans un coeur pur!" (p. 90).

The epigraph might well have come from Hogarth's famous praise of the "precise serpentine line, or *line of grace*": "the serpentine line, by its waving and winding at the same time different ways, leads the eye in a pleasing manner along the continuity of its variety, if I may be allowed the expression; and which by its twisting so many different ways, may be said to inclose (tho' but a single line) varied contents." (William Hogarth, *The Analysis of Beauty*, 1753; reprint., Merston, Yorkshire: Scolar Press, 1971), pp. 38-39.

As for this wandering, it might be described by a phrase relating both to the arabesque, in Poe's "Philosophy of Furniture"—"cloths of huge, sprawling, and radiating devices, stripe-interspersed, and glorious with all hues, among which no ground is intelligible." (*The Complete Tales and Poems of Edgar Allan Poe*, ed. Hervey Allen, New York: Random House, 1938), p. 463, and also to the land lying about "Landor's Cottage": "There were few straight, and no long uninterrupted lines." So much for the tissue of the text and the lay of the land.

as the decorations play—against a surface at least apparently open to vacancies, and to ramify upon that surface, living, as Wylie Sypher says of the Rococo, "along the line."[3] The line chosen, arabesque as opposed to straight, serpentine, although not necessarily of a serpent-like wisdom, may well be only a sort of "rebesque work, a small and curious flourishing,"[4] one of the delicate definitions given to the arabesque in the seventeenth century.

This flourished work may appeal to the modern spirit because it is convergent with play, the play upon and of the surface, a sort of sparkle apt to arouse a gleam even in a jaded eye. As Sypher says of Pope's particularities: "the glitter of a necklace, the carp's luster, the sheen of a pheasant crest." If I omit from that catalogue, appropriately miniature, the expression "apparatus of the boudoir," it is for reasons that may be apparent later in my meanderings: other things are on my mind.

Now, the arabesque is said to have aroused interest in the Renaissance for its combination of three characteristics: median symmetry, freedom of detail, and a heterogeneity of ornament; while it is plainly not essential to adapt your critical style to the object under consideration (we scarcely feel obliged to speak in purple prose of the Romantics, in classical periods of the classics, or in Surrealist and sybilline tones of the Surrealist), those characteristics are pleasurable to consider. Let me posit Pope and then Watteau, as the middle points or medians for my *errance*, and turn to glance at the notion of ornament that will be the very foundation of this light and fugitive construction. We might, even passionately—provided that the passion is sufficiently delicate in texture—consider the vines and ribbons, the fronds and tendrils of the arabesque, the particular and detailed "compartments of ornament" as Fiske would have it, and Sypher too, the little knots of weapons and hunting gear called trophies, as in Watteau's "recueil d'arabesques, trophées, et autres ornements décoratifs" (gathering of arabesques, trophies, and other decorative ornaments): for this meandering chase, a perfect miniature trophy.

This fascination with border ornament and this intertwining of foliage over an empty space, in fact, this play of the complicated against a central void, surely befits our present textual concern[5] and might even be a

[3] Wylie Sypher, *Rococo to Cubism in Art and Literature* (New York: Random House, 1960), p. 9, and *passim* for the description of Rococo, to which the first chapter is devoted.

[4] The nice irony of such a flourish is that, as it might apply to a frame (as in "The Oval Portrait," still by Poe), it applies also to the simplest of objects contained in the ornamented edge. "Manners," says Schlegel, "are characteristic edges" (*Critical Fragment* 83).

[5] See my *A Metapoetics of the Passage: Architextures in Surrealism and After* (Hanover, N.H.: The University Press of New England, 1981) and "Vers une architecture du poème surréaliste," in *Ethique et esthétique du XXᵉ siècle*, ed. Cagnon (Stanford: Anma Libri, 1978), pp. 58-66.

contributing element to the flexibility of perspective. Just as the Surrealist fascination with labyrinths picks up from the nineteenth century Romantic and Gothic wandering and, earlier, from the Mannerist device of the late sixteenth and early seventeenth centuries,[6] so now we might insert a central passage, primarily from the eighteenth century, in our intertextual wandering, the scroll might well be found to have one more round, the serpentine line to have another coiling,[7] the arabesque to apply to yet one more device, and to develop its own light complications. The term arabesque applies first to the scroll-pattern decoration from Arab lands (whether with or without the birds which then were banished as representations of the animal). Then joined with the Romanesque arabesques found at Herculaneum, and published in 1757 by the Comte de Caylus in his *Recueil de peintures antiques*, it was enthusiastically picked up by 1770 when the models proliferated all over Paris.[8] Used by Goethe, Schlegel, and Poe as a component of romantic irony, it then leans heavily to the side of the grotesque, as in Poe's initial title to his stories: *Tales of the Grotesque and Arabesque*.[9] In Schlegel's *Lectures on Poetry*, the

[6] Gustav Höcke's *Die Welt als labyrinth* (translated in French as *Labyrinthe de l'art fantastique: le surréalisme dans la peinture de toujours*, Paris: Mediations, 1967) furnishes a brilliant testimony to this labyrinthine passage.

[7] See the article on arabesque in the Encyclopaedia Britannica.

[8] See the chapter on "Harmony and the Serpentine Line" in Mario Praz, *Mnemosyne: The Parallel between Literature and the Visual Arts* (Princeton: Princeton University Press, 1970).

[9] An extraordinarily detailed account of the paradoxical relations between the notions of arabesque, grotesque, and Gothic in Poe's tales is to be found in G. R. Thompson, *Poe's Fiction: Romantic Irony in the Gothic Tales* (Madison: University of Wisconsin Press, 1973). See the chapters "Explained Gothic" and "Grotesque and Arabesque": in the former, the shifting meanings of "regular" Gothic and "arabesque" Gothic are traced (pp. 70-73), where arabesque is treated as a "deceptive pattern," and applied especially to "Ligeia" (79-87)—Ligeia's head suggesting the skull grinning in its symbolization of crumbling and decay, like the fissures zig-zagging down the House of Usher. The latter chapter traces the relation of grotesque to arabesque in the German Romantics and their conception of irony: "a carefully patterned union of ironic opposites giving rise to a transcendent vision of the true state of things . . . the arabesque suggests . . . a sense of ironic perspectives in the midst of confusion and ominousness" (p. 109). Thompson studies the tales "Masque of Red Death," "The Assignation," "The Fall of the House of Usher," and "The Oval Portrait," with references to arabesque in "The Philosophy of Furniture" and contrasts the gloomy usage of the term to apply to the "writhing adders" and the snaky lights from all those hanging censers, thus the kind of light visible through a Gothic window, ruby-red, with the vision of beauty in "The Domain of Arnheim," as it contains the "arabesque." Here the notion is seen as both "dazzling" and "bewildering" and connected with those devices in vivid scarlet inscribed on an irregularly crescent-shaped ivory canoe, itself related to the windings of the river and the concentric circles of the outdoor amphitheater: that is, the arabesque governs the design of the tale (p. 131). Thompson discusses Sir Walter Scott's use of E.T.A. Hoffmann's Gothic and the various uses of the term throughout the criticism

arabesque structure of Cervantes is called an "artfully regulated confusion, that symmetry of contradictions, that strange and constant alternation between irony and enthusiasm present even in the smallest parts of the whole," and fragment 418 of his first Athenaeum volume characterizes Tieck's works as "poetical arabesques."[10] Even in the term, then, there is a divergence of tone; the line here pictured is more than just picturesque.[11] My object would be to trace that super-paradoxical line, subjectively presenting the fore- and the after-play of Rococo, as one might play along one literary line, or in one visual site, or, to remain in the area of Rococo imagery, on one decorative knot, the not and its own reversals in the negative not (like the "noeud" and the "ne")[12] making up the sufficient complication, like Hamlet's own knotted debate, about being and being-not.

SKY AND COLORING

As to what we are sighting here, I should like to cast one momentary glance at the color of the Rococo sky, bearing in mind Artaud's haunting statement that "All problems are incomprehensible"[13]—which would include that of the Rococo line—together with what we too might take as the poetic plan of our action, assuming, with Schlegel, that poetic criticism is free to see and to be what a prosaic criticism cannot, seeing the part always as part of a whole.[14] Artaud continues, about what is presupposed in the look: "Metaphysical feelings to be unearthed, to be condensed in states which presuppose certain classes of images, just as the color of certain skies presupposes the flight of certain birds":[15] these

of the period: his wealth of commentary renders unnecessary any further meanderings on my part about these subjects.

[10] For example, The World Turned Topsy-Turvy, and in general the union of contraries in the attitude of Romantic irony. See also Schlegel, Lucinde and the Fragments.

[11] For it is deliberately patterned to join contrary forces (see above) in the production and also the maintaining of the ironic descriptions—of both the artificial and the artificial natural perceived in such Gothic tales as Melmoth the Wanderer. Scrolls and tendrils join with the menaces of the mind, the swerves of the landscape, the fragmentation of manuscripts, and the discovery of lost or hidden icons—portraits, skeletons, keys, and clues of all sorts. My own arabesque here is meant to join the diverse epochs of literary and visual imagination, but lightly, as with a tenuous line.

[12] See Daniel Sibony's article on Hamlet as a figure of writing in Yale French Studies, (1978); pp. 53-93, Psychoanalysis issue: "Hamlet: A Writing-Effect."

[13] Antonin Artaud: Selected Writings, tr. Helen Weaver (New York: Farrar, Straus, 1976), p. 189.

[14] See, again, Victor Lange's article, for the best discussion of this.

[15] This wonderful passage begins with a noble wish: "If one could think of everything" (p. 189).

birds will return. The color of this sky, perceived first in the Mannerist Scève, and, of course, in Marino's sky and that of Sidney, penetrates also the Spanish sky of Góngora, whose lighting continues into our present. This lighting and these lines may clarify our next wanderings in a check-ered forest of Pope and along some meanders of Rousseau, whose own serpentine wanderings themselves lead oddly to Valéry. Illumination may be cast too upon some gardens of Marvell that Swinburne forsook in his "Forsaken Garden," upon the twists of Baudelaire, Poe, and Lautréamont, and later of the Surrealists' public park, the Buttes Chaumont in the Parc Monceau, chosen for its *allées* and winding ways. In the meandering way of my own text also, Baudelaire's celebration of the thyrsus, where the arabesque twists about a stick, should provide an image for still other twists and circlings.[16]

I have pointed out before how the Mannerist "linea serpentinata" can be seen to lead to Bréton's Surrealist serpentine. The Surrealist cel-ebration of the Buttes Chaumont in Aragon's *Paysan de Paris* (The Peasant of Paris) is cultivated or then naturalized in the text in an outdoor passage parallel to the indoor Passage de l'Opéra, the covered gallery or arcade, glass-roofed, thus in keeping with Breton's praise of the crystal, and of transparent works and life.[17] The glass may be inverted or transformed: the Paris peasant or Surrealist stroller who wanders first in the covered gallery, like a city street gone inward, sighted by night and day, then wanders in the city park by night where the statues and ruins and mean-ders serve as landmarks to the mind, as a passage in, along, and out. Here in the creations and recreations of Surrealist myth, *Melmoth the Wanderer* is updated, but not forgotten:[18]

[16] See Richard Klein, "Straight Lines and Arabesques: Metaphor as Metaphor," in *Yale French Studies*, no. 45 (1970), pp. 64-86 (Language as Action issue).

[17] Breton, "L'Éloge du cristal," a text itself much eulogized, "L'Amour fou" *Minotaure*, no. 5, p. 13 (and later, the book-length *L'Amour fou*, Paris: Gallimard, 1937). See, on the crystal, and alchemy the chapter "The Alchemical Work," in my *Surrealism and the Literary Imagination: A Study of Breton and Bachelard* (The Hague: Mouton, 1966), especially, pp. 46-50, where I try to study the transmutation of opposites in this light.

[18] *Melmoth the Wanderer: A Tale*, by Charles Robert Maturin (1820), in the Oxford edition, ed. Douglas Grant (London: Oxford University Press, 1968). Much in this tale could bear out my wanderings here: the fascination with ruins Roman and Moorish (thus, classical as combined with arabesque), the equal fascination with the fragmentation of discourse and text—the manuscript found with just the parts missing which are stressed by the violence of the expectation, just at the interrupted point: "And he was right: but this did not diminish the eagerness of his

* * * * * * *

* * * *

(p. 31)

Serpents, serpents, vous me fascinez toujours. Dans le passage de l'Opéra, je contemplais ainsi un jour les anneaux lents et purs d'un python de blondeur. . . . Que le concept sinueux de l'allée vous reprenne, et vous mène à de veritables folies labyrinthiques . . . Nouez comme la voile au vent toujours changeur les allées au jardin où vos mains s'abandonnent.[19]

Snakes, snakes, you always fascinate me. Once in the passage de l'Opéra I was meditating on the heavy and pure coiling of a blond python. . . . Let the sinuous concept of the *allée* seize hold of you once more, leading you on to real labyrinthine madness . . . Knot, as the sail to the always shifting wind, the pathways to the garden, where your hands give themselves up.

But now we return to the eighteenth century, which is our median point, and now another step can be added: a study of Wieland's *Don Silvio* (1764) makes yet another prediction of the clash of contraries associated with the Baroque and then with Surrealism.[20] In Wieland's gardens, the carp sing in the fountains, and how can we not hear this as a prediction of Breton's magnificently Baroque statement: "Les oiseaux n'ont jamais mieux chanté que dans cet aquarium" (The birds have never sung better than in this aquarium)? And how can Wieland's "flaming fountain" not recall to us the summit perception of the "Route qui monte et qui descend" (Road Climbing and Descending), Breton's equivalent of an *ars poetica*, already quoted as an example of Baroque convergence: "Flamme d'eau guide moi jusqu'à la mer de feu" (Flame of water lead me to the sea of fire)?[21] And are not those pathways very like Aragon's invocation of the delights of wandering in the sinuous alleys and paths in which dizziness is to be found and fostered?

Now this wandering line can be seen quite clearly in earlier visual

The manuscript concludes, rather in the same tone as Desnos' *Liberté ou l'amour!* ("Ce fut alors que le Corsair Sanglot"), like this:

> Perhaps our final meeting will be in * * * * * * *
> (p. 59)

The character of most impressive mien drops dead in the attitude of pointing, the figures wind in and around, as in a maze (or Marvell's "amaze"), and a hidden portrait is the key to it all.

[19] Louis Aragon, *Le Paysan de Paris* (Paris: Gallimard, 1926), p. 182.

[20] Breton picks up Reverdy's illuminating advocacy of two elements taken from widely differing fields in order to provoke a brilliant clash on contraries, and adds the stipulation that the image is irreversible, oriented toward the better always.

[21] See Chapter 3. The quotation is taken from "Sur la Route qui monte et qui descend," André Breton, *Poèmes* (Paris: Gallimard, 1948), p. 79.

patterns, if not always in the composition, then at least in the individual figures. The twisting of Bronzino's *Allegory* or that of Vasari, many of Tintoretto's figures, and those of Titian, El Greco, and Correggio (figures 5-7, 9, 10, 19, 20) or the twists of Salviati's *La Carità,* or those stairs in *Bathsheba betaking herself to David* which Praz pictures, like the poetic enjambements of Giovanni della Casa—all these are properly serpentine windings, arabesque twisting. And in all these, the head of a figure moves to one side, the arms to the other, so that the movement pulls in contrary ways, as might some text concerned above all with the divergent angles of seeing.

INSCRIPTION AND THE EYE

It is time to play in those fields that the Petrarchist concetto has colored. It is not here so much a question of the key to the fields—I am thinking of Breton's "Art of madmen as the key to the fields" ("L'Art des fous, la clé des champs")[22] and of Desnos' assurance that Góngora simply runs away with key and field together—as of their color. The notion of *cangiantismo* or twisting to-and-fro may be useful as a metaphor, a twist as Rococo as it is Mannerist and Surrealist. Now in these fields, a certain odd foliage will flourish, quite like that "resbesque flourishing in small and curious ways," quite as certain birds are seen as auspices in the sky.

And here I should like to wander through a garden. In Marvell, those green shades where Navagero would shelter the traveler or *viator* provide shelter for our own green thoughts.[23] Now as for the gardens of surprise to which Marvell leads us, they are stressed in their confusing quality, with the conclusion of the first line, deliberately labyrinthine: "How vainly men themselves *amaze*" (NA, p. 154). Those lines include their own labyrinthian maze, a snare for the unwary, much as the later Rococo fancy traps the fellow traveler or reader in the narrator's imagined falling, beflowered and soft: "Insnared in flowers, I fall on grass" (NA, p. 154). Here too the birds attract the flickers of the light, and each plume or pen makes its own stippled pattern as it glides across the lawn or the page.[24]

[22] André Breton, *La Clé des champs* (Paris: Editions du Sagittaire, 1953).

[23] I am thinking of "a green thought in a green shade" from Andrew Marvell's "The Garden," in *Norton Anthology of Poetry,* ed. Allison, Barrows, Blake, Carr, Eastman, English (New York: Norton, 1975), p. 154. Hereafter referred to as NA. Fred Nichols is responsible for my acquaintance with Andrea Navagero (1483-1529), and his "Umbraue viventi" or green shades. See his *Anthology of Neo-Latin Poetry* (New Haven: Yale University Press, 1979).

[24] I am thinking of Mallarmé's commentary on the ballerina on her *point,* as one might see the period in the sentence, and on the *plume* or feathery delicacy with which some Hamletian text might be inscribed upon a white page. See also, in *Yale French Studies,*

But what of the game on the grass?[25] The chess game like the game of pastoral is played out within a garden or a garden of the mind, like Paris Bordone's chess game (figure 31), or then the game of chess in Marino's *Adone* that is finally and strangely inscribed upon the back of a turtle.[26] Here the artificial mingles with the natural and the nature of artifice, for the light and witty struggle of opposing forces. So too the contraries in Scève and in Desnos pull back and forth, now separately, now together, each coloring the other with a paradoxical hue both opposite and same, where absence and presence are likened:

> Je m'en absente et tant, et tant de foys,
> Qu'en la voyant je la me cuyde absente:
> Et si ne puis bonnement toutesfoys,
> Que, moy absent, elle ne soit présente.
> . . .
> Mais quand alors je la veulx oblier,
> M'en souvenant, je m'oblie moymesmes.[27]

> I am absent from her so, and so many times,
> That seeing her I think her absent from me:
> And so cannot honestly avoid,
> While I am absent, her being present.
> . . .
> But then wanting to forget her,
> Remembering her, I forget myself.

In this intensity of self-awareness and awareness of the other, what can presumably be counted on, like memory and sight, proves faithless, and the poem winds its contradictory way to annulling all certainty except its own self-nourishment, feeding on its lines.

We might think too of Donne's "Love's Deity" in which the changes are rung so lovingly on just the oppositions:

Mallarmé issue, 34 (1977), Thomas Hanson on Hamlet's hat and its plume: "Mallarmé's Hat," pp. 215-227, and Albert Sonnenfeld on "Mallarmé: The Poet as Actor as Reader," pp. 159-172.

[25] A remarkable poem of Max Jacob combines the garden and the tomb, and is, appropriately enough, called "Cimetière": see my commentary in "Jacobean Structures and a Few Signs," in *Folio* (ed. Jacob, 1978).

[26] The chess game haunts Dada and Surrealism, as it did the chequer'd shade of earlier, Rococo texts. See Duchamp's game and Man Ray's "Knights Move" in relation to the title of the chapter: "Knights of the Double Self."

[27] Maurice Scève, *Oeuvres Poétiques*, ed. Hans Staub (Paris: Union Générale des Editions, 1970), p. 137. See my commentary on Scève and Desnos in "Ode to a Surrealist Baroque," in *A Metapoetics of the Passage*.

I must love her, that loves not me

　. . .

　　　it cannot be
Love, till I love her, that loves me.

　. . .

　　　It could not be
I should love her, who loves not me.

　. . .

　　　and that must be
If she whom I love, should love me.[28]

The deity might well be language itself and not love, and one might well die just as soon of language as of love. But the twist is a light one: the changes are rung in the texture of the poem and not in the tissue of some handkerchief, wrung dry from its knots and twistings. Not the beaten breast or the hollowed eye but rather a surface color, never too strong: look at Sidney's Arcadian blush as it is transmitted back and forth like the delicate pink and white of some Boucher canvas:

. . . and once his eye cast upon her and finding hers upon him, he blushed: and she blushed, because he blushed: and yet streight grew paler, because she knew not why he had blushed.[29]

As for the blush, it can of course take on larger dimensions: ardent deeds and thoughts are kindled in the pastoral air and arbor by the concept of love, the words feeding on their implied action.

It is along Marino's lines that Saint Teresa, already present in these pages, experiences her wondrous dart, like the pointing finger of the sky, pointed out by Crashaw:

Thou are *Loves* Victim; and must dye
A death more mysticall and *high*.

　. . .

His is the *Dart* must make the *Death*
Whose stroake shall taste thy hallow'd *breath*;
　. . .　　　　　　　　　　　　　　So rare,
So spirituall, pure, and faire,
Must be th'immortall instrument,
Upon whose choice point shall be sent,
A life so lov'd.[30]

[28] In *John Donne: The Complete English Poems*, ed. A. J. Smith (Harmondsworth: Penguin, 1971), pp. 65-66.

[29] Philip Sidney, *Arcadia*, 2nd version, quoted in Praz, *Mnemosyne*, p. 104.

[30] Richard Crashaw's "Hymn to St. Teresa" is discussed at some length in the preceding

This point would bring a rightful blush to the cheeks of any reader of Crashaw, who speaks a good deal of his own blush. Several darts are interchangeable here, love-giving, life-giving, giving the paradoxical lie to the alleged superficiality of surface complication; the art may not penetrate deep, but the wound is no more superficial than is the word. The twist given to language twists the knife well into the wound: while not overtly licentious, it is quite sure of its licence and its aim. The text tissues over and covers up as the Rococo plays mass against vacancy, that vacancy behind and between the coilings of the scroll. As the language *frets* its texture, like the Gothic fret work with which a certain arabesque is compared, the word outsmarts the wound itself, taking on the very sting it provides.

SWANS, PEACOCKS, AND SERPENTS

Nowhere is the twist given to language more overt than in Góngora's windings: there are fewer darts and stings than in the metaphysical poets, fewer gasps of horrified delight, but the reader may well find these twists no less addictive than those of the dangerous and delightful knife. In a typical Góngora conceit, the elements strike a perfect balance and the verse sways from side to side, the ends playing against the opposed middles along the poetic line, "living along the line" as the Rococo look is said to do. The odd pairings complicate the surface and ensnare the look: "pavón de Venus es, cisne de Juno" (she is the peacock of Venus, the swan of Juno).[31] Juno is paired with the swan of Venus, who gets her peacock. I think of a later peacock on a lake, frozen not at all like the white swan on Mallarmé's white page of a lake in the sonnet "Le vierge, le vivace et le bel aujourd'hui" ("The virgin, lively and lovely today"),[32] but rather differently inscribed, and funnily, in twentieth-century shellac:

Aux lacs des lacs
Meurent les paons
Enlisés dans la gomme laque[33]

In the lakes of lakes
The peacocks die
Stuck in shellac

chapter, in the version given by Helen Gardner in her *Metaphysical Poets* (Harmondsworth: Penguin, 1975), pp. 210-215. These lines are from p. 210.

[31] Luis de Góngora, *Antología* (Madrid: Austral, 1979), p. 87.

[32] *The Penguin Book of French Verse*, ed., Woledge, Brereton, and Hartley (Harmondsworth: Penguin, 1975), p. 434.

[33] Robert Desnos, *Corps et Biens* (Paris: Poésie/Gallimard, 1968), p. 63.

But it works, and the forced pairing in the mind of Juno and the peacock, Venus and her swan[34] takes place simultaneously with the opposite pairing on the page, so that the swerves are clear:

pavon de Venus es, cisne de Juno

peacock of Venus she is, swan of Juno

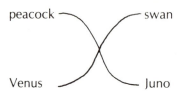

We have only to compare the pattern to the twistings of El Greco's *Laocoön* (figure 5) or of Titian's *Venus and Adonis* (figure 10) and the lines of the following illustration to the long-necked Madonna (*La Madonna al col lungo*) of Il Parmigianino to celebrate the Mannerist attitude. So much for mythology. In terms of life and death, love and fear, the sketch of another line shows similar swerves:

muerta de amor y de temor no viva

dead from love and from fear not alive

For one further example, let us glance at another arabesque line of nature, created by the hand the artist; that is, Ronsard's beginning line to one of the Mary sonnets:

Comme on voit sur la branche, au mois de Mai, la rose[35]

As we see, on the branch, in the month of May, the rose

[34] Góngora, *Antología*, p. 94. Compare also Friedrich Schlegel's swan: "Only a word, an image as a farewell—not only the royal eagle can despise the croaking of the ravens; the swan too is proud and does not hear it. Nothing concerns him but to keep the brilliance of his white feathers pure. His only thought is to nestle in the lap of Leda without hurting her; and then to breathe out in song every shadow of mortality" (*Lucinde and the Fragments*, p. 42).

[35] Pierre de Ronsard, *Poésies choisies* (Paris: Garnier, 1969), p. 103.

The branch is overarched by the season and the subject, and the quenching of the thirst of the parched and soon to be murdered rose (for she is killed by the envy of the fates) takes place within the line itself, at the end of the branch in the very arching of the poetic line: "la rose" may be reread as "l'arrose," literally, "waters her," so that the source is found at the conclusion, within the rose which it must water, against her fate. And yet, the image of the rose at the end leans back on the branch to the verb of sight at the beginning, past the specification of place and time.

Lighting a Garden, with a Personal Twist

The gardens of the Rococo and its neatly meandering forests are characterized by their wavy lines: Pope's groves in his "Windsor Forest," Sidney's *Arcadia* and Marino's *Adone* are all "chequer'd" like a game of shadow and sunlight as if some limber nymph were to pull against and almost give in to a lightly poetic embrace:

> Here waving groves a chequer'd scene display,
> And part admit and part exclude the day;
> As some coy nymph her lover's warm address
> Nor quite indulges, nor can quite repress.
> There, interspers'd in lawns and op'ning glades,
> Thin trees arise that shun each other's shades.[36]

If this tug of war and love in "Windsor Forest" is held up to the later poem of Mallarmé's faun's afternoon celebrated with its own partly lucid shade and partly shadowy light, comparisons would wax complex. In the line swerving from Scève to Marino to Góngora to Pope to Mallarmé, I am not trying to confuse or conflate Symbolism with Mannerism or with Rococo, but suggesting that to follow the varying illuminations and shadows might help us cast a new light on an old subject.

[36] The text is quoted by Sypher in *Rococo to Cubism in Art and Literature* as an example of a Watteau-like pattern from *The Oxford Book of Eighteenth Century Verse*, ed. David Nichol Smith (Oxford: Clarendon Press, 1926), pp. 92-93.

Take, for example, the lock: as we remember the *Spectator's* railing against the Rococo ornaments surrounding every lock, we may reread Pope's *The Rape of the Lock* with particular interest and concern. Might it be the fault of ornament that the doors of the *Lock* are opened? Does not a meditation of these locks and others lead to a wondering about waves, as in Baudelaire's obsessive hymn in "La Chevelure" of curly tresses he nibbles on and bathes in, the locks of which imprison ships and masts and perfumes?[37] Might not the endless meditations upon the mirror and the woman in her self-regarding posture, as she arranges locks and braids, lead to a musing on the being wrapped up in self and in sight of self? Take, for example, two texts from the Rococo period: first, Marivaux' *Paysan Parvenu* with its waking of self-contemplation:

Je me suis vu . . . je me trouvais quelque chose.

I looked at myself . . . I found myself quite something.

as it contrasts with L'Abbé Prévost's *Manon Lescaut* holding up the mirror to her erstwhile lover to force his self-contemplation:

"Voyez Monsieur," lui dit-elle, "regardez-vous bien."

"Look, Sir," said she, "just look at yourself."[38]

The second self-observing text of concern at this moment is Rousseau's own self-recognition as a self-nourishment and a parasitical self-winding, serpent-like: "ce séjour isolé où je m'étais enlacé de moi-même, dont il m'étoit impossible de sortir, sans assistance et sans être bien apperçu. . . . Réduit à moi seul, je me nourris, il est vrai, de ma propre substance"[39] (This isolated sojourn where I was wrapped up in myself, unable to extricate myself without help and without being seen quite clearly. . . . Reduced to myself alone, I feed on my own substance). We might compare this winding into the self with Valéry's serpentine lament: "Je m'enlace/Être vertigineux."[40] (I wind about myself/Vertiginous being.) In both cases, the twist is memorable, and yields stylistic as well as thematic complication.

[37] I am thinking of Baudelaire's "La Chevelure," of Mallarme's "La Chevelure vol d'ume flamme" included in his "Déclaration foraine," framed thus by prose as if another frame were set outside the frame of that text, and finally of Michel Leiris' *Aurora*—I comment later on hair imagery in Chapter 13.

[38] For the comparison of the two texts, Robert Loy was responsible; my thanks to him. The quotations and passages about mirrors occur in *Le Paysan Parvenu*, ed. F. Deloffre (Paris: Editions Garnier, 1969), p. 24, and later, in *Manon Lescaut*, ed. F. Deloffre and R. Pizard (Paris: Editions Garnier, 1965), p. 123.

[39] Jean-Jacques Rousseau, *Promenades d'un rêveur solitaire* (Cinquième promenade) in *Oeuvres complètes* (Paris: Ed. Pléiade, 1959), p. 1075.

[40] Paul Valéry, *Poèmes* (Paris:Gallimard, 1942), p. 56.

FIGURES, KNOTS, AND LINES

As long as the reading eye perceives, like the I of the self, it feeds well and wisely, snaking in and out of its complex nourishing, with a liquid grace. Compare Apollinaire's serpent as he is contemplated on the stage of "Les Collines":

> Un serpent erre c'est moi-même
> Qui suis la flute dont je joue[41]

> A serpent wanders, myself
> Being the flute on which I play

The ode is plainly, and elegantly, sung to the self.

We might take hold, if not too firmly, lest it elude our grasp, of Baudelaire's thyrsus, the emblem of the magical powers of poetry and medicine, thus as emblem of poetry, like a serpent wrapped about a stick, a metaphor about a concept; a poem of prose, a medley of female sinuosity twined about a central male finger, pointing at its own harmonious pattern:

> Autour de ce bâton, dans des méandres capricieux, se
> Jouent et folâtrent des tiges et des fleurs, celles-ci
> sinueuses et fuyardes, celles-là penchées. . . . Et une gloire
> étonnante jaillit de cette complexité de lignes et de couleurs. . . .
> Ne dirait-on pas que la ligne courbe et la spirale font leur cour
> à la ligne droite et dansent autour, dans une muette adoration?
> Ne dirait-on pas que toutes ces corolles délicates, tous ces
> calices, explosions de senteurs et de couleurs, exécutent un
> mystique fandango autour du bâton hiératique?[42]

[41] Guillaume Apollinaire, *Calligrammes* (Paris: *Poésie*/Gallimard, 1966), p. 32. In her *Défigurations du langage poétique* (Flammarion, 1979), Barbara Johnson discusses the metaphor of the stick surrounded with flowers in its relating of the two different parts—poetry and prose—and natures—sinuosity and hardness, female and male—and the paradox of its relating, as Baudelaire says, "variety" and "unity": how is it, she asks, also to be, as he says, "duality"? Does it not become, rather, one of the two terms in the very relationship it figures? the flowers surrounding yet another stick? "Does it contain its own center or does it only exist in function of a center which goes past it?" (p. 64). The text is, she continues, an arabesque about its own initial question as to the definition of a *thyrse*, a figure of the relation between the literal and the figured, "an infinite mise en abyme of its own incapacity to serve as a model" (p. 65). She relates, in a later chapter, Mallarmé's own "thyrse plus complexe" in its reversal of straight and winding lines of verse and prose to the literary act in its own arabesque, Mallarmé's "totale arabesque," in *La Musique et les Lettres*. All these discussions, in their turn, wind about the initial definition and the redefining role of reading.

[42] Charles Baudelaire, "Le Thyrse," *Petits poèmes en prose* (Paris: Garnier, 1962), pp. 162-164. For a good literary example of the thyrse we have only to imagine the Princesse de Clèves as she winds the colors of M. de Nemours around a stick suggestively.

Around this stick, in capricious meanderings, flowers
and stalks frisk and gambol, the former sinuous and
evasive, the latter, oblique in their leanings. . . .
And an astonishing halo breaks forth from this
complexity of lines and colors. . . . Couldn't we say that
the curved line and the spiral court the straight line
and dance attendance upon it, mutely adoring?
Might we not say that these corollas and chalices,
in their delicacy, odor and color exploding, perform
a mystic fandango about the hieratic stick?

But as for the arabesque design itself, it can contain just these op-
posites. Heavy-handed and heavy-lidded melodrama is made of such
romantic and post-romantic writhings: it would be a fitting groan to end
all our word play and image play if we here struggled with our writings,
inserting the purloined mysteries of an arcane letter,

W R I T I N G S
(H)

These lines meandering freely upon and among themselves in this
psychological as well as decorative twisting, like a continous Moebius
strip circling in its own wonderful gyre, remind me that in looking at
Piranesi's writhing serpents, the delight taken by the observer is an uneasy
one. The winding in and out, in its delicate balance, will lead at last to
another kind of self-feeding and self-feasting, in the androgynous line
freely participating in both sides at once: "In music, I am only a serpent.
The materiality of this art in its nervosity would distract me unfruitfully
from my designs of a severe abstraction"; or then, in the following quo-
tations from Josephin Péladan's "De L'Androgyne,": of which this "Hymn
to the Androgyne" forms the concluding passage:

O indecisive moment of the body as of the soul, delicate
nuance, imperceptible interval of plastic music, supreme
sex, third mode![43]

Or, again, with the dilution of color characteristic of Mannerism (for
instance, the washed-out paintings of Pontormo) and Rococo (for in-
stance, Watteau's pastels):

[43] Sâr Joséphin Péladan's *L'Androgyne* is the volume from which all these quotations are
taken: *La Décadence latine: Ethiopée VIII* (Paris: E. Dentu, 1891), pp. ix, and 5-9. A new
edition has just been published by Les Formes du Secret (Paris, 1979).

this vague hour of the body and this confused point of the soul,
this hesitating color, enharmonic chord, heros and nymphs.[44]

It may be permissible for such a twisted eye to consider some writer
among others, especially a codecracker-poet like Poe, whose mastery of
the twist is unsurpassed, whose interest in the Saracenic light of a censer,
stated in the first version as arabesque, is vision enough for any observer:

> a censer arabesque in pattern, and with many perforations so
> contrived that there writhed in and out of them as if endowed
> with a serpent vitality, a continual succession of parti-colored
> fires. (EAP, p. 80)

The perfume hangs as heavy as in Baudelaire's own "Harmonies of Eve-
ning"; this flickering light from the light, this uncensored sensuality, yields
a perfect aura shining finally on some figures in the carpet or upon the
rug. Remembering the anamorphic play in the Holbein *Ambassadors*,
where the skull of the implied *Vanitas* is seen only from the right angle,
we might take one perspective only, as in the expression "from a single
point of view," used in the passage from Poe quoted below. Next one
might contemplate some heavy drapery, a Belgian or Flemish tapestry,
so that the figure in the carpet might be seen hanging straight up, for the
reader's delight:

> . . . patterns of the most jetty black. But these figures partook of
> the true character of the arabesque only when regarded from
> a single point of view. (EAP, p. 81)

Which then is the true figure: the grotesque patterns seen ominously, or
the black arabesque, like some Ad Reinhardt lines, black on black, visible
only from a single viewpoint?

As Lautréamont and then Aragon pursue their serpentine and sinuous
wanderings, elegantly capricious, the eye has learned a flexibility essen-
tial to it: in to out, out to in, side to side, and the mind to meander, all
the while keeping one line in view.[45] Might one write, against all histories,

[44] Ibid.

[45] It seems only proper to end on the serpentine meanderings of the pastoral and the most
singular instance of Eros disguised and yet conscious: see Gérard Genette, "Le Serpent dans
la bergerie," *Figures* (Paris: Seuil, 1966), on the subject of *l'Astrée* as it includes, "and in
all innocence, a novel and its anti-novel, Pure Love with its libido: the snake in the
sheepfold" (p. 123). Because Céladon is disguised as a girl, the intertwinings of "innocent"
friendship are double-sided, and the *dénouement* is an unlacing in many senses: this final
note, then, is meant to link the nymph-and-shepherd meditations of Desnos in his final
writings, *Calixto* and *Contrée*, at once classical and "précieux," lyric and Rococo, to the
figure of Rrose Sélavy as "she" links by her androgynous conception in the minds of
Duchamp and Desnos, two sexes, two sides of the Atlantic, two minds. She too might

the manifesto of an androgynous arabesque? But let me end on a circle that includes some arabesques in an American garden, that of William Carlos Williams. This too is a "Portrait of a Lady," like Poe's "Oval Portrait," whose pattern is perhaps no less deceptive:

> Your thighs are appletrees
> whose blossoms touch the sky.
> Which sky? The sky
> Where Watteau hung a lady's
> Slipper. Your knees
> are a southern breeze—or
> a gust of snow. Agh! what
> sort of man was Fragonard?
> —as if that answered
> anything. Ah, yes—below
> the knees, since the tune
> drops that way, it is
> one of those white summer days,
> the tall grass of your ankles
> flickers upon the shore—
> Which shore?—
> the sand clings to my lips—
> Which shore?
> Agh, petals maybe. How
> should I know?
> which shore? Which shore?
> I said petals from an appletree.[46]

Each of Williams' lines is perfection in its swerve toward the next, in its mannered tension and various resolutions: here our encounter with Rococo will prove to have been illuminating, but only by means of a "chequer'd" light.

speak with a forked tongue, like some other thyrsus of a text, an arabesque entwined about a masculine imagining of Eros, a rose and an *errare* mingled ("ERROSE/arroser/RROSE/errer") in various combinations wrapping itself about and in the page. Both names are, as it were, foregrounded by the initial phonetic presentation: "C'est": Céladon/Selavy, like the tale of Adonis (Adone) and the tale of life ("la vie").

[46] William Carlos Williams, "Portrait of a Lady" in *The Imagist Poem* (New York: Dutton, 1963), p. 86.

6

..

TLOOK AND INSCAPE IN
ＤADA AND SURREALISM

> Et cet endroit est cet envers
> Passé à travers cet endroit.
> (And this right side is this wrong side
> Passed through this right side.)
>
> —Jean Pierre Duprey, "Mouvement plié"

ιbove all, a state of mind" said Artaud.[1] My very modest
ιly to discuss a few texts symptomatic of that state of
ee them and how they see: that is, a double outlook.
 was suggested to me by a line of Artaud, from what is
ι "Surrealist text": "The material world is still there. It's
ιe self which is looking" (Ar, 1:243). He does not say,
e, "myself looking from a parapet," but makes, rather,
the identification of the observer with the place from which he observes.
It is as if the outlook were first a specific location for the vision, like a
lookout point on a scenic highway, and then a perspective adopted. The
person seeing, or the poet recounting, seems to be sufficiently defined
by the two former notions: he is where he sees from, and he is his
judgment. When the Surrealist, defined as one sharing Breton's outlook,
proposes that the eye is one with what it sees, a distance is suppressed.
One might, however, wish to retain the distance, as it exists initially here,
between what I am calling the outlook and the inscape.

The latter term I take from Gerard Manley Hopkins, who was not
much of a Surrealist. He meant by it the individual essence of a thing,
its "thisness," or its "oneness," usually defined as "the outward reflection
of the inner nature of a thing, or a sensible copy or representation of its
individual essence," and associated with it the term "instress," being the
sensation of inscape, "the energy by which all things are upheld."[2] If a
tinge of those rather Symbolist notions appears in the reflections I am

[1] Antonin Artaud, *Oeuvres complètes* (Paris: Gallimard, 1956—), 1:269, 263. Hereafter cited as Ar. It seems that this text was written under the influence of a canvas of André Masson where a parapet is in fact visible.

[2] Gerard Manley Hopkins, *Poems and Prose*, ed. Gardner (London: Penguin, 1963), pp. xx-xxii.

making here, it will not have been entirely unpredictable, although the stress is plainly different in Hopkins and in Surrealism. By inscape I mean also the telescoping of the two terms: *inner* and *landscape*, as if the eye could also turn inward, training its gaze upon that same parapet of the self, this time not facing outward toward the object, but inside.

The self-regarding self is rarely at ease. The reflective despair of Jacques Rigaut is in some sense the despair of each of us as we remain too conscious: "I consider my most disgraceful trait to be a pitiful disposition: the impossibility of losing sight of myself as I act (. . .). I have never lost consciousness."[3] This inscape has limits then: it denies any unreflecting passion, any action unaware. Artaud's Paolo Uccello in his three-page play: *La Place de l'amour* (The Plaza of Love) could have thrown dice with any of Mallarmé's own figures.[4] He struggles with a properly unthinkable problem: "to determine yourself, as if not being the one to determine, to look at your self with the eyes of your mind without it being those eyes looking. To retain the benefit of your personal judgment, all the while alienating the personality itself from that judgment. To see yourself and overlook your being yourself that you see. But may this view on yourself stretch out and become essential before your eyes, like a measureable and synthesized landscape" (Ar, 1:205). Here we have strongly the sense of a tripled personality: my acting self, its overseer, and my further consciousness of that other look, like an overseeing overseen. So far, at least, the distinction between outlook and inscape is clear; a simple alteration of perspective in the viewing line, directed outward or inward.

What lasts is the convergence of inner and outer realities; the world is remade according to what one imagines, as well as suiting the outer surprises of chance and their repercussions on the inner:

Sous le bandeau de fusées
Il n'est que de fermer les yeux
Pour trouver la table du permanent[5]

Under the blindfold of rockets
You have only to close your eyes
to find the chart of the permanent

[3] Jacques Rigaut, *Ecrits*, ed. Martin Kay (Paris: Gallimard, 1970), p. 113.

[4] See Michel Camus, "Paul les Oiseaux ou la dramaturgie intime d'Artaud," in *Obliques/Artaud*, 10-11 (1976), 21-34, on *Uccello le Poil* as the "anti-Artaud" whom Artaud would have liked to become. Of particular interest is his study of the "vitre/glace" as a grid slipped between two texts. Excerpts from the texts on Abelard and Uccello are filled with the two senses of "vitre" discussed here.

[5] André Breton, *Poèmes* (Paris: Gallimard, 1955), p. 192. Hereafter cited as P.

Here the real stress—the instress of that inscape, to continue Hopkins' terminology—falls not on the accidents of sentiment or of chance but on the communication between the two sides of the Surrealists' swinging door, and on the possibility of a two-way passage, as in Duchamp's door opening out and in (11 rue Larrey), closing one room and opening another (disputing Musset's proverbial title: "Il faut qu'une porte soit ouverte ou fermée"/A door has to be open or closed), or then as in Jean Pierre Duprey's "Movement plié," the doubled movement of the epigraph, "pleated," in which the frenetic consciousness of the reversibility of vision endows the quivering motion of a wing with a doubled force it has not always in Symbolism, for instance. (Mallarmé's virgin and vivacious present contained a wing visible only in act, in its possible "coup d'aile," some single blow of the wing.)

Plainly, the ideal would be a self-forgetting glance: but we are never self-forgetful. The contemporary passages of the eye in the text are turned by the self-reflective vision into a confrontation: the onlooker or that other I stared at through a window: the problem is, as always, what is in and what is out, how the out relates to the in. There is also a question of framing—what does the spectator face, and how does it face him, or then, us? Dada, in its trick reversals and revisions, retraces its ambivalence on which the trick doors and trick mirrors, suitable to those images concerned with their own representation as well as ours, open either way, outward or inward, on either seen. As Edmond Jabès reminds us, "The inside and the outside are only the arbitrary part of the division of an infinite-time whose minute, always moving forward, calls the center constantly into question."[6]

It is interesting, if perhaps not altogether appropriate, to remind ourselves here that the inward/outward concern, the problem exemplified in a Moebius strip, is a constant: the alchemical fascination of texts written on both sides, in and out, or the vertical ambivalence of such painters as Van Eyck, whose Virgin writes her positive response to the Deity wrong side up for us, so that the sky may read it—the fascination with script and direction, with the direction of the script, is an enduring part of visual and verbal drama, as of the Dada circus.[7]

The communicating vessels of perception serve to awaken our sensitivity: their passage is the reader's threshold for participating in the out and the in, the right-to-vision from both, in Dada or out. Take, for instance, from an artist of a different breed, Edward Hopper's door, open to room and sea (figure 37). Here the room is invaded in its reality by

[6] Edmond Jabès, El (Paris: Gallimard, 1973), p. 31.

[7] Michel Butor comments on the Van Eyck Annunciation in Les Mots dans la peinture (Geneva: Skira, 1969), p. 135.

the sea, seemingly nearer than the edge of that sofa not to be sat in, than the border of that picture not to be looked at, than that rug not to be walked on—the same examination of out and in, as is offered by Magritte's picture of *The Scars of Memory*, with its door opening into nothing, or then *Poison* (figure 38), open on nothing but the sea, where the cloud enters through the door, the sea and the sky also entering by implication what normally shuts them out. All this is exemplified, of course in *The False Mirror* (figure 1), as that eye becomes the clouds it stares at, that vision of the seeing eye kept in our mind as in our text.

Another privileged door for the exercising of what we might call *liminal sensitivity* is found in a poem aptly called "Le Contrefacteur," that is, a forger or "faussaire," or by extension a person going against the facts or "faits," or then a counter-mailman; it ends with Aragon's name signed inside out, written backwards, "in white letters on the door."

On lit à peu près sur la porte
Les lettres blanches retournées[8]

You can just make out on the door
The white letters turned around

It appears impossible to tell which way we are meant to be looking. For instance, from outside we might see through the glass door to the reverse side of the name, which appears right way round to the poet inside, who would be on the other side from us: the text, as such, would be written uniquely for him, so that we would be privileged to see only its backward trace. Or then he sees the reversal of what is written for the outside. But "Le Contrefacteur" is itself in fact a two-faced text of a passage totally ambiguous, revealing the opposite of what a postman would see, that is, the opposite of a name outside, straight-side up, legible: its opening is complicated, as it looks out *or* in. Duchamp's *Large Glass* forms, of course, the summit for such perceptive training of perception: its multiple complexity of meaning has the depth and brilliance of a Mallarmé text, *Igitur*, or *Les Noces d'Hérodiade*, pictured from both sides: to that Glass a later chapter on Duchamp and Mallarmé returns.

The mirror questions even our own identity: this is the liminal stage of doubt for the passenger of the rites, whose humiliation precedes his purification. Ribemont-Dessaignes poses an identical question, in an essay called, precisely, "Identity":

Philosophical identity reduces for us to mathematical identity.
Chair = Chair
17 = 17

[8] Louis Aragon, *Le Mouvement perpétuel* (Paris: *Poésie*/Gallimard), p. 192; first printed in 1925.

—That is to say that an object whose characteristics are enumerated is assimilated to a number or to a series of numbers. . . .
—To judge things in that way you have to start by assuming: Such a character is equal to such a character. And as in mathematical identity reduce all equality to

$$1 = 1$$

Which is to say to return to the conception of unity.[9]

And so on. This passage is to be compared with another passage from Ribemont-Dessaignes, from his *L'Empereur de Chine* (The Emperor of China):

There are between two and three many other numbers. Squaring them gives you a result larger than four and less than nine.
It's a mysterious world which is not measurable, and which is used to measure that which is not measurable. (Da, p. 132)

Although in a very dull and prosaic disguise, this concern with identity and self-measurement is in fact a good part of the vital leap which, says Tzara, is called thought: "le salto vitale s'appelle Pensée."[10] Not a leap of faith or of death, but of life—that humor set in philosophical motion and flexibility both unsettling and complex.

In his splendid book on beginnings, *Je n'ai jamais appris à écrire ou les incipit* (How I Never Learned to Write, or Les Incipit), Aragon praises a Matisse image of a *Door-Window*—what better title for a discourse on inside and out?[11] In the case of such a window or opening—for it is also an opening into the imagination—one enters exactly what one sees through; whereas in the case of Braque's tiny book of four pages called "My Picture," the picture in question making itself through the removal of the dust covering it, or by the colors' own passage through page and canvas, it is not a question of the reader's or artist's entering, but rather of proffering the invitation to enter, and providing the way.

The several obvious privileged places for the examination of the double consciousness of in and out, up and down, forward and backward are in mirror, window, door, and stair. Elsewhere I maintain that the reason for their privilege, like the reason for the privilege of the crossroads as a place of confrontation of self and other has to do with the rites of

[9] Georges Ribemont-Dessaignes, *Dada: manifestes, poèmes, articles, projets* (1915-1930), ed. Jean-Pierre Bégot (Paris: Projectoires/Champ Libre, 1974), pp. 130-132. Hereafter cited as Da.

[10] Tristan Tzara, *Oeuvres*, ed. Henri Béhar (Paris: Flammarion, 1975), 281. Hereafter cited as Tz.

[11] Louis Aragon, *Je n'ai jamais appris à écrire, ou les incipit* (Geneva: Skira, 1969). Hereafter cited as Je.

passage that I take poetry to be. Very briefly, as the anthropologists have taught us, in the words of Van Gennep and Turner, three times are clearly marked within these rites of passage or transformation: the moment of separation or the pre-liminary moment, the liminary moment, at the threshold between one state and another, and the moment of reintegration, in one's changed state.[12] If we situate poetry in the middle or liminary stage, it signals adequately the equal importance of the outlook and that telescoping of the inner landscape that I am calling the inscape: the viewing line alters with the direction outward or inward, up or down. For example, the multiple stairs, visual and verbal, that mark the change of status, of literary pace and of perception, often signify the descent in one's own mind and into its depths: the most famous example is, of course, Duchamp's remodeling of Laforgue's ascending motion in *Encore à cet astre* (figure 35) and then his *Nude Descending the Staircase*, which he describes as a great step to the *Large Glass*: thus the stair and the mirror combine their two privileged passages whose conjunction reaches from Mallarmé's *Igitur* to T. S. Eliot's conscious reading of Laforgue, and the latter's Hamlet to the Hamlet of Tzara, as well as the celebrated Surrealist conjunctions and constellations of Breton, Leiris, and Desnos.[13] Robert Desnos' sphinx majestically takes the downward path at dawn, and Michel Leiris' *Aurora* is thirty pages just coming down one flight. We can take these downward passages to be descents into the self or out into the other, but undeniably these places of passage: stairs and mirror,

[12] Arnold Van Gennep, *Les Rites du passage* (Paris: Nourry, 1909); Victor Turner, *Drama, Fields, and Metaphors* (Ithaca: Cornell, 1974). See also my "Poème du passage," in *Cahiers de l'Association Internationale des Études Françaises* (Paris: Collège de France, 1978), pp. 225-243, and my forthcoming *A Metapoetics of the Passage*.

[13] Wallace Fowlie, in his *Mallarmé* (Chicago: University of Chicago, 1953), p. 118, likens Igitur's stairs to a "graphic representation of the recurrent beats (of the heart as of the clock)." The best example of mirror and stair combined is perhaps Breton's "Je rêve je te vois superposée" (P, p. 129; I dream I see you indefinitely superimposed upon yourself), where the image of the lady seated before her mirror "in its first crescent" is transposed to the image of a child at the top of the stairs and then to the goddess Sivas. Michel Leiris' *Aurora* opens with a slow, thirty-page descent of a set of stairs, and Robert Desnos' "Pour un rêve du jour" (For a dream of day) begins with a sphinx ascending and then descending the staircase, whereas his "Idée fixe" (Obsession) seats a lady before her mirror to receive the tribute of the sea. Since he claims each poem as part of one great poem, I may, without stretching a point, treat these images as convergent. In each of these texts, the other great image, that of the arrangement of the coiffure, takes a primary role: Aragon, Breton, and Desnos ensconce their ladies before a mirror, a sort of Great Glass in which to fix their hair, and in each case the association is made with water ("the water wing of your comb," insists Breton, and Desnos' algae are brought to the mirrored lady from the very depth of the sea, that other crystal responding to the mirror; the homage is then made from the lively water to the frozen water of the mirror, if we take the Baroque view). Aragon's *Anicet* from 1921 combines the threshold of perception, the mirrored image, and the rivulets of hair matching the wetter ones in a particularly forceful way.

door and window (figures 35 through 42), threshold and crossroads exist to be traversed and retraversed, to be meditated in. They are, after all, texts.

More powerful still in its questioning, the written passage from one side to the other is examined, with its attendant problem of slippage, in Breton's epic poem *Fata Morgana*:

> Qu'est-ce qui est écrit
> Il y a ce qui est écrit sur nous et ce que nous écrivons
> Où est la grille qui montrerait que si son tracé
> extérieur
> Cesse d'être juxtaposable à son tracé intérieur
> La main passe (P, p. 184)

> What is written
> There is what is written about us and what we write
> Where is the grill that would show that if its exterior
> trace
> Can no longer be set beside with its interior trace
> The hand passes

In this passage, the writing hand penetrates the barrier between the sides to link them. In a lighter mood, consider Robert Creeley's poem on the hand, reaching both ways as it does, palm in and out:

> Inside
> and out
>
> impossible
> locations—
>
> reaching in
> from out-
>
> side, out
> from in-
>
> side—as
> middle:
>
> one
> hand[14]

This would presumably be the case with most poetry, if not with most writing; it would first link perceptions, and then descriptions of the object perceived and described. Obviously, in Surrealist poetry, the case is

[14] Robert Creeley, *Pieces* (New York: Scribner's, 1969), p. 4.

strongly made for a projection of vision on the exterior object, which is to receive a fresh structure from the perception, and then confer in its turn a new structure on the perceiver, in an exchange reaching past mere surface modification and one-way development. The point of Surrealism is at least double and is at its best multiple.

This point itself being debatable, however, it calls for a few words. To be sure, Breton often spoke of a "sublime point," in which the contraries of life and death, up and down, and high and low were to be assembled to converge in a new whole as in the Zen vision. Tzara, before him, spoke of a point where the yes and the no could meet, each retaining its essential distinction; both spoke of the image as the translation in verbal and conceptual terms of this experience of contraries and of the marvelous conjunction, both expecting still more illumination to be forthcoming from this point than Reverdy had hoped for from his poetic image, whose elements were to be taken from fields far apart. But fortunately, there was to be no dwelling on or in this point which could only be shown from a distance, as Breton's glass house was only to be wished for and not inhabited, similar to Tzara's glass corridors, and his crystal mountains where creatures of light were to disport themselves in freedom.

For each Surrealist experience lived, recounted, read, or reread is meant to remain as double as the perception, and as open. So that the swinging door, this time between reader and poet, remains swinging on or even in the text. Desnos' novel *La Liberté ou l'amour!* (Freedom or Love!) finishes unfinished. After the literally polar experiences of the Corsair Sanglot lost in the desert and halted in the ice floes—both loss and halt being partial reflections of Mallarmé's imprisoning and marvelous white page—the final line opens once more in its very closure, reading in its entirety as follows: "It was then that the Corsair Sanglot. . . ." What might have been a Dada autobiographical novel, Tzara's *Faites vos jeux* (Place Your Bets) was never completed, and Breton's *Nadja* ends with a substitution that does not exclude, even for the reader unacquainted with the further story of Breton's life, further substitutions. One of the determining characteristics of the state of mind we accept as Surrealism or poetic Surrealism is just this unresolved ambivalence.

Take the lines quoted here from the collective text by André Breton, René Char, and Paul Eluard: *Ralentir Travaux* (Slow Down Men Working) of 1930.

Décors

Nous avons jeté la maison par la fenêtre
C'est un jardin d'intérieur

Ici les rosiers sont tracés à coups de couteau
 sur le corps des femmes[15]

DECOR

We threw the house out of the window
It's an enclosed garden
Here the rose bushes are traced with knife strokes
 on women's bodies

The odd passage of the entire house through its own orifice is, to say the least, surprising. What might have been the architectural center or the enclosed garden within the house, becomes an outer manifestation of nature enclosed in culture, like a "jardin d'intérieur," forming a sort of *mise-en-abyme* in and out. The reader could well imagine several next steps: elaborations on the traditional rose image or then a series of erotic branchings or more Alice-type transpositions: gardens smaller and smaller, or roses bigger and bigger. As in all the accordion images flourishing like so many flowers in so many Dada-Surrealist gardens of prose and poetry, there is no necessary end to the swellings and shrinkings of landscapes, the openings out and openings in; compare, for instance, the image of the accordion in Tzara's early circus poems, in Aragon's *Paysan de Paris*, and in Breton's *Fata Morgana*, used as a privileged image of expanded perception.

These infinitely extensible impressions contrast with the terse and illogical finality of one of Char's later poems, "Sur les hauteurs" or "On the Heights":

(Il y avait un précipice dans notre maison.
C'est pourquoi nous sommes partis et nous sommes établis ici.)[16]

(There was a precipice in our house.
That's why we left and settled here.)

There is, from here, plainly no going back inside after the initial transposition in which the outside precipice moves to the inside of the house, so the inhabitants move outside, to the heights from which, supposedly, the precipice originally came. The poem ends with the ironic perception itself, and does not, could not extend past it. The effects of the perceptions in those two texts are diametrically opposed.

The Surrealist perception is typically a labyrinthian one. Tzara's

[15] *Ralentir Travaux* (Paris: Editions surréalistes, 1930).
[16] René Char, *Les Matinaux* (Paris: *Poésie*/Gallimard, 1969), p. 45.

"approximate man" wanders lost in himself with "packets of labyrinths" attached to his back. The "paysan de Paris" wanders in a vertiginous confusion of senses, "errance" leading to the marvelous "erreur," the rearranger of the universe for the wanderer of the multiple and the multiply-sensed text. The most effective texts demonstrate not just the shifting perspectives of outlook and the fertile confusions of inscape, but a veritable transport of obsessive and obsessed language, where the image in metamorphosis determines the structure and suffices as its own passage from inner to outer or the reverse.

Less exterior than the image of a house thrown out through its window like an object melodramatically turned inside out, Artaud's verbal labyrinth provides a profound and far-reaching inscape in the sense in which we use the word here. The text has two parts: *Uccello le poil* (Ar, 1:140-142; Uccello the Hair) makes an identification between the painter Uccello and a linear form, the special figure of his obsession: either one hair, one eyelash, one line, one thread, or one wrinkle, these diverse and single objects by which the passage from inner to outer realm is accomplished. A thread like that held by Ariadne is suddenly thrust into another realm from the linear and the formal, for "ligne" is now transposed into "langue," via "lingua," tongue, as the singular thread takes on itself the manifold possibilities of a skein endlessly divided, in "tous les sens du monde." All the senses, all the meanings, and all the directions, "sens" taken in all senses, mingle in a tongue at once crazed and poetic. An epic patience is required, the time of which the wrinkles are a symptom and to which the windings of the tongue eventually lead: "You, Uccello, you learn to be only a line and the elevated place of a secret." In a second movement, the poet will himself be identified with the artist, Antonin Artaud taking on the myth of Paul les Oiseaux, together with his obsession. The obsession becomes at last the text.

Now the accepted reduction of the painter or the poet to a single line would seem the abandonment of what is multiply sensed, the betrayal of the meandering inscape. Yet Henri Michaux's transcriptions of his mescaline fantasies bear poetic witness not only to the possible lyricism of that reduction and then to its ultimate multiplicity, but above all to a flexibility of expression and a depth of vision reassuring as they are incontrovertible. What is sacrificed is the individual outline we might have thought stable; to Breton's "crisis of the object" Michaux adds a crisis of the subject through whose uncomfortable corridors we might have to pass in order to enter Artaud's own inscape more knowledgeably. In the nightmare experience of Michaux, the subject is traversed by a deep groove, "without beginning or end . . . it crosses me heading for

the other end of the world."[17] He loses his normal profile, the outline of human complexity, to become a single line, remaining all the while "in a horror of this reduction." But the line diverges, to the poet's wonder:

> A line breaking out in a thousand directions . . . To have become a line was catastrophic, but still more unexpected, more prodigious if possible. My entire self had to pass through that line. And by the terror of intense shocks. Metaphysics gripped by mechanics. I, my thought and my vibrations had to pass by one path.
>
> Myself only a thought, not thought having become myself or evolving in me, but myself *shrunken to its size.*[18]

In Michaux, the minimality of Uccello's line as seen by Artaud is retained, but proliferates.

Now in Artaud's second text on Uccello in his mental drama, *La Place de l'amour ou Paul les Oiseaux* (Ar, 1:143-146; The Square of Love or Paul the Birds)—the latter being the pluralized French name of the artist which Artaud will take for his own—he takes upon himself, or within himself, the myth of the artist, reflecting then on his own reflection on Uccello in all its reversals of possibility: "He is now the container, now the contained." A hall of mirrors where the same personage passes constantly, now accompanied, now alone. Uccello, as seen by Artaud/ Paul les Oiseaux, "builds his story and little by little is detached from himself: the answers meet in him outside of time." The atemporal setting of such a mythical inscape permits a constant flux, and Artaud points out that the scene takes place on three levels; the following is one reader's perspective on that tripartite interplay and its scene.

First the poet observes, creates, and chooses to become Paul les Oiseaux, who wills himself toward the immaterial and the linear, and speaks from the distance of the third person pronoun: "dépourvu de tout corps, tel qu'il aurait voulu être" (stripped of all body, such as he would have chosen to be). But in the scenic juxtaposition with Selvaggia, his companion, a formal and gestural opposition of lines is developed, in the second stage leading toward the mental drama, a state of polar contraries:

Je suis à la fenêtre et je fume.

. . .

Elle est assise et elle meurt.

[17] Quotations from *L'Espace du dedans* (Paris: Gallimard, 1966), pp. 354 ff.

[18] Ibid. See also Michaux's haunting by lengthening of objects and their spreading apart, *Mouvements* (Paris: Gallimard, 1967), p. 143 and *L'Espace du dedans*, p. 326.

I am at the window and I am smoking.

. . .

She is seated and she is dying.

Her fading is a condition of his determination and a disproving of Uccello's own surprising plaint, now phrased in the first person: "Je suis tel qu'on m'a fabriqué, voilà tout" (I am such as they have made me, that is all). "And yet"—here Artaud speaks again from the first of the three stages or levels of the mental drama, and from the third person:— "he makes himself" (Et cependant c'est lui qui se fabrique). In still another scene, situated on the third level, Uccello converses with Brunelleschi, himself a figment of the imagination of Paolo Uccello or of Paul les Oiseaux/Artaud, who states unequivocally: "Tu es tel que je te veux bien" (You are the way I like you to be).

The confusion of the passage is intense—here one might use the term as a scenic identification, like one of those corridors or wings of the stage called passages, but here made vertical, leading from one level to another as to that "elevated stage of the secret," just alluded to. The complication of the passage of personage is attributed by the poet to the parallel operations on the poet and on dramatic character, a magical operation like that of his alchemical theater, intensely ritualized, thus elevated and secret. The unity behind the confusion is offered by the central conviction of the poet, spinning the drama from his own obsession: "Je suis vraiment Paul les Oiseaux. Je suis tel que je me suis vu" (I am really Paul les Oiseaux. . . . I am such as I have seen myself). Artaud is, as he has seen Uccello to be, and Uccello has created himself as Artaud in Paul les Oiseaux. This mental poem of the inpalpable line becomes a mental drama of multiple lines in a dramatic passage from the one to the one and from the one to the other, from poet to myth, outside to in, container to a contained that then contains a further drama, as Artaud contains Uccello, who then contains Brunelleschi in his own vision.

Artaud's insistence that the unity of the work is bestowed by the poet or his personage becoming what he sees himself acting out, shows an optimism about the efficacy of vision and of language that he is not long to keep: after the miracles of the tongue, this "langue miraculée," what continuity? All the other senses weaken one by one: "Je n'entends plus, je n'entends plus" (I no longer hear, I no longer hear). Now remembering that instress signifies the feeling of inscape, the realization of the energy behind all things as they are individuated, then once more we can borrow a term of Hopkins for our own stage setting. When Benjamin Péret directs his gaze not at but through the woman he loves, toward a universe newly colored by his vision, he states quite simply: "Aujourd'hui je regarde par

tes cheveux (. . .)/ et je pense par tes seins d'explosion" (Today I see through your hair (. . .)/ and I think through your exploding breasts).[19] The statement is neither obscene nor erotic, but rather transfiguring. The intense and explosive outlook itself radically alters view and viewer, each working into and through the other in a Surrealist passage seen, now at its most sublime point.

MERGING WITH THE EYE

We know that the outlook may eventually meet with insight. "The eye and its eye," the Dada writer Ribemont-Dessaignes wanted to entitle one of his projects, "l'oeil et son oeil." The reader of a text might, in super self-consciousness, keep his eye upon his own eye reading: the very uncomfortableness of this exaggerated look appears in a contemporary text staring back at us, a literal exemplification of the eye in the text that initiates this volume. Lionel Ray, who is, like Marcel Duchamp, the adopter of other personalities (formerly Robert Lorho, he is switching to still another name for his newest poetry) forces the reader to contemplate his own contemplation of the reader and of himself. Ray's rays mock us, changing the textual passage into an encounter, not entirely welcome, between the author's gaze and our own (figure 60).[20] We can manage only a passive stare at this stare, and he outstares us, easily, in this narrow passage, already determined. Since the time of God, we had grown used to the contemplation of the sky and its contemplation of us, and the emblematic eye contemplating both: but have we not always identified the seer with ourselves, included an I in the seen? The assaults upon the eye, like that of Buñuel's slashed eyeball, reminiscent of Magritte's severed red globe as if the pointing finger had done violence to it, sends us back to Ribemont-Dessaigne's "L'oeil couchant," for the setting sun's eye brings back Apollinaire's "soleil cou coupé," that severed neck of a sun. A scene contemplated by such an eye could only be dramatically staged and transformed, vision by vision; see Redon's *Vision* (figure 2) and the concrete poem "Soleil mystique" (figure 59).

To the notion of the transforming eye a series of images bears homage and witness. To the eye as a source of metamorphosis and anamorphosis, the eye itself in anamorphic representation (such as the one set up by Cardinal Colonna, for example) refers most appropriately, this being a

[19] Benjamin Péret, "Rosa," in *Poètes d'aujourd'hui* (Paris: Seghers, 1961), p. 107.

[20] Lionel Ray, *Les Métamorphoses du biographe* with *La Parole possible* (Paris: Gallimard, 1971). The eyes staring back at us from these pages keep, as they should, our own eyes upon the text. (See figure 60.)

self-referring image, turning about the eye, and the possibilities of that eye using, moreover, the eye itself as object: this is a Baroque view of vision. In accordance with the Surrealists' recommendation, centuries later, that the distance between the seeing and the seen should be suppressed, the object and the observer, the experimenter and the experiment are made to merge in one shared view, this self-consciousness having no need of outer object; thus again the Baroque view leads to the Surrealist, as it does to the Symbolist view which is its predecessor. Redon's startling instances of the eye on stage is another of the early metavisual images as perfect examples of a self-referring temper: the observers here stare at a theatrical eye, itself forming the subject of the sight (figure 2). The Surrealists could go no further than this.

Now plainly the mirror is the privileged image and place of such self-regard: Magritte's images of mirror and window are good training for the flexibility of mind needed to deal with the complications of this concept and its corollaries. To take only a few examples, first of aggressive vision, his *Month of Harvest* (figure 39) confronts the would-be outlooker with a series of faces looking in through a window ordinarily suited to contemplation of the exterior. Their gaze, directed at ours, and all the more terrible for being a multiplication of the same look, blocks our outlook and renders us a prisoner of the room, denying us even the most ordinary of landscapes. To continue the play of in and out, *In Praise of Dialectic* (figure 40) presents a window frame with the panes turned inward, as is normal, toward the room from which or upon which the gaze is to be trained; but on the inner wall of the room into which the panes reach, there is, contrary to all expectation, a building façade with five windows and a door, so that the outside is transferred to the inside, presenting a disquieting inner landscape that is still outer. As if in a mostly unsettling *mise-en-abyme*, the look is made to imagine an infinite recess and regress, leading only to a sameness of surface: no possibility will ever be offered of a passage to a deeper inside. Now these two images respond to and mirror each other: in one, no outer landscape, because it is blocked by an inward gaze, and in the other, no inner scene, because it is blocked, in turn, by yet another outer surface. In neither finally, is there any outlook, and even the possible depth of inscape is threatened by an inviolable blockage at the surface level, a halt to the imagination.

Magritte's celebrated *False Mirror* (figure 1),[21] with its eyeball across

[21] In relation to the concepts of false mirror and to the images of mirror images, consider, from Claude-Nicolas Ledoux, the "Coupe d'oeil de théâtre de Besancon" in his *L'Architecture considérée sous le rapport de l'art, des moeurs, et de la législation* of 1804, an engraving of the right eye which, since it is an engraving, reverses the image and restores the eye to its original position on the plate. The eye on the plate sends us back to certain images of Magritte, as does the reversing of vision and of conception.

which wisps of clouds are floating, as the reversal of the seen in the seeing, juxtaposes the stability of the fixed and unblinking eye with the ephemeral image of clouds passing. The outer text is transposed into the representation of vision itself, raising the whole problem of seeing and registering and interpreting the passing scene together with that of consciousness. The convergence of seer and seen is complete, as Breton would have wanted it. But the very separation of the eye from the context of the body makes of it an icon and puts its own relevance into question: does not this eye forfeit its insertion into the meaning of sight, to become simply a part of our literary and visual landscape, seen as an object of little more interest than the clouds registered upon it? Or does it rather provoke our thought as to the concept underlying it? Where is the place of the I contemplating this other eye and its own reflection therein? How is the mirror "false," and to what? The questions raised by Magritte, insoluble in the space of his work and difficult to solve in ours, are the very reason for his own insertion in the labyrinth the present text means to construct. (I would not say, for instance, that the poetry of Eluard raised this kind of question in spite of the prevalence of eye-imagery in it, or that in fact it concerned itself with difficult conceptual questions as such.)[22]

Many of Magritte's images form in pairs an extraordinary dialectical examination of inside and out, front and back, mirror and reflection— the latter taken in both senses of the word. To take only one of the pairs, as I did for the window and gaze phenomenon, we might compare *Reproduction Forbidden* (figure 41) with *The House of Glass* (figure 42). In the former, the mirror betrays all the laws of mirroring: instead of sending back to us the front of the man facing the mirror, we see once again the rear of his head, and instead of seeing the exact reflection of the Poe volume placed on the ledge, we see an edge of it that would not be visible under such conditions. That the volume should recount the adventures of Arthur Gordon Pym, adventures far from realistic, is fitting; that we should be prevented from seeing what we normally expect to

[22] Just the titles of some of Eluard's more important works give an impression of the importance of the eyes and of seeing in his Surrealist imagery: for example, *Les Yeux faciles* (Uncomplicated Eyes) of 1936, and the eight "Poèmes visibles" in his *A l'Intérieur de la vue* (On the Inside of Sight) of 1948. The multitudinous allusions to eyes themselves and to the exchange of looks in his poetry and the explicit and implicit collaborations with Surrealist artists in whom the imagery proliferates—eyes in a hand or a building, strings of eyes and eyes in rows for a particularly complicated perspectival play, an eye for a landscape, and so on, would furnish superabundant material. A study of this subject would not be relevant to the present work, precisely as it is usually so explicit as to need to commentary. My interest here is rather in the connections the individual reader may make if he chooses to, in this labyrinth of his own devising.

see in the mirror, that, in fact, it should be the mirror that blocks our view of the normally seen, is no less so. We are seeing the other side of the real reflection, so to speak, which is in this case what we see multiplied—we simply see it twice. Now the contrary is true with the second canvas: the man looking into a mirror with his eyes reversed in his head in order to stare at our staring at him seems to be looking slightly to the right of our look. Were he not standing in front of the mirror, we assume, we would not be called upon to reflect on his reflection on our own. But here once again, we have to reexamine thought in reexamining appearances, and the mirror's betrayal—yet another false mirror—is really its revelation and that of our imaginative perception. We see more than we see, and something else, once we consider our ways of seeing.

As for our seeing, we may make our own scene by the inward juxtaposition, mentally, of two moments or visions. For example, while looking at Magritte's candle burning behind the back of a man looking seaward in *The Siren Song*, we think not only of the relation of the glass of water to the sea (and perhaps also of his picture about Hegel's "vacation," with its glass of water suspended on the umbrella, in this dialectical dilemma, presumably having already caught the rain), not only of water and fire as the two elements here in dialectically-exact contrast and response. For the canvas is set up like all the paintings of the *Vanitas* in which a candle burns beside a glass, upon a table, as a reminder of mortality. Those earlier meditations may now intrude on our mind, so that we remember de La Tour's *Repentant Magdalen* (figure 14), for instance, where the centered flame of the foreground seems, oddly, to extend in front of and beyond the mirror's flame, which even the mirrored candle fits imperfectly, from the onlooker's point of view. Since the candle and its illumination are slightly to the side, nothing is directly seen, and everything avoids the gaze: the objects are too near, like the candle before the eyes, all too closely symbolizing the brevity of life and its flickering. In the Magritte canvas, the head of the man turned seaward may send us back to that Magdalen's averted gaze: only the skull is lacking to the Magritte. In their brightness and in their shadows, the Baroque and the Surrealist meditation may deepen our own perception, as Rossetti's *Beata Beatrice* deepens, retrospectively, our contemplation of the Magdalen, meditation summoning meditation (figures 13 through 16).

For a final and ambiguous reflection on both outlook and inscape, we might consider the self-contemplation of the Dada Jacques Rigaut. Until his suicide, itself aesthetically plotted, as before a mirror, he remained haunted by the endless mirroring of the look perfectly conveyed in the nonstop sentence that his Lord Patchogue chants before the mir-

ror in a series of reflections entitled: "Derrière la glace" (Behind the Look-ing-Glass): "L'oeil—qui regarde l'oeil—qui regarde l'oeil—qui regarde l'oeil—qui reg-" (The eye—looking at the eye—looking at the eye—look-ing at the eye—look—). Both in this ceaseless reflection of the most sterile inscape and of nightmare and in the static fixation of an outlook mirrored, the passage from observer to the view is threatened, as in his fragment of "The Mirror": "ET MAINTENANT RÉFLÉCHISSEZ, LES MIROIRS" (AND NOW. REFLECT, MIRRORS).[23]

It would seem, finally, that in a Dada or Surrealist text or canvas, the look itself is to be questioned: in Uccello's abysmal detailing, for instance, an eyelash leads only to a contiguous eyelash and not to what the eye might see, and the vision is mocked by the fixed stare of mummy cases that haunts some of Artaud's poems, such as "La Momie attachée" (The Tied-up Mummy): "Grope at the door, the eye dead and turned about onto this corpse, this flayed corpse washed by the atrocious silence of your body" (Ar, 1:234). The state of mind Surrealism is must retain its problematic ambivalence and lack of assurance, on which the doors can open either way, outward or inward.

Such complex perception, in all its intense uncertainty is rendered unforgettable by Artaud's description of a state outside ordinary life: "There are no words to designate it but a vehement hieroglyph designating the impossible encounter of matter and of spirit. A kind of vision inside . . ." (Ar, 1:202). Here I leave the quotation also incomplete, as the Surrealist text is ideally incomplete, its passage left forever open to the reader who is meant to see out and in. A chosen obsession may be interdependent with the multiple perspectives offered by the inward sight, that "vision en dedans" partially offered only and partially concealed, in the passionate mystery depicted by Artaud's "vehement hieroglyph-ics," whose signs point in both directions unendingly.

[23] Jacques Rigaut, *Écrits*, ed. Martin Kay (Paris: Gallimard, 1970), p. 113.

7

THE ANNUNCIATION OF A TEXT: RILKE AND THE BIRTH OF THE POEM

How should this be?
—Mary to the Angel

RILKE'S "Mariae Verkündigung" (Annunciation to Mary) makes an annunciation interesting not only for the extraordinary abundance of illustrations of the event, but because of the nature of the theme itself.[1] The poem is actually an announcement of an announcement, the effective setting for an illocutionary speech act concerning the nature of the poem, which is thus created by a sort of rational verbal miracle. Like the expressions: "I promise," or "I say," the annunciation as a poem of an event might be called auto-performative, for the poem-event *is* and does what it enunciates or announces. Not only is the text engendered by the announcement at its close, but the annunciation itself either in, or parallel to, the poem's conclusion may be considered to last as long as the poem; thus the poetic enunciation and also the message annunciated to us endure through our own reading.

As a further complication, the announcement of this particular birth implies, for the knowledgeable spectator, not only an incarnation but the consequence of ultimate crucifixion and resurrection, although this latter knowledge is not included in either text, neither in the angel's speech or song, nor in the poem concerning it. As Mary thinks of birth and incarnation, the reader or observer may well think of death and resur-

[1] The poem is from 1912; an earlier poem of "Annunciation to the Shepherds" holds far less interest from the point of view taken here.

For commentary on the "Marien-Leben," see Marianne Sievers's "Die biblischen Motive in der Dichtung Rainer Maria Rilkes" (Berlin: Germanische Studien, Vol. 202, 1938), especially the chapter "Die Bedeutung des 'Marienlebens,' " pp. 104-108; and also Friedrich Wilhelm Wodtke, "Rilke und Klopstock" (1949) on the sources and beginnings of the cycle (pp. 67-74); also Albert Scholz, "Rilkes' 'Marien-Leben,' " *The German Quarterly*, 33 (1960), 132-146; and in particular Rilke's letters to his publisher in 1912: (January 6 and 15, October 2, 18, and 25, and December 9). I am grateful to Dr. Joachim W. Storck of the Deutsches Literaturarchiv in Marbach for this information and to Dr. Richard Sheppard for his interest.

rection. Mary may well hear one message and the reader another: two texts are being received here, the second text including the reception of the first. There is then a double consciousness at work in the conveying of and the hearing of the announcement, as of its timing: the annunciation, one might say, is necessarily of an event ahead in relation to the time of the poem, but past in relation to us. In one possible reading, as the text ends, the annunciation is about to be made, that is, the "melody" of the angel's horn remains forever future to the text; in another, it is made within the text, and the angel sings after speaking it, or makes the message part of his song; in the third and most challenging, the one suggested here, the annunciation includes the making of the poem as creature and creation, so that the text is brought about by this extraordinary encounter.

The temporal complexity necessarily a part of the three readings— the annunciation about to be sung, the annunciation of the poem, or then part of the poem itself—is mirrored in the enunciation or the narration of the event by a similar spatial complexity. For the time and the setting of the Biblical annunciation are already double, since it takes place first at the spring—metatextually interesting in the idea of source, as the source of the tale—and then at Mary's house. The verbal and visual drama is thus necessarily divided in at least two acts, with an announcement made in the open, or disclosed, and then made in private or enclosed, in the *hortus conclusus* of the secret or final text.

The original textual referent is found in Luke 4:276-338:

> And when she saw him, she was troubled at his saying, and cast in her mind what manner of salutation this should be. . . . Then said Mary unto the angel, "How should this be?"

So the question is already raised as to the saying and the manner of salutation within the text. Here at the beginning one might consider also, particularly in the light of the Rilke poem which will serve as the way of passage here, the description of the event given in the *Protoevangelion* of *St. James the Lesser,* then taken up in the Latin *Pseudo-Matthew:*

> And she took the pitcher and went forth to fill it with water . . . and being filled with trembling she went to her house and set down her pitcher, and took the purple and sat down upon her seat and drew out the thread.
>
> . . .
>
> Again on the third day, while she wrought the purple with her fingers, there came unto her a young man whose beauty could not be told. When Mary saw him she feared and trembled.
>
> . . .

But the Virgin, who had before been well acquainted with the countenance of angels, and to whom such light from heaven was no uncommon thing, was neither terrified with the vision of the angel, nor astonished at the greatness of the light, but only troubled about the angel's words, and began to consider what so extraordinary a salutation should mean, and what sort of end it would have.[2]

Of particular importance to us for the background of the announcement is Mary's work, for, as we remember, she was chosen to spin the purple: she "drew out the thread," as one might spin the yarn for the weaving of the tissue of a text. The story is spun in the differing colors and patterns of the varied annunciatory tableaux, which form in their turn a composite text.

Now in the annunciation as topos, two formal aspects are stressed: the narrative passage of the event heralded and the designation of the central figure in whom the future action is centered.[3] The implications for the poetic development are multiple: the announcement traditionally made by the herald and named once more by the poet predicts a future birth or an incarnation, but that announcement is, at least in the present reading, already responsible for a metaphoric action within the text: it is, in fact, the poem called "Annunciation to Mary."

READING THE ANNOUNCEMENT

Before the sixteenth century and the antipapal reaction in Northern Europe, and in all but one of the annunciations discussed here, the annunciation was usually meant to be read from left to right, often from lower left to upper right, from a kneeling angel to a standing Virgin, or one

[2] From the Latin *Pseudo-Matthew*, quoted in Elizabeth Dow, "Iconography of the Annunciation in the Early Christian period" (M.A. Thesis, New York University of Fine Arts, 1938).

[3] Now plainly the relation of Mary to Gabriel is of prime importance. Lucien Rudrauf, in his structural study of the annunciation, *L'Annonciation: Étude d'un thème plastique et de ses variations en peinture et en sculpture* (Paris: Grou-Radenez, 1943), points to this: "The theme of the annunciation, a subject with two characters different by their origins and their physical nature, because of the principles of polarity and dissymmetry which are of its essence, produces a division of the space into two unlike parts forming a contrast . . . between an open space and a closed, or at least limited space" (p. 26). It is this play of two forces and two spaces, and of two words toward the creation of the one Word that gives its interest to our text.
The Rilke poem would in all probability fit somewhere within Rudrauf's category of "compositions scandées" (strongly hierarchized in rhythm) and in the subdivision of a "composition axée," that is, organized around a group of figures as a pivot.

seated higher than the level of the angel, thus, in keeping with the cult of Mary who dominates the scene and is "the goal of the event."[4] This is the normal progression of the movement of the text, and the image of the annunciation has an inescapable parallel with narrative or enunciation itself, for the Virgin will give birth to the Word. Mary, chosen as the vessel, is found at the fountain and is therefore situated at the source. The words announced can be read or seen as the generation above all generations. Later on, as we know, one glorious assumption will be made.

When this message was originally conveyed, the annunciate as the receiver of the message could have accepted or rejected it, participated or not in its realization or Christ's incarnation.[5] In any case, she can certainly be said to have questioned its style and the manner in which it is made: "What sort of salutation is this?" In the exemplary text of Rilke to be examined here, itself the illustration of the series of pictures of the event, the action is indeed directed toward the future, and the reading here should have nothing of the passive or the past about it: not even "unto you is born" but rather "you shall bear." For the text of prediction to work itself out properly, then, and even now after the event, agreement must have been reached: Mary must have said yes, so that the melody might ring true, for both the angelic horn and the accepting vessel.[6] The

[4] Don Denny's The Annunciation from the Right (New York: Garland, 1977) resumes changes visible in the representations of the annunciations by the end of the fifteenth century: "These changes include the enclosure of Gabriel and the Annunciate together without intervening elements; an emphasis on Gabriel as a forceful figure, usually placed higher than the Annunciate; a corresponding placement of the Annunciate lower than Gabriel, in poses indicating humility, piety, and an open acceptance of the event, as contrasted with the somewhat withdrawn and mannered response which she had so frequently shown in earlier art; and the substitution of the Annunciation from the right for the Annunciation from the left" (p. 134); "the Annunciation from the right, a Northern type, is the opposite of the Quattrocento Annunciation, which is from the left, just as the two forms tend in opposite directions in most respects—so that, for example, the Northern annunciation tends toward an increasingly dominant Gabriel whereas the Quattrocento Annunciation tends toward an increasingly submissive Gabriel (as in Botticelli). The anti-Italian character of the Annunciation from the right cannot always have been absent from the understanding of Northern artists in this period when anti-papal feeling was widespread in the North, especially in France and Germany" (p. 146). Wayne Dines acquainted me with this work, an essential one.

[5] I am reminded by Walter Ong that in one version, the child is conceived by Mary first in the mind. The whole thing, furthermore, he says, is a matter of her saying Yes: thus a speech act at the beginning.

[6] In L'Espace du regard (Paris: Seuil, 1965), Jean Paris has examined, in a series of five annunciations, how the angel and the Virgin exchange glances, with various implications of domination and possession, of acceptance and questioning (pp. 201-203). He explains the importance of the theme and of the symbols tradition had fixed: "Each painter, thinking

very metapoetic nature of this passage holds us by the inexorable nature of the announcement, arresting like some final cry, as birth is given, now, to this poem.[7]

INSTRUMENTS AND INSTANCES

As a further reflection on instruments of arousal, on marks of dramatic separation, and on instances of raising and generation, or penetration and announcement of glad tidings, let me now sketch out a few proposals concerning Rilke's "Annunciation to Mary" and its interplay with some visual renderings.

The Rilke poem is not directly related to any one specific picture; we know that he was particularly attached to the Florentine painters,[8] and that among the annunciation images, one by Titian and one by Tintoretto, as well as a few included in the *Painter's Picture Book of Mount Athos* were of inspiration for the poems of this period and for the two poems of annunciation Rilke speaks of in his letters.[9]

afresh about their positioning, thus had to rethink his relationship with the divine" (p. 203). And Jean-Pierre Lyotard studies the pointing gesture as it is posited on seeing and is therefore mobile: "To designate is, to be sure, not to stare at something fixedly. The unmoving eye would not see, the pointing finger is that of the stone statue" (*Discours, Figures*, Paris: Klincksieck, 1974, p. 41).

[7] Louis Marin, in his *Sémiotique de la passion: topiques et figures* (Paris: Bibliothèque de Sciences religieuses, 1971), studies the performative utterances of the Gospels; see also the comments on this work by Richard Jacobson in his "L'Autre de l'Hautre," *Diacritics* (Summer, 1977), 35-43, concerning the second Isaiah: "So shall my word be that goeth forth out of my mouth: it shall not return unto me void, but it shall accomplish that which I please" (Isaiah 55:10 f.). Marin gives, in his "Puss-in-Boots: Power of signs—Signs of Power" (found in the same issue of *Diacritics*, pp. 54-63) what one might call a privileged example of Presence: "This is my body," in the ritual formula of the Eucharist. "This utterance raises the theological problem of a *power speech* in the sense that it transforms a thing into another thing . . . If there is a metaphor, it is an ontological one, the transference being operated within the thing itself by the speech act, by its force" (pp. 55-56).

In his *Études sémiologiques* (Paris: Klinckieck, 1971) a chapter on Port-Royal inspires Marin to meditate upon the extent to which the gesture of holding out the bread: "Hoc . . . pane," changes the wafer if it is already changed, and so on; it is surely one of the most subtle studies ever done on the subject. (Speech act theory as J. L. Austin works it out in *How to Do Things with Words*, Cambridge, Massachusetts: Harvard University Press, 1975, finds an interesting response in Barbara Johnson's on "Poetry and Performative Language," in *Yale French Studies*, no. 34, Mallarmé issue, 1977.)

[8] August Closs, "The Influence of Art on Rilke's Poetic Vision," *Acts of International Congress of Modern Languages and Literatures* (Florence: Valmartina, 1955), p. 525.

[9] In the letter of March 17, 1922 to Grafinin Sizzo-Noris Croug, Rilke comments: "Naturally it is not excluded in the slightest that the arts work into one another and upon each other, juxtaposed as they are." Much in the detail and arrangement "of this sequence of images" (of the Marienleben) "does not originate from my invention."

I shall mention a few only of the better-known pictures on this theme, and only from the perspective each takes on the specific interest here: the separation of the angel and Mary, for this is the walled surface, visible or invisible, through which barrier the poem must penetrate. As the type and number of architectural partitions differ in the various renderings, so the effect on the spectator alters, and the different yarns of the different texts are spun, although the result is the same. Whether the partitions are one or two, how the inside of the house of Mary is related to the outside and to the heaven-sent angel as to the heavens themselves, what marks the partition in its actual absence, and, more important, what agent passes the message or the announcement through the partitions, all these and other questions should be posed from the very outset; at least they concern the contemporary reader, exposed to multiple images on that topos, affected by the Rilke poem, and curious as to how a specific form of a poem carries through its own message, in its own line, for its own efficacy. The case is peculiar, since the poem is really the announcement of an engendering, a supreme speech act; had there been no follow-up to the tidings, that is, no miraculous birth, the poem as annunciation would have been untrue even as poetry, announcing a nonevent.

Before considering the poem itself, I should like to consider a few annunciations from a particularly dramatic point of view: that of the traditional and clearly-marked separation of the announcing angel and the annunciate, so marked indeed that its occasional infringement arouses the most intense surprise, and more than that, a veiled erotic charge. The tradition itself imposes a weight of artistic authority, the visual equivalent

Elsewhere, to H. Pongs, Rilke explains that he wrote some of these poems only to prevent Vogeler's illustrating his Mary poems in his guest book: "In order to prevent that and in order at least to supply him with better and more coherent texts, I wrote in a few days, consciously retracing my moods, these . . . insignificant poems." (Quoted in William L. Graff, *Rainer Maria Rilke: Creative Anguish of a Modern Poet*, Princeton: Princeton University Press, 1956, p. 274.)

Speaking of the relation of Rilke's poems to paintings, J. B. Leishman says, convincingly: "Many confident identifications have proved to be quite illusory, and more than once I have found myself trying to recall a painting which I believed I had seen somewhere, but which I was finally compelled to recognise as a painting which Rilke had led me to imagine. He has many painterly poems, but they were not inspired by particular paintings. As the result of much looking at paintings he had come to look at things in a painterly way" (in Rainer Maria Rilke, *New Poems*, tr. and ed. by J. B. Leishman, New York: New Directions, 1964, p. 6). The same point could be made about the point I am trying to make in this essay: that our looking, and Rilke's looking, at the images of separation in the annunciation renderings is responsible for a particular dynamic charge given to the separation and junction in the poem, all of which is more powerful for its force of understatement and implication, as opposed to a facile overstatement and explication, which would unfold the drama and not preserve it.

of the heavenly power play; what concerns me is exactly the artist's, and, in this case, the poet's conception or, more exactly still, how the event is conceived.

As there are, for instance, categories for the annunciation from the left or right, we might well group the types of annunciations by the sort of separating device, and the effect of the separation upon the scene, and the agent and manner of penetration through that separating device. The examination of a number of annunciatory tableaux gives rise to a number of recurrent questions and to one in particular. Given the objects or partitions that separate the figures—the wall or the lectern or the vase of lilies or the columns, whether of royal porphyry or some other material—given, that is, that the narrative unfolds in such an explicitly architectural setting in the great majority of visual renderings, what carries the force of the narrative or enunciatory flow from one side to the other, from Gabriel to Mary? And how is this paralleled in the verbal text of the poem? As for the agent of passage whose possibility was mentioned before, an angelic finger, or a scepter, like some cherub's dart, or a lily, or even a piercing look, may point across the boundaries. It is perhaps unnecessary to remark that the erotic but understated possibilities do not subtract from the religious intensity of Rilke's vision, but rather the contrary.

Let me start with an hypothesis about strongly-enforced structures: that when such structure is apparent in the architecture, the emotional impact on the viewer may well be less pronounced than is the case when the structure of separation is implicit and carried over from other texts, visual or verbal. If we compare for example, in the Simone Martini *Annunciation* (figure 43), the emphasis upon the centered figures and borders with their elaborate framing and separation to the architectural splendor of the annunciations of the Master of the Barberini Panels (figure 46) and Crivelli, it is the former that is likely to permit the observer's participation, or the viewer's share, like that beholder's share of which Gombrich speaks. But even so, the simplest and most literal description of a series of these presentations is the best way of entering the conceptual labyrinth or the labyrinth of conception that involves us in the text. A thorough discussion might range from the most separate—as separate as in Pontormo's separate platforms[10]—to the most intimate breakthrough, as in the final Tintoretto mentioned here.

[10] My thanks to Rosalind Krauss for drawing the Pontormo to my attention; Jan Van Eyck's *Annunciation* in the Thuyssen collection has the angel and the virgin standing within painted frames, each on a pedestal, inserted again in the wood frames of the diptych: these separations are clearly felt. When they are simply marked upon the floor, by a line or by an architectural barrier, the reading is no less clear for the observer of the distance. As a further

To clarify the positive and engendering value of the annunciatory obsession, we might take for contrast a negative image of annunciation such as Carpaccio's *Dream of Saint Ursula*. Carpaccio's annunciation here, as Michel Serres puts it,[11] is not really an annunciation, but a statement of a martyrdom instead of a birth: the images are intensely self-destructive, being the enunciation not of an act but of a refusal. The narrow-necked vase with the myrtle as the symbol of love, dedicated thus to Venus, is placed beside the open vase with the carnations, symbolizing, as well as Christ and the Virgin, the nails of the Crucifixion. The sky is empty, the cupboard opens on a black hollow, and the angel carries the palm of martyrdom or the triumph of chastity—thus the nails.[12] This dream of an annunciation effectively "resists the Annunciation," as Serres puts it, or can even be interpreted as an annunciation of death; and all space is seen as cut in two, even at the divided window joining heavenly space and earthly room. The other annunciations will appear in strong contrast to this one.

The Barberini and Crivelli annunciations have in common a strong slant to a left-arching opening, so that the structure does indeed dominate the figures; the Barberini master slants the line of vision even more strongly to the left by a median white line, leading through the vase with its flowery profusion and pointing at the lily held by the angel; the heavenly dove sends his rays down in a gold line toward the annunciate, herself standing in the line of the arches on the right, her head and halo fitting into the curve by implication, so that here even the architecture works in with the scene. Both renderings play on the open and the closed, the open arch and the joined buildings at the rear, and on the lines of reading. In the Crivelli as in the Barberini *Annunciation*, the building line in the foreground slants up toward the left, toward the arch as if preparing

example of the linear barrier, El Greco's *Annunciation* from the right, with its gigantic angel stepping from the cloud, is properly dramatic: the virgin shrinks.

Even in the Russian icons of, for instance, the sixteenth century, Mary will generally be inscribed within the line of one architectural construction, and the angel will not cross the reading of that line, but will hold the staff or the announcing emblem forward toward Mary, stretching across that uncrossable space—the actual dividing wall does not have to be marked, for it is present in the observer's imagination, by force of much seeing. Or then it does not matter.

[11] Michel Serres, *Esthétiques sur Carpaccio* (Paris: Hermann, 1975), pp. 103-105. (This is not, of course, the annunciation in the Ca d'Oro, but the bedroom scene with Saint Ursula.) In her master's thesis for the New York University School of Fine Arts (May, 1939), "The Icon of the Annunciation in Florentine painting in the Third Quarter of the XVᵉ," Gizella Firestone reminds us of Fra Filippo Lippi's *Annunciation of the Death of the Virgin*.

[12] The interpretation of the carnations as reminders of the nails of the Crucifixion is due to Victor Lange.

the line of the announcement, but this time a golden ray from heaven pierces through to the kneeling Mary, through the wall directly, so that the partition is penetrated. The elaborate and balanced construction contrasts the bustle of exterior business with the single figure in her inner sanctum; the connecting and yet separating window grill is paralleled by the contrast of angel without and woman within, as the peacock's worldly pride and ornamentation is opposed to the utter simplicity of Mary's face. The Titian *Annunciation* that seems to me closest to the Rilke poem (figure 50) shows the same piercing ray and the same simplicity of the annunciate (figure 52).

Still on the topic of separation, Piero della Francesco's *Annunciation* from the right sharply divides kneeling angel from standing Virgin, and the three arches and dividing columns form a scene in three acts to be read simultaneously, forcing the angel's gaze and the message to stretch across the terribly vacant middle opening; Tintoretto's *Annunciation* (figure 49) made across an empty inner arch can be seen parallel to this one, as the intense emptiness will be built up for the viewer, accumulated as it is through all these annunciatory preparations. The opening or the closing-off of the view is of similar importance with the contrasts of exterior and interior, of business and quiet: Masolino da Panicale (figure 44) places a column squarely in the center of the arch, between the angel and the Virgin, blocking the open door, whose own arch is echoed above three times, and whose circular form refers us—as in the Barberini *Annunciation*—to the duet of heads and halo as they fit into that circle, like another halo of an arch, another symbolic crown here studded with light. The viewer's look must pass through the column, but the crowded scene does not here cause the same vague anguish as in the empty centers of the Piero and Tintoretto renderings, with their obsessive vacuum, so strongly sensed in the Rilke poem. The arches are complicated, and are surrounded, like the Crivelli rendering, with complication; the drama of the spiritual encounter of the two central figures seems pre-empted by the sumptuous architectural design, which is the opposite case from the Rilke poem.

Now the partition may be only suggested: in the *Annunciation* of the Moulin Master (figure 47) the angel's pointing finger is first seen to be stressed by the response given to it in the Virgin's gesturing hand, and secondly, by the coincidence of the gesture with the corner of the arch and the room in one case, the edge of the door in the other. In this, as in Veronese's *Annunciation*, the bed has a prominent place, joined in the viewer's mind, perhaps, with the phallic force of the finger and the rays of the dove, all signals of the future event, but of course both Marys

turn away their visage from the bed, and the angels alone are in the same line with it. (An amusing trace of the bed, left by such images as Carpaccio's *Dream of Saint Ursula* and these two, is Magritte's *Annunciation*, a Surrealist rendering where only two bedposts are left to mark the event, or the nonevent.) The question of engendering is omnipresent, for the Veronese dove is pointed to by the angel's finger, as the source of heavenly conception, being the spirit who, in principle, does the deed. In the Moulin rendering (figure 47), the dove is just as present to Mary, but here the nonmeeting of the looks of angel and Annunciate gives an odd, oblique quality to the reading; the meeting and nonmeeting of the look figure importantly in the Rilke poem, as do the images of opening and closure, of public and private views.

Still on openings: among the most strongly marked are those Mannerist conceptions of Lotto and of Botticelli where the angels raise an arm and bend the opposite knee, in a curious balance, and where Mary retreats from the announcement; so will the Rilke Virgin shrink, in fear. The divisions are marked in the Lotto from sharp edges to the open arch with the Fatherly figure, this arch containing the angel's gesture upward toward the cloud supporting the Father, and containing also a stylized landscape of tree and column and sky. To the bed, once more, the Virginal back is turned, and on it, the curtains are drawn: this contrasts with the open arch, as if for private and public settings. Mary is raised on a platform, so that her fright is stressed, as she faces us; even the cat turns its head anxiously. The Titian Treviso *Annunciation* (figure 51) with the young angel shows just such an apprehensive Mary, shrinking from the message presented in a stagey fashion, with the lurking figure as yet another observer watching us watching her. The checkered squares divide angel from annunciate: Lucien Rudrauf, in his extensive studies of the placement of the figures in the annunciations, remarks that in this painting the angel would be superimposed upon the kneeling Mary were it not for the artificial perspective, created by the squares of the scene.

The Botticelli Virgin shrinks with the same complicated advance and retreat as Titian's own *Noli me tangere* (figure 19) referred to in the essay on the Baroque and Mannerist gesture and is more complicated even than the famous Correggio *Noli me tangere* (figure 20). And in Botticelli's opening too, tree and river and castle form a tidy landscape in an exact pattern, like the porch seen between the room and the exterior, the edge of the door opening exactly coincident with the angel's right hand which is thereby stressed, while the median line of the squared floor draws our attention to the lily held by the angel for Mary, this lily echoed by the treetop beyond, the flower by the vegetation. The stem of this lily, as in

the Rossetti *Annunciation* (figure 48)[13] may be thought of as the agent of conception, and the open door, as the penetration of consciousness. Consciousness itself, the heart of the matter, takes many forms in these readings: light, as in the dove or the heavenly ray passing through a wall, in Filippo Lippi (figure 45) for example, and also in Tintoretto's great *Annunciation*, the partial source for our poem. Or sometimes a scepter held out points to the conceiving thought as indeed an angel's finger often does, in an arousing signal.

Two of the more interesting and pointed cases of pointing gestures are those of Poussin, for his angels point both up and at Mary. In his *Annunciation* in the Musée Condé at Chantilly, the angel points at the heavenly group, while pointing also at Mary, like a statement doubly stressed: this is the cause, this the vessel, below. This painting, represented here (figure 53), sets in subtle play the images of verticality and horizontality, of architectural mass and openings, light and dark, of heavenly gestures and human response. The lines of the floor tiles serve not only as perspectival markings, but—for the present observer—as a reminder of the traditional separation between the figures. The slight transgression of the line by the corner of background material serves as an earthly respondent to the heavenly crowd of figures and the dove, weighing portentously over the scene, literally surveying it in all its potential drama. The light outside the window corresponds in the same opposing and stressing way to the dark through the door so that the observer's attention is drawn from one to the other, and the movement seems to pass through the space in which the attention-demanding gesture occurs. The flowers at the height of the triangular mass formed by the kneeling virgin answer the tiny blossoms in the cherub's hand at the height of the heavenly triangle, as her open book catches the light from above and responds to the open window, vertical now joined to horizontal, heavenly frame to earthly. The mass at the left, descending but celestial, is nevertheless given its light by the space behind the window,

[13] Ruskin's defense of the modern simplicity of Rossetti's *Annunciation* serves to emphasize the complicated and full tradition; as he describes the simple girl awakened in a simple bed, upright in her robe of white—no elaborate blue with gold border and no elaborate garment for the angel either, who comes barefoot—the gravity and the modesty of the announcement stands out. In my reading of this canvas, the shock is utter, that of the lily's pointing, that of the angel's holding it out toward Mary upon the bed, and the line in its direction signaling the future event. Ruskin stresses the fact that this heavenly messenger has no wings: I would stress the fact that the observer is plunged directly into the announcement by the gesture and the lack of ornament with the only line of separation remaining in the corner, as if to mark the tradition. Indeed the simplicity increases the emotional effect, within and without. See John Ruskin, "The Three Colours of Pre-Raphaelitism," in *Sesame and Lilies* (London: George Allen, 1899), pp. 317, 321-322.

while the mass at the right, from which it remains separated, is earthly but called upward. The harmony is as surely architectural as it is thematic and figural.

In the National Gallery of London, the other Poussin *Annunciation* (figure 54) shows the same double signal, horizontal and vertical, and here the separation is so slight as to bear out the truth sensed in the Rilke poem: Mary, her eyes closed, accepts the force we are inclined to see here as generating: behold, reads the announcement, thus accomplished by its very saying and pointing out.

The variation even of the traditional imagery is great: the lily is, for example, an agent of separation in many renderings where the base of lilies divides the floor space between angel and annunciate. But as the Mary-device, when it is the agent of pointing or designating, and thus, in the view expressed here, of penetrating, it is turned against herself: in the Rossetti *Annunciation* (figure 48) the aggressive, close lily, held by Gabriel seems to point its way directly toward her womb. And here, were we not acquainted with myriad forms of the annunciation and their divisions, we might not recognize the edge of that partition, and its reduction to a standing rectangle in the lower right of the canvas would simply not be readable. It is this sharply pointed agent or instrument of the holy transgression of the barrier to which I wish to compare the last note of the Rilke poem, for it is above all a poem of encounter.

Surprising Song

The final element to be stressed besides the separations and the consciousness of penetration, and pointing at that penetration, is surprise, the extreme of which is the alarm and shrinking from the announcement visible in the Treviso Titian. A further and striking example of the tradition carried on until now is Alberto Savinio's gigantic angel head looming in the window for yet another annunciation from the right, to surprise the drowsing Virgin with her animal head: the window frame serves the same purpose as the door edges and the sharp lines of the architecture in Renaissance versions of the image, dividing sharply outside from in, so that the eventual penetration may be all the more imbued with fright, for the annunciate and, by extension, the reader of the announced text. As background for the Rilke poem, particular consideration has to be given to both the Titian announcement already discussed with the young angel rushing from the right and Mary's retreating figure, and the Tintoretto *Annunciation* in Berlin (figure 49) whose open arch and closed garden are pointed to by the median line and the angel's finger. The Rilke scene has its own corresponding rapid and slow pace, its open and closed

figures, its pointing, its fright, and its drama, and of all the annunciations preparing our perception, the Titian is perhaps the most relevant in our context. The median line sharply divides the scene, leading, like a pointing finger—this deictic stress sharpens the scene—up toward the middle of the garden in its own enclosed opening, like a natural equivalent of the Mary figure. The arch divides the space and separates the figures, while the eye is led beyond them to a higher significance, upward. Both Virgin and angel are turned toward it, and the angel, pointing this time at the door, seems to regard his own finger, as he carries the lily as upright as the column, the marker of the space eventually to be transgressed. The separation is sharp, but no less so the possibility of crossing, and the Virgin clutches her heart in a way that may remind the reader of Saint Teresa's own anguish and pleasure; she also looks away, and downward, as if lost in self-reflection. The space to be crossed is great, and the chosen instrument, signaled here twice, as if the angel were pointing to the pointer itself and bearing its analogue, all the more revelatory by being Mary's own flower.

This scene conveys most of the feelings of the Rilke poem as it is structured: the frightening transgression of the private place, the infraction of the visual and mental rule of closure; the tension between heavenly apparition and earthly presence of the quite human Mary could scarcely be more vivid. But the Rilke poem combines the qualities of the different visual representations, and we must bring to it all our experience of partitioning and opening, of violation and infraction, both literary and visual, throughout the entire preparation of our annunciatory readings.

The lesson learned from them can be stated now quite briefly: parallel to the strongly-marked architectural or literary constraining divisions, formal and grammatical, and the implicit attention focussed precisely on their transgression, the visible attitudes of the announcement which is already its own enforcement read like a heavenly power play sure to succeed. The responding attitudes of meek acceptance or shrinking terror may produce an understated but quite sensible erotic tension in the text, that is, the "beholder's share" of the engendering excitement. The following analysis is meant to answer, partially, a single question and its own double meaning and reception, a double-entendre in the fullest sense: how is the poem conceived?

MARIÄE VERKÜNDIGUNG

Nicht dass ein Engel eintrat (das erkenn),
erschreckte sie. So wenig andre, wenn
ein Sonnenstrahl oder der Mond bei Nacht

in ihrem Zimmer sich zu schaffen macht,
auffahren—, pflegte sie an der Gestalt,
in der ein Engel ging, sich zu entrüsten;
sie ahnte kaum, dass dieser Aufenthalt
mühsam für Engel ist. (O wenn wir wüssten,
wie rein sie war. Hat eine Hirschkuh nicht,
die, liegend, einmal sie im Wald eräugte,
sich so in sie versehn, dass sich in ihr,
ganz ohne Paarigen, das Einhorn zeugte,
das Tier aus Licht, das reine Tier—.)
Nicht, dass er eintrat, aber dass er dicht,
der Engel, eines Jünglings Angesicht
so zu ihr neigte; dass sein Blick und der
mit dem sie aufsah, so zusammenschlugen
als wäre draussen plötzlich alles leer
und, was Millionen schauten, trieben, trugen,
hineingedrängt in sie: nur sie und er;
Schaun und Geschautes, Aug und Augenweide
sonst nirgends als an dieser Stelle—: sieh,
dieses erschreckt. Und sie erschraken beide.

Dann sang der Engel seine Melodie.

ANNUNCIATION TO MARY

Not that an angel entered (know this)
was she frightened. As little as others,
when a ray of sun or the moon at night
busies itself about their room,
was she bothered at the shape
in which an angel went; she scarcely
gathered that this sojourn
is toilsome for angels. (Oh if we knew
how pure she was. Did not a hind, that
once, recumbent, espied her in the wood,
so lose itself in looking, that in it,
quite without pairing, the unicorn begot
itself, creature made of light, pure creature—.)
Not that he entered, but that he bent,
the angel, a visage of a youth
so near to her, that his gaze and the one
with which she looked up so struck together,
that space outside seemed suddenly quite empty

as if what millions saw, did, bore,
were crowded into her: only herself and him;
seeing and what is seen, eye and eye's delight
nowhere else save in this space—; see,
this frightens. And they were frightened both.

Then the angel sang his melody.[14]

The initial entrance is singularly negative: "not that the angel en-
tered," later repeated, as if the partitions within the paintings were to be
echoed here, like so many acts of the act of the word. Mary does not
fear, either, the end that only we are privileged to know, for the angel
(as we have seen) tells her nothing of the future death, only of the birth:
yet reading of Mary's surprise at the beginning of a new word and of her
troubled wondering, we may already remember the end. The divisions
of scenes in the long first stanza may represent for us other divisions:
annunciation, evangelization, crucifixion, as if this projected Christian
drama were a condensation of the future within past history, a sort of
mise-en-abyme. Although the reader's knowledge is brought to bear, the
poem is also its own self-announcement, as a poem and a promise, made
not just for or to Mary but for us, as it will engender its own fruition, and
the event.

From the low-key and quiet beginning, negative and oblique: "Nicht
dass . . . ," the tension builds up to the final dominant melody in a single
line. The stress on our knowing and hearing, the initial call for our
attention is placed between parentheses: ("das erkenn"), as the threshold
or the limen of the annunciatory text already announcing itself as prelim-
inary to another future entrance, the birth of this poem-in-process parallel
to the religious event. If this act of birth, literary and religious, is con-
sidered as a rite of passage, the post-liminary act would include the
integration of the Word and the world.

As a theatrical presentation, the poem has three acts and an epilogue,
or then four acts, depending on the interpretation of the drama within
the text. "Not that . . . " begins the first act, and also the third, resembling
in that the text from the Protoevangelion already quoted. The second act
is a shorter one, another parenthetical interruption to respond to the first
announcement; these two parentheses form the background for the rest.

[14] Translation thanks to suggestions by Dorrit Cohn, Victor Lange, and Allen McCormick,
here gratefully acknowledged (for the penultimate line, one reading suggests not "And they
were frightened both," but "And both of these frighten her," both the act of seeing and
what is seen). The angel's inclusion in the fright, or exclusion from it, might form as
interesting a topic of debate as the relative positioning of Mary and her visitor, and for
reasons much the same.

Here, in the second act, the two principal characters, Mary and the angel, are mirrored by another cast. Mary and a hind become involved with generation in their very purity: the unicorn is, as we know and as we see in the *Unicorn Tapestries*, attracted, trapped, and loved by the Virgin and has generative and regenerative power even as he is captured.[15] The parentheses may suggest, furthermore, the circular fence within which he is to be found, like the imprisoning and nuptial "ring" in the Cluny cycle, which René Char calls "L'Anneau de la licorne" (The Ring of the Unicorn), in a poem to which I have already referred.

The third act, an evident response to the first line, is placed in a subtle formal parallel to the second act, for the "nicht dass," itself enclosed in a circular setting by its formal rhyme ("Nicht dass . . . aber dass er dicht") thus mirrors the parenthetical ring about the unicorn, his horn serving as a sceptre, or a finger, or an angel's dart, making its first appearance as the implied agent of the announcement. As the reader sees, the Virgin, the subject and center of this reading, sees too, and is afraid. At last the one-line epilogue or the fourth act refers back to that second parenthetical act, erotic yet virginal, as it alters the significance of the rest of the passage.

The negative entrance—coinciding with the *limen* of the poem— "not that . . . was she frightened," opens up some questions one might have chosen to leave implicit: "Then why?" or "What is the terrible fascination of this angel?" The terrible angels of the *Duino Elegies*, whose outline only can be invoked here, call for the same verb used in three forms in the poem: "erschreckte/erschreckt/erschraken" (was she frightened/this frightens/they were frightened both): the angel is, in both senses, fearful. The text struggles, in a sense, as does Mary, against its own annunciatory angel chosen by Rilke as the most poetic of opponents. And indeed Rilke's conception of a "blind" angel looking into himself might yield a key to this picture, completely directed toward an inner announcement.

Mary's fear, first stated quite simply and with no explanation ("erschreckte sie") will then make its way to the penultimate line of the drama-as-poem. The unicorn in a forest or a garden, as in the Cluny tapestry, forms a fitting background for Mary's own enclosure and isolation in her garden, whose boundary will then be penetrated for the engendering. Effectively, the circle of protection isolates angel and Virgin from all other until there are only two: "nur sie und er" (only she and he), the receiver of the text and its messenger.

[15] Elsewhere, Rilke pictures the unicorn as existing because of the possibility that "it might exist": it is thus the perfect agent for such an understated annunciation, all in the nuances of the possible, where nothing is explicit and everything implicit

In the annunciations generally pictured the architectural separations or the psychological distance or difference of levels prevent this feeling of intimacy: only the poem conveys it by the look as it is stressed to which our look as readers in turn responds. Seeing and seen, "Schaun und Geschautes," like the text and the vision, the eye and eye's pleasure; the intensity and extreme focusing of the scene are terrible and nevertheless common to all readings:

> . . . sieh,
> dieses erschreckt. Und sie erschraken beide.
> . . . look,
> this frightens, And they were frightened both.

See, says the poet, and the terrible and wonderful sight is also the beholder's.[16] We were asked before to pay our fullest attention to the passage, and to understand it: "das erkenn" (know this); now we are asked to see what is the point of the poem. Both figures are frightened now, by the terrible beauty of the act predicted and accomplished, in all purity. The announcement will engender, as in the parenthesis, "quite without pairing," an unparalleled act.

We can scarcely avoid a thought of Saint Teresa and the cherub's dart, either as Bernini pictures her, or then in the Seghers painting to which Crashaw's "Hymn to Saint Teresa" probably refers (figure 11).[17] Johannes Tauier, a pupil of Eckhart, comments thus on Mary's "State of ravishment":

> The Very Holy Virgin in her sincere humility having understood this mystery was alarmed. . . . Then suddenly the Very Holy Trinity entered her and illuminated her with a lasting and resplendent brightness. A divine ray, or rather a flaming shaft of divine love, penetrated her inmost being, and humbly, lovingly she consented to be the mother of the Son of God. . . . Mary . . . was troubled because of the majesty of that salutation and also because of the state of ravishment in which she was discovered.[18]

[16] In his reading of the "Die Erwachsene" in *The Unmediated Vision: an Interpretation of Wordsworth, Hopkins, Rilke and Valéry* (New Haven: Yale, 1954). He speaks of this call to sight: "The 'Sieh' which is most frequent in Rilke imitates a sign whose locus and significance are neither in sight nor in sound taken individually: behold! is the essential gesture of what Rilke calls 'things' ('Dings'). . . . For this 'behold!' is no more than an insufficient hieroglyph to suggest the call and summoning of all creation" (p. 74).

[17] Gerhard Seghers' *Saint Teresa in Ecstasy* is to be found in Antwerp; it is probably, says Louis Martz, the painting on which Crashaw's "Hymn to the Name of St. Teresa" is based, since Bernini's statue is posterior in date to the poem. (See note 17 for Chapter 3.)

[18] From the translation of E. P. Noel, *Oeuvres complètes de Jean Tauler*, Paris, V, pp. 86 f. Quoted in Denny, *The Annunciation from the Right*, p. 141.

And her answer to the shaft of love that is the piercing and generative brightness (like the shaft of light in Titian's *Annunciation* from the Scuola di San Rocco, figure 50), makes a proper ending for the act of speech, accepted: "Let it be done unto me according to His word." The terrible emptiness outside, abruptly made visible, as the surrounding world suddenly is seen as vacant, prepares the action in all the fullness of time and of interior space. For the hour is ripe, and the sentence crowds, with the vision, into the space of Mary's enclosed garden. The language now tumbles upon itself in a monosyllabic rush of a triple verb—a trinitarian invasion of a single privacy—just as so many individuals are made into a crowd of millions, so that what they "saw, did, bore, were crowded into her." Pregnant then with multitudes and given the center of the poetic stage by monosyllabic stress, Mary finds herself part of a pair, in a double isolation; in a formal parallel, she is separated by the punctuation, from the crowd. The eye's delight, and the mind's own de-lighting here are made up also of the subtle play of massing and emptying, of obscurity and mystery interspersed with clarity, of the antagonisms and pairings thrusting toward the unique place ("nowhere else save in this space") where we are called upon to see, and perhaps, to understand, what is announced.

The intimacy of the moment when the angel has made his entrance explains, or at least gives a proper setting to, the sharp line of the trumpet or the horn like the unicorn's, the metaphoric (and phallic) finger of the messenger, which, like an angelic dart or pointer, singles out, designates, announces, and finally enacts. This is represented by the one concluding line where the "Melodie" rhymes only, and paradoxically, with the "Sieh," identifying and stressing for one instant, the encounter of hearing and sight, poem and picture, what the reader has heard and what he glimpses anew. But, of course, the whole story is not told here: we know the end and read backwards into time and legend and even now, into the poem. The announcement made in the final moment—whether its unique melodic line is heard or observed, beyond or within the text—penetrates the vessel of Mary's consciousness, but also retrospectively the poem-as-vessel, the poem whose Mary this is.

Indeed, the space outside this spectacle that we are privileged to witness may appear "suddenly empty" around the figures whose double gaze provokes the melody in its sharp visual and verbal stab, the fertile enunciation necessary for such a poetic birth. The poem itself is engendered by the scene of the encounter: this is the point of the annunciation, which the reader, like Mary, can scarcely miss.

PART III

HOMAGE TO MALLARMÉ

8

BRANCUSI AND MALLARMÉ, OR, ABOUT AN EGG

Le livre, expansion totale de la lettre doit d'elle tirer,
directement, une mobilité.

The book, a total expansion of the letter, must draw
from it, directly, mobility.

—Stéphane Mallarmé, *Quant au livre*

TWO OF BRANCUSI'S OWN REMARKS lead me to a brief discussion of a topic
that would daunt the more knowing. The first I shall take straight, as it
were; the second, reversed. The first indicates that the space of the work
itself is not meant to be closed off, so that some is different from other:
"In art, there are no outsiders."[1] The second I must take from its other
side: "High polish is a necessity which relatively absolute forms demand
of certain materials." Since the style of this essay aims at no absolute,
since its materials are but carefully chosen fragments, it demands no high
polish and would in fact refuse it as inappropriate. Ideally, its nature
might reveal itself little by little as a would-be aesthetic object: "A work
of art," said Brancusi, "should be like a well-planned crime" (S, p. 153).

Two sets of materials, textual and visual, may eventually converge
within a particular perspective; whether or not this convergent perspective
can be successfully shared, whether it will or will not reveal a "hidden
dimension," it is at least to be hoped that the implicit conviction of this
convergence on the inside will excuse the necessary exterior ellipsis.
Brancusi's forms themselves were intended to guide the observer toward
an inner meaning, the necessity he sensed, intended to participate in an
ordering progressively more interior and increasingly meditative. The
setting for his final project—the Temple of Love for the Maharajah of
Indore with its private meditation chamber containing a "mirror of square
water" as a pool, toward which stairs ascend, its only opening furnishing
a skylight for illumination—bears an ideal resemblance to the setting of
Mallarmé's *Igitur*. The stairs, the isolated chamber, and a tomb—all per-
fect in the Hamletian manner; what would have been the natural sky is

[1] All Brancusi citations are taken from Sidney Geist, *Brancusi: A Study of Sculpture* (New
York, Grossman, 1968). Hereafter cited as S.

reduced to a square of light, as is the ocean to a square pool, and the landscape to "shining walls" ("tout était luisant et propre"). Here, no roughness where some spidery traces of "suspicion" might lodge; instead, the smoothness of a "well-planned crime," without the slightest rough-ness to mar Brancusi's shining surface, not the least trace of sin or spot. This is Mallarmé's surface too: "What was clear," says Mallarmé, was that this sojourn "matched itself perfectly," that "it was the place of perfect certainty."[2] And later, "Everything had returned to its primary order: There was no more doubt possible" (MI, p. 60). There is neither doubt nor suspicion nor exterior trace. This inner and necessary order reminds us of Brancusi's compatriot, Papa-Dada or Tzara-Dada, whose poetics are based on just such orderings.

As for the high artistic polish, in both visions—that of the poet and that of the sculptor—it is intimately related to the interior mystery, in an extraordinary dialogue such as that between the two luminous walls of Mallarmé and the two gaps of massive shadow that work as the negating force in *Igitur*. To read Mallarmé's description is to experience the disquiet of complete architectural exactitude, quite as if one were reading one of Robbe-Grillet's descriptions but still in the spirit of Brancusi's well-planned crime, with no holes or slips: it is to be remembered, here in the highly charged but completely silent drama of *Igitur*, that we are still in the "place of perfect certainty."

> L'ombre n'entendit dans ce lieu d'autre bruit qu'un battement régulier qu'elle reconnut être celui de son propre coeur: elle le reconnut, et, gênée de la certitude parfaite de soi, elle tenta d'y échapper, et de rentrer en elle, en son opacité: mais par laquelle des deux trouées passer? dans les deux s'enfonçaient des ap-paritions, bien que différentes. (MI, p. 59)

> In this place the shadow heard no other sound than a regular beating which it recognized as that of its own heart: recognized it and, bothered by its own perfect certainty, tried to escape it, to return into its own opacity: but through which of the two gaps to pass? in both there plunged divisions corresponding to the infinite of the apparitions, although different.

Both gaps contain a view in depth of two different apparitions—already the play of the opposites "apparition" and "disparition" has composed a prelude to this opposing of walls shining and opaque, of light and shadow. These divisions, however, correspond "à l'infini," and the *mise-*

[2] Stéphane Mallarmé, *Igitur, Divagations, Un Coup de dés* (Paris: Poésie/Gallimard, 1977), p. 59. Hereafter cited as MI.

en-abyme or plunging view in its endless mirroring and doubling provokes a dizzying view. Just as in Robbe-Grillet's *La Jalousie*, the vertiginously detailed description is forced into hardness by the narrator's mind, in order to avoid the penetrating ubiquity of his jealous sentiment, itself as deforming as the slats of the Venetian blinds that effectively blind the ordinary vision, so in *Igitur* the partial and complex view taken by the shadow is eventually that of the tomb, its shutters noiselessly opened on what Brancusi might call another well-planned crime. The tomb's atmosphere in turn will determine such expressions in the Mallarmé text as "escape" and "doubt," as well as the image of the loudly-beating heart itself, at least by the reader placed to observe the silent opening of the tomb doors, since the secrets the tomb holds for the dead are mysteriously implicit in the secrets held by the heart for the living:

> . . . [the shadow] looked once more at the room, which seemed identical to itself, except that the gleam of brightness was reflected in the lower polished and dust-free surface, while in the other surface, vaguer in appearance, there was an escape of light. The shadow decided for the latter opening and was satisfied. The sound it heard was again distinct and exactly the same as before, indicating the same progression. (MI, p. 60)

This sound is eventually understood as that of a bird escaping, although the silence that fits the light "solitary and pure" is equalled in the reader's mind by the whiteness of Mallarmé's famous page of purity, across which no wing or pen—no "plume" in either sense—should move. Nevertheless, some minimal signs might remain behind, like the barest traces of past motion, the hieroglyphs of the dance[3] to which Mallarmé refers and with them as the cornerstones, "a place is instituted" (MI, p. 202). And among them one might well find two sculptures of Brancusi as the signs that most closely correspond to the writing investigated here: the ovoid shape of *Beginning of the World* (figures 55 and 56) and the vertical streak that forms the bird refined in its later stages in *Bird in Space* (figure 22) and includes with its feathers both wing and pen.

Even such an extreme and deliberate limitation has its text: "Simplicity is not an end in art, but we arrive at simplicity in spite of ourselves as we approach the real sense of things." The essential form Brancusi sought might well be the objective of our perception. About his *Bird in Space*, Brancusi said: "I seek the essence of flight," and continued, in a Mallarméan vein, "They are fools who call my work abstract. What they think abstract is the most realistic, because what is real is not the

[3] Like the ballet of the plumed pen across the page.

outer form, but the idea, the essence of things." His description of the sculpture *Fish* explains exactly this sense of the "realistic": it is a matter not of scales and fins and eyes, he says, all of which are irrelevant to our conception of "its speed, its floating, flashing body, seen through water." Were the sculptor to depict the details visible on the exterior, such as those just mentioned, he "would arrest its movement and hold you by a pattern, or a shape of reality. I want just the flash of its spirit."[4] It is obvious that the present essay depends on inwardness and intuition, on one reader's and one viewer's own way of seeing, on quotations verbal and visual as they are interpreted within a system of perception and consciousness, both private and shared. In this passage, Brancusi's streak or the flash of spirited light and flight leaves its definite trace, the terms and images appropriate to a mind given to metaphorizing. Now that bird in space had, in its progressive evolutions over the years, been greatly simplified: the first bird had a separate demarcation for the neck, to emphasize the thrust forward for flying, whereas the flight is finally absorbed within the bird itself. At last, nothing could be permitted that was not directed toward the interior, and it is for that conception and for its figures that Brancusi is here placed beside Mallarmé, the only poet who could ever have done him justice. Everything was a search for form, and for essential form (S, pp. 179, 180).

And precisely, with interiority and simplification comes increased significance and real dimension: in the Brunner Gallery in 1953 there was exhibited a "project of Bird which, when enlarged, will fill the sky" (S, p. 172). No small ambition: the flight's own concerned interiority gives it the needed intensity, in brief, what we call its poetry, always defined as an interior direction and an interior drama.[5]

A parallel increase in dimensions makes itself felt in another project of architectural significance, phrased in the same terms: "a project of columns which, when enlarged, will support the arch of the firmament."[6] The ambition, *demesurée* or exaggerated by any ordinary means of measuring, approaches that of Mallarmé's *Livre*: for neither creator is there a stopping point or a discontinuous line. Brancusi insists: "I think a true form ought to suggest infinity; the surfaces ought to look as though they went on forever, as though they proceeded out from the mass into some perfect and complete existence" (B, p. 21).

The means toward this end are double: first, the stripping down to

[4] Malvina Hoffman, *Sculpture Inside and Out* (New York: Norton, 1939), p. 52.

[5] On the notion of theater at the center of poetry, see my *Inner Theater of Recent French Poetry* (Princeton: Princeton University Press, 1972).

[6] Athena Tacha Spear, *Brancusi's Birds* (New York: New York University Press, 1969), p. 29. Hereafter cited as B.

bare essentials, to the glory of polished stone or marble, as for the *Bird in Space*—never to be made of wood, since the material must be "difficult," itself of an ideal hardness. The noblest struggle is engaged against the noblest matter: thus, stone, marble, bronze, or gold, as in the egg shape of the *Beginning of the World*. Mallarmé's midnight, "Le Minuit" against whose backdrop Igitur moves, is revealed in the "absolute present" of the infinite space of the essential thing, identical to that in which the creatures of Brancusi's imagination are supposed to extend. Midnight itself, darkly resounding and empty, finds its own opposite in the brightness of constellations and their reflections in the sea. The setting, as if for a jewel, stresses vacancy, absence, and uselessness:

> Certainement subsiste une présence de Minuit. L'heure n'a pas disparu par un miroir, ne s'est pas enfouie en tentures, évoquant un ameublement par sa vacante sonorité. Je me rappelle que son or allait feindre en l'absence un joyau nul de rêverie, riche et inutile survivance, sinon que sur la complexité marine et stellaire d'une orfevrerie se lisait le hasard infini des conjonctions. (MI, p. 45)

> Certainly there is still a presence of Midnight. The hour has not disappeared through a mirror, has not been buried in draperies, evoking a furnishing by its vacant sonority. I remember that its gold was about to feign, in absence, a null jewel of reverie, a rich and useless survival, except that over the marine and stellar complexity of a goldsmith's was the infinite chance of conjunctions to be read.

In a perfect and melodramatic initial description of midnight, where the two extremes of black and bright clash in what the Baroques would have called a "dazzling darkness" the stress is clearly laid on the golden syllable and its transformations: "*heure . . . sonorité . . . son or . . . orfèvrerie*" (my italics). As the "*orfèvrerie*" is already a phonetic reminder of the "rêverie," the working of the gold in the "joyau nul" unites the two concepts as the "orfèvrerie" unites sea and star ("marine" and "stellaire"). So the Mallarméan construction of a richly useless monument might take the shape of Brancusi's golden orb or a streak, as they form the gleaming punctuations of a sentence, its miraculous discontinuity and yet its juncture, since periods and apostrophes, the two forms recalled, serve both to link and to separate letters and thoughts playing thus the same role as the conjunctions mentioned here in their "infinite chance." Here these shared constructions, themselves the conjunctions between Mallarmé and Brancusi, between language and sculpture, find jointly their complex and enduring survival.

For the poet, words alone do not show the wearing down by the "misfortune of incarnation" as Bonnefoy puts it in his masterful preface to the prose works. Words, he says, speaking of Mallarmé, "can give us back the earth, that earth took from us."[7] The bare simplicity of the highly polished language from which all detail is removed, shows us, as in the sonnet of the swan, "the region . . . where we might live." This region is the place for the alchemical and poetic transformation of midnight into gold, and absence into presence, and of tomb into page. So the streak of the bird's flight, which I am likening to the letter's stroke (the *trait de plume*, by extension) now encounters the egg of origin, the point at the sentence's end, paradoxically entitled *Beginning of the World*.

As the walls in *Igitur* reflect, radiant and obscure like sky and sea, the contraries summon each other even in the titles; the golden or marble orb or the ovoid is now the first cry of an infant, at the beginning of the word and world, now again Prometheus or a sleeping muse, and the cycle is thus complete, from birth to dream, beginning to closure. Or a sculpture for the blind, to be held on the lap, with closed eyes: we notice the links between the concepts, as in Brancusi's description combining the cycle of forms from birth to death: "I put my curiosity of the unknowable into it—an egg where little cubes seethe, a human skull" (S, p. 57). The traditional *vanitas* is thus renewed by the reader's curiosity about the beginning and the end. So the skull is linked with the egg in a dialectical inner conversation, like one more interior flight taken from the origin. In a flash of fancy more than of flight, although those two streaks might themselves converge, we return to the idea of the page. As the shape of the orb or the egg is identified also with the period in a dialectical opposition, and that of Brancusi's *Sleeping Muse* with his world's beginning, so the streak serves as an apostrophe joining two separate elements, like a bridge; this punctuation in turn itself bridges literature and art.

We know that Brancusi worried over the form of his pedestals for the bird in flight and therefore over the joining of art to reality, of the pedestal to the floor, or of the bird to the floor where the viewer stands. When he placed a bronze ovoid on a polished disk, he saw to it that its own reflection repeated its form: it even repeats our own, deforming our image if we choose to bend over it, as a reader bends over a text. Of these reflective surfaces, Brancusi said: "I do not care what they reflect so long as it is life itself" (S, p. 26). The reflection is also a subtle invitation to the convergent as well as to the cyclical, a reminder that birth is only

[7] Yves Bonnefoy, ed. *Mallarmé* (Paris: *Poésie*/Gallimard, 1976), p. 9.

the reflection of death and vice versa as the still surface reflects movement.[8]

Even the point of the toe of Mallarmé's observed dancer-as-hieroglyph joins this reflection on punctuation, on origin, and on ending. Mallarmé's complex aesthetics call for similar reflection and imply similar convergence within a chosen circularity from conception to realization of the page as an art object in its own space. Brancusi's sleeping muse, then, keeps watch over the beginning of the world and the skull, over the rhetoric as over vision, over the page as over the flight. . .

BRANCUSI'S WORK, like his aphorisms, denies age: he once said of his heads, "I would rather make them and be wrong than make the Venus de Milo and be right, for she has been done. And she is unendurably old." His art, through its very circularity, does not age but rather takes an interior flight: "There still hasn't been any art," he said in 1927, "art is just beginning" (S, p. 180).

In the end, only one unfinished sculpture was found in Brancusi's studio: that of still another bird in space. Here the text reflects on its earlier problem, like a mirror held up to the egg of beginning, like any self-reflective discourse on convergence, where the reflection, however streamlined, does not depend entirely on exterior polish: "I am no longer of this world; I am far from myself, detached from my body. I am among essential things," he said (S, p. 178). And, in response: "He can advance," Mallarmé might have added here, as he did in *Igitur*, "because he goes forward into mystery" (MI, p. 64).

Brancusi summed up his life's work in a comment on his bird's upward flight through space: "Like everything I've done, it struggles bitterly to rise skyward" (S, p. 35). At the point when the high polish given to the essential surface of the streak is equated with the interior

[8] Rosalind Krauss comments on the difference in kind "between the reflections that will register in the lower portion of the form and those that will form upon its upper half. Fraught with distorted patterns of light and dark reflected from the space of the room in which the object is seen, the smooth shape of the top half is contorted by myriad and changing visual incidents. The lower portion, on the other hand, simply reflects the underlying disk, and this reflection has the smooth uninterrupted flow of a gradual extinction of light. Where the object touches base with the disk, the reflection it receives is the shadow of its own nether side cast back onto its surface, as if by capillary action." Contrasting the rounded curve of the underside to the flattening of the upper surface and the kinesthetic quality created, she remarks that sculpture "calls for us to acknowledge the specific way in which matter inserts itself into the world" (pp. 86-87), whereas, of the *Bird in Space*, she signals the "gestures that themselves express a moment in which the self is formed" (p. 99). From her *Passages* (London: Thames and Hudson, 1977).

mystery of the egg, the descending steps of Igitur toward the tomb can be seen to rise, as they must be imagined also, about to rise toward some ephemeral presence. At this point too Mallarmé's entire *Igitur*, in the magnificent obscurity of its setting, can be seen as the "excessive escape from brightness," sensed as "the trace of the bird, the propagation of whose flight had seemed to him continuous" (M, p. 62). Brancusi's *Bird in Space* (figure 22) unhampered finally in its noble soaring, like a streak of light, converges with the mysteriously bright beating of wings of Igitur's own infinitely imagined creature, that nameless and therefore universal bird pared down until it is motion itself, "sa fuite indéfinie" (MI, p. 48), its indefinite flight and fleeing here pointing, like that statue of Mercury, only to its own stroke.

All his life Brancusi tried to seize the essence of flight: it is toward this essential movement upward as a pure sign that his work, like Mallarmé's, directs, into the infinite interior, the flash of its absolute flight.

9

·······························

DADA'S TEMPER, OUR TEXT:
KNIGHTS OF THE DOUBLE SELF

> What for the other literature used to be the *characteristic*,
> is today *temperament*. . . . It's only natural for the old
> not to perceive that a type of new man is being created
> almost everywhere. I think the intensity is the same all
> over, with insignificant variations in race, and if any
> quality is to be found in common among those who are
> creating literature today, it is that of antipsychology.
> —Tzara, "Open Letter to Jacques Rivière" in *Lampisteries*

THIS TEXT takes its starting point in the Dada temperament and in what it
perceives, as well as the way in which it perceives it, moving from the
double and two-way images of Duchamp and Tzara to an apparently
closed door, in reality open.[1] The Dada temperament is opposed to
closure of all sorts.

From "M. Antipyrine" to "M.AA l'Antiphilosophe," from "M.Anti-
psychologue" to "M.Antitête" the antis have it: anti-aspirin, but also anti-
head and anti-the-workings-of-the-head, philosophical and psychologi-
cal: Tzara's approximate man, savage or not, will have none of the noble
confessional about him. His self-portraiture is ironic and a put-down: he
stutters: "Aa," or then "da-da," and he is given to odd stylistics, half-
repetitions, ruptures, and incompletions: "Je me, en décomposant l'horreur,
très tard" (Tz, 2:293; I myself, decomposing horror, very late), or, dis-
guising his disorder in the reassuring cliché style of a proverb, even more
offputting: "Quand le loup ne craint pas la feuille je me langueur" (Tz,
2:293; When the wolf does not fear the leaf I langor me). Tzara will write
later about the "Automatism of Taste" and is, at the time of "M. AA
l'anti-philosophe," preparing a one-up on *haute couture*, which is to say,
an *haute coupure*, cutting and shaking up the elements in some hat or
other, making a cutting for a transplant and a sample—a "Treatise on
Language," in fact, but the fact is hidden within the body of the "Sluice-
gates of Thought," a brief manifesto in the *Antitête* about the "roundness

[1] Tristan Tzara, *Oeuvres complètes*, ed. Henri Béhar, vol. 1:1912-1924, vol. 2: 1925-
1933 (Paris: Flammarion, 1975 and 1977), 1:409. Hereafter cited as Tz.

of my half-language." About this language, we had scarcely to be told
that it was "invertebrate." The intensity of the temper already stressed
may be antipsychological, but there is clearly no question of forgetting
the mental mechanism or what contains it. Tzara's incompleted novel
is called *Faites vos jeux* (Place Your Bets) and the play does begin here,
but in the head. The last four chapters are entitled "The Surprise Head,"
"The Tentacle Head," "The Head at the Prow," and, as a resumé, "Tête
à Tête." The collection begins with the expression: "le coeur dans le
coeur" (the heart in the heart) and ends not with a heart-to-heart chat
but a head-to-head summary: this self-portrait is based on an intellectual
self-mockery.

Now Dada is a self-regarding movement in moving opposition to its
own image and self-image. That there should be a paradox of this kind
available is all to the good, for, as we know, Dada and Surrealism flourish
on the juxtaposition of contraries: yes and no meeting on streetcorners
"like grasshoppers," according to Tzara, and, for Breton, the meeting of
high and low, birth and death, absence and presence. Take, for instance,
Tzara's "Static poem" (which transforms the words into individuals:
"from the four letters 'bois' there appear the forest with the fronds of its
trees, the forest-keepers' uniforms and the wild boar; perhaps also a
Pension Bellevue or Bella Vista" (Tz, 1:726). Now whatever lovely view
there is is enhanced by its own opposition, cheerfully and vigorously
stated: "Long live Dadaism in words and images! Long live the world's
Dadaist events! To be against this manifesto means to be a Dadaist" (Tz,
1:358). Self-regarding and self-negating, keeping its humor good, Dada
keeps it well.

As for the regard of self, one of the most instructive texts "signed
by" Rrose Sélavy, herself already the imagined female double of Du-
champ as we know, was supposedly written in German by a girlfriend
of Man Ray and translated into English, therein entitled, sardonically
"Men before the Mirror." The text in this table-turning description is
cruel, as one might expect: Rrose Sélavy's adopted text is not directed
at a mirrored man, standing for all men, but at men, less general, more
sex-specific:

> Many a time the mirror imprisons them and holds them firmly.
> Fascinated they stand in front. They are absorbed, separated
> from reality and alone with their dearest vice, vanity. . . . There
> they stand and stare at the landscape which is themselves, the
> mountains of their noses, the humps and folds of their shoulders,
> hands and skin, to which the years have already so accustomed
> them that they no longer know how they evolved; and the

multiple primeval forests of their hair. They meditate, they are content, they try to take themselves in as a whole.[2]

Already, of course, a woman writing about these men as they are mirrored—whereas in art the woman is usually mirrored—is retracing the gesture of the one and the other, herself and them, in opposition and in fascination; to complicate things further, a woman writer writes of Marcel Duchamp playing Rrose Sélavy playing at being a German girl playing at watching men watching themselves. The self-regarding game is right up Dada's alley, but only the sensitive reader will be bowled over by a direct hit: "The mirror looks at them. They collect themselves. Carefully, as if tying a cravat, they compose their features" (MS, pp. 195-196). The very act of looking as it is seen by the other her or himself creating that self in the act of its own self-regard and self-creation occupies the center of the fascinated gaze.

Since it is Duchamp who reminds us that "It is the OBSERVERS who make the pictures" (MS, p. 173), it is scarcely necessary to point out a certain possible supersensitivity in the reaction of the female eye to some particularly aggressive images such as, for instance, the famous Mona Lisa inscribed by Duchamp to make a sort of Lady Lisa in hot pants ("L.H.O.O.Q." which is an abbreviation for "Elle a chaud au cul," or she has a hot seat).

As to this self-regarding self, it is rarely at ease: we remember the reflective despair of Jacques Rigaut already quoted: "I consider my most disgraceful trait to be a pitiful disposition: the impossibility of losing sight of myself as I act. . . . I have never lost consciousness."[3] Dada, that ambivalent, bisexual, two-headed delight, contemplates its own visage in some of Ribemont-Dessaignes' artichauds, hot spots for art, or really hot plates, keeping them available on the burner, like a réchaud, to heat and reheat, looking and not looking, in one temper now, and now another: "Dada, o Dada, what a face! so sad as all that? so merry? Look at yourself in the mirror. No, no, don't look at yourself."[4]

Full of doubt, even as to the writing, the narrator of Faites vos jeux laments his inability to step outside the self, or to judge himself more independently. That alone:

[2] Marcel Duchamp, Marchand du sel: Ecrits de Marcel Duchamp, ed. Michel Sanouillet (Paris: Le Terrain Vague, 1958), p. 95 (hereafter cited as MS): the text signed "Rrose Sélavy," the name of Marcel Duchamp's double, himself—like his text—in drag.

[3] Jacques Rigaut, Écrits, ed. Martin Kay (Paris: Gallimard, 1970), p. 113.

[4] Georges Ribement-Dessaignes, Dada: manifestes, poèmes, articles, projets (1915-1930), ed. Jean-Pierre Bégot (Paris: Projectoires/Champ Libre, 1974), pp. 15-19, for this and the following quotation.

is sufficient for me to detest myself, for me to despise my egoism.
I am lacking a distance between the characters and the events
they give rise to. My criticism is not objective. My readers will
never be able to follow me. (Tz, 1:284)

What is this but a contemplation in the mirror of his own writing? That
the woman in the text should be called "Mania," a sort of transformation
of a "manie" or obsession predicting Breton's own *Nadja*, whose ob-
sessed vision inspires our reading of Breton, is not without its own ob-
sessive interest. The entire text of the unentire novel is based on the
substitution and the repetition of self and other, and on the fatigue of the
reflective game, no matter how fascinating:

Although visibly false, this adventure excited me to such a de-
gree (doubt had already substituted another self for my own)
that I left to see her. . . . But distance had already withered my
passion. For the first time I felt fatigue and boredom inhibiting
the flow of my speech. . . . We, the knights of the double-
self. (Tz, 1:290)

This double self, here pictured as tragic, is referred to in an early
passage of *L'Anti-tête* (The Antihead) as a sort of Rimbaldian parody,
without the tragedy:

Je m'appelle maintenant tu.
Je suis meublée et maison de Paris.
. . .
Maison de Paris, je suis très belle.
Bien imprimée.
. . .
Monsieur Aa l'antiphilosophe Je-Tu tue, affirme de
plus en plus que, sans ailes, sans dada, il est comme
il est, que voulez-vous . . . (Tz, 1:399)

I am now called you.
I am furnished and a Parisian house.
. . .
A Parisian house, I am very lovely.
Well printed.

Mr. Aa the antiphilosopher I-You yous, kills,
affirms more and more that, without wings.
without her, without Dada, he is as he is,
What can I tell you . . .

And yet the knight of the double countenance here leads the game, just as Tzara did in his early role of circus-tamer. "De mes maux qu'on m'a fait subir" says the narrator of *Faites vos jeux* (Place Your Bets) which reads: "Of the sufferings I have had to undergo/ I am the elegant inspirer"—or then, and I believe we should read it both ways: "Of my words I am the elegant lover," for that animateur, returning to us the "animal" with the "anima," is also an "amateur" (Tz, 1:284).

Amateur, chiefly, of the word and the eye: Ribemont-Dessaignes' "oeil verbe" or "eye word" in the strong sense of that world-creating word: it is on that globe, assuredly, that we should keep our eye. "Sous je," reads one of his titles, literally "Under I," if I may be allowed to profit from the English word play. The spirit of Dada includes plays in all senses and in the most slippery ones, including the game's denial as its own mirror image. Witness Ribemont-Dessaignes' *Manifeste avec Huile* (Manifest with Oil), a text at play at not-playing.

> Dada is no longer a game. There is no longer a game anywhere.
> . . . There is one moment of the game when you play at not playing, and when it ends badly. That moment is now.
>
> The street must be sad in your eyes when you go out into it. And there must be no more consolation for you in the pit of your stomach. . . . But DADA knows choreography and the way to use it. . . . For you have to love me right through the cancer of your heart, through the heart-cancer that I shall have given you.

Aragon's *Le Paysan de Paris* (The Peasant of Paris) is also a spreader of this other sort of social disease in the passages of Paris, the vertiginous poison and poisonous vertigo of "that vice," as he called Surrealism, destructive to the middle-aged mind. But Dada's choreography, subtle and unsubtle, is really supervisual, and metaphysical, superirritating, and superb, as well as upsetting. Tzara's repeated sounds that are to start the listener yelling, as Marinetti's did, put the reader's nerves also on end:

> car il y a des zigzags sur son âme et beaucoup de rrrrrrrrrrrrr
> ici le lecteur commence à crier (Tz, 1:87)

> for there are zigzags on his soul and plenty of rrrrrrrrrrrrr
> here the reader begins to scream

Verbal aggression, then, and visual too—the *rrr* on the page are irritating to the eye as they would be to the ear. The whole matter turns about the self-contemplation of the reader in the text as it frames the vision, self-conscious in its own exacerbation.

Tzara is in particular the poet of self-consciousness, of the man masked, and perpetually ambivalent, of the tragic hero, mirrored in his double role as narrator and actor. The main questions raised by this game of double perception are those of identity, of mask, and of approximate relation: Tzara's approximate man, who "laughs face on and weeps behind" (Tz, 2:102), as touching as he is brilliant—a mirror of the poem itself—confesses his doubts facing others, or on that place of passage that is the stair:

> tu es en face des autres un autre que toi-même
> sur l'escalier des vagues comptant de chaque regard la trame
> dépareillées hallucinations sans voix qui te ressemblent
> les boutiques de bric-à-brac qui te ressemblent
> que tu cristallises autour de ta pluvieuse vocation—où tu
> decouvres des parcelles de toi-même
> à chaque tournant de rue tu te changes en un autre toi-même
>
> facing others you are another than yourself
> judging on the staircase of waves the texture of each look
> dissimilar voiceless hallucinations that resemble you
> that you crystallize around your rainy calling—where you find
> portions of yourself
> at each turn of the road you change into another self.[5]

In the realm of the stair, the crossroads, or the circus ring, the page, or the game, around the window or the table, upon the canvas or in the mirror of a large glass and a Great Work, be it alchemical labor, epic poem, or lyric life, the animator of the circus leaves his mark on every passage, which is to say, at every threshold of perception and passion:

> mais que la porte s'ouvre enfin comme la première page
> d'un livre
> ta chambre pleine d'indomptables d'amoureuses coincidences
> tristes ou gaies
> je couperai en tranches le long filet du regard fixe
> et chaque parole sera un envoûtement pour l'oeil et de
> page en page
> mes doigts connaîtront la flore de ton corps et de page en
> page
> de ta nuit la secrète étude s'éclaircira et de page en page
> les ailes de ta parole me seront éventails et de page en page

[5] Translation from Mary Ann Caws, *Approximate Man and other Writings of Tristan Tzara* (Detroit: Wayne State University Press, 1973), p. 53. Hereafter cited as AM.

des éventails pour chasser la nuit de ta figure et de page
 en page
ta cargaison de paroles au large sera ma guérison et du
 page en page
les années diminueront vers l'impalpable souffle que la tombe
 aspire déjà.

but let the door open at last like the first page of a book
your room full of unconquerable loving coincidences
 sad or gay
I shall slice the long net of the fixed gaze
and each word will be a spell for the eye and from
 page to page
my fingers will know the flora of your body and from page to
 page
the secret study of your night will be illumined and from page
 to page
the wings of your word will be fans to me and from page to
 page
fans to chase the night from your face and from page to page
your cargo of words at sea will be my cure and from page to
 page
the years will diminish toward the impalpable breath
 that the bomb already draws in. (AM, p. 155)

These pages of Tzara, themselves sufficient as a landscape, indicate the truest temper of Dada, and our truest text of that movement. That the "page" should be so plainly part of, and such an essential part of the "paysage" and that they should both be part of the "passage" as it is part of them, is an unmistakable truth identical to itself, in whatever mirror we might choose to see ourselves and our text: "De vastes paysages s'étendent en moi sans étonnement" (Tz, 1:349; Vast landscapes stretch out in me without astonishment), says Tzara in L'Antitête. Toward these interior landscapes Duchamp also directed himself, his thought, and his surest contemplation and art: "My aim was turning inward, rather than toward externals" (MS, p. 11); "Dada was a metaphysical attitude." Thus the closed door of his Etant donnés (Given . . . ; figure 36), the great door of the given, as we might phrase it, imposes a frame on the eyes of the beholder, forced into the position of peeping-tom or peeping-reader, his view necessarily concentrated through the small holes pierced, upon the parts exhibited. It is itself an art related to the whole and raises the questions of identity, of perception and of passion—this door is the

perfect example of what opens on an inner landscape and what frames a privileged inner seen.

Let us end our own scene here by a metaphysical paradox: what most hides is most revealing. Artaud's paradoxical description of a state outside ordinary life that we could see as equivalent to the Dada temper should be taken as sign and as sight, a reminder of the text as a liminal state for threshold experience, of the viewer as a passenger in Dada's rite of passage. "There are no words to designate it but a vehement hieroglyph designating the impossible encounter of matter and of spirit. A kind of vision inside" (Ar, p. 202). Here that quotation also may be left as incomplete, as our own architexture is ideally incomplete, its passage left forever open to the reader.[6]

[6] For the term "architexture," already used in the introduction, see my "Vers une architexture du poème surréaliste," in *Ethique et Esthétique de la littérature francaise du XXe siècle,* ed. Cagnon (Stanford: Stanford University Press, 1978), pp. 59-68.

MALLARMÉ AND DUCHAMP: MIRROR, STAIR, AND GAMING TABLE

Figure que nul n'est . . .

(Figure who no one is . . .)

—Stéphane Mallarmé, "Richard Wagner"

INTO THE MIRROR—fascinating to all the spirits whom we imagine as seated about the gaming table of the self, like Tzara's "chevaliers du double-moi" in his aptly-titled but incomplete novel, *Faites vos jeux* (Place Your Bets) of 1923—is born that "Figure que nul n'est" (figure who no one is). Or then, the expression can be reread as "que nul naît" (figure like which no one is born). If Tzara as "*M. Antipyrine*," and "*M.AA l'Antiphilosophe*," and in short, "*L'Antitête*" itself ("et tant d'autres et tant d'autres") avows himself approximate, if Marcel Duchamp posing as Rrose Sélavy was not just posing in drag, but temporarily taken into another personality altogether, not just mirrored and pictured but also signing the text (as when she is said, by Robert Desnos, to be dictating), are these not metaphysical attitudes as well and as surely as surface attitudinizing?

Duchamp, who maintains a will to the minimal physicality of painting ("Reduce reduce reduce was my thought—but at the same time my aim was turning inward, rather than to externals"),[1] who refuses retinal or surface ease in favor of metaphysical and conceptual difficulty, can never be said to concentrate on the costume or the stance more than on the essential intellectual substance that is the self doubled and thereby understood. And thus when he refers back to the poet who is at the beginning of many contemporary texts, the reference can be taken in the strongest sense and with a wide range: "Mallarmé was a great figure. This is the direction in which art should turn: to an intellectual expression, rather than to an animal expression" (MS, p. 114). Mallarmé not just as Stéphane but as Rrose Sélavy; Hérodiade, to be sure, but Hamlet also,

[1] Marcel Duchamp, *Marchand du sel: Écrits de Marcel Duchamp*, ed. Michel Sanouillet (Paris: Le Terrain Vague, 1958), p. 111. Hereafter cited as MS.

and Saint John the Precursor,[2] Igitur, and Pierrot as well. Narcissus takes on many forms.

Before the mirror, Hérodiade casts a cold yet ardent eye upon her own beauty, herself perhaps the precursor of Duchamp's *Bride surrounded by her Bachelors, even*. Like some other sacred, presumably virginal bride, some traditional rendering of a group in a *conversazione* with the Virgin at the center giving oral birth to multiple subjects, this Bride makes way for several trains of thought. "Ainsi ce dégagement multiple autour d'une nudité" (Thus this multiple disengagement about a bareness)[3] reads a line of Mallarmé. The *mise-à-nu* of any bride before or in any glass and by any hands—Octavio Paz points out the likeness with a *mise-à-mort*[4]—is bound to engage and disengage bonds of all sorts. "Voilà l'aveu de mon vice, *mis à nu*. . . . cela me possède" (Here

[2] In the *Noces d'Hérodiade*, ed. Gardner Davies (Paris: Gallimard, 1962), including the pages left from the unfinished Hérodiade that was to have been Mallarmé's masterpiece. Hereafter cited as NH. Here Saint John is called the Precursor; elsewhere, Mallarmé speaks of "ma mission de Précurseur." I am grateful to Joan Dayan for drawing my attention to this volume.

[3] Stéphane Mallarmé, *Oeuvres* (Paris: Edition Pléiade, 1945), p. 309. Hereafter cited as M.

[4] In his study of Duchamp (*Marcel Duchamp, or the Castle of Purity*, New York: Cape Goliard/Grossman, 1970), Octavio Paz compares Igitur to the Nu as the nude descends the staircase and the game of dice to the chance figures of Duchamp. See Wallace Fowlie's "Igitur: Mallarmé as Hamlet" (*Mallarmé*, Chicago: University of Chicago Press, 1953), pp. 105-118: Hamlet will return. Bettina Knapp's "Igitur" in the Mallarmé issue of *Yale French Studies*, no. 54 (1977), pp. 188-214, and Julia Kristéva's Mallarmé in her *Révolution du langage poétique* (Paris: Seuil, 1976) form two more highly differentiated aspects of the figure: what could be more appropriate for a "figure que nul n'est?" André Breton's study of Duchamp's Bride "Phare de la mariée" (*Le Minotaure*, 6, 1939) is unsurpassed as a brilliant example of double reflection. John Golding in his study *Marcel Duchamp: The Bride Stripped Bare by her Bachelors, Even* (New York: Viking, 1972), says of this bride: "she recognizes herself as the true descendent of Flaubert's *Salammbo*, of Villers de l'Isle Adam's *Axel*, and his *Eve future*, or Mallarmé's *Hérodiade* and perhaps more immediately of Laforgue's *Salomé*" (p. 53). Moreover, in the case—somewhat more trivial, if that is a criterion acceptable in this context—in the case of a mirror, or in the mirror as it supports the case, Magritte's nuptial suitcase called *The Chariot of the Virgin* might indeed remind us of some bride disrobed by her bachelors, even, as her garments travel on the strength of her mirror and the forms, whether naked or robed, implicit there. The implied spectacle is the implied cause of her "Invitation au voyage"; her invitation to a bridal trip: she is, it would seem, some looker.

In a recent article for *Enclitic* (no. 3, Univ. of Minnesota, 1978), Carol James examines the play between inside and out in the *Large Glass*, where the dust collected on the outside of the sieves is sealed in by means of varnish on the back of the glass, and the way in which Derrida's own *Glas* (Paris: Galilée, 1974) becomes a new large glass, in which "a nineteenth-century bachelor" (Hegel) faces a twentieth-century "bride" (Genêt); an endless text "bears witness to the complexity of marriages of difference," p. 80. See also her article, "Marcel Duchamp, Naturalized American" (*The French Review*, 49, no. 6, May, 1976).

is the avowal of my vice *laid bare*. . . . it possesses me), Mallarmé says also.[5] And this naked avowal of whatever vice and whatever possession is beyond our control—ours also, as the observers of the act—means searching forever for the source of that other *Mariée mise à nu*, after Baudelaire's own heart: "mon coeur mis à nu" (my heart laid bare). But by whatever process the bride is stripped bare, through whatever verbal or constructive (rather than painterly) tricks, the game goes far past the "physique amusante" (the amusing physics) of Duchamp's notes for his *Large Glass*. The game and the intricate notes—a language that may well, as Duchamp points out, be appropriate only for that one construction— reminds us of Mallarmé's Book worked at and out, of those *feuillets* found and forever incomplete.[6] Duchamp's search for prime words (divisible only by themselves and by unity) may remind the reader of the celebrated attitude of Mallarmé's line, as he longs for the prime and untouched and must recreate them: "Rendre un sens plus pur aux mots de la tribu" (To give a purer sense to the words of the tribe). As for the pure and its rituals, I have already spoken of the rites of passage, connected with other virginal senses of the word and the work, and especially visible in threshold markers and situations: stair, and window, corridor, and door.

Contemplating Marcel Duchamp's *Stoppages-étalon*, those strings or "stoppages" stopped, pasted as they fall, we might wish to trace those lines back to that original throw of the dice and those haunting constellations of the page and the mind. "*Briefly*," said Mallarmé, and no one is briefer, "*in an act where chance is in play, chance accomplishes its own Idea in affirming or negating itself*" (M, p. 441). For Igitur, Mallarmé's player at chance or that other Hamlet—in his white lace ruff (*dentelles*) where the "dent" or tooth of conscience, some "agenbite of inwit" separates thinking head from black-costumed body—stands contemplating his mirror, at once obliged to stare at his figure so as not to doubt himself, yet wishing himself away: "the purity of the mirror will be established, without this personnage, this vision of myself" (M, p. 439). We might trace our steps back to Igitur and his mirror, perceiving the Dada temperament in a time before and as through some large glass, not too darkly. We might then perceive that a predecessor of the Duchampian delay in glass, that *retard en verre*, had already caught the observer before, in another "vers" or verse, another image mirrored in another page. In that empty Mallarméan mirror, horribly void and "frozen in its cold," we find not just the page, but the other lake where the other swan is caught: from this Baroque image, as of a living water changed to ice by its *ennui*,

[5] My underlining and my supposition.

[6] Jean-Jacques Schérer, *Le Livre de Mallarmé: premières recherches sur des documents inédits* (Paris: Gallimard, 1957).

Igitur's inopportune face will disappear, and yet we see it replayed in the drama of Hérodiade in her staring purity, her most sensual virginity self-exposed and self-wounding. "The Cornet," we read in *Igitur*, "is the Horn of the unicorn" (M, p. 441), and just so, from that shake of the dice in the single horn, the play on which Duchamp based his own Great Work, there arise these two figures now before our gaze, Hamlet's black *"latent lord who cannot become"* (M, p. 300) and his own female double called Hérodiade, each taking shape before the mirror of Mallarmé, surrounded as we know by the figures of unicorns, those most ambiguous beasts. For the unicorn, captured only by the virgin, wounds his captor: the balm lies only in the powder from that horn. The "fraise arachnéenne" (spidery ruff) itself, like the rose at the base of a stag's antler, makes the horn the transposing element here effective by way of the unicorn, in the passage from Duchamp's Virgin to his Bride.

And does not the severed head of John the Baptist, the Precursor for Mallarmé, lying on its platter, correspond to the severed head of Igitur, distanced and displaced by the white ruff? Or to the strangulation of the poet himself? The transforming and temperamental look works a metamorphosis in each mind, best demonstrated by Mallarmé, himself the truest precursor, changing as he did the *fiole de verre*, that poison vial of glass, into a vile poison of the verse, that other "vers" where Valéry will stress yet another "ver" or worm to eat at the entire body of literature and thought. As Mallarmé changed this "fiole" into "folie" (flask into madness), Igitur's *Folie* becomes the reader's, like some androgynous Virgin of the serpentine Passage, the proud vessel that bears on to Breton's passionate vision of forever communicating vessels and of a mad Nadja whose clairvoyance we would share: Nadja as reader of the modern text. Nadja passes, then, through Duchamp's door as if it were in fact a "porte battante," swinging from closure to openness, or beating like the pulse of a heart at the center of perception, Nadja as perfect spectator for the *Large Glass*, which can be looked through or at or in, Nadja, in short, reflected in the opaque mirror of Hérodiade in her pallor. Her nuptials in the *Noces d'Hériodiade* might have prepared Nadja's equivalent entry into the asylum. The mirroring device puts, in fact, things as they may be: this Hamlet/Hérodiade "mis(e)-à-nu(e)" like Mallarmé's own "vice, mis à nu," is exposed, exhibited, and extraordinary. The extraordinary scene seeks its passage.

Of all the ceremonies of passage celebrated in modern French literature, the closest approximations of Duchamp's *Passage from the Virgin to the Bride* are the bridal ceremonies of Hérodiade, annotated and incomplete even for the *Large Glass*, itself never completed. Both might be called, as Mallarmé called *Les Noces d'Hérodiade*, "un rite de l'Idée"

(a ritual of the idea). Both, under the false appearance of the present moment, refer to moments beyond themselves, and to a time outside the time of viewing, like our definition of the poem as a place of passage, we should note that the Noces have their setting in a "lieu nul" (a nul place) and that the dance performed is immobile. In both these Great Works we read the partial against the potential, the fragment against the whole it might have been, held as we are by that possibility unrealized: "Croyez," said the note Mallarmé left for his wife and daughter about the Noces, "que ce devait être très beau" (Believe me, this was to have been very beautiful).[7] The specific gaps in the Mallarmé text may correspond, in the reader's mind, to the empty spaces in the Duchamp Large Glass, for what was to have been set therein and was not. The unrealization seems particularly appropriate for these two sets of nuptials here compared, whose passage to the marriage presumably desired is never perfectly realized in an "effective action," but remains at the level of the idea. Thus the bridal rites are placed under the sign of the hypothetical that initiates the text:

Si . . .

. . .

Triomphalement et péremptoirement si (NH, pp. 55-56)

If Hamlet is in his act and his being only potential "ce seigneur latent qui ne peut devenir" (MI, p. 187, my italics; this latent lord who cannot become), so Saint John the Baptist is here "le seigneur clandestin," the clandestine lord whose look or whose act is hidden from our eyes. As the personality of Saint John—Mallarmé's last figure, as he says—is severed from its trunk, his head "d'un personnage dont la pensée n'a pas conscience de lui-même . . . séparé de son personnage par une fraise arachnéenne et qui ne se connaît pas (NH, p. 17; of a character whose thought is not conscious of itself . . . separated from its character by a spidery ruff and which does not know itself), thus appears quite like Igitur's Hamlet ruff dividing thought from action, and in the other, the glass is divided, as if to stop the action between the virgin and the "Malic moulds" of the male process. All these suitors for the act are improbable characters for a true nuptial feast: they do in fact not suit, being saints on the one hand and, on the other, bachelors (even).

Nor does Hérodiade give undue importance to the completion of the act: "Elle s'arrête au seuil solitaires noces" (NH, p. 82; She stops on the threshold solitary nuptials). The noces are therefore neither completed nor communal; they are only virtual. The virgin dancer is marked with

[7] In the introduction to the Noces d'Hérodiade, ed. Davies.

ambiguity in each step, her dance and its reflection being held in a terrible mirror's frozen water from which all trace of the natural is absent, visited neither by living nor by literary creature, neither by "plume" nor by wing, for there remain only the "trous d'aile" (NH, p. 143; holes of the wing):

> Pas de feuillage! l'eau fatale se résigne,
> Que ne visite plus la plume ni le cygne
> Inoubliable: l'eau reflète l'abandon (NH, p. 144)

> No foliage! the fatal water is resigned,
> No longer visited by feather or unforgettable
> Swan: the water reflects desertion

Compare Laforgue's lament on stagnant waters surrounding Hamlet's tower:

> O pauvre anse stagnante! Les flotilles des
> cygnes royaux à l'oeil narquois n'y font
> guère escale. Du fond vaseux de paquets d'herbages,
> là, montent, aux pluvieux crépuscules,
> vers la fenêtre de ce prince si humain, les choeurs
> antiques de crapauds. . . .

> O pauvre anse stagnante! Crapauds chez eux . . .
> c'est pourquoi (sauf orages) ce coin d'eau
> est bien le miroir de l'infortuné prince Hamlet. . . .[8]

> Oh poor stagnant bay! The flotillas of royal
> swans with mocking eye scarcely halt there.
> From the glassy bottom with its dumps of weeds
> there rise, to the rainy twilights,
> toward the window of this so human prince,
> the ancient choirs of frogs. . . .

> Oh poor stagnant bay! Frogs at home . . .
> that is why (except for storms) this bit of water
> is just the mirror for the unhappy prince Hamlet. . . .

[8] Jules Laforgue, "Hamlet," in *Moralités Légendaires* (published in *La Vogue*, Nov. 15, 1886), reprinted (Paris: Gallimard, 1977), pp. 23-24. Claudel's comments on Igitur/Hamlet illuminate these interconnected figures: "Le suprême Hamlet au sommet de sa tour, succédant à deux générations d'engloutis, tandis que l'inexorable nuit au dehors fait de lui pour toujours un *homme d'intérieur*, s'aperçoit . . . qu'il est enfermé dans une prison de signes" (The supreme Hamlet at the top of his tower, succeeding two generations of people swallowed up, while the inexorable night outside makes of him forever an *inside man*, perceives that he is surrounded only by objects whose function is to signify that he is enclosed in a prison of signs); from Paul Claudel, "La Catastrophe d'Igitur," *Oeuvres en prose* (Paris: Ed. Pleiade, 1965), p. 510.

Transfixed by tedium, the glass reflects a place of action nullified, so that Hérodiade is the ballerina's polar opposite, devoid of both *plume* and *pointe* and projection:

> une sorte de danse,
> effrayante esquissé
> —et sur place, sans
> bouger
> —lieu nul (NH, p. 114)

> a sort of dance
> sketched out frightful
> —and in one place,
> motionless
> —non place

All the action takes place inside, as it were, within some Large Glass like some game of chess with no spectators, or some private throw of the dice:

> seul monologue
> éclat intérieur (NH, p. 118)

> only monologue
> interior flash

If the ambiguity of the dance paralyzes exterior action, the interior scene is no less ambivalent: the *glaive* or sword, like that "petite épée" of Laforgue's Hamlet described here, is vain since here it has been used to the wrong end and under the sign of a double transfer: first to a female desire for the death of the other rather than a masculine procreative impulse and then used as ordered by another, rather than by the virgin herself. As the sword is in vain, turned here against its proper use, so too is Hérodiade's sheath (an item of costume, but also the proper sheath, presumably, for Saint John's potential sword). The sheath is nullified, as the virgin stands only at the threshold of the rites, in utter solitude, therefore prepared for the dance—not that of Salomé and the seven veils— but before the lonely mirror reflecting, like herself, the firmament all in vain:

> La fiancée adorable et funeste
> Dans sa gaine debout nulle de firmament (NH, pp. 82-83)

> Fiancée adorable and fatal
> In her slip standing void of firmament

And yet the surrogate action of the sword provokes a brief and fecund flash, so that the murderous action, presumably negative, nevertheless serves as agent for the passage from virgin to bride:

le glaive qui trancha ta tête a déchiré mon voile

. . .

Tu me possèdes. . . (NH, p. 136)

The sword which sliced off your head has torn my veil

. . .

You possess me. . . .

Now instead of the writing of stars against sky, black ink against snow or frozen lake, or feather pen on its balancing point against stage, the blood of the severed head held against the thighs of the virgin writes its red history in the present of the poem.[9]

In the following lines—a remarkable trinity of condensation—we have the prefiguration of the inside/out motion of Surrealism and of later poetry, a downward passage and plunge where the erotic and the brutal are joined in a supremely terrible and convulsive beauty, a murderous deflowering and a semiotic flowering:

Le signe de ton meurtre a
 fleuri
 à l'envers (NH, p. 133)

The sign of your murder
 has flowered
 on the wrong side

Now the poem suffices for the depiction of the act, like the virgin glass as it becomes the page: by every gesture traced therein, the word wounds and also fecundates both actress and onlooker or spectator or reader. "Ces mots—rigides comme une epée—ils le furent" (NH, p. 28; These words—rigid as a sword—that they were).

In one of Mallarmé's more extraordinary pages of notes for the Hérodiade, the "passage" takes on its full sense, including the sense of Duchamp's later passage through his own glass and also through Hérodiade's mirror; it includes the reader in the nuptial rite, now acknowledged even as it is (although incompletely) refused—for it has already taken place:

[9] The oxymoronic link—the terrible delight, the fiendish flash, the union of purity and danger in the unicorn—is typically Baroque.

passant
dont le sort se mêla
à tout cela entre nous
 s'est passé quelque chose

Ma voix
s'adresse à quiconque
passa non loin de moi
. . . (NH, p. 129)

passerby
whose fate mingled
in all that between us
 something happened

My voice
is addressed to whomever
passed by not far from me

And later:

entre nous s'est passé quelque chose
 je me
plutôt que consentir (NH, p. 134)

between us something went on
 I
rather than consenting

The unfinished line: "je me" strikes with horrible force, for all the verbs
unstated may be read also, in a reader's rite of reversal, as suppression.
Hérodiade's ambivalent monologue mirrors the love and hate exaltation
of both characters exulting over the decapitation-as-act, in which the
intensity of poetic discourse is augmented by its inconclusiveness, the
latter producing at once a positive and negative effect in the passage.
Finally, this passage of the virgin is established with an element of luck:
for these pages too are an object found in the papers of the poet and
celebrated, a glorious *objet trouvé* presented to the reader or the passerby
in the text, so that he may observe the ritual, and not just by chance.

The *Large Glass*, Paz reminds us, was finally unfinished in 1923; but
the structure is left there, like a set for some act into which the spectator
too must make a mental leap; more than that, the works in their working
out determine their own seeing and being. Duchamp's "malic moulds"
are themselves the playing out of some great intellectual game, chess
made into this greatest of glasses, with the roll of the dice added as one

chance more. Playing chess, says Duchamp, is like making a sketch of something, constructing the mechanics by which you win or lose; and so the painting: "Faire un tableau de *hasard heureux ou malheureux* (veine ou déveine)" (MS, p. 30; To make a painting of lucky or unlucky chance [good or bad fortune]). And does not Midnight's own statement in *Igitur*: "J'étais l'heure qui doit me rendre pur" (M, p. 435; I was the hour which is to make me pure) ring phonetically, at least, with a certain chance or *heur* about it? The self plays with itself all the roles, and most of the games. The play and the work, or the work of the play form yet another inversion of concepts on the way to the poem.

As for the mirror exchange, that *renvoi miroirique* of poet and spectator, and the multiple meanings produced, warranted, and even forced upon reader and test—visual or verbal—by any machine going about any work or play, the enabling gesture is still a look thrown as if by chance: "jeter un coup d'oeil," "jeter les dés" (to glance, to throw the dice). Mallarmé's "pureté de la glace chimérique" (the purity of the chimerical glass) will triumph even as the Arensberg's glass is cracked—but the cracks, though (or because) they mark an otherness, are to be celebrated in their trace:[10] "j'aime les fêlures, la manière dont elles se propagent. . . . Elles ont une forme, une architecture symmétrique. Mieux, j'y vois une intention curieuse dont je ne suis pas responsable, une intention toute faite en quelque sorte que je respecte et que j'aime" (MS, pp. 149-150; I like the cracks and the way in which they propagate themselves. . . .They have a form, a symmetrical architecture. Better yet, I see a curious intention for which I am not responsible, a sort of ready-made intention which I respect and love). So that other intention (not of his doing) is celebrated in the constructed as in the ready-made or the Ready Maid, like the conjunction of male and female: Rrose and Marcel, Hérodiade and Hamlet, ballerina and poet. The doubling of personality is doubled by the double attitude, by the gesture dry and mechanical as it welcomes the marvel of chance: what throw of dice except that of genial thought at its summit could possibly reflect the workings out of such a machine as Duchamp's *Broyeuse de Chocolat* (Chocolate Grinder), a sort of pulverizer and synthesizer of thoughts. "Toute pensée émet un coup de dés" (MI, p. 428; All thought emits a shake of the dice), ends the *Coup de Dés* which began it all.

Tzara's own Dada protests against the dark and sickly-rich sentimentality of thought as the "Chocolat dans les veines de tous les hommes"

[10] The driver transporting the *Large Glass* knew nothing of the contents of his truck. This can be seen as a perfectly good trick and Transposition in Mallarmé's sense of the term. "Cette visée, je la dis Transposition—Structure, une autre" (M, p. 366; This aim, I call it Transposition—Structure, another).

(Tz, 1:156; chocolate in the veins of all men), that cause of ghastly smears and tears in those otherwise perfectly transparent crystal corridors and upon those crystal mountains of Dada's new and luminous creation. And just in the same way, Duchamp's gesture in his chocolate grinder, fertile to the extreme, is still dry to the extreme: "Je voulais revenir à un dessin absolument *sec*, à la composition d'un art *sec* et quel meilleur exemple de ce nouvel art que le dessin mécanique. Je commençais à apprécier la valeur de l'exactitude, de la précision, l'importance du hazard" (MS, p. 154; I wanted to return to an absolutely *dry* drawing, to the composition of a *dry* art, and what better example of this new art than mechanical drawing? I began to appreciate the value of exactness, of precision, the importance of chance). Now in this canned chance ("hasard en conserve") or this luck-on-ice or in glass, the glass itself is valued not for its transparency—not a window in sight finally—[11] but for its silvering: "Faire une armoire à glace. Faire cette armoire à glace pour le tain" (MS, p. 33; To make a chest of drawers with a mirror. To make this for the mirror's silvering). The *renvoi* is as poetic as it is *miroirique*: the poetic crisis or "crise de vers" could just as surely have been "crise de verre" a crisis in glass, that other vice, laid bare: "vice, mis à nu." The poet is, like the reader, possessed by the play of the language, by the worm and the verse and the glass, the "verre/ver/vers." Alas, as Duchamp says, "on peut regarder voir; on ne peut pas entendre entendre" (MS, p. 31; You can look at someone seeing; you can't hear someone listening).

Be that as it may, Mallarmé's own Precursorship is not in question here: graver things are at stake. Any roll of the dice may be a protest against a standard measure: Duchamp's *Stoppages-étalons* as they are thrown are the traces of a meter thrown from a meter, themselves a referent for poetic gesture and themselves a refusal of standard meter. The throw of the *Stoppages-étalon* was intended, Duchamp claims, to give another idea of the unit of length: this corridor of humor he saw as opening out on the oneiric, thus on Surrealism. Taking a meter measure and breaking it, said Duchamp, would have been Dada; but, for us, to take the measure of Dada is more difficult.

As for the delay in glass, the *retard en verre*, "comme on dirait un poème en prose ou un crachoir en argent" (MS, p. 34; As you might say a prose poem or a silver cuspidor), that delay also in verse works like a

[11] But see Robert Greer Cohn's "Mallarmé's Windows," lifting the curtains, as usual, toward the luminous text. (The implicit reference is to his *Towards the Poems of Mallarmé*, Berkeley: University of California Press, 1965.) These windows, with some doors—the panels in Igitur, for example, as the doors to the womb—are found in *Yale French Studies*, 34 (1977), pp. 224-232. See also the article of Renée Linkhorn, " 'Les Fenêtres': Propos sur trois poèmes" (*The French Review*, 44, no. 3, February, 1971).

slow-motion refusal and a celebration of refusal, a movement captured like a sign taking not even a swan's flight upon a glass, a mane of hair caught shining like jewels in a mirror or another Stéphane's diadem[12] in Mallarmé's sparkling and empty "vers." Is it not the opaque silvering of the "verre," after all, which makes it, and us, reflect? Otherwise, a forward motion of thought would too quickly take us into habit: the pulling back and forth, from delay to acceleration and back, holds and renews our glance. What better protest against the habit of thinking habitually? Duchamp announces the danger of taste acquired, even the taste of that chocolate as it is pulverized and even of a pulverizing machine: "Recommencez la même chose assez longtemps et elle devient un goût. Si vous interrompez votre production artistique après avoir créé une chose, celle-ci devient une chose-en-soi et le demeure" (MS, p. 156; Keep to the same thing long enough and it becomes a liking. If you break your artistic production after having created something, that thing becomes a thing-in-itself and remains it).

To preserve chance then, canned, on ice, or in glass ("en verre"), a double reflection is required—like some "frémissement" of the plumed figure already referred to as both pen and feather, spiraling across the stage and back in order to make (just) a point, another ambivalent and indicative virgin. Unlike the walker, the dancer goes nowhere. "Un pli frémissant de sa jupe simule une impatience de plumes vers l'idée" (M, p. 306; a quivering pleat of her skirt simulates an impatience of feathers toward the idea). Of course, any gesture made on these stagey "Planches et Feuillets," pli selon pli[13] is part of a "paysage faux," of a "mensonge glorieux." Mallarmé declares in favor of spectacle: "Notre seule magnificence, la scène" (M, p. 313; Our only magnificence, the stage). And on the stage, the philosophic or—as Duchamp would say—the metaphysical interchange develops, between the ambivalent aspects of the ballerina in her female appearance (her "pirouettes") and her male act of designation in its pricking and puncturing precision: between the concepts of "point" and of "pointe," the period at the end of the sentence and the prow of a ship. The verb poser (to place or to pose) here plays out its role, in the moment's fiction, which is to say, its poem:

> À déduire le point philosophique auquel est située l'impersonnalité
> de la danseuse, entre sa féminine apparence et un objet mimé,

[12] On diadems and hats, particularly the Hamlet hat or the Hypberbowler, see Thomas Hanson, "Mallarmé's Hat," in Yale French Studies, 34 (1977), pp 215-227. Compare with Tzara's analysis of the hat as an exteriorization of desire, in Le Minotaure, no. 3-4 (19—).

[13] "Pli selon pli" is the title given by Pierre Boulez to his setting of Mallarmé's verse, a difficult unfolding.

pour quel hymen: elle le pique d'une sûre pointe, le pose, puis déroule notre conviction en le chiffre de pirouettes prolongé vers un autre motif, attendu que tout . . . est, comme le veut l'art même, au théâtre, fictif ou momentané. (M, p. 296).

To deduce the philosophic point at which the impersonality of the dancer is situated, between her feminine appearance and a mimed object, for what marriage: on point, she pricks the surface surely, with a precise placing, then unfolds our conviction in the number of pirouettes prolonged toward another motif, since it is expected that everything . . . is, as art desires it, fictional or momentary in the theater.

The real gesture is made inside, in accordance with the voluntary and deliberate exterior effacement Mallarmé adopts: "A la rigueur un papier suffit pour évoquer toute pièce: aidé de sa personnalité multiple chacun pouvant se la jouer en dedans, ce qui n'est pas le cas quand il s'agit de pirouettes" (M, p. 315; If need be, a paper suffices to evoke a whole play: aided by his multiple personality, each being able to play it to himself inside, which is not the case when it is a question of pirouettes). We may set Igitur ourselves in his scene, but also any glass, as its title indicates, to be "looked at . . . for an hour," like that of Duchamp. The spectator must be included in the scene, to make the work. The delay here, literally, the "retard en verre" or delay in glass is represented by the required hour-long vision, or rather, by seeing through that hour. The site is built into the stage set, or then, we cannot see, in either "vers" or "verre." But in Igitur the curtains and the panels set the stage with the same evidence as, for instance, in Breton's own poem "Rideau rideau" (Curtain, curtain), an insistence on the theatrical setting for the mechanics of poetic self-slaughter. The act and the gesture are sure: "Ce séjour concordait parfaitement avec lui-même . . . le lieu de la certitude parfaite" (M, p. 446; This sojourn was in perfect concordance with itself . . . the place of perfect certainty). As always in Mallarmé and Duchamp after him, or alongside, the reader is sure of having finally come to the right place, and the most complex one. Here, then, in the mirror placed exactly in the place to reflect the constellation of the sky, like some perfect page with its silvering just so, Mallarmé's "sonnet nul . . . se réfléchissant de toutes les façons," that null sonnet reflecting upon itself and us in all possible ways like the "nul" sound of his "Penultimate" (MI, p. 208), is quite the opposite of Breton's "moment nul" or void moment and its wasted time, blank and annulled.[14] To vanquish the

[14] Referring to a description in Dostoievsky, Breton accuses him of not sparing us the

constant and passive ennui ("quand je suis las de regarder l'ennui dans le métal cruel d'un miroir"/when I am tired of looking at boredom in the cruel metal of a mirror) turned positive by its poetization, what better than some *crise de verre*, far from the neurotic crisis or *crise de nerfs* on which the play is set?

Laforgue's "Complainte" is notably ambivalent as regards its sex, and leads to a refusal of the vivid, the colorful, the toneful:

Le Spleen, eunuque à froid, sur nos rêves se vautre.

. . .

Tachons de vivre monotone.[15]

Spleen, a eunuch cold, sprawls upon our dreams.

. . .

Let's try to live monotonous.

And Mallarmé makes characteristically the same deliberate shrugging off of the fertile and the bright: "moi, stérile et crépusculaire" (I, sterile and crespuscular).[16]

Thus, when the cards of the game are reshuffled, the latent lord, which is to say Hamlet in Laforgue's "noctambulist sombrero" and his black velvet,[17] mirrors in reverse the dazzling white of Pierrot, who, like Hamlet himself, has not yet become still and always a "fantôme blanc comme une page pas encore écrite" (MI, p. 203, a white phantom, like a page as yet unwritten). Also, as the latent hero of the story here, insofar as it is story, he is represented by Laforgue and Mallarmé but also by Tzara, the realist knight of the double-self. He meditates, as in Shakespeare, upon the emptiness of words said and read: "Des mots, des mots," and upon his descent—for which he longs—into the most authentic emptiness of his tomb. Laforgue's Hamlet too comes down from his tower ("descend de sa tour") like another *Sad Young Man in the*

null moments of ordinary descriptions; this attitude is the basis for much of the Surrealist aesthetic of the extraordinary.

[15] Jules Laforgue, "Complainte d'un certain dimanche" in *Oeuvres poétiques* (Paris, Belford, 1965), p. 56. Laforgue's "Complaintes" are indeed "à froid," like Duchamp's dry gesture; for the supreme gesture of throwing the dice, which Claudel compares to a "grand seigneur qui jette sa bourse"—a Pascalian gesture, as the latter points out in his "Catastrophe of Igitur."—See "Dada's Temper."

[16] Stéphane Mallarmé, *Oeuvres* (Paris: Pléiade, 1945). Hereafter referred to as M.

[17] *Moralités*, p. 25. For instance, "des roses blanches tombent du velours noir" (white roses fall from the black velvet), "lune d'or qui se mire dans la mer calme et y fait serpenter une colonne brisée de velours noir" (moon of gold which contemplates itself in the calm sea and causes a broken column of black velvet to snake about it), and a "pourpoint de velours noir" (a doublet of black velvet).

Train, Duchamp's own: again, the current passes from Laforgue to Duchamp, or another nude, descending some stairs.

Tzara's *Mouchoir de nuages* (Cloud Handkerchief)[18] presents, within its fifteen acts, a Hamlet who is Igitur-like to the extreme—an Igitur excessive in every gesture, deliberating on madness, "folie": "Poussez consciemment la folie a l'excès, vous serez moins fou que les autres" (Tz, 2:350; Deliberately push madness to an extreme, you will still be less mad than the others). As Igitur descends the stairs to his tomb, Hamlet is tempted by the downward climb: "Where would you like to go?" asks Polonius, "where else but here?" "Into my tomb," replies Hamlet in Tzara's version of the Prince (Tz, 2:343). And this grave descent is balanced only by the contemplation of the staircase image of Duchamp, by his *Nude Descending a Staircase* on one side of the motion and his figure climbing the stair in his drawing based on Laforgue's poem "Encore à cet astre" (Still to this Star): Mallarmé is not far off. The up and downness of the plays's action, parodical and no less dramatic for that, is perfectly resumed when the concierge shakes her head with an "Ah! Ah! Mon bon monsieur c'est l'âge où l'on préférait descendre tout le temps les escaliers au lieu de les monter" (Tz, 2:350; Ah! Ah! Dear sir, that was the time when everyone preferred coming down the stairs constantly to going up them).

But Tzara's Hamlet resumes as well in himself all the black velvet of Laforguian and Mallarméan settings and costumes, and all the transmutations of words, meant to catch the multiplicity of Hamlet/Igitur, as a dazzling diamond of midnight includes, or again mirrors, not just the blank white of Pierrot's costume but the painful if androgynous flash of Stéphane's diadem and of Hérodiade's virginity. Surrounded like a doubled Duchampian Rrose Sélavy, Eros (Rrose) with a vitally embattled virgin (Sélavy, pronounced "C'est la vie" or "that's life!") in whom an anterior nude model, *nu* or *nue* (Like Tzara's own *Nuages*) has passed, she refuses any laying-on-of-hands, rightfully protecting her own space and her own rite of this nonpassage from virgin to bride.

As the ballerina is a "virgin index," marking a perfect turn—whether poetic or pictoral, always stagey—her whirling skirt forms the ideal *roto-relief*[19] like a writing read by and in a whirlwind reading, like a figure

[18] This play is composed of three different sets of Hamlet texts: see the notes of Henri Béhar in his edition of Tristan Tzara, *Oeuvres completes* (Paris: Flammarion, 1975, 1977); see also the Ebauches or sketch of Hamlet, 1:437-40. Louis Aragon was effusive in his praise of this play: see his essay in *Les Collages* (Paris: Hermann, 1965).

[19] The roto-reliefs were optical discs, spinning about with puns, revolving in and before the reader's eye and in his mind.

spiraling, making way for the passage leading on, from the celibate chain to the bride, or then, to the "pliage" or pleating of the sheet (feuille): "Le pliage est, vis-à-vis de la feuille imprimée, grande, un indice, quasi religieux" (MI, p. 267; The pleating is, across from the printed leaf, large, an index, almost religious). The sheet takes, like the Word, a multiplicity of senses, as dizzying in its spin as the Surrealist vertigo Aragon claims to inflict by means of the image on the sedentary mentality. The "Déclaration foraine" may have been the verbal inspiration for Duchamp's own mannequin of a virgin and the bets placed here remind us of Tzara's Faites vos jeux, like a wager in favor of multiplicity of chances around that gaming table where we may have seen, on some Surrealist occasion. Marcel Duchamp seated in his multiple super-and juxtapositions of the same pose, as in Man Ray's magnificent portrait of him (Marcel Duchamp Seated Around a Table). These many Duchamps, like so many tries of chance, so many stoppages of the self, perfectly represent the way in which the double self leads finally to the self multiplied, just as the dice are thrown: Mallarmé too can be considered as seated around Duchamp's table. But this table now leads me in turn to another reading of the "mise à nu": could not some "mise" or bet be placed here nakedly, like another Bride made naked by a disrobing, but in overlay and not in subtraction, like a multiple costuming—white on white, glass on glass, delay on delay, as the die is cast? Or then, by the Baroque heritage of an imagination of dazzling darkness, black on black, in the most velvet of nights?

Sufficiently, I was faithful to my image, says Mallarmé: "suffisamment je ne fus fidèle." To the multiple possibilities of the self, the self is faithful, even when the background for them is acknowledged as only appearing. Tzara's own Hamlet, Laforguian but no less Mallarméan, found in fragments only (Tz, 1:342-344), wonders about existence and departs in a cloud (handkerchief, I read here) of misunderstanding and forgetfulness, while from Duchamp's Nu, his naked descent and ascent, and his Vierge, disrobed and added to, both naked model and naked virgin are absent. Might not such a parallel delay in glass or retard en verre produce a long-delayed child of night, some "Enfant d'une nuit . . . d'Idumée" (and was this "Gift of a Poem," this "Don du poème," to be finally the Hérodiade, as Mauron thinks?) Such delays result in the consumption of project and poem by their matter: "par le verre brûlé."

Between the panels of Igitur, set in the velvety black luxury and dazzled with the reflection of the star's own writing in the sky, the act is "transposed" from thought on planches or on feuillets, in mirror and in glass, in figure and in furniture, one continually reflecting upon and against one another, in a self-referential series ("se mirer en un soi

propre"/MI, p. 48; to contemplate oneself in a proper self). What better source for Aragon's own Mire, the heroine of his early novel, *Anicet, ou le panorama*, who contemplates herself in the mirror of his page?

"Rien n'aura eu lieu que le lieu" (Nothing will have taken place but the place), states *Un Coup de Dés*, but the act takes place and is its own measure, like another grave shaking of the dice, sufficient into itself, like a poem. Hamlet's own irony, heavy-handed and Laforguean ("j'admets bien la vie à la rigueur. Mais un héros!"/H, p. 70; If need be, I will put up with life. But a hero!), or delicately ambivalent according to Duchamp's recipe for three pounds of light stuff ("3 livres de plume"/MS, p. 180; feather or pen), and sardonic and self-referential in Tzara's own fifteen Hamletian acts of the *Mouchoir de Nuages*, conjures up, as in the mirror of Mallarmé's "personnage unique d'une tragedie intime et occulte" (M, p. 299; unique character of a tragedy intimate and occult) the characteristic self-meditating literary irony: "Me voici, oubliant l'amertume feuille-morte" (M, p. 299; Here I am, forgetting the dead-leaf bitterness). Let these "leaves" not die, or their act, or this other figure who no one is: the injunction we might all make to ourselves is quite properly that of Mallarmé's own mirror, that of Hérodiade/Hamlet/Igitur: "Réfléchissons" (Let us reflect). The mime is, after all, the thinker and the actor or the player ("l'acteur mène ce discours"/M, p. 300; the actor guides this discourse), against the machine, who will neither break the glass or the ice nor deny the fertile falseness of the androgynous setting,[20] this artificial landscape. Each virgin indication of an act, both male and female, creates a double crisis: a "crise de vers" of chance and necessity, of cracked glass and incomplete poem, and works a double delay, a "retard en verre" like a descent into a profound mirror and along a protracted and ambivalence of word and self, beyond the simple and single identity reason would wreak, toward the shadowy complexity of the doubled self, that superb "figure que nul n'est."[21]

[20] Like Bachelard's androgynous moment, like Mercurius' hermaphroditic nature, and the being defining itself by a self and a *counter-self* in a constant dynamism, discussed in my *Surrealism and the Literary Imagination: A Study of Breton and Bachelard* (The Hague and Paris: Mouton, 1966), especially pp. 37-46.

[21] To whom I have tried to render a longer homage in compiling the best translations of his work: *Stéphane Mallarmé: Selected Poems and Prose* (New York: New Directions, 1981).

PART IV

THE INNER SEEN

11

BAROQUE LIGHTING
IN RENÉ CHAR

Qui appelle encore?
(Who is still calling?)
—René Char, La Nuit talismanique

AN ESSAY about the serious contemplation of the Baroque artist by the con-
temporary French writer must get its own sights straight and take its time:
"Ceux qui inspirent une tendre compassion au regard qui les dessine
portent en eux une oeuvre qu'ils ne sont pas pressés de délivrer." (Those
who arouse a tender compassion in the gaze which outlines them bear
in themselves a work which they are in no hurry to hand over.)[1]

The scope of the present investigation is deliberately limited. To
illustrate the contemporary attraction to thematic contraries of the sort
considered to have a Baroque appeal—a term here taken as devoid of
all pejorative connotation—and of the highly oxymoronic style charac-
teristic of Baroque attitudes, we have taken two figures presented by quite
different Baroque artists, themselves forming their own contrary grouping,
juxtaposed within the mind's eye, and in one poet's work.

In choosing Poussin's Orion,[2] the blinded hunter (figure 57), and de
La Tour's Magdalen as she looks regretfully and in penitence at her vigil-
lamp (figures 13 and 14), René Char responds to the Baroque play of
darkness and light and to the Baroque fascination with a violent change
of state. Char's Orion, a fallen meteor, has the gigantic stature of a hero
of Poussin. From the obscure expanse of the nocturnal sky with its myriad
of lights, he plunges to earthly darkness and physical blindness, yet ca-
pable of a lucid pursuit and a lucid poetic choice; when he rises again,
it will be by a path of a fire lit by men and made of passionate and human
adventure. The Magdalen of Char and of de La Tour, an originally fallen
woman, rises from her erstwhile blind and touching affections to her

[1] "Se Rencontrer paysage avec Joseph Sima" (To Meet as a Landscape with Joseph Sima),
catalogue of exhibition of Sima, Ratilly, 1972 (no pagination).

[2] See E. H. Gombrich, "The Subject of Poussin's Orion," in Symbolic Images (New York:
Phaidon, 1972), first published in the Burlington Magazine in 1944. Gombrich discusses
Poussin's reading of a humanistic reinterpretation of the legend as referring to the cycle of
nature on one level, thus including both esoteric and exoteric meanings.

meditation over a single light, from then on keeping watch over and against the surrounding and inner dark. Both figures are profoundly shadowed, and profoundly lit.[3]

The contrasts are marked: of the many with the one and the light with the dark, multiple stars and a lone lamp or candle standing out against the blackness, of the pagan and Christian universes, of the mythical male hero and the legendary female heroine of regret. The spirit of these contrasts can be seen as fitting the Baroque view, for the heroic contours and figures of the poems are given their perfect symmetry and their active duality by their implicit opposition and convergence in the poet's own vision. René Char's own "Madeleine with the Vigil-Lamp"— Madeleine, as he says, in the English version and not Magdalen, because he wants to picture the woman before her conversion—is central to his own interior vigil. The flame guides the passage from image to image, in his text and in ours.[4] Furthermore, the importance of de La Tour's Madeleine and Poussin's is stressed by the poet himself. In one of the texts of the long construction called "Contre une maison sèche" (Against a Dry House), a poem built of statement and echo, Char lists the painters who provide the woolen skeins of his "rocky nest": "The Lascaux painter, Giotto, Van Eyck, Uccello, Fouquet, Mantegna, Cranach, Carpaccio, Georges de La Tour, Poussin, Rembrandt."[5] These fidelities are of long standing, especially that of de La Tour. Moving back in reverse order from the text just quoted (dated July, 1969) to a text of 26 January 1966, called "Justesse de Georges de La Tour," we may see why this artist and this lighting rather than another. His precision is an exemplary one, which Char illustrates in two parts, the first, nocturnal, the second, diurnal. The nocturnal text is a celebration of shadow and of limited light:

> L'unique condition pour ne pas battre en interminable
> retraite était d'entrer dans le cercle de la bougie, de
> s'y tenir, en ne cédant pas à la tentation de remplacer les
> ténèbres par le jour et leur éclair nourri par un terme in
> constant. (NP, p. 73)

> The only condition for not beating an interminable retreat
> was to enter the candle's circle, there to remain, never

[3] Between and among images, Char selects, but the reader might well refer to them all: "Madeleine à la Veilleuse" (Magdalen with the Vigil-Lamp), "Madeleine aux deux Flammes" (Magdalen with Two Flames), and "Madeleine au Miroir" (Magdalen at the Mirror).

[4] And this image keeps watch also, over another text: see my *Presence of René Char* (Princeton: Princeton University Press, 1976).

[5] In *Le Nu perdu* (Paris: Gallimard, 1972), hereafter cited as NP; reprinted with *La Nuit talismanique* (Paris: Poésie/Gallimard, 1979), p. 123.

acquiescing to the temptation to replace the shadows by daylight and their full brilliance by an inconstant end.

Here we envision the Magdalen before her mirror, even though she is not mentioned explicitly, for she endures in our own imaginations. To cite a passage from 1972, that "Talismanic Night" of the poet's insomnia of fourteen years earlier revealed a darkness lit, not by the crude and sterile electric light anathema to mystery, but the simplest flame cast by a more primitive illumination. So, the "Talismanic Night which shone in its circle"[6] of flame is seen as completing an earlier gesture of lighting a candle in order to deepen and clarify the work:

> Servante ou maîtresse, proche du souffle et de la main, rasante et meurtrie, cette flamme dont j'avais besoin, une bougie me la prêta, mobile comme le regard. L'eau nocturne se déversa dans le cercle verdoyant de la jeune clarté, me faisant nuit moi-même, tandis que se libérait *l'oeuvre filante*. (NT, p. 12)

> Servant or mistress, near the breath and the hand, closeskimming and ravaged, this flame which I needed was lent me by a candle, as mobile as the gaze. Night's water poured into the greening circle of young clarity, rendering me night myself, while the work *streaking by* was set free.

And that text of 1958 in its turn lights a former one of 1947, concerning the great Magdalen, de La Tour's *Magdalen with the Vigil-Lamp* (figure 13). As the repentant fallen woman muses on death and passion, the poet meditates through her meditation, and the reader completes once more the passage from figure to artist to poet, in a multiple gaze directed now at the text aflame:

Madeleine à la veilleuse

> Je voudrais aujourd'hui que l'herbe fût blanche pour
> fouler l'évidence de vous voir souffrir: je ne regarderais
> pas sous votre main si jeune la forme dure, sans crépi de
> la mort. Un jour discrétionnaire, d'autres pourtant moins
> avides que moi, retireront votre chemise de toile, occuperont
> votre alcôve. Mais ils oublieront en partant de noyer la veilleuse
> et un peu d'huile se répandra par le poignard
> de la flamme sur l'impossible solution.[7]

[6] And originally in *La Nuit talismanique* (Geneva: Skira, 1972).

[7] My translation here represents a slight and recent rethinking of the one appearing in *Poems of René Char*, tr. Mary Ann Caws and Jonathan Griffin (Princeton: Princeton University Press, 1976).

Madeleine with the Vigil-lamp

Today I would like the grass to be white, to
tread underfoot the sight of your suffering: I'd not look
under your youthful hand, at death's hard smooth form.
One day at their discretion, others, though
less avid than I, will remove your homespun blouse, will
occupy your alcove. But they will forget to put out the
lamp leaving and a few drops of oil will spill
out by the flame's dagger onto the impossible solution.

We remember how, in the vision of the metaphysical poets such as
Crashaw, the ardent gaze of the weeper at her flame inspired the respond-
ing passion of the sky, releasing the heavenly rays like tongues of fire or
like tears in return, to rain radiant upon the earth, thus rekindling the
flame of the impassioned lady and so provoking a new flood of tears,
their crystal then changed to the ruby of blood as the cycle reveals its
complexity and the clash of its contrary juxtapositions.

In the chapter on gesture, this clash is compared to the flashing of
contrary elements in Surrealism one against the other, in the oxymoronic
style, or then one in the other as in the serious game of poetry: "Is she
a Flaming Fountain or a Weeping Fire?" The question may still be read
alongside the corresponding invocation to a barbaric flame rushing along
Breton's path, implored to serve as the directing image in the passage
from individual experience to collective passion: "Flamme d'eau guide-
moi jusqu'à la mer de feu" (Flame of water lead me to the sea of fire).

In the privileged scene of the Magdalen seated in her bright shadows,
in her dazzling darkness, if we choose thus to see it, the imagination of
contraries is given its fullest possible exercise of perception, as are poetic
complexity, an innocent and yet passionate purity, and the purest of
suffering passions. In the light of our reading of the metaphysical poets,
this summit-text of Char's own meditation assumes a gravity in no way
inimical to its deep eroticism: the poem, like the meditative figure, com-
bines regret with desire, the clear with the mysterious. The poem perfectly
responds to and completes de La Tour's Baroque statement in its chia-
roscuro lighting, lends its strange density to the reading of that canvas
and to our own responding contemplation of flame and darkness, life and
skull, book and text. The painting outwardly mirrors the inner mirror of
the mind.

The "doux danger" of the flame may persist, even through the day,
and for Char, even through the paintings of de La Tour that we might
consider less profound or less "dangerous," those "tableaux de jour" or
paintings of the daytime. The dreamer of the nocturnal scenes, like Char's

own "Extravagant," an imaginer of voyage and adventurer, is at last awakened in the second text on the "Justesse de Georges de La Tour" from 1966:

> He opens his eyes. It is daytime, it seems. Georges de La Tour knows that the wheelbarrow of the damned has started out everywhere with its clever content. The vehicle has overturned, and the painter establishes its inventory. Nothing of what belongs infinitely to the night and to the radiance which exalts its lineage is to be found there. . . . It's daytime, the exemplary turncock of our troubles. Georges de La Tour was not wrong about this. (NP, pp. 73-74)

Both the dream and the candle are absent here, apparently, so that the first text, that of the candlelight's circle, is at a distance from the second. Different in costume and decor, in action and in lesson, the daylight scenes play out their evident openness to the hilt, as in the "knife about to strike" in one of these tableaux. And yet even this open setting is deepened by the suggestion of another and quieter space, this time of day remaining in correspondence with the time and the tone of that other "murmured" ceremony heard and glimpsed within this talismanic night of scorpion sting and single-horned beast, referred to in the chapter on the Mannerist gesture. For this time the poem situated on the page opposite to the one concerning de La Tour is a "Mute Game" where the knife of a youth: "Le couteau de ma jeunesse" (NP, p. 75) or as we might say, that of a gay blade, leads to the appearance or the reappearance of Orion's dart.

The images too have come full circle, as suggested at the beginning: the figure of Orion, as Char pictures him is lord of the bees, those intermediaries between heaven and earth, says Rilke, and king of poets, as poets make the earth's honey from their suffering granted and imposed: "Nous sommes les abeilles de l'infini. Nous butinons le miel" (We are the bees of the infinite. We gather the honey), says Rilke,[8] and Char's Orion is in search of just that gathering of the space in between or the "entredeux," as the chiaroscuro lighting is between the dark and light. To balance the Magdalen as the feminine figure of falling and rising who represents the change of moral state in its Baroque fascination, Orion, whom Char pictures as a fallen meteor, is thus a bright and solitary figure fallen from the constellation of stars above, his bow still arched as he is still in pursuit, of the flowers, but mainly of himself. This giant "chasseur de soi," blinded by the rays of the stars, in all his nobility moves from

the passionate brightness to a groping gesture, with a cloud before his eyes in Poussin's spacious landscape with the figure of Orion (figure 57) before returning with his arched weapon to the heavens whence he came. Char's depiction of Orion in the book dedicated to that figure, *Aromates chasseurs* (Hunting Herbs), itself moves through four particular stages. From his descent ("Evadé d'Archipel"/Escaped from the Archipelago) to his terrestrial work of bridge-building ("Orion Iroquois"), the text leads in a crescendo to the twin poems of his "Reception" and his "Eloquence," both including the habitations of men and of the eternal and both constructing a third space where the two vertical extremes might meet: this would be the final construction and would take in the canvas with the poem and the sky with the earth, in a complementary and inclusive universe fitting the atmosphere of Baroque and Surrealism. Char's landscape is no less spacious than that of Poussin, and no less noble. Here Poussin is reinvented by the poetic mind, and on an image of Poussin a final chapter will close (figure 58).

In the Baroque mentality, and in its enduring, in the modern and in its vision and revision of other times and other attitudes, it is not only artists and poets as they are but as they expose us to ourselves that we most deeply understand them. Cézanne says of Poussin that he reveals the artist to himself: "Je veux que la fréquentation d'un maître me rende à moi-même toutes les fois que je sors de chez Poussin, je sais mieux qui je suis" (I want my being close to a master to restore me to myself; every time I leave Poussin, I am a little more aware of who I am).[9] What Cézanne says of Poussin, Char might say of the Baroque artists who have formed him, as he has, in his turn, formed us.

The juxtaposition in Char's canvas and in our own responding mind of the Magdalen as de La Tour sees her and of Orion as Poussin sees him form their own setting for us, visual, textual, and moral. Surely it is also the privilege of the reader in this freely intertextual universe of the spirit to weave the skeins of wool chosen by the poet to line his "rocky nest" into the picture most nearly befitting our own view of his work. And so we can take the lighting from that single candle, whether it betokens danger or delight, into our corridor of the museum of the mind, until its flame touches the other, that of the "only sun," on which closes the entire volume of *Le Nu perdu* (Bareness Lost). Only the dazzling darkness of a black sun could light such an image as this, weighted like a nocturnal sky sparkling with many lights, or leading to a darkened room and a dark passion, contemplated by a unique and inner circle of flame:

[9] In Cézanne exhibition, Museum of Modern Art, New York, 1978.

Tout ce que nous accomplirons d'essentiel à partir d'aujourd'hui, nous l'accomplirons faute de mieux. Sans contentement ni désespoir. Pour seul soleil: le boeuf écorché de Rembrandt.

<div align="right">(NP, p. 131)</div>

All the essential things that we accomplish from now on we shall accomplish for want of anything better. Without satisfaction or despair. For our only sun, the flayed ox of Rembrandt.

Like Heraclitus, says René Char, de La Tour teaches us in what habitation the mind can dwell. And I would add, teaches us how best that room is lit, so that its images may endure.

12

THE ART OF ANDRÉ MALRAUX

Ce que je tiens le plus à dire n'est pas, il s'en faut, ce que je dis le mieux.

(What I most care to say is far from being what I say best.)

—André Breton, La Clé des champs

TO THE QUESTION, "What is art?" Malraux replies, in Les Voix du silence (The Voices of Silence): "That by means of which forms become style."[1] And to a parallel question about poetry or even poetics, we might give this partial response: That art of making by means of which thought conveys passion. How may we address ourselves simultaneously to style, to thought, and to the passion informing them better than by insisting on the presence of the text in page or painting? The journey of each reader through the ways of a living thought must find the passage and passages bespeaking that presence as it must also find its own best-suited vehicle: Malraux's intensity demands always our own commitment, our passion, and our brevity.

Art—and in that we may include poetry, in the sense we are using it here—is that which triumphs over accident and imbues it with irony. For it is in the individual and the accidental that we suffer what is called the human condition,[2] man's fate, of which André Breton says that our way of accepting and refusing it as unacceptable makes of us what we are. And the smallest perceptions of all writers who are poets bear the weight and finally, the importance of the most cosmic: there are not, perhaps, lesser and greater sights. Malraux constantly describes evil as pitted against fraternity in the grimmest battlefields of the First World War, where our eye is held along with that of the narrator, in Lazare and before that in Les Noyers d'Altenburg (The Walnut Trees of Altenburg), first by the decayed grass, the gigantic vegetation of slime, and the spider webs sparkling with poisoned dew in the meadows thus "abjectly ornamented," but then, in a superb moment, by the single ray of the setting sun catching in its glow the cross of Lorraine on the chest of a fallen

[1] André Malraux, Les Voix du silence (Paris: Gallimard, La Galerie de la Pléiade, 1951). Hereafter cited as VS.

[2] André Malraux, La Condition humaine (Paris: Gallimard, 1938).

soldier. Even when the emotional charge is emptied from the image, the aesthetic detail sustains and brightens the text, like a ray of light in a Rembrandt or a Caravaggio, an oblique grace redeeming the darkness. To be sure, after this passage by death and horror, Lazarus is raised, whether from the battlefield or the sickbed;[3] we remember now the early morning scene of *Les Noyers*, the brilliant green after the fog and gray of the world marked by war, when the multicolored washing hung out on the line had all the surprise of renascence. In the reader's mind, the title *Lazarus* and one of the paintings in *Les Voix du silence* intersect; by a wonderful irony, Malraux turns upside down his reproduction of Giotto's *Resurrection of Lazarus* (VS, p. 253), to show the sculptural forms: for a raising to be upside down as a training of the viewer's eye is worthy of a Surrealist imagination.

Repeatedly, in all the works of Malraux, moments of narrow focus balance against the great and wide-ranging dialogues. The huge red hand on the glove maker's signboard in *Lazare* could be interpreted, for instance, as pointing toward whatever we might not have seen before, for example to the separations experienced and distancing through Malraux's long passage through art and poetry, for the hand is again and again unrecognized by the man possessing it, and the voice is repeatedly unrecognized by the ears because it is known in the throat; the outer and the inner are split, observation opposing intuition. But what the uncaring or hasty eye might not have seen is precisely the convergence operated by art in spite of such separation and because of it. Now when we look back at the whole span of Malraux's work as only his death permits us to, which its closure thus opens, certain images cluster unexpectedly in relation to each other, in mutual illumination.

The play of lamps and of shadows in *La Condition humaine* with its Chinese lighting sets up its own dramatic contrast of black and white against the gray death and green renascence of the France to which Malraux returned. Our political and historical memories may differ, while our perceptions share the same scene. A train passing through a tunnel conveys Nietzsche's mad laughter and also a peasant woman on her way to market ramming a chicken's head back into a basket: these two images already juxtaposed in *Les Noyers*, form a scene in our mind with an image from *Lazare* where exhausted refugee children sleep under the rain as it beats down on the cardboard cartoon figures brought to divert them in the terrible hours of the Spanish Civil War.

In the long run of art, both geography and events, terrible or touching, become part of the value we choose to make for ourselves as a second

[3] Or in the back canvas of some double portrait as in Chapter 3.

human condition. We know, of course, that art finds its own sense in and through the absurd; that the answer to Sartre's question and ours, "What is literature?" (*Qu'est-ce que la littérature?*) may differ; that what Malraux calls the "irrational of caverns" is essential both to fraternity and to the sacred, that is, also to poetry. We know that the taste of bitter almonds of which he speaks may have its final importance on the same scale as the whispered question, "Why?" pondered by generations before the caves of Lascaux and Les Eyzies, asked by Malraux once more, explicitly and implicitly. Corpse and cavern, "cadavre et caverne"—the sound of the words casts its own spell. When the word "convulsion" haunts Malraux, or an expression like a lightning stroke, a "possession foudroyante," it is the word itself also and not only the abstract concept that convulses and possesses him. The poetic prose of René Char on his own illness like a lightning stroke closely resembles that of Malraux: "éclair, convulsion, foudroyant": the hero is struck down from the sky, in a sense, but he survives by words and by the smallest details perceived, gathered, expressed, and thus illuminated: "L'effroi, la joie" (Fright, joy). Each poet is his own phoenix.

The word against the concept, as Yves Bonnefoy would say, and the imperfection of a human tongue against the perfected form of an idea, for that is poetry. As it is for Wallace Stevens, in "The Poems of Our Climate,"

> Note that, in this bitterness, delight,
> Since the imperfect is so hot in us,
> Lies in flawed words and stubborn sounds.[4]

In the mines, Malraux tells us, the word *lamp* is said with the respect due to it, is pronounced as befits the darkness, in solemnity. And only a poet would notice.

The *Voix du silence* speak, like poetry. In one of the illustrations to this volume, Caravaggio's Saint Jerome stretches out his right hand and the pen it holds, beyond the book. His eyes—which our own can never meet, since they are turned away and, perhaps, even closed—are directed toward his left hand rather than his text. The painting, singled out by Malraux, is neither that of a reading nor of a creation, but rather of an interior concentration, its verticality concealed in opposition to the clearly visible horizontal line of book and table and writing hand. This line would lead us to another interior scene, whose lighting Malraux draws in correspondence with this one, that in which Georges de La Tour's Magdalen

[4] Wallace Stevens, *The Palm at the End of the Mind*, ed. Holly Stevens (New York: Random House, 1972), p. 158.

gazes past what we shall all become, so that our human fate is read into the canvas. (Skulls have never laughed before as they do now, says the doctor in *Lazare*; "What is a life?")[5]

"I have seen," begins a sentence on the penultimate page of *Les Voix du silence*; and, separated by other voices and other visions, its continuation is only implied: "In the evening where Rembrandt is drawing still, all the illustrious Shadows, and those of the cavemen artists, follow with their gaze the hesitating hand that prepares their new survival or their new sleep" (VS, p. 640). The meditation concludes with the "song of constellations" triumphant in and against man's most ironic fate, whereas the artist's hand, like the poet's, trembles with all the paradoxical privilege of mortality, this action drawing its tragic strength from its extreme human frailty. In the force of the contradiction we recognize a Pascalian quivering of contraries, in style as in thought, a vibration rendering all the more intense the unique resonance of Malraux's discourse. And of this night of stars, like this flame and this cave at the conclusion, for Malraux eternally dialogues with his stars and ours, as his caves and constellations echo those of Plato and of Pascal, dark and light hurled together. "L'éclat des flammes vient aussi de la profondeur de la nuit" (The flash of flames comes also from the very depth of the night).[6] From the Baroque artists and poets to Char's contemporary *Talismanic Night*, the haunting contrast of obscurity and luminosity holds us present to the scene, splendidly and horribly mortal.

A black sun haunts a tragic and lucid sky. Malraux takes for his visible guide the same image as his contemporary René Char, who finally chooses, as his remaining sun, as his only clarity the horrendous and yet magnificent *Flayed Ox* of Rembrandt (figure 3). It is not, after all, extraordinary that the human condition should take on the very color of its suffering from cruelty, for that, too, is the color of its passion. It is rather to be marveled at—in the face of all natural elements and all logic—that the artist, whom we would always by choice identify with the poet, should continue endlessly to ask the same questions when contemplating beauty or anguish: "Can art hold firm when confronted with a meadow and with human mortality beside it?" asks Nietzsche. "Can it hold its

[5] André Malraux, *Lazare* (Paris: Gallimard, 1964), p. 130.

[6] Of de La Tour's light, Malraux says the following, as it is in relation with his night: "The night extended over the earth, the secular form of the mystery calmed. His figures are not separated from it, they are its emanation. . . . The world becomes like the vast night over the sleeping armies of bygone days, where under the lantern of the night watch, immobile forms came forth step after step. . . . No painter, not even Rembrandt, suggests this vast and mysterious silence: La Tour is the only interpreter of the serene part of the shadows" (VS, pp. 388-389).

own in the face of a wheat field?" asks Braque. "And," asks Breton, more pointedly, "can it hold in the face of starvation?"[7] It must, or must not be. These concerns haunt the long history of Malraux's speculations on art and on life: his answers, partial of necessity, are ethical as they are aesthetic.

Poetry, like philosophy, like life, like art, consists of a series of these answers to what Malraux calls "the invincible question" (VS, p. 629), answers perhaps ephemeral, possibly eternal, gathered up forever in a work of art. And as we interrogate or respond, the gaze we turn—whether to a smiling angel or a reading saint or a flayed beast—is already the stuff of our own making. "I have seen," Malraux continues, for his sight and ours, and he spares no aid to vision, turning the *Raising of Lazarus* upside down to detect the sculptured forms, examining a negative of a Caravaggio or a Rubens, enlarging, reducing, meditating. All of this so as to see or to bestow sight, as on some other Lazarus newly arisen. For the seer who offers sight himself sees more richly. Again, each permitted resonance increases the field of hearing, as Malraux's own *Voix du silence* are also "voies" or ways of keeping silent and then again, paths for a language supremely visible.

Now the underlying question is unforgettable, as we are not, and the voice also: "la voix intérieure" (VS, p. 298) is not just the voice we hear through our own throat, anguished in its alienation from the ear, but also an interior path we choose to follow in spite of its ending, that place marked by the death skull upon the reader's table, by his candle, and his mirror.

If poetry is linked, as Malraux reiterates of art, to that which lies beyond appearance and yet is tied to matter and to form, it bears witness also to the anguish of that trembling hand. "What does Rembrandt matter in the flow of nebulae? But it is mankind that the stars deny and to mankind that Rembrandt speaks" (VS, p. 639). That language is the language of poets, of the great voyagers whom Malraux calls the great navigators for their passage across the trackless domains of the heart as of the mind. *Poiesis*, after all, meant the constructing of ships and the making of perfume:[8] the senses were not to be isolated from the mental venture.

[7] In 1928, Breton had already insisted that a painting must hold good against famine; in 1939, he goes further; insisting that art must be situated: "the problem is no longer, as it used to be, whether a canvas can hold its own in a wheat field, but whether it can stand up against the daily paper, open or closed, which is a jungle" (from André Breton, "Prestige of André Masson," in his *Le Surréalisme et la peinture*, Paris: Gallimard, 1965, pp. 151-152, translated in my *Poetry of Dada and Surrealism*, Princeton: Princeton University Press, 1970, p. 91).

[8] Peter Caws reminded me of this.

Finally, we can only be lit by the torch we carry in our own hand, Malraux reminds us; and that torch may well singe the hand bearing it. The flame on which we meditate and the illumination of art are far from being mere consolations. The poet, according to Yves Bonnefoy, is the one who burns. Seeing, in the framework of *Man's Hope*, that place of possible convergence for the world and art, we may well discover in reality only the place of actual loss, that loss intensified by all that might once have been hoped. Bonnefoy maintains, and we with him, that "the anguish of the true place is the condition of poetry." Which of us is to say whether that anguish is nostalgia or prediction, or where our place might finally be? "The true place is given by chance. . . ."[9] Poetry, like all art, is made of presence, and we would celebrate, in spite of all our open contradictions and our only half-hidden anguish, the ways of those silent but speaking voices, *Les Voix du silence*, as they lead us paradoxically, now, toward the sustained presence of André Malraux.

[9] Yves Bonnefoy, "L'acte et le lieu de la poésie," in *L'Improbable* (Paris: Mercure de France, 1979), p. 128.

FOR A CINEMA OF THE
CENTRAL EYE: SAINT-POL-ROUX
TO SPATIALISM

Real cinema does not yet exist, it is in a state of
becoming, it is potential.
—Saint-Pol-Roux, Cinéma vivant.

MUSING ON A MEDIUM

LIKE LIZARDS, said Saint-Pol-Roux, those most endowed with imagination
possess a third eye, a central one: with that eye, I think, we must all learn
to see. If we were to take only the early years of the century, and only
the French poets and theoreticians of the cinema in the 1930s, we might
see a cinema of the text. The latter I have tried to glimpse with this central
eye, one trained, at least for this occasion, less on a multitude of actual
films or scenarios than on certain peculiar textual and filmic passages.

Among all the theories flourishing still within our minds, those of
Saint-Pol-Roux (known as "The Magnificent") surely provide one of the
oddest perspectives. Of his Cinéma vivant (Living cinema), the title given
to an unfinished manuscript left behind him, we learn that its principles
are few in number; roughly stated, they are the generation of energy, the
expansion and even multiplication of the individual consciousness, and
the interior illumination provided by visions. Here we might be reminded
of the eulogies made by the Surrealist Robert Desnos of the darkened
cinema hall as the place of privilege, where the dreams of many unite
in one lighted spot, mingling all possible perceptions and possibilities.

> The cinema's perfect night offers us not only the miracle of the
> screen, a neutral country for the projection of dreams, but also
> the most agreeable form of modern adventure. Not in vain do
> these men and women gathered together under the projector's
> comet-like tail compare their lives with the equally real life of
> the starring heros. . . . The seated dreamer is swept into a new
> world beside which reality is only a not very appealing fiction.

A perfect opium, the cinema entices us away from material concerns, gives us the perfect indifference generating great actions, sensational discoveries, lofty thoughts.[1]

The accent falls on the collective dream as surely as on the individual dreamer: the dream held together, and holding together the spectators is for Desnos as for Saint-Pol-Roux a great modern myth of hope. Antonin Artaud, for his part, considered it the greatest of modern myths until the era of silent film ended; then he lamented the closing-off of ambivalence and imaginative possibilities by the inescapable precision of speech: "Not from the cinema can we expect the restitution of the Myths of man and of life today."[2]

Now the original enthusiasm of Artaud, of Desnos, and of Saint-Pol-Roux for the cinema reminds us of that shown by Blaise Cendrars whose own "ABC of the Cinema" is marked by the same intensity and all-encompassing energy:

The Cinema. Tornado of motion in space. Everything is falling. The sun is falling. We are falling after it. . . . Fusion. Everything opens, crumbles, mingles today, burrows deep, rises up, spreads.[3]

Cendrars' cinema of adventure has the unrelenting and irremediable quality Artaud had advocated, where the unexpected (which he equates with poetry) was in fact to be expected, because the initial force came not from the human psychology behind the acts but from the acts themselves, in "their original and profound barbarism" (A, p. 23).

Each of these concepts insists on the mingling of things and the human spirit. Each of these eulogies can be read—together with the films to which it is related—as a manifesto of some middle ground between the purely abstract, linear, and machine-like (Léger's cubist *Ballet mécanique*, for example) and the melodramatic spectacle we associate with the later tear-jerking cinematic era. "Constellated with dreams," said Artaud, the cinema was to take its matter and its *play* from "the human skin of things":

It exalts matter and makes it appear before us in its profound spirituality, in its relations with the spirit from which it came. Images are born, are deduced, the ones from the others, im-

[1] Robert Desnos, *Cinéma*, ed. André Tchernia (Paris: Gallimard, 1966), p. 139. Hereafter cited as C.

[2] Antonin Artaud, *Oeuvres complètes*, Vol. 3 (Paris: Gallimard, 1961), pp. 99, 244c. Hereafter cited as Ar.

[3] Blaise Cendrars, *Aujourd'hui* (Paris: Grasset, 1931), p. 128. Hereafter cited as A.

posing an objective synthesis more penetrating than any possible
abstraction, creating worlds which ask nothing from anybody
or anything. . . . It is not separated from life but it finds again
the primitive disposition of things. (A, p. 23)

And objects themselves create by their inevitable conflict with each other
"a shock for the eyes," so that the cinema's true place is within the look
itself.

Now Cendrars' spectator is to expect to be "snatched up and roughed
up," since he is deeply involved in the action, to the point of seeing
himself on the screen and convulsed with the crowd.[4] Just so, Desnos'
transported dreamer in the darkened cinema hall and Artaud's own spec-
tator of the cinema or the theater are never left unaffected or untouched.
In the intermingling of day and night, reality and dream, objects and
human reactions, or things and ideas, the audience is to experience
multiple possibilities. The potential of the cinema has nothing whatsoever
to do with periods or with epochs or techniques, rather with the endless
hopes of poetry: for Artaud, as for Desnos and for Cendrars, poetry is
unpredictable motion, and for Saint-Pol-Roux, in his living cinema of the
"Future Sun":

The principle of the cinema is movement but above all LIFE.
The word of the future will be "volo." Poetry signifies action.
. . . The Poem is Life.[5]

Artaud's *passage*, or liquid transmutation of the ideas into things and
things into ideas, has a parallel in Saint-Pol-Roux's *Idéoréalité* (CV, p.
24) the means by which mechanical processes can be made "to dream."[6]
The apparatus of the film was to be the *Idéoréalisateur*, bringing dreams
or ideas into reality or into plasticity, thus *Idéoplasticité*, totally opposed
to a simple "screenism," which would be addressed to the eyes alone,
like the retinal art Duchamp rejects. Here, as is always the case in Artaud,
a larger force is to be felt behind the scene and the impulse to human-
ization and even idealization: "Until now: the image. But we shall be
the image and we shall be the idea" (CV, p. 114). Again Artaud's col-

[4] Blaise Cendrars, *Trop c'est trop* (Paris: Denoel, 1957), p. 191.

[5] Saint-Pol-Roux, *Cinéma vivant* (Paris: La Rougerie, 1972) , pp. 37, 71. Hereafter cited
as CV.

[6] Breton called upon water to paralyze machines in order to liberate the irrational or
dreaming function of Surrealist imagination, associated with the feminine. See also my
comparison of the imagining of water by Breton to that by Bachelard in *Surrealism and the
Literary Imagination: A Study of Bachelard and Breton* (The Hague: Mouton, 1966). In
Entr'acte the dreamer's forehead is traversed by images of water: "Swan Lake," of course,
but also other sources.

lective initial passion, Desnos' shared dreams, and Cendrars' participatory cinema are gathered together by the words of the Magnificent; a generative cinema, he says, would put the many in the place of a man alone: "To create oneself, to double oneself, to multiply" (CV, p. 52; Increase and multiply, so we read the text). We must use each trace of personal vitality as it is amassed for our own nourishment, he maintains, and combine with others; the tone of his manifesto of collective energy is unmistakably and forcibly lyric: "steps on the road, heartbeats, sounds? The cries of crowds? Human sweat? . . . Do not all these lost and neglected strengths constitute a human radium?" (CV, p. 37).

This appeal to the collective and the vivid is not unlike the tone of Desnos' own comment on Eisenstein's *General Line* (1930), beginning by a shout "To give things concreteness" and ending on a level of imagery not even to be outdone by Saint-Pol-Roux's loftier expressions. Confronted by such junctions of idea and object as Eisenstein offers in *The General Line*, Desnos exults:

Once more lyricism born of certainty and faith broke through the obstacles of life.

And there were only men on a planet turning regularly about its sun, in a sky encumbered with planets and suns.

(C, p. 195)

All this cinema of the vital idea, of energy caught and transmitted at its highest peak, this multiplication of beings and this apotheosis of movement moves along in high gear: placed as Saint-Pol-Roux places it under the somewhat odd heading of the Infused Sun (in capital letters), it may well seem to justify these theoreticians being relegated to the realm of the "illumined" but impractical. "Our Earth is a future Sun," he says, and we shall gradually move accordingly from the terrestrial to the "Terreastral" to the "Interastral." It is, he continues, under the influence of the sun that we grow and multiply; as opposed to photography, which captures the sun on the outer surface of things, the cinema takes the orb within itself. "*The sun inside*" is Saint-Pol-Roux's definition of the cinema. In fact, since our double is solar, "we shall be in the sun," shall participate in both realms, the animal and the ideal, in a juxtaposed contrast: "animalement idéale." As to the further profusion of energy, it must operate also from the inner man: "Will the sun act by direct heat or will people be able to produce their life from themselves as the glowworm produces his own light? This is the miracle to be hoped for" (CV, p. 55).

It is not my wish to reduce the Absolute to more modest proportions or the lofty ideas of such a Magnificent idea-man to merely manageable

ones. The lesson we might learn from this exalted theory goes beyond an energetic dynamism already part and parcel of our creative theorizing, in this era he refers to as our *Posthistoire* or Afterhistory. The cinema is still "gerundive," as he claims, still partial, still about to be. In particular, the concept of the mirror inside seems appealing to our sensibilities as does that profound look within the self, that "Plastic, objective, attentive examination of the internal I" which Artaud recommends as the only manner of understanding his film *La Coquille et le clergyman*, /The Seashell and the Clergyman (Ar, 3:82). In this light, certain Surrealist texts may now take as their own the sense of this newly energized passage toward an inner perspective, however oddly phrased by the Magnificent theorist "Let us open this third eye of Vision: Let us surnaturalize" (A, p. 31).

TEXTS FOR AN INNER EYE

It is in the light of the preceding remarks that I should like to consider the cinema of the Surrealist text, with especial references to Michel Leiris, to Robert Desnos, and in particular to Louis Aragon.

Any number of Dada and Surrealist scenes can be considered as related to each other in a series of reflections and cross-reflections: the term is deliberately used, itself reflecting upon the mirror image that will form the conclusion of this chapter. Duchamp's index finger in *Tu m'* of 1928 points the observer's way toward the gesturing finger in Leiris' *Point Cardinal* of 1928 and Desnos' "Doigt indicateur" to illustrate his own 1928 novel *La Liberté ou l'amour!* (Freedom or Love!). The habitué of Dada and Surrealist texts is haunted by such visual criss-crossing of images, and their convergence is given a privileged status through Reverdy's remarks concerning the illumination provided by the clash of two elements taken from widely distant realms, these remarks seconded and enlarged upon by Breton. In the universe whose profile Breton sees as open or fluid (see, for instance, his "Crisis of the Surrealist Object"), imagination finds free flow, liberated from the rational or hard-line objective viewpoint that is Surrealism's easily-vanquished enemy.

The transmutation of objects in flux might well take place in the "Passage de l'Opéra onirique," that covered gallery of the dream work in which Aragon's *Paysan de Paris* (The Paris Peasant, 1924) is inscribed. A perfect image of the dreamer is offered by the genial *Entr'acte:*[7] over

[7] The imagining of the hair is also at times, linked to more spectacular passages. For instance, in the *Aurora* of Michel Leiris ("L'Aurore" written in 1927-1928), the hair of the anonymous heroine is the very emblem of freedom, its fiery waves in the wind of passion surviving to the last, even after the destruction of the woman's body. It first initiates a

the forehead of the dreamer, in the film, the waves carry all the flux of possibility. Images flow one into the next, visibly through his mind and ours in response, reminding us of the theorizing of Bachelard as to the enabling function of water for the freeing of images and of Breton's hoping for the paralysis of machines and logical masculine *animus* by the irrational feminine element, by the *anima* of the wave.

In a remarkable play on the verbal and visual elements of the wave as such, the sustained rhapsody on the waving of blond hair occasioned by the hairdressers of the *Passage de l'Opéra* and the undersea atmosphere combined, wave and wave. We remember the mane of wavy hair in Baudelaire's "La Chevelure" and "Une Hemisphere dans la chevelure" as it links with the water imagery, and we imagine the suggested chain *onde/onde/ondine*, the verbal and visual obsessions providing the generating source for the flow of the text, these "waves," closely linked with the water imagery, leading to a series of beauty-before-the-mirror-scenes. Thus the proliferation of convergent images, such as the "water-wing" of the comb held by the woman dreamed of in Breton's famous visionary poem beginning "Je rêve je te vois superposée" (I dream I see you superposed) and the manes of hair passing in Desnos' "Paroles des rochers," those "words of rocks" upon the deserted beach. Elsewhere Desnos fixes his gaze upon a mass of neatly braided hair ("But your hair . . . has the form of a hand") whereas Aragon sees "A braid of hair hanging from tousled night." What the reader sees is more likely to be the fixation of the Surrealist look, apparently inescapable. The object fixated serves as a visual model, and at the same time as the focus for verbal repetition: "But your hair . . . But your hair," and as a model for the creative gaze and the cinematic expression: The image of flowing hair serves as a

passage on pursuit, regeneration, and cyclical motion: "What searcher will be able to find this miraculous hair whose wave gives the only true image of the surging forth of springs, of vegetal death and of passion's bird-like circling?" (p. 35). When Aurora is destroyed little by little, the hair remains: it "floated freely above her, the only living undulation in this desolated world. . . . Languidly, Aurora's eyes had closed, but her hair continued to float, the last conscious part of herself, even more caressing than a snake" (p. 74). And finally the consummation of the passion at its apogee, an obsession finding its fullest realization, destructive but redeeming: "Then Aurora's hair transformed itself into a flaming whirlwind, as the furthest comets rushed forward in a blink of an eye to increase the ardor of this brasier by their own incandescent manes" (p. 75). And, in Artaud, at the end of "La vitre d'amour" ("The pane of love"), a mane of blonde hair hangs (Ar, 1:155). For some possible intertextual references in *Entr'acte*, for example, see the little paper boat sailing in the rain, as in the tiny and frail paper boat sailed by a child in a mud puddle at the end of Rimbaud's "Drunken Boat" ("Le Bateau Ivre") or the end of the film where the "director" crashes through the canvas as the clown or poet of Mallarmé's "The Chastised Clown" ("Le Pitre châtié") bursts through the circus tent at the conclusion of the poem.

guiding thread given the pervasive liquidity of the element of dream, whose waves should not be overlooked.

These references and others give an intertextual dimension to an extraordinary passage in Aragon's early view of the universe in *Anicet ou le panorama* (Anicet or the panorama, 1921), from the chapter entitled "Mirabelle ou le dialogue interrompu" (Mirabelle or the interrupted dialogue). Now Mirabelle, literally, the beautiful lady given to looking at herself (or "Look, Lovely!") is of course a transposition of the Symbolist mode of lady-before-the-mirror, of Mallarmé's Herodiade and others. Mire, for short, is seated before her dressing table.

> . . . on the other side of the Pacific, a fearful space of curly wool a five-sided carpet obliquely laid across the room, from the feet of the young man to those of the faithless lady. She did not turn around, still unfastening her black hair, looking at the intruder in the mirror of her dresser. The idea that she was seeing him in this little circle opposite to him, like a tiny marionnette reduced in size by his respectfulness, while he could only see Mire's face and her silver eyes, disturbed Anicet as if he had felt himself swept away by an enchanter's wand and transported into a virtual domain, far on the other side of walls and seas. So he felt light, light like a man slightly tipsy.[8]

The juxtaposition of close and long shots yields to a dialogue, not between Mire and Anicet, but between the severed head (for what is seen by Anicet, as in the mirror, becomes true of the scene) and the "faraway image," taken from her point of view. "The mirror speaks," says the text, and then the reflection—his, not hers, for this is again her view. The persuasion of the scene is such that the text imposes on its own seer or reader the vision included in its construction: not "as if the reflection were to speak" or "as if the mirror spoke" but an evident assertion of the fact, in reality "contrary-to-fact." In the beginning of the scene, Anicet felt himself indeed transported beyond the ocean suggested by the rug's white woolliness, like so many foaming waves; here asserting himself necessarily against what was seen, Anicet confuses text and illusion:

> —Mire, here I've approached you to be by your side, *life-size* like a man and unlike the hesitating and diminished image you had of me just a moment ago. (An, p. 164)

[8] Here the play is on "mouton" (lamb), so that the verb relates "Moutonner," or to curl whitely, like lamb fleece, to clouds and white caps on the waves. Baudelaire, who haunts Aragon's writing plays in much the same way when it is a question of hair. See Louis Aragon, *Anicet, ou le Panorama* (Paris: Gallimard, 1921), p. 155. Hereafter cited as An.

The tone of his speech strikes us as odd, and the words "grandeur nature" (lifesize) and the denial of his previous miniscule image—appearing to himself as indeed he appeared to her—leave the question open as to what we were supposed to have seen. Characteristic of Aragon and of his "passages" (as in the symbolic wandering in the *Passage de l'Opéra*) are the interplay of out and in, of cosmic and trivial, communicating contradictions between the concepts of "real" and "illusory" or "lifesize" and "unrealistic": the switching back and forth between two elements, proper to Surrealism.

Anicet's statement is as far removed from the simple one-way visualization Artaud rejected in merely "seeable" texts as it is from the closed off and congealed quality he so hated in the speaking films picturing an "arrested world." We observe a sort of speech-scene, combining the psychological flow of the visual images one from the other, and a verbalization of the mental process:

> I no longer separate the tragic from your hair undone, the only
> reality remaining, with the white of your dress and that table,
> in the dim light coming from the shutters, where you are seated,
> the table like a new extension of your body. (An, p. 164)

Here a scene from Robbe-Grillet's film *L'Immortelle* may present itself to the viewer, as woman and white dress and shutters flicker before the eyes like the white dress and feathers of the woman on the bed in *L'Année dernière à Marienbad* (Last Year at Marienbad). But the vision we are led to share is then distanced once more by the narrator, sounding like the voice of truth, speaking of the "real":

> There must really have been a certain dizziness in the top of
> the room under the cone of light and near the dressing table,
> for Anicet, remaining there, seemed to stumble on the edge of
> some abyss. Mire's hair was spinning, spinning like an electric
> siren and Mire's eyes were only flat dim metallic facts where
> the daylight's beams took risky directions, criss-crossing sud-
> denly in a web of incomprehensible letters and numbers which
> may have explained the Universe but did not manage to hold
> Anicet's interest. (An, p. 165)

It should be noted that the room is envisioned already like a page, in whose upper part ("le haut") the fascination is concentrated. But the hair/siren suggestion is only skimmed over before the so elaborately spun spell is broken; henceforth a reduction is manifest, from the erstwhile silver eyes to the metallization, the psychological lessening of interest on Anicet's part being signaled also in the text by the words "flat" and "dim"

("plate," "obscures"). For the charmed is no longer charmed, and the turn takes place. Everything turns upside down and inside out while the scene returns to the book, although with a certain displacement: the door is thrown open with a great burst to interrupt all the former speech and scene, and this "grand éclat" takes place before our eyes, clearly stated as being on the page for a textual passage across the threshold; in the moment of reversal itself:

> . . . all of a sudden the values were reversed: the protagonists became the spectators, the direction of the room changed. The top of the page was near the threshold. (An, p. 165)

Now the protagonists, toward the "bottom of the page," see the intruder toward its top, as the screen becomes the page once more.

This whole extraordinary passage between two media was predicted a few pages earlier in a chapter called, appropriately enough, "Movements." Inserted in the text still considered as film, on its screen, "someone to whom no attention had so far been paid" acts as a mirror for Anicet's own look, a revealer or a developer:

> Seeing it on another's face, Anicet more easily understood the drama going on in himself, which his own features must have betrayed. For one instant he identified himself with the concerned personage looking at him from the canvas, and he no longer knew whether he was before a screen or a mirror.[9]

At one time, Anicet had explained that he was leaving—as one would a forest of signals—the time when one looked in oneself by the help of a system of mirrors. The system has changed, and the way of looking, and the self. Still seen with the central eye, the internal vision where the screen shows itself visual but also conceptual is less illuminated by the external light of photography and "real" outer transitions than by what Artaud calls the "furtive idea of passage and of the transmutation of ideas into things." Both mirror and screen move inside.

[9] Aragon, *Anicet, ou le Panorama*, p. 143. Again, in preparation for the following scene, of hair and mirror, Anicet's intertextual remark made here: "I almost said to him: 'Ma Douleur' ": the reference is to Baudelaire's famous sonnet about twilight and his companion sorrow. In her article called "*Anicet*, or the pursuit of *pulcherie*," in *Symbolism and Modern Literature: Studies in Honor of Wallace Fowlie*, ed. Marcel Tetel (Durham: Duke University Press, 1978), Anna Balakian comments on the panorama spread out for our vision: "The central magnet of the 'Panorama,' as Aragon calls his narrative, is a woman named Mirabelle. If 'belle' obviously stands for beauty, 'mira' may well imply a reflection—which indeed makes her the center of a multi-faceted courtship. But it also suggests the mirror vision, the false appearance, the semblance, implying the mistake that the generation of 1918 may have made in its definition of Beauty" (p. 238).

A second passage toward a cinema of the text may be made through Aragon's *Le Paysan de Paris*, where a few pages are peculiarly set, stressed by being far more grandiose in conception than the rest and deliberately distinguished in vocabulary and tone from the passages of a more routine perception. Given the color of the presentation and its intense visuality, it would be considered, by any but the most strait-laced of criteria, a highly cinematic setting:

> Ici ne peut se passer qu'une grande chose . . .
> La grande femme grandit.
>
> Here nothing but a great thing can happen . . .
> The tall woman becomes taller.[10]

The set is grand, the heroine tall, and the language appropriately high: "grande . . . grande . . . grandit." The scene opens with a cape of stars far-flung, and then undone: "Et le silence est un manteau qui se dénoue. Voyez les grands plis pleins d'étoiles" (PP, p. 204; And silence is a cloak unknotted, Look at the great star-filled pleats). This initial exposure is given a star-filled cast. The sea passes or sweeps through the poet, by his own wish, consuming him entirely, absorbing not only his perception but also his substance and his speech: "pass through me"; even in its details, the scene functions in a unusually dramatic fashion, as intimate as it is dramatic. For example, the constant implied verbal play of "mer" against "mère," sea against mother, permits the gradual traversal of the poet by the invoked object of his desire, in a passage easily dominating his own presence: "Femme, tu prends pourtant la place de toute forme" (PP, p. 209; Woman, you take the place of any form). The mother/woman liquid element is at once here the piercing; she is limitless and yet near, like Surrealist thought and expression in all their fruitful contradictions. This kind of expression is perfectly instanced by the line "Tu es l'horizon et la présence" (PP, p. 209; You are horizon and presence), startling to the perception in its odd juxtaposition of the close-up with the distance, the merging of the long and near shot, quite like Desnos' anguished expression of the contrasting views of love: "Loin de moi, ô mon présent présent tourment . . . Si tu savais" (Far from me, oh my present present torment . . . If you knew). "Along with the desired dispossession from the self goes an intensive verbal repetition, heard as a stammer, leading toward silence and embedded in the text: "Eau pareille aux larmes . . . Tue, tue" (PP, p. 210; Water resembling tears . . . Kill, kill), as if the sound

[10] Louis Aragon, *Le Paysan de Paris* (Paris: Gallimard, 1923), p. 208. Hereafter referred to as PP.

[11] Robert Desnos, *Corps et biens* (Paris: Gallimard, 1968), pp. 95-97.

track were to be double, so that we could hear in the single expression just quoted, still other meanings: "Ô pareille aux larmes" (Oh like tears . . . stilled, stilled).

Now the poet's delirium, bathed as he is in the magna mater, rolled in her waves as his speech is enveloped in her voice, permits him a heroic delivery combining the cosmic and the personal, shifting wildly from out to in to out: "My forests, my heart, my cavalcades" (PP, p. 213). The genders too lose their separation, as the erotic wandering pursues its epic way through grotto and furrow plowed, through cannon fire, through a sword-marked path, through a gamut of blood and sighs. The cloak once unknotted has finally enfolded the narrator in the pleats of a double role, played out alone, as he is himself traversed, by his own voice and with that sword, by the vision and the voice of the woman as seascape, mistress, and mother.

Yet an intense loneliness is revealed under the cloak of poetic language, in a repeated questioning:

> Suis-je seul vraiment, dans cette grotte de sel gemme. . . . Suis-je seul, sous ces arbres taillés avec soin dans une chaleur d'azur . . . suis-je seul dans cette voiture de livraison. . . . Suis-je seul au bord de ce canon. . . . Suis-je seul n'importe où. . . . Suis-je seul dans tout abîme. . . . Seul par les labours et les epées. Seul par les saignements et les soupirs. . . . Seul par les bourrasques, les bouquets de violettes, les soirées manquées. Seul à la pointe de moi-même. . . . Plus seul que les pierres, plus seul que les moules dans les ténèbres, plus seul qu'un pyrogène vide à midi sur une table de terrasse. Plus seul que tout. Plus seul que ce qui est seul dans son manteau d'hermine, que ce qui est seul sur un anneau de cristal, que ce qui est seul dans le coeur d'une cité ensevelie. (PP, pp. 213-215)

> Am I really alone, in this grotto of rock salt. . . . Am I alone, under these trees carefully pruned in an azure heat . . . am I alone in this rented car. . . . Am I alone on the rim of this cannon. . . . Am I alone in each abyss. . . . Alone through the ploughings and swords. Alone through the bleedings and sighings. . . . Alone through the gusts of wind, the bouquets of violets, the failed evenings. Alone, at the point of myself. . . . More alone than the stones, more alone than the mussels in shadows, more alone than an empty pyrogen at noon on a terrace table. More alone than anything at all. More alone than what is alone in its hermine cloak, than what is alone on a ring of crystal, than what is alone in the heart of a buried city.

After the extraordinary initial proliferation of natural and cultural images in series, the question of solitude—more and more feverishly posed, "seul . . . seul . . . seul," as the images become graver, moving from crystal to abyss—has no answer but an implied one: yes, I am alone. Subsequently, the epic suffering is spelled out in terms of emptiness and effort; through traces of work and of struggle, of wounding and weeping and desertion, until the final climactic statement: "More alone than . . . " Here the movement works from present flowers and stones and absent fire to the crystal, alas condemned. I am reminded of the end of a poem of Robert Desnos:

> Jamais jamais d'autre que toi
> Et moi seul seul seul comme le lierre fané des
> jardins de banlieue seul comme le verre
> Et toi jamais d'autre que toi.[12]

> Never never anyone but you
> And I alone alone alone like withered ivy
> in suburban gardens alone like glass
> And you never anyone but you.

As the question moves toward its inexorably tragic answer, the narrative voice refuses even our response, choosing to be alone and without audience, lonely, lonelier still.

The round danger of the cannon's rim becomes merely a transparent circling—"lonelier than what is alone on a ring of crystal"—as if Breton's celebrated praise of the clarity and candor of crystal in his "Éloge du cristal" (Praise of the Crystal) were to have left behind as a splendid trace only that endlessly repetitious image with no beginning and no end. The discourse itself is swallowed up in the heart of a central hush of a civilization doomed beyond speech and life: "lonelier than what is alone in the heart of a buried city" (PP, p. 215), while the speaker's visage fades out from its lonely self-questioning, and the screen goes dark, in a final passage from cinematic text and narrated vision to silence, abandon, and closure.

THE MIRROR INSIDE

To return to the central eye, let us reflect for a moment on reflection. One of the oddest associations of eye and mirror is found in Saint-Pol-Roux, exemplified in his prose poem called "The Glass Cupboard" ("L'Armoire à Glace"):

[12] Desnos, *Corps et biens*, p. 143. Translation from my *Poetry of Dada and Surrealism* (Princeton, Princeton University Press, 1970), p. 193.

S'y mirer égalait s'y baigner.
Et la vivance d'un oeil.[13]

To look into it was the equal of bathing in it.
And an eye's liveliness.

Even his peacock has cruel eyes of icy crystal, like frozen mirrors of which the ice is never broken, as in the two senses of the "glace" in their "regards de glace." As with Aragon's ring of loneliness just seen, the round and crystalline object serves as a focus of fascination, to hold the gaze, within the text and without. We look at the look in its glassy stare: "The emotion of the mirror is the newborn wailing of the work./ What constitutes the work is its effect made plastic" (L, p. 27).

Now the inner or central eye may be likened to this cold reflector as it functions in the middle ground between the outer scene or verbal expression and the implications of thought. To see, within the text, not only its visual suppositions and suggestions but the alterations made in it by our own perspective befits the *inscape* or the space of the inner vision referred to before, to be contrasted with the *outlook* of exterior vision. As a further image, the Egyptian mummy case on which the glassy painted eyes look without or within, reveals the inner eye as we see it here, in its gaze directed not only toward the seen, outer or inner, but— as in Leonardo's text on the look of the text—toward the onlooker's look which it mirrors in its turn. What we see, it is said, sees us; the centrality of the cinematic text is of course also that of the "I." But the eye may be figured too by an image opposite to a frozen *glace* or mirror (both included, reflected in the word "glace"), rather by a sun as in Saint-Pol-Roux's extraordinary passage on the sunflower. Breton's own "Tournesol" may be a reflection upon this text, which here is celebrating a convergence of the sun and the eye and the flower, all turning and spinning, in a high fervor and fever:

La Religion du Tournesol

Tout à virer après le Soleil qu'ancillairement il admirait, jamais ce Tournesol, fervent comme un coup d'encensoir figé en l'air, n'avait daigné m'apercevoir, malgré ma cour de chaque heure et de chaque sorte.

Oeil du Gange en accordailles avec le nombril du firmament, la fleur guèbre ne voulait se distraire de son absolue contemplation. . . .

[13] Saint-Pol-Roux, "Liminaire," in *Les Reposoirs* (Paris: Rougerie, 1972), p. 62. Hereafter cited as L.

Alors, me prenant sans doute pour le Soleil, le Tournesol
tourna vers moi son admiration,—et dans cet oeil je m'aperçus
tout en lumière et tout en gloire. (L, p. 58)

THE RELIGION OF THE SUNFLOWER

Spinning after the Sun which it admired in its ancillary way,
never had this Sunflower, fervent as the shaking of a censer then
transfixed in the air, deigned to notice me, in spite of my paying
tribute each hour and in every fashion.

Eye of the Ganges in agreement with the navel of the Fir-
mament, the fire-worshipping flower refused to be distracted
from its absolute contemplation. . . .

Then, taking me probably for the Sun, the Sunflower turned
toward me its admiration—and in that eye I perceived myself
all in light and all in glory.

(We recognize the eye and peacock motif, and that of the sunflower,
from the English aesthetic movement with its bridge to the French sym-
bolists: Whistler and Wilde are not far off.)

As a visual illustration of the central eye which in this case is also that
of the sun, we might consider the "Soleil mystique," the mystic sun of
Pierre Garnier, a contemporary spatialist poet (figure 59). As the wing
("aile") from the left resembling an inflying plane, prods the central and
amassed force of the sun ("soleil"), it is flanked, as it were, in its flying
formation by two partial anagrams of the word "soleil," the "île"—
suggestive of an island ("ile"), but giving also the simple sound of "he"
("il"), as the "aile" itself sounds like a simple "L," or then the feminine
referent "elle." These contrasts are met in the "oeil," the eye that will
then take its place in the center of the page, directly beneath the sun's
streaming force surrounding it, dispensing it, and guaranteeing its vision.
At the right side of the diagram, as the eyes come finally forth independent
from the sun's rays, all the words from the leftward wing are pushed
outward toward the border, as if radiating into space. The energy of
reading moves then both outward from the center, streaming suns down
and up the page, and also across the page from the left-hand aggressive
insert of the v-shaped wing to its opposite number, the emptied "v" to
the right, opening like a future thrust toward the infinite of the space
beyond the page. The reading of this text is made left to right, so that the
energy of the eye figured and responding is controlled by the direction
of the passage.

After this paradigm image, a final meditation. In Breton's *Vases com-
municants*, we read the following statement: "the production of dream

images depends always upon this double play of mirror," and pursue his remarks into the interior mirror of our own mind. Now why should we not consider the production of visual images—that is, those corresponding to the cinematic imagination I call the cinema of the central eye—to lead to a production of that kind? This reflection, as a double reflection, upon what is to be seen, whether in exterior or in interior reality, whether in a text or in a dream makes the same juncture as Surrealism's conducting thread, linking contraries: the outer and inner, the waking and sleeping, like Freud's "dreamer in broad daylight." This imaginative leap of the verbal toward the visual and vice versa is the subject of the present essays, directed not toward the poet but toward the reader as spectator finding his own source of light within the seen.

14

DWELLING ON THE THRESHOLD

> Peut-on à la fois espérer et ne pas espérer, me dis-je,
> même aujourd'hui. . . . Ah! combien nous faudrait-il
> abandonner de ce que nous sommes, quelles couleurs
> . . . quels épanchements de clarté sur de la noirceur.
>
> (Can one at once hope and not hope, I wondered, even
> today? . . . Ah! how much we would have to abandon
> of what we are, what colors . . . what effusions of clarity
> on the blackness.)
>
> —Yves Bonnefoy, preface to *Haiku*.

SETTING THE SIGHTS

IN THE THOUGHT of Bonnefoy, and in his writing, the threshold remains. Considering the work of contemporaries, he often sees one object contained by another, one place or one text as the essential reference for another, and by implication and extension, one artistic effort leading to the other, for the most intense consciousness of crossing: "And I thought, each time in this studio of another one, having also something transcendent about it in relation to the world of other men, and where you entered therefore with the feeling of crossing a threshold which had only the slightest possibility of return."[1] Now the conception of the threshold as such—whether it is taken as the state in-between, as the beginning boundary, or as the specific setting of the setting, a scene where, long ago, a sign used to be placed—has a certain simplicity to it. The transfer from the exterior of a structure to the interior and back serves to imply another, deeper transfer: here, the threshold may be seen to recede into the far distance.

In concluding this volume of essays with a threshold, I shall limit myself to a few recent texts of Yves Bonnefoy, his *Le Nuage rouge* (The Red Cloud, 1977) referring to Mondrian's painting by the same name, mentioned first in *L'Arrière-Pays* (The Country Beyond); later he places that crimson image in *Dans le leurre du seuil* (In the Threshold's

[1] *Claude Garache* (Paris: Galerie Maeght, 1978).

Lure, 1975) which itself forms the guiding text for our present crossing, together with a brief essay on a volume of *Haiku* in 1978.[2]

At the center—itself also the threshold, as Jabès claims: "Le centre est le seuil"—I would place the thought of Mallarmé. His concern, and ours, is first that for a relation between exterior and interior and for faithfulness to reality as to the mind: "Nothing," says Mallarmé in a defense of the natural object, "transgresses the figures of the valley, the meadow, and the garden" (NR, p. 184). Within language there must be maintained the real sense of the real: it is Bonnefoy's great and most optimistic contention, based on his attitude toward poetry, that indeed "words can give us back the earth, which the earth took from us" (NR, 186). There is real being in words ("il y a de l'être"), even if their acts seem highly restricted as in Mallarmé's essay on limits, or "l'action restreinte."

Dans le leurre du seuil describes a verbal and visual rite of passage both formal and conceptual: a river, to be forded and followed, like an obstacle and yet a passageway, exposes the threshold of the text, majestically. The poem commences in mid-path, for the initial protest of the first two words. "Mais non" (But no) at once joins and cuts the poem off from all that went before: discourse and presentation are new and yet linked to the past by negating it. But then the initial description is itself interrupted by a summons, categorically demanding our most attentive perception: "Regarde! De tous tes yeux regarde!" (DLS, p. 232; Look! Look as hard as you can!), repeated a few lines later, in a terse one-word imperative filling a line to itself, marking the text by its repetition: "Regarde!"

But suddenly then the scene is perceived through another's eyes, for the poet's companion dreams: "That a boat laden with black earth shoved off from a bank." It is this mythical voyage on the Styx—away, thus, from memory—that guides him toward the celebration of the nearby earth, toward a questioning of the meaning of perfection and completion, divorced from the specific image in its brightness and sharp profile, or then recalling the memory of some other similar image, of which it is perhaps only a repetition, recalling color, sound, and happiness:

O terre, terre,
Pourquoi la perfection du fruit, lorsque le sens
Comme une barque à peine pressentie
Se dérobe de la couleur et de la forme,

[2] *Le Nuage Rouge* (Paris: Mercure, 1977), hereafter cited as NR; *L'Arrière-Pays* (Geneva: Skira, 1972), hereafter cited as AP; "Dans le leurre du seuil," in *Poèmes* (Paris: Mercure, 1978), hereafter cited as DLS.

Et d'où ce souvenir qui serre le coeur
De la barque d'un autre été au ras des herbes?
D'où, oui, tant d'évidence à travers tant
D'énigme, et tant de certitude encore, et même
Tant de joie, préservée? (DLS, p. 233)

Oh earth, earth,
Why the perfection of fruit, when meaning
Like a ship scarcely foretold
Slips away from color and from form,
And whence this heart-wrenching memory
Of another summer's ship level with the grasses?
Whence, yes, so great an evidence through
Such great enigma, and such sureness still, and even
Such joy, preserved?

The poem questions memory, and yet retains it in its own flow: against the river's current, a few pictures play, each of which foreshadows the final pool of water in which all of eternity will be seized in just a few words. Each image radiates beyond itself into some quietly symbolic fullness: the bright picture of a young god fording the stream, a shepherd moving off slowly in the dust, some children playing noisily in the foliage, and, guiding the whole, the renewed and simultaneously renewing image as in *Moses Saved* (figure 58), Poussin's great canvas, the culmination of Bonnefoy's visual and verbal autobiography called *L'Arrière-Pays*, the predominant image lasting through his texts; the poet is ferryman, and in that sense, the traverser of boundaries, the instrument of crossing over from one place into the place redeemed. The waters by which he plies his trade are both mysterious and "burned with enigma": he, the poet, carries us across them toward the perception of a nearby land, in all its presence, today. The vision of past and the acceptance of the present vitally reinforce each other, consented to in a refrain that scans the length of this epic work, a personally committing statement of the meaning of poetry, and of the vision it alone affords: the summons once addressed to perception is now addressed to hearing, and is answered positively: "J'écoute, je consens" (DLS, p. 263; I listen, I consent).

After the hearing and agreement, now for the first time the poet is given to see and to understand the brightest threshold of perception itself, where light is designated, rent apart, and purified. The speaking subject remains unsure, still, of existence outside the individual image, which itself now takes on the substance of reality, not in the repeated or remembered, but in the singular moment:

Sous le porche de foudre
Fendu
Nous sommes et ne sommes pas (DLS, p. 278)

Under the porch of lightning
Cloven
We are and are not

And the day ends with the simplest images and in acceptance of the simplest natural manifestations. Bonnefoy's prevailing aesthetic will place value primarily on the modest and the minimal as the surest sources of deep feeling, those subject to the least betrayal. In his essay on the haiku form, as in his essay on "Peinture, poésie: vertige, paix" (Painting, Poetry: Vertigo, Peace), Bonnefoy concentrates on small and hallowed tasks, making no separation between the domestic and the artistic, sweeping or drawing a few lines while an insect scratches at the door: "Bringing in the wash, breaking up the wood, brushing the embers of the hearth into a little heap at midnight, each act in this mental space—the haiku being one among the others, with its special contingent of words to aid in these tasks—is as if one were to wash the windows of a perfect house made of light wood and glass, or to place in its center a few flowers summing everything up."[3]

In the "place which is language," the word finds its unique triumph, like the image itself, in the few shades of a smallish scale of colors, in a mellowed time. Accordingly, in the following lines related to perception itself, the crystal is slightly yellowed, in striking contrast, for instance, to Duchamp's Great Glass with its obscurity for the brain only, in contrast to the mirrors frequent in Mallarmé, Breton, Desnos, Aragon, and Eluard, reflecting the figures of Hérodiade or some Nude or Virgin or Bride on her way to some kind of conception or other. The value is differently placed, and the vision, complicated in Duchamp and Mallarmé where an element of violence is often present, is of an uncomplicated consenting in Bonnefoy, where violation is done neither to the physical nor to the mental:

Et tant vaut la journée qui va finir,
Si précieuse la qualité de cette lumière,
Si simple le cristal un peu jauni
De ces arbres, de ces chemins parmi des sources
. . .
Oui, moi les pierres du soir, illuminées,
Je consens.

[3] Yves Bonnefoy, *Haiku* (Paris: Arthème Fayard, 1977), p. xxxvii. Hereafter cited as Ha.

Oui moi la flaque
Plus vaste que le ciel . . .

. . .
Et moi le feu, moi
La pupille du feu, dans la fumée
Des herbes et des siècles, je consens. (DLS, pp. 280-286)

And such is the worth of the day about to end
So precious the quality of this light,
So simple the slightly yellowed crystal
Of these trees, of these paths among the springs.

. . .
Yes I the stones of evening, lit,
I consent.

Yes, I the pool
Vaster than the sky . . .

. . .
And I the fire, I
The pupil of the fire, in the smoke
Of grasses and of centuries, I consent.

Seeing, Near and Far

> Puisque l'arrière-pays, c'est d'abord un regard sur le
> lieu proche.

> Since the back country is first of all a view of a place
> nearby.

—Yves Bonnefoy, L'Arrière-Pays

In the paths of the apparently simple, where poetry now moves, we may still not be cured of the nostalgia for a garden of perfect things, in their full flowering. But the reader, like the poet, learns to accept the fragmentary, once reassembled, as a possible fulfillment: provided perception can be so guided, the most minimal sign can indicate the way toward the deepest passage of water and word and toward the theshold of this visible construction, sufficient to dwell in. This then is the convergent text, introduced by an invocation of sight and illumination, of linguistic and visual transfiguration:

Je crie, Regarde,
La lumière
Vivait la, près de nous! Ici, sa provision
D'eau, encore transfigurée. Ici le bois

Dans la remise. Ici, les quelques fruits
À sécher dans les vibrations du ciel de l'aube.

Rien n'a changé,
Ce sont les mêmes lieux et les mêmes choses,
Presque les mêmes mots,
Mais vois, en toi, en moi
L'indivis, l'invisible se rassemblent.

* * *

Je crie, Regarde,
L'amandier
Se couvre brusquement de milliers de fleurs. (DLS, pp. 271-272)

I cry, Look,
The light
Lived there, close to us! Here its supply
Of water, still transfigured. Here the word
In the shed. Here, the few fruits
To be dried in the vibrations of the sky at dawn.

Nothing has changed,
These are the same places, and things,
Almost the same words,
But, see, in you, in me
The undivided, the invisible are met.

* * *

I cry, Look,
The almond tree
Is covered suddenly with a thousand flowers.

Like the apple tree flowering "of the sea" that culminates in a crossing over of land into water imagery in the greatest poem Breton ever wrote on vision ("On me dit que là-bas"/They tell me that over there), already referred to, from his *L'air de l'eau* (Water Air), the fullness of this one image justifies the close attention paid to the rightness of word and gaze, to the direction in which they point. Bonnefoy's essays on art and on poetry, like his poems and gravest meditations, all led inexorably to this place:

Qu'aurons-nous eu, en verité, si nous
n'atteignons pas le vrai lieu?

What shall we have had, in truth, if we
do not reach the true place?[4]

[4] *L'Improbable* (Paris: Mercure, 1978), p. 130.

But the passage over the threshold is never as easy as it may appear. Bonnefoy's optimism is tempered with the deepest of doubts. Seeing itself betrays weakness, absolved only insofar as it is confessed. Against this recurring deception and avowal, the threshold must hold, and the image must stand, for the salvation of sight itself. The final yea-saying in its accumulation of image upon image, acceptance upon acceptance, has all the deeper value now for this passage "par le noir," through the blacker side of perception, like an ordeal ("L'ordalie") of poetry and of vision, temporarily blinded yet eternally marked:

Mais toujours et distinctement je vois aussi
La tache noire dans l'image, j'entends le cri
Qui perce la musique, je sais en moi
La misère du sens. Non, ce n'est pas
Aux transfigurations que peut prétendre
Notre lieu, en son mal. . . .

* * *

Ici, la tâche
Que je ne sais finir. Ici, les mots
Que je ne dirai pas.

Ici, la flaque
Noire, dans la nuée.
Ici, dans le regard,
Le point aveugle. (DLS, pp. 295-303)

But always and distinctly I also see
The black spot in the image, I hear the cry
Piercing the music, know in myself
The misery of meaning. No, not to
Transfigurations can our place
Lay claim, in its suffering. . . .

* * *

Here, the task
Which I know not how to finish. Here,
The words which I shall not say.

Here, the black
Pool, in the cloud.
Here, in the look,
The blind spot.

This spot of unseeing within the eye and upon the image warns against the lure of specious meaning and calls for faith in spite of such

imperfect perception. Its recognition seems to enable the poem's own moving passage, based on the modest image of a small pool rather than the grandeur of a sea.

At last, after this passage through the dark of things, the missing stone for the threshold is found, and reparation is made precisely at the place of bridging. But the passage is marked as incomplete by a dotted line; silence falls after the finding:

> Oui, par l'arche brisée
> Du seuil
> Dont nous avions trouvé la pierre manquante
> —Passe, fleuve de paix, fais refleurir
> L'oeillet de cette rive.
>
>
> Oui, par ce feu,
> Par son reflet de feu sur l'eau paisible,
> Par notre lieu, qui va,
> Par le chemin de feu sous le fruit mûr. (DLS, pp. 320-321)

> Yes, by the threshold's broken arch,
> Whose missing stone we had found
> —Pass, stream of peace, make the carnation
> of this shore flower once again
>
> Yes, by this fire,
> By its fiery reflection on peaceful water,
> By our place, moving,
> By the fiery path beneath ripe fruit.

A few radiant fruits operate this convergence of sight and language that Bonnefoy has recently described in his essay on painting and peace. In a series of positive images, the tree now yields a fruit capable of its own illumination and renewal, as if by a natural parallel to the threshold healed of its lack: "On dirait que le fruit du premier arbre/ A terminé sa journée dans les branches/ De la douleur du monde" (DLS, p. 321; One might say the first tree's fruit/ Had ended its day in the branches/ Of the world's pain).

The red of the setting sun merges with the other fiery red, the red of suffering, as the fruit ripens: thus the motion takes place through time as through space. The ship passes, and so too perhaps the suffering, consumed by this fire, in whose reflection there is reflected our own. The arch of the bridge under which the ship passes forms the final threshold to be examined here, or better, to be shown, and left in silence, since the ship moves on with no words.

Et à ses vitres les feuillages sont plus proches
Dans des arbres plus clairs. Et reposent les fruits
Sous l'arche du miroir. Et le soleil
Est haut encore, derrière la corbeille
De l'été sur la table et des quelques fleurs. (DLS, p. 322)

And in its window panes the foliage is nearer
In brighter trees. And the fruits rest
Under the mirror's arch. And the sun
Is high still, behind the basket
Of summer on the table, with a few flowers.

This still life in its plenitude marks the return of confidence. Nevertheless, the final assertion does not return us to that high garden, the nostalgia for which has haunted the space of the poetry before. The text does not demand more than these few flowers, nor does the narration make any pretense at heroic action or noble telling. The imperfect voice, broken, and the barest gesture, brief, are moving as only the simplest act can be:

Oui, par la main que je prends
Sur cette terre. (DLS, p. 325)

Yes, by the hand I take
On this earth.

To capture the sky in a word or in an image is the whole aspiration of this poetry. Even in the untroubled water of the river, or in the threshold repaired, or the fruit now ripened, the statement once heard is not forgotten: "Es-tu venu pour dévaster l'écrit. . . . Je ne t'ai pas permis d'oublier le livre" (DLS, p. 299; Did you come to lay waste the written. . . . I have not permitted you to forget the book). Each word is now to be given its true importance, as written, in the understatement that is Bonnefoy's greatest stylistic strength. The poem ends with the most modest image, reminding us of Rimbaud's mud puddle at the end of his "Bateau ivre" (Drunken Boat), that puddle to which the epic voyage was reduced, and of Bonnefoy's own small pool, where earlier a child was playing:

Les mots comme le ciel,
Infini,
Mais tout entier soudain dans la flaque brève. (DLS, p. 329)

The words like the sky,
Infinite,
But entire suddenly in the brief pool.

And in correspondence, the essay in Bonnefoy's recent book of criticism, *Le Nuage rouge*, concerning convergence, "Painting, Poetry: Vertigo, Peace" picks up the earlier image of a pool and ends with a modest praise of painting, bestowing quietly on the hand as it traces a few words across a page a sudden insight. "Ah, this is no small thing! And the world could very well come to an end, absurdly, for not having understood the worth—for the only quest that matters—of the nearby smell of damp grass, of an ant scurrying across a page, of an owl's hoot at the door as it suddenly illuminates a sign still sealed" (NR, p. 326). The smallest things may be signs, place, and truth, and perhaps even more. For at last and at this last threshold of a painting and poetry now to be crossed, "Le signe est devenu le lieu" (DLS, p. 66; The sign has become the place). But what of color lost, after painting, on the written page? Does the writer imbued with painterly vision still sense a lack in the book?

The answer is implicit, as one might have expected, in a series of meditations Bonnefoy makes on two colors. Poussin's blue tints, for instance, may be efficacious to "deliver him like lightning from the rationality in which . . . his personality was about to be lost" (NP, p. 321). Of the color red, Bonnefoy speaks most convincingly: that color appears in Delacroix, in his violently red sun, "putting an end to centuries of narrative painting" (NR, p. 320), whereas, against the stark black backgrounds in Baudelaire, the reddening of coal mixes with the rose vapors of his twilight: here, the vision is again far more vivid than the content, setting a model for the contemporary poet. The painter Garache, illustrator of Bonnefoy's *Ordalie* and the subject of an essay entitled "In the Color of Garache"—in whose atelier this final essay on the threshold begins—chooses to paint only in rose: "I have spoken of reds opposed to meaning, carried to the point of combustion, where everything is consumed except for the intensity of words" (NR, p. 321). And Mondrian's red cloud, which gives its title to *Le Nuage rouge*, guides the ship passing in the "Lure of the Threshold," and has its implicit echo in Bonnefoy's essay on the haiku, connected as it is to hope, and to color itself, and to lighting: "And desiring to show the sparkling white cloud where all is gathered and dissipated . . . I look on the horizon, in the setting sun, at a red cloud setting the sky aflame with its light, asking myself if it is not the reflection of another light" (Ha, p. xxxvi).

And yet there is nothing for which the writer should envy the painter, not even the red that clarifies the absence of meaning, exalts the intensity of the vision, and guides the passage. For red is only one of the components of the color spectrum, says Bonnefoy, "and since we use them each and know their relationships, here already a language reigns, and

there has been no transgression" (NR, p. 321). Thus the poet answers at last Mallarmé's structure, forming the basis of our concern: nothing, he said, must transgress the reality, of objects, or, as we might add, cross the threshold inarticulately or awkwardly into whatever real is chosen, when words have once restored it to us. This last traversal is to be protected; the multiplicity of visions in the word and the image it translates and captures can be defended. Only the image of a small pool, at the end of a long text, suffices to catch a cloud, or then a constellation, as if they might be consumed and clarified thereby.

To be sure, the word is only black against white; its branchings must somehow show "this presence of everything to everything," this ethical and metaphysical anxiety that is the essence of poetic being. But now at last the painter's signs merge with those of the poet, with those modest scratchings on the page, like the gathering of evening's embers, or with a metaphorical voyage, perhaps the poling of some raft down some river, each assuming the significance visible from the beginning, like so many fragmentary signs now reassembled:

> Le clair, le sombre, leur douce continuité ou la violence du contre-jour . . . c'est plus originel qu'aucun signe humain dans les choses, mais non, c'est déjà une structure, et la plus signifiante et contraignante qui soit, puisque dans sa figure duelle le désarroi ou l'espoir s'inscrivent et se décident. Rien que du noir contre du blanc sur la page, et bruissent déjà toutes les décisions de l'éthique, tout le feuillage des mots. (NR, p. 322)

> The bright and the dark, their gentle continuity, or the violence of the backlighting . . . are more original than any human sign in things, but no, for the least sign is already a structure, and the most meaningful and demanding possible, for, in its dual figure, disarray or hope are chosen and inscribed. Only black against white upon the page, and already all the murmur of moral choices, all the foliage of words.

In the clear light of that perception, cannot the written page be seen to include the image also, joining sign to text, and serving both as threshold and as dwelling for a well-versed eye?

INDEX

Abelard, 88
Ades, Dawn, 67
Adonis, 86
Alabaster, William, 38
M. L'Antipyrine, 133, 141
M. L'Antitête, 133, 135, 141
Apollinaire, Guillaume, 65, 83, 99
arabesque, serpentine, 8, 18, 70-86
Aragon, Louis, 16, 21, 74-75, 85, 90-91,
 137, 155, 178-84, 192
architexture, 7-10
Ariadne, 96
Arnheim, Rudolph, 3, 7-8
Artaud, Antonin, 60, 64, 73, 87-88, 96-
 98, 103, 140, 175-76, 181
Ashbery, John, 51-52, 68-69

Bachelard, Gaston, 38, 157
Balakian, Anna, 182
Barberini Master, 110-11
Baroque, 5, 10, 17-18, 35-37, 41-42, 44,
 60-61, 65, 75, 113, 161-67
Barthes, Roland, 62-63
Baudelaire, Charles, 17, 74, 82-83, 85,
 179, 182
Bernini, Giovanni Lorenzo, 42-43, 63,
 120
Boa Constructor, 7
Bologna, Giovanni de, 51
Bonnefoy, Yves, 15, 21, 24-25, 65, 130,
 173, 189-99
Bordone, Paris, 8, 54, 67, 77
Botticelli, Sandro, 107, 113
Boucher, François, 78
Boulez, Pierre, 152
Brancusi, Constantin, 125-32
Braque, Georges, 8, 91, 172
Breton, André, 35, 37, 47-48, 64-65, 74-
 76, 92-93, 94-95, 168, 172, 176, 192
brisure, 15
Il Bronzino, 76

Calas, Nicolas, 67
Caravaggio, Michelangelo, 169, 170, 172
Carpaccio, Vittore, 111, 162

della Casa, Giovanni, 76, 162
Cave, Terence, 42
Caws, Peter, 3, 172
Caylus, le Comte de, 72
Cellini, Benvenuto, 55
Cendrars, Blaise, 175-77
Cervantes, Miguel de, 73
César, 49, 62
Cézanne, Paul, 166
Char, René, 17, 23-25, 38, 59-60, 64,
 94, 119, 161-67, 171
Chirico, Giorgio de, 8, 65, 67
Claudel, Paul, 146
Closs, August, 108
Clouet, François, 53-59
Cluny tapestries, 60
Cohn, Dorrit, 118
Cohn, Robert Greer, 157
Colonna, Cardinal, 99
conjunctio oppositorum, 55
convulsive beauty, 38
Correggio, 50, 52, 63, 76, 113
Cranach, Lucas, 162
Crashaw, Richard, 35, 42-43, 45-47, 120,
 164
Creeley, Robert, 93
Crivelli, Carlo, 110-12
Cupid, 55, 63; see also Eros

Dada, 16, 87-103
Dali, Salvador, 49
Davies, Gardner, 142
Dayan, Joan, 142
defamiliarization, 8
Deguy, Michel, 16
Delville, Jean, 64
Denny, Don, 107, 120
Derrida, Jacques, 15, 20, 32, 142
Desnos, Robert, 18, 41, 60-61, 75, 77,
 85, 92, 94, 141, 175-79, 183, 185,
 192
Diane de Poitiers, 53-59
Dines, Wayne, 107
Donne, John, 18, 41, 77-78
d'Ors, Eugenio, 50

Dostoievsky, Fyodor, 153
Dubois, Claude-Gilbert, 39
Duchamp, Marcel, 8, 20, 64, 69, 77, 85,
 89-90, 92, 99, 135, 139, 141-57, 177,
 192
Dupin, Jacques, 22-23
Duprey, Jean-Pierre, 89

Eckhart, Meister, 120
Ehrenzweig, Anton, 58
Eisenstein, Sergei, 177
Eisler, Colin, 54
El Greco, 11, 18, 76, 80, 111
Eliot, T. S., 92
Eluard, Paul, 65, 94, 101, 192
Ernst, Max, 6, 61
Eros, 86
explosante-fixe, 38
Les Eyzies, 170; *see also* Lascaux

fil conducteur, 37
Firestone, Gizella, 111
Fletcher, Angus, 15
Flocon, Albert, 49
Fouquet, Jean, 162
Fowlie, Wallace, 92

Gabriel, 107-21
Gabrielle d'Estrées, 53
Galatea, 18
Garache, Claude, 189, 198
Garnier, Pierre, 187
Genêt, Jean, 142
Genette, Gérard, 9, 35, 85
Giacometti, Alberto, 49
Giotto, 162, 169
Gombrich, E. H., 3-5, 7, 9, 161
Góngora, Luis de, 18, 74, 76, 79, 81
Gothic, 79
Graff, William, 109
Greene, Thomas, 37

Hamlet, 73, 92, 125, 141-57
Hanson, Thomas, 77, 112
Hegel, Georg, 142
Heraclitus, 166
Hérodiade, 141-57, 192
hippogram, *see* hypogram
hippothesis, *see* hypogram
Höcke, Gustav, 36-37, 72

Hoffman, Malvina, 128
Hogarth, William, 70
Holbein, Hans, 85
Hölderlin, Friedrich, 16
Hopil, Claude, 65
Hopkins, Gerard Manley, 67
Hopper, Edward, 50
Hulme, T. E., 10
hypogram, 6

Igitur, 92, 125, 132, 156-57
immaculée conception, 63
Ingres, Jean Auguste Dominique, 50
inscape, 87-88, 100
interior distance, 8
intertextuality, 6
intertexturality, 10
Iser, Wolfgang, 7

Jabès, Edmond, 20, 21, 23, 25, 27-30,
 89, 190
Jacob, Max, 77
Jacobson, Richard, 108
James, Carol, 142
Jauss, Hans Robert, 7
Johnson, Barbara, 83, 108
Juno, 79-80

Klein, Richard, 74
Knapp, Bettina, 142
Krauss, Rosalind, 15, 110, 131
Krieger, Murray, 5
Kristeva, Julia, 142

Lafayette, Madame de, 83
Laforgue, Jules, 92, 142, 146-47, 154-57
Laocoön, 18
Lascaux, 170
de la Tour, Georges, 18, 42, 47, 66, 69,
 102, 161-67, 170
Lautréamont, 74, 85
Lazarus, 54-56, 169, 171-72
LeCoat, Gérard, 36-37
Ledoux, Claude-Nicolas, 100
Leiris, Michel, 60, 62, 82, 92, 118-19
Leishman, J. B., 109
Le Moyne, 44-45
Leonardo, 64
limen, 15-16
Linkhorn, Renée, 151

Lippi, Fra Filippo, 114
de l'Isle Adam, Villiers, 142
Lomazzo, Gian Paolo, 37
Lord Patchogue, 102-103
"losing the surface," 9
Lotto, Lorenzo, 113
Loy, Robert, 82
Lyotard, Jean-Pierre, 108

Magritte, René, 55-56, 60, 65, 90, 99-102, 113, 142
Maharajah of Indore, 125
Mallarmé, Stéphane, 8, 17-18, 20, 22-23, 28, 30, 32, 76, 79, 81-83, 88-90, 124-57, 179, 190, 192
Malraux, André, 17, 168-73
Mannerism, 5-6, 9-10, 18, 36-38, 40, 42, 47, 49-51, 53, 60, 76, 81, 84, 113, 165
Man Ray, 8, 49, 77, 134
Mantegna, Andrea, 162
Marin, Louis, 49, 108
Marino, Giambattista, 8, 18, 37, 74, 77-78, 81
Marinetti, Filippo, 137
Marivaux, Pierre de, 82
Martz, Louis, 18
Marvell, Andrew, 74-76
Mary (Virgin), 18
Mary Magdalen, 42-47, 66, 69, 102, 161-64, 166
Matisse, Henri, 16, 91
Mauron, Charles, 156
McCormick, Allen, 118
Melmoth the Wanderer, 73-74
Mercury, 51, 132
metaphysical, 17, 35-36, 42, 67
Michaux, Henri, 96-99
mise-en-abyme, 15
Mondrian, Piet, 198
Moulin Master, 112

Nadja, 19, 47, 63-64, 66, 144
Navagero, Andreas, 76
Nichols, Fred, 76
Nietzsche, Frederick, 169, 171

Oedipus, 58, 64
Ong, Walter, 107
Orion, 161-62, 165-66

Panofsky, Erwin, 6
Paris, Jean, 17, 57, 107
Il Parmigianino, 51-52, 55-60
Pascal, Blaise, 171
passage de l'Opéra, 74
Le Paysan de Paris, 96
Paz, Octavio, 149
Péladan, Sar, 84
Péret, Benjamin, 99
Petersson, Robert, 43
Peyre, Henri, 6
Picasso, Pablo, 17, 60, 64-65
Piero della Francesca, 112
Plato, 171
Poe, Edgar Allan, 8, 71, 74, 81, 85, 101
Polonius, 155
Pongs, H., 109
Pontormo, Jacopo da, 84, 110
Pope, Alexander, 8, 71, 74, 82
Poulet, Georges, 8
Pourbus, Frans, 53
Poussin, Nicolas, 18, 49-50, 114-15, 161-62, 191, 198
Praz, Mario, 5, 17, 72
L'Abbé Prévost, 82

Ray, Lionel, 21-25, 30-32; as Robert Lorho, 99
Raymond, Marcel, 54
Ready Maid, 150
Redon, Odilon, 4, 65, 99
Reinhardt, Ade, 85
Rembrandt, 17, 162, 167, 169, 171
Reverdy, Pierre, 17, 20, 23, 25-27
Ribemont-Dessaignes, Georges, 135-37
Riffaterre, Michael, 6
Rigaut, Jacques, 88, 102-103
Rilke, Rainer Maria, 18, 104-21, 165
Rimbaud, Arthur, 179, 197
Robbe-Grillet, Alain, 127, 181
Roche, Denis, 20
Rococo, 5, 8, 70-86
Roethke, Theodore, 7, 17
Ronsard, Pierre de, 80
Rossetti, Dante Gabriel, 18, 102, 114
Rousseau, Jean-Jacques, 8, 74, 82
Rousset, Jean, 35-36
Rrose Sélavy, 85, 134-35, 141
Rubens, Peter Paul, 172

Rudrauf, Lucien, 106, 113
Ruskin, John, 114

Sacré, James, 39
St. Aubyn, Frederic, 63
Saint Augustine, 43
Saint John the Baptist, 51,142-49
Saint John of the Cross, 37
Saint Teresa, 42-46, 63, 78, 120
Saint-Pol-Roux, 174-88
Saint Ursula, 111
Salomé, 51, 142
Salviati, Francesco, 26
Sartre, Jean Paul, 10
Savinio, Albert, 115
Scève, Maurice, 74, 77, 81
Schefer, Jean-Louis, 36, 54
Schérer, Jean-Jacques, 143
Schlegel, Friedrich, 70-72, 80
Schwenger, Peter, 35
Seghers, Gerhard, 42, 120
self-reference, 8
Serres, Michel, 111
Shakespeare, William, 17
Sheppard, Richard, 104
Sibony, Daniel, 73
Sidney, Philip, 74, 78, 81
Sima, Josef, 161
Sonnenfeld, Albert, 77
Soutine, Chaim, 17
Spatialism, 16, 187
Spear, Athena Tacha, 128
Sphinx, 50
Sponde, Jean de, 18
Steinberg, Leo, 6-7
Stevens, Wallace, 170
Stokes, Adrian, 58
Storck, Joachim, 104
Surrealism, 5, 10, 17-19, 35-38, 41-42,

47, 49-50, 53, 64-69, 74, 76, 87-103,
174-88
Swinburne, Algernon, 74
Symbolism, 5, 10, 17, 81, 89
Sypher, Wylie, 37, 81

Tauler, Johannes, 120
Taylor, Joshua, 92
Tesauro, E., 35, 47
Tieck, Ludwig, 83
Tintoretto, 10, 18, 51, 76, 114-15
Titian, 18, 59, 76, 80, 112-13, 115
transparency, 10
Turner, Victor, 92
Tzara, Tristan, 37, 65, 91-92, 94-96, 126,
136-37, 150-57

Uccello, Paolo, 50, 63, 88-90, 162
unicorn, 24, 55-60, 119

Valéry, Paul, 8, 23, 65, 70, 74, 82
Van Eyck, Jan, 89, 110, 162
Van Gennep, Arnold, 92
Vasari, Giorgio, 50
Velásquez, Diego, 43
Venus, 79-80
Veronese, Paolo, 112-13
via oscura, 38
Vogeler, Heinrich, 109

Warnke, Frank, 43
Watteau, Antoine, 71, 81, 84
Whistler, James Abbot McNeill, 189
Wieland, Christoph, 75
Wilde, Oscar, 182
Williams, William Carlos, 86
Wölfflin, Heinrich, 4
wound, 22-30, 79

Zerner, Henri, 37

Library of Congress Cataloging in Publication Data

Caws, Mary Ann.
 The eye in the text.

 Includes bibliographical references and index.
 1. Arts—Psychological aspects—Addresses,
essays, lectures. 2. Perception—Addresses, essays,
lectures. 3. Visual perception—Addresses, essays,
lectures. I. Title.
NX165.C38 701'.1'5 80-8540
ISBN 0-691-06453-9
ISBN 0-691-01377-2 (pbk.)

Mary Ann Caws is Professor of Comparative Literature and French at Hunter
College and the Graduate Center, City University of New York.

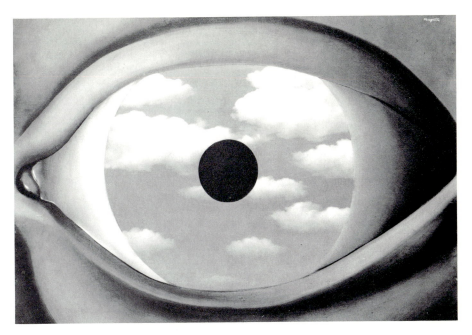

1. (top) Magritte, *The False Mirror*. The Museum of Modern Art, New York. 2. (bottom) Redon, *The Vision*. Bibliothèque Nationale, Paris.

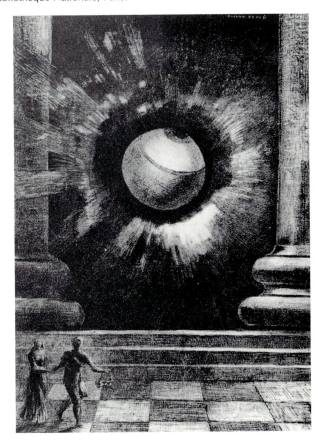

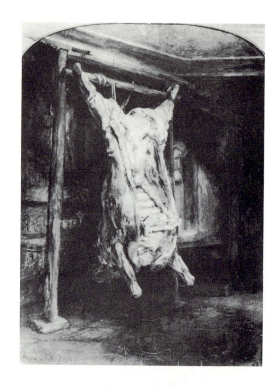

3. (top) Rembrandt, *Flayed Ox*. Louvre, Paris. 4. (bottom) Soutine, *Flayed Ox*. Musée de Grenoble.

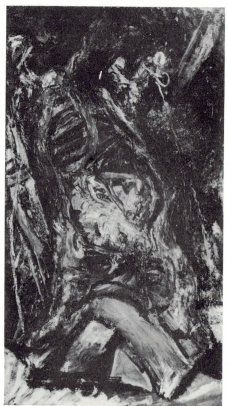

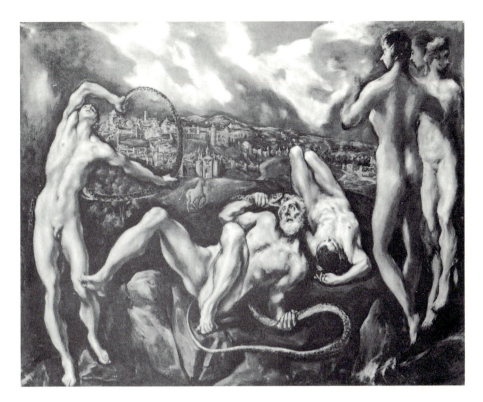

5. (top) El Greco, *Laocoön*. National Gallery of Art, Washington, D.C. 6. (bottom) Titian, *Venus and the Organ Player*. Museo del Prado, Madrid.

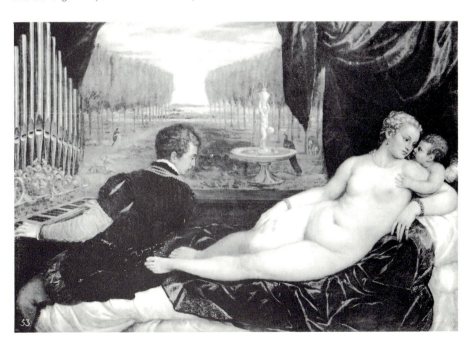

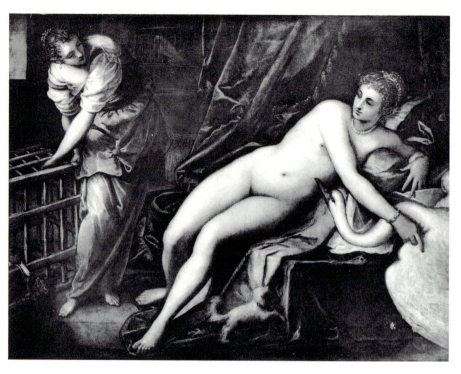

7. (top) Tintoretto, *Leda and the Swan*. Galleria degli Uffizi, Florence. 8. (bottom) Desnos, "Vanity Memory of the Swan" in *The Night of Loveless Nights*. The Museum of Modern Art, New York.

vanité souvenir du cygne

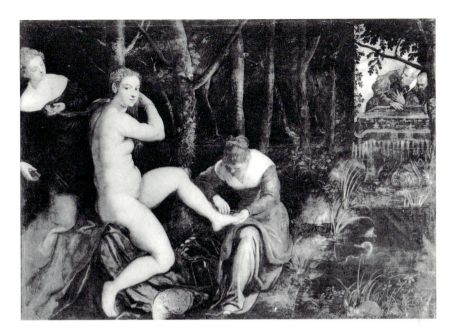

9. (top) Tintoretto, *Suzanne and the Elders*. Louvre, Paris. 10. (bottom) Titian, *Venus and Adonis*. Museo del Prado, Madrid.

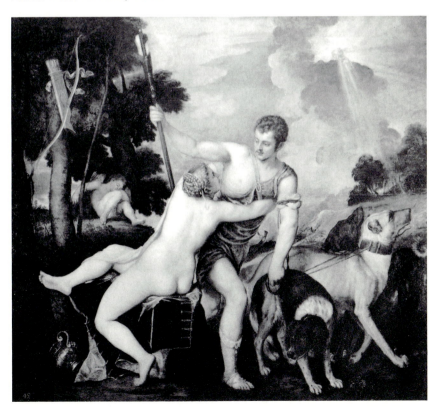

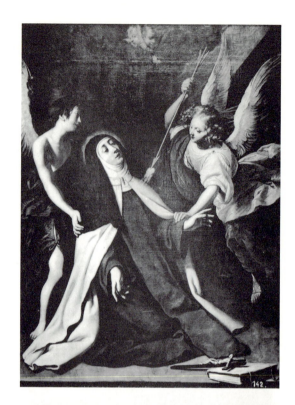

11. (top) Seghers, *St. Teresa in Ecstasy*.
Koniklijk Museum voor Schone Kun-
sten, Antwerp. 12. (bottom) Bernini,
St. Teresa in Ecstasy. Santa Maria della
Vittoria, Rome.

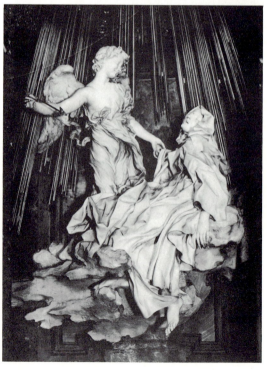

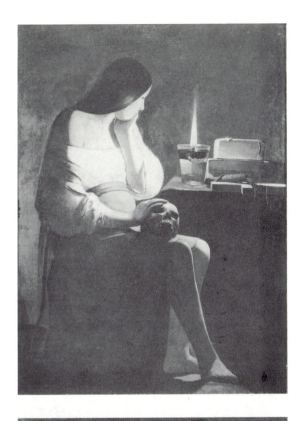

13. (top) de La Tour, *Magdalen with the Vigil-Lamp*. Louvre, Paris.
14. (bottom) De la Tour, *Repentant Magdalen*. National Gallery of Art, Washington, D.C.

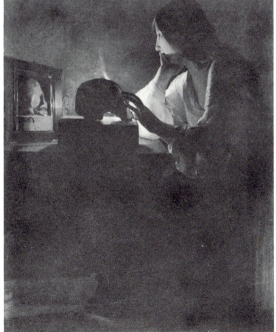

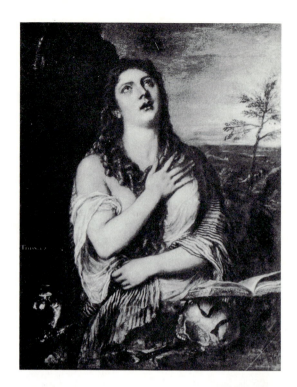

15. (top) Titian, *The Magdalen*. Hermitage, Leningrad. 16. (bottom) Rossetti, *Beata Beatrice*. The Tate Gallery, London.

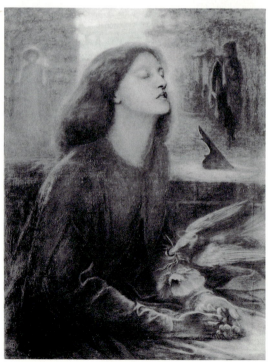

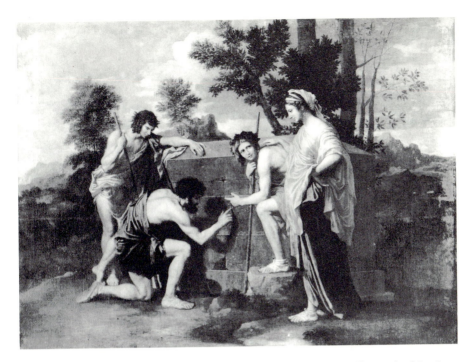

17. (top) Poussin, *Shepherds of Arcady*. Louvre, Paris. 18. (bottom) Uccello, *Battle of San Romano*. Louvre, Paris.

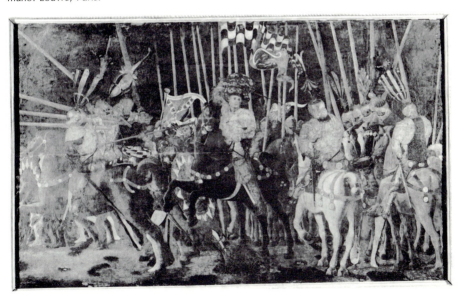

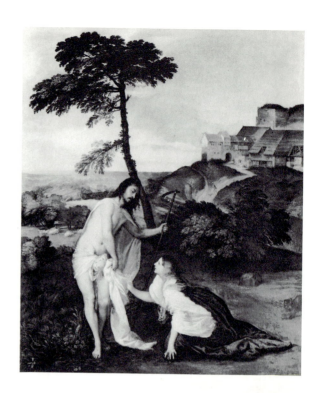

19. (top) Titian, *Noli me tangere*. National Gallery of Art, Washington, D.C. 20. (bottom) Correggio, *Noli me tangere*. Museo del Prado, Madrid.

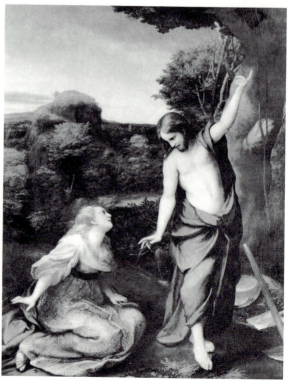

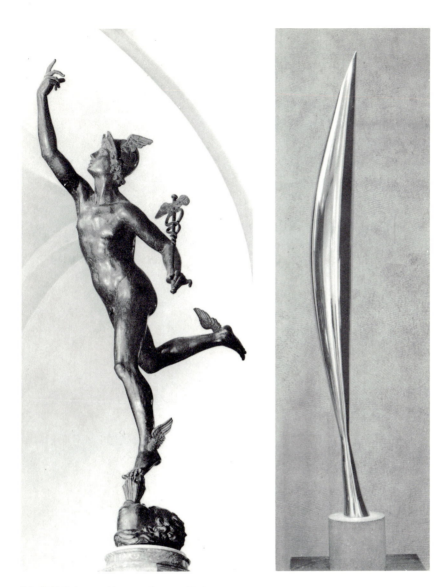

21. (left) Bologna, *Mercury*. Louvre, Paris.
22. (right) Brancusi, *Bird in Space*. The Museum of Modern Art, New York.

23. (top) Il Parmigianino, *Self-Portrait in a Convex Mirror*. Kunsthistorisches Museum, Vienna.
24. (bottom) Titian, *Venus of Urbino*. Galleria degli Uffizi, Florence.

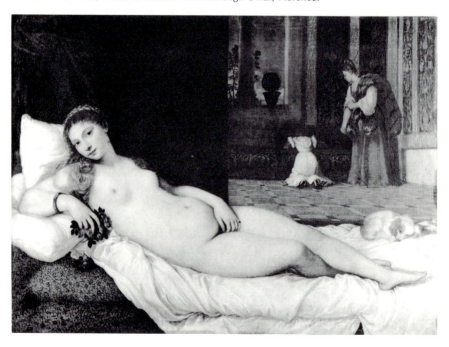

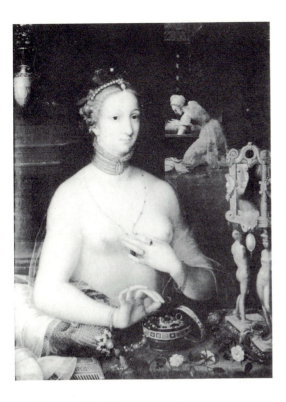

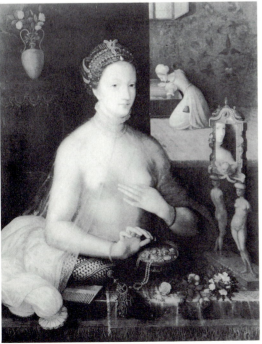

25. (top) Ecole de Fontainebleau, *Woman at her Toilette*. Musée de Dijon. 26. (bottom) Ecole de Fontainebleau, *Woman at her Toilette*, Worcester Art Museum.

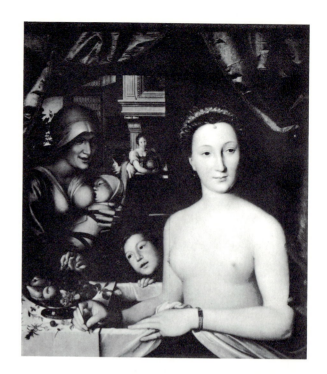

27. (top) Clouet, *Diane de Poitiers*.
Cook Gallery, Richmond.
28. (bottom) France, second half of
the sixteenth century, *Portrait of
Gabrielle d'Estrées in her Bath*.
Musée de Condé, Chantilly.

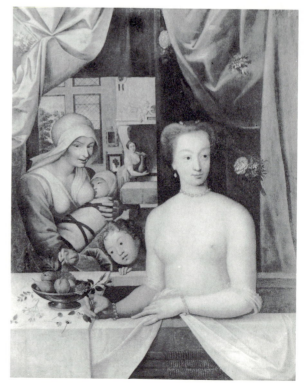

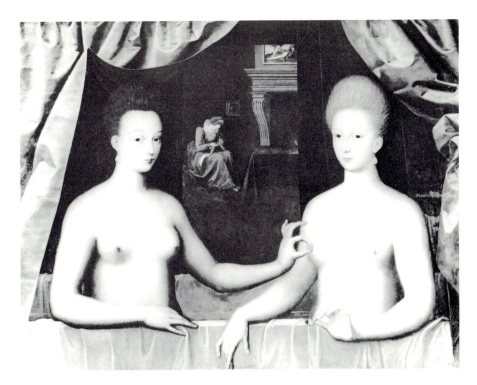

29. (top) Ecole de Fontainebleau, *Double Portrait of Gabrielle d'Estrées and her Sister*. Louvre, Paris. 30. (bottom) Ecole de Fontainebleau, *Gabrielle d'Estrées and the Duchesse de Villars*. Hotel de Lunaret, Montpellier.

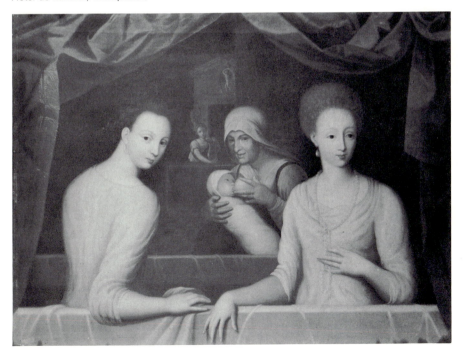

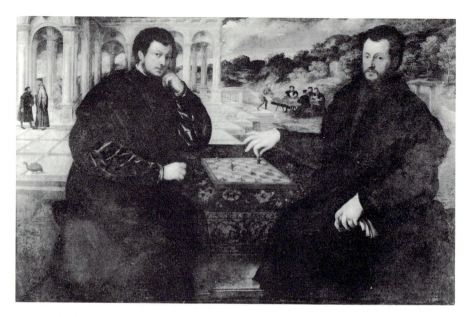

31. (top) Bordone, *The Chess Game*. Staatliche Museen Preussischer Kulturbesitz, Gemälde-Galerie, West Berlin. 32. (bottom) De Chirico, *The Enigma of Fatality*. Kunstmuseum Basel.

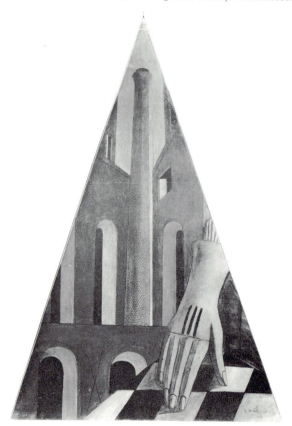

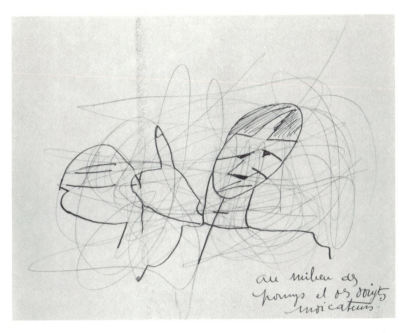

33. (top) Desnos, "In the Middle of Signaling Fists and Fingers," in *The Night of Loveless Nights*. The Museum of Modern Art, New York. 34. (bottom) César, *Thumb*. Centre George Pompidou, Paris.

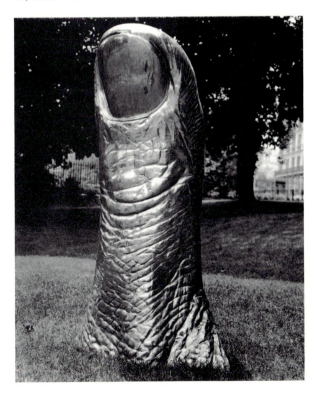

35. (top) Duchamp, *Encore à cet astre*.
Philadelphia Museum of Art.
36. (bottom) Duchamp, *Etant données*.
Philadelphia Museum of Art.

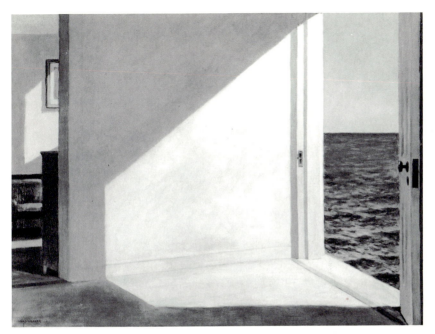

37. (top) Hopper, *Rooms by the Sea*. Yale University Art Gallery. 38. (bottom) Magritte, *Poison*. Edward James Foundation.

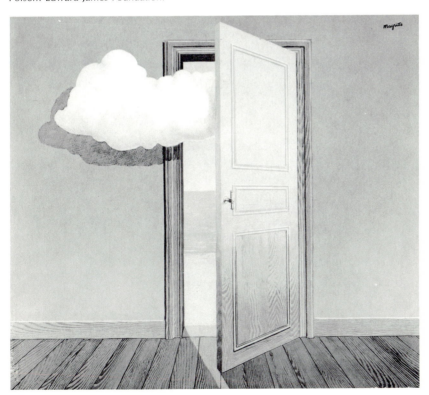

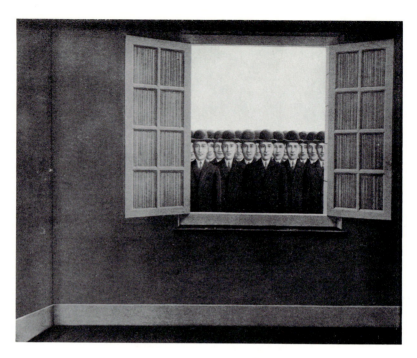

39. (top) Magritte, *The Month of Harvest*. Private collection. 40. (bottom) Magritte, *In Praise of Dialectic*. Musée d'Ixelles, Brussels.

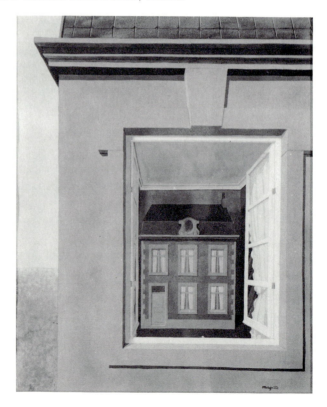

41. (top) Magritte, *Reproduction Forbidden*. Museum Boymans-van Beuningen, Rotterdam. 42. (bottom) Magritte, *The House of Glass*. Museum Boymans-van Beuningen, Rotterdam.

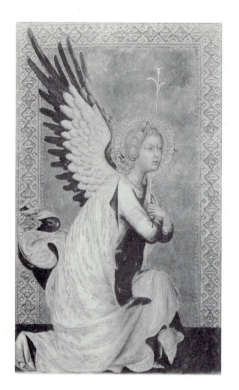
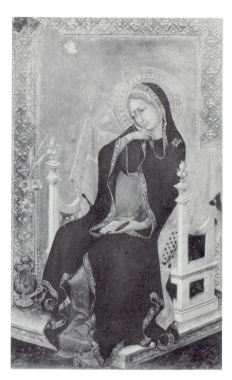

43. (top) Martini, *The Annunciation*. Koninklijk Museum voor Schone Kunsten, Antwerp. 44. (bottom) Masolino da Panicale, *The Annunciation*. National Gallery of Art, Washington, D.C.

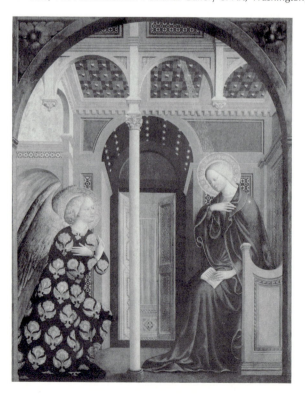

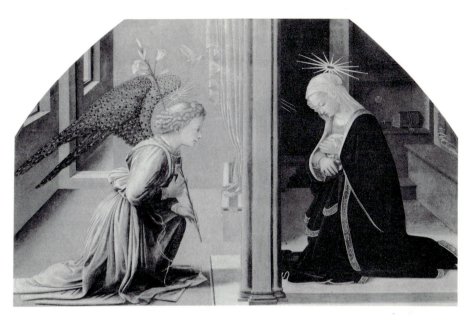

45. (top) Lippi, *The Annunciation*. National Gallery of Art, Washington, D.C. 46. (bottom) Barberini, *The Annunciation*. National Gallery of Art, Washington, D.C.

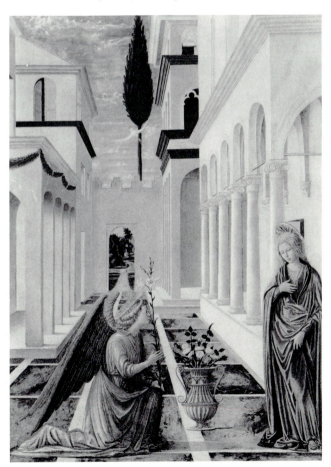

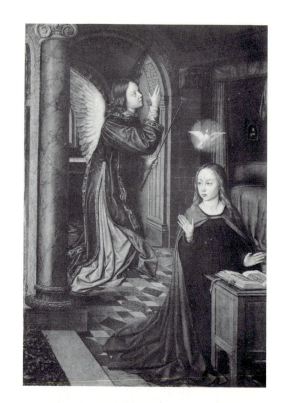

47. (top) Maître de Moulins, *The Annunciation*. The Art Institute of Chicago.
48. (bottom) Rossetti, *The Annunciation*. The Tate Gallery, London.

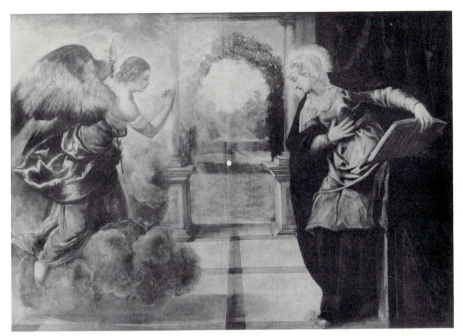

49. (top) Tintoretto, *The Annunciation*. Staatliche Museen zu Berlin, Gemälde-Galerie, West Berlin. 50. (bottom) Tintoretto, *The Annunciation*. Scuola di San Rocco, Venice.

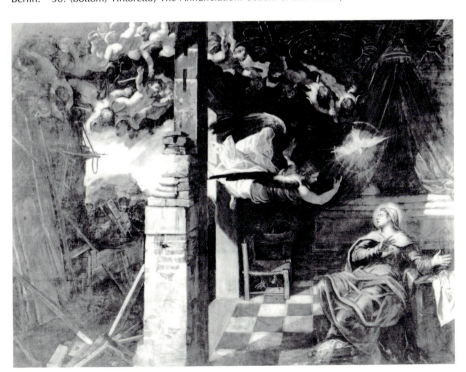

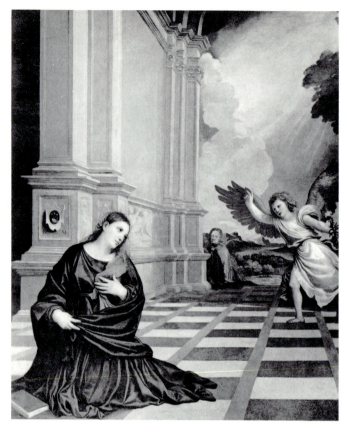

51. (top) Titian, *The Annunciation*. Cattedrale, Treviso. 52. (bottom) Titian, *The Annunciation*. Scuola di San Rocco, Venice.

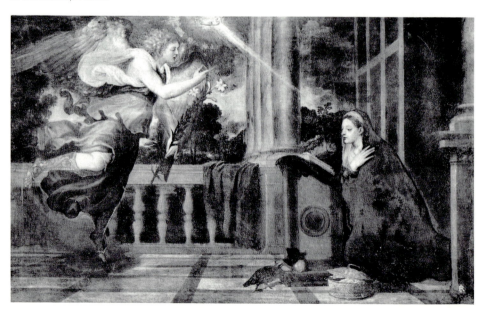

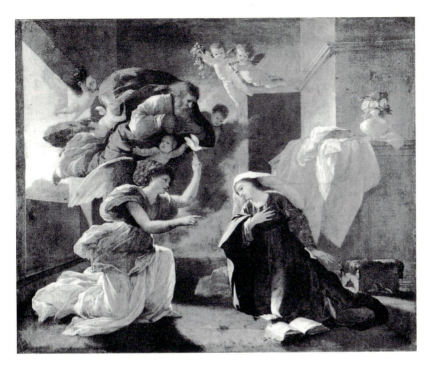

53. (top) Poussin, *The Annunciation*. Musée Condé, Chantilly. 54. (bottom) Poussin, *The Annunciation*. The National Gallery of Art, London.

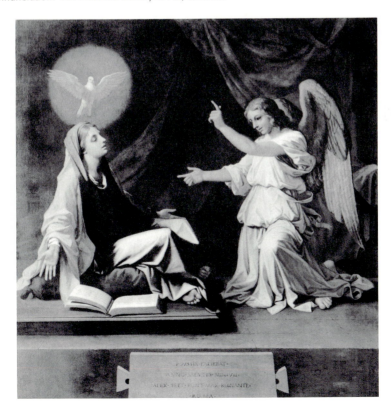

55. (top) Brancusi, *Beginning of the World*. Musée National d'Art Moderne, Paris. 56. (bottom) Brancusi, *Beginning of the World*. Dallas Museum of Fine Arts.

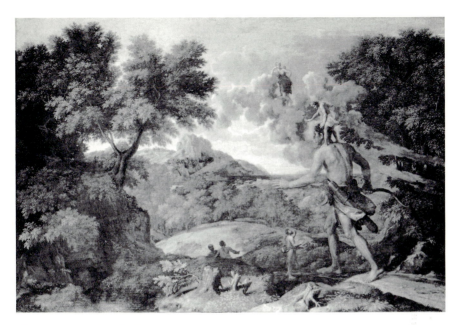

57. (top) Poussin. *The Blind Orion Searching for the Rising Sun*. The Metropolitan Museum of Art, New York. 58. (bottom) Poussin, *Moses Saved from the Waters*. Louvre, Paris.

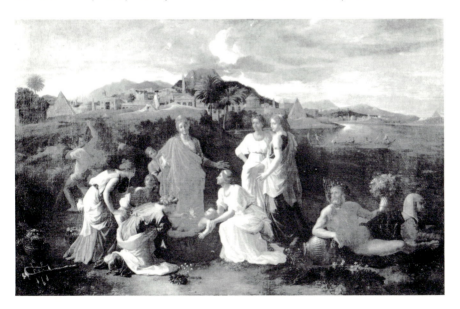

59. Garnier, "Soleil Mystique," from *Spatialisme et Poésie concrète* (Paris: Gallimard, 1968), pp. 168-169.

il se prête au frisson tragique des feux à proportion
de ses refus, en face d'un parapluie : nu de Cranach
ou robe de Watteau prétexte visible à solitude immense
(innocence des pommes) puis un appel où semer ces rou
coulements de fleurs ces eaux suaves la
graine des fo- rêts, n'insul
tez pas la nuit aux
draps sans sa
gesse aux fr
uits aveu gles demâ
in le miel au be éparse épa
noue l'objet réel comme feuillage
intime (lui qui peignait une évasion traçant des gos-
tes aux cheveux pâles des routes ressemblantes et bru
squement un cheval d'Uccello ces lignes rares magie de
l'oiseau géomètre) il est la clef unique féconde ces
bleus mouvants, serait la revanche d'un enfant perdu
qui a compris les paroles dormantes les risques les
pôles l'équilibre du comme, étoile de ses nostalgies

Œil où
tournent les
sphères centre
lucide vorace
où tout s'
engloutit

le mot écriture lent comme un mufle de taureau sourd
comme l'audace et le blanc qui imite les fleurs à la
manière des joies mais solitaire épaule de colline et
présence extrême mains greffées de feuilles nous vi-
vons dans un mot physique dans un objet à figure jau-
ne éclairé par la so litude dans un jar
din à mi-chemin entre l'ombre
et la mélan colie pos
sédés par l'
incar nation
des voix dans les
yeux imaginai res multiples
où foisonnent les champs chaque jour
nous approchons de toutes parts de l'infini : jeter ces
confuses couleurs cet éparpillement cracher au soleil
que les fruits éclatent saignent pourrissent *Lionel*
Ray pas plus que moi n'existe sinon dans ce vêtement
qui nous construit arbres cortèges combats complots,
fermer les yeux des objets inassouvis des races vieil-
lissantes posséder tous les mirages le génie des ours
ins des fées être l'immédiat l'interdiction le feu ca
ché entrer dans cet aveuglement qui me justifie dans
l'impatience des possibles, ——— le sang nu

Œil où
j'inscris Ray
nom qui ouvre
et qui ferme
les chemins
du soleil

60. Ray, Passage from Les Metamorphoses du biographe, suivi de la Parole possible (Paris: Gallimard, 1971), pp. 118-119.

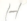

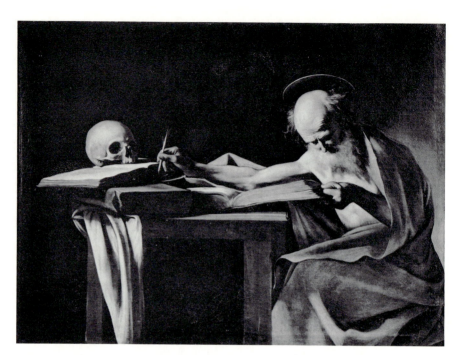

61. (top) Caravaggio, *St. Jerome*. Galleria Borghese, Rome. 62. (bottom) Magritte, *L'Oeil*. Collection of Madame Georgette Magritte, Brussels.